WHAT WAS OBSERVED BY US

IS THE NATURE OR MATTER OF THE MILKY WAY ITSELF,

WHICH, WITH THE AID OF THE SPYGLASS,

MAY BE OBSERVED SO WELL THAT ALL THE DISPUTES

THAT FOR SO MANY GENERATIONS HAVE VEXED PHILOSOPHERS

ARE DESTROYED BY VISIBLE CERTAINTY,

AND WE ARE LIBERATED FROM WORDY ARGUMENTS.

GALILEO GALILEI

MEDICAL STATISTICS WILL BE OUR STANDARD OF MEASUREMENT:

WE WILL WEIGH LIFE FOR LIFE AND SEE WHERE THE DEAD LIE THICKER,

AMONG THE WORKERS OR AMONG THE PRIVILEGED.

RUDOLF VIRCHOW

IF YOU LOOK AFTER TRUTH AND GOODNESS

BEAUTY LOOKS AFTER HERSELF.

ERIC GILL

EDWARD R. TUFTE

BEAUTIFUL EVIDENCE

GRAPHICS PRESS LLC

Third printing, May 2010

Contents

With gratitude to my excellent colleagues at Graphics Press,
for their help with my books, teaching, and landscape sculpture:

Karen Bass, Cynthia Bill, Andrew Conklin, John Fournier, Brian Kelly,
Elaine Morse, Kathy Orlando, Peter Taylor, Carolyn Williams

Introduction

A COLLEAGUE of Galileo, Federico Cesi, wrote that Galileo's 38 hand-drawn images of sunspots "delight both by the wonder of the spectacle and the accuracy of expression." That is beautiful evidence.

EVIDENCE that bears on questions of any complexity typically involves multiple forms of discourse. Evidence is evidence, whether words, numbers, images, diagrams, still or moving. The intellectual tasks remain constant regardless of the mode of evidence: to understand and to reason about the materials at hand, and to appraise their quality, relevance, and integrity.

SCIENCE and art have in common *intense seeing*, the wide-eyed observing that generates empirical information. *Beautiful Evidence* is about *how seeing turns into showing*, how empirical observations turn into explanations and evidence. The book identifies excellent and effective methods for showing evidence, suggests new designs, and provides analytical tools for assessing the credibility of evidence presentations.

EVIDENCE presentations are seen here from both sides: how to *produce* them and how to *consume* them. As teachers know, a good way to learn something is to teach it. The partial symmetry of producers and consumers is a consequence of the theory of analytical design, which is based on the premise that the *point of evidence displays is to assist the thinking of producer and consumer alike.* Evidence presentations should be created in accord with the common analytical tasks at hand, which usually involve understanding causality, making multivariate comparisons, examining relevant evidence, and assessing the credibility of evidence and conclusions. Thus the principles of evidence display are derived from the universal principles of analytical thinking—and not from local customs, intellectual fashions, consumer convenience, marketing, or what the technologies of display happen to make available. The metaphor for evidence presentations is analytical thinking.

MAKING an evidence presentation is a moral act as well as an intellectual activity. To maintain standards of quality, relevance, and integrity for evidence, consumers of presentations should insist that presenters be held intellectually and ethically responsible for what they show and tell. Thus *consuming* a presentation is also an intellectual and a moral activity.

HERE we will see many close readings of serious evidence presentations—ranging through evolutionary trees and rocket science to economics, art history, and sculpture. Insistent application of the principles of analytical thinking helps both insiders and outsiders assess the credibility of evidence.

THE images and diagrams in this book reward careful study. Many are excellent treasures, complex and witty, intense with meaning. Some 20 illustrations are special beauties; these page-spreads, greatly enlarged, are published separately in a series of large fine-art bookprints. Several images have been edited and redrawn (as indicated in the citations) to repair battered originals, make color separations, and improve the design. Primary sources, the themes for my variations, are always indicated.

MY books are self-exemplifying: the objects themselves embody the ideas written about. This has come about, in part, because my work is blessedly free of clients, patronage, or employers. Enchanted by the wonder of the spectacle and the accuracy of expression of excellent displays of information and evidence, and inspired by the idea of self-exemplification, I have written, designed, and self-published 4 books on visual evidence and its representation:

The Visual Display of Quantitative Information (1983, 2001)

Envisioning Information (1990)

Visual Explanations: Images and Quantities, Evidence and Narrative (1997)

Beautiful Evidence (2006)

At least a quintet is expected.

THE principles of analytical thinking (and thus analytical design) are universal — like mathematics, the laws of Nature, the deep structure of language — and are not tied to any language, culture, style, century, gender, or technology of information display. As a result, our examples are widely distributed in space and time; the illustrations come from 14 centuries, 16 countries, 3 planets, and the innumerable stars. From the illustrations, it is difficult to identify what place or time this book is from, which is the point.

Acknowledgments

Many have provided advice, examples, and assistance during the past
8 years. I remember gratefully:

For their work in providing original visual material for this book:
Nicolas Bissantz (photograph), Jean Dubout (photograph), Tim Granger
(bumps chart), Philip Greenspun (photographs), Megan Jaegerman
(news graphic of gun detection), S. Alex Kandel (hyperbolic paraboloid),
Claudine Kleb (photographs), Dmitry Krasny (typeface ETBembo),
Stephen Malinowski (music animation machine), Peter Norvig (Lincoln's
Gettysburg address in PowerPoint), W. Brad Paley (sparklines), and
Bonnie Scranton (logarithmic graph of animals, letterform graphics).
Uncredited photographs were taken by the author.

For co-authoring the material on the Budapest Stalin, Reuben Fowkes.

For superb research work, Graham Larkin at Harvard University;
Justin Florence, Karen Weise, and Patricia Thurston at Yale University;
Dawn Finley and Virginia Tufte at the University of Southern California.

For translations, Dawn Finley (French), Reuben Fowkes (Eastern
European languages), Kenneth Lapatin (Latin).

For the valuable and lyrical published translations by Joscelyn Godwin
(*Hypnerotomachia*), Albert Van Helden (Galileo's works), and Brooks
Haxton (Victor Hugo's poems).

For production, design assistance, and reconstructions of the translated
Centaur and Minard's *French Invasion of Russia*, Elaine Morse.

For work on landscape sculpture, Andrew Conklin; John Hilzinger, Sr
and John Hilzinger, Jr of Heavyweight, Inc; John Gavin of United
Concrete; and the fine staff at Polich Tallix foundry.

For helpful ideas and reviews of the manuscript, Nicholas Cox,
Inge Druckrey, Howard I. Gralla, Megan Jaegerman, Graham Larkin,
Seth Powsner, and Virginia Tufte. Drafts of 3 chapters were posted
at my website, where an invisible college of Kindly Contributors made
many good suggestions and helped correct my errors.

Most of all, I am grateful to my Graphics Press colleagues, to whom
this book is dedicated.

March 2006

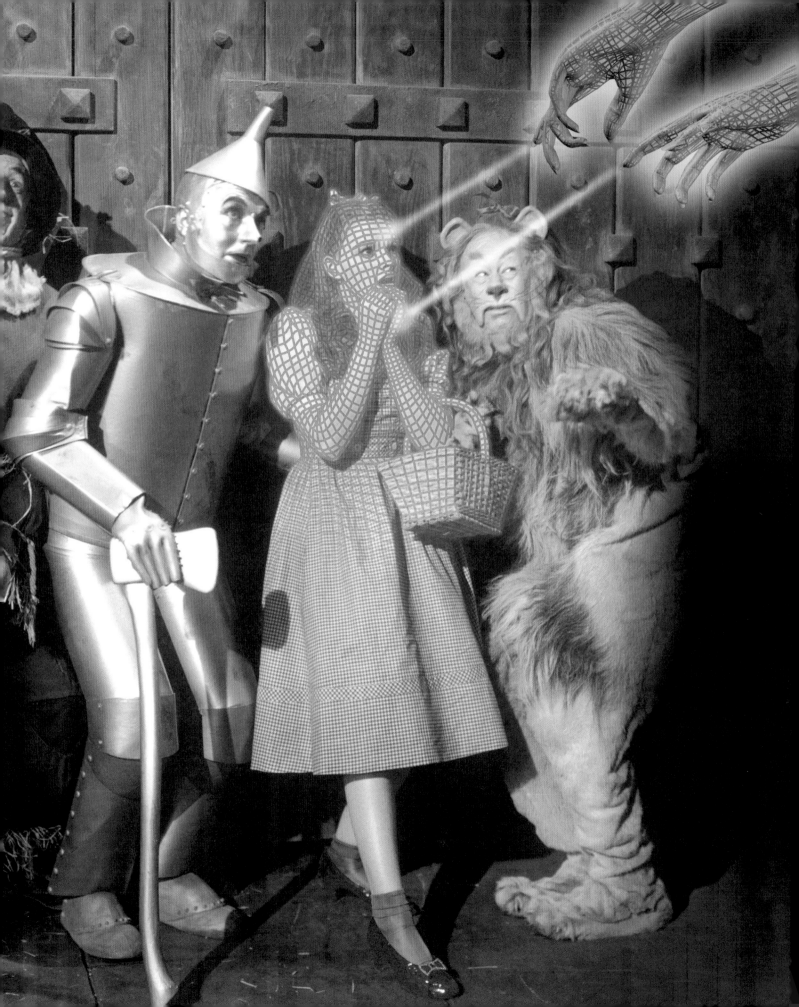

Mapped Pictures: Images as Evidence and Explanation

UPON seeing the satellites of Jupiter, Galileo recorded the discovery by means of hundreds of *annotated and scaled images*:

This series of drawings noted the observation time, labeled the 3 satellites, and measured distances in terms of Jovian-radii, the only relevant unit of measurement available. Because of the detailed annotations, the drawings became *credible quantitative evidence* about satellite motion, not merely still-land sketches of telescopic views. Many images in Galileo's scientific notebooks are annotated with words, numbers, scales, linking lines.

When Francis Crick and James Watson identified the structure of DNA, they constructed a 3-dimensional demonstration model. The photograph shows a label with a measurement scale, 0 to 10 angstroms. This becomes especially notable upon recalling that 1 centimeter = 100,000,000 angstroms and 1 inch = 254,000,000 angstroms. Should not most explanatory images of DNA—from journalism to science—show the molecule with a scale of measurement? Such documentation assists understanding, helps to turn a visual representation into more precise evidence, and may even signal that the display is explanatory rather than commercial art. It also makes clear to readers the incredibly small scale of the workings of the genetic code that Crick and Watson sought to explain.

Unlike Galileo's annotated images and the DNA model, many scientific images today are published simply as amazing celebratory photographs, without any scale of measurement or relevant comparison. Here, placing a comparable image of Earth next to Saturn provides some sense of scale for the millions of people admiring astronomical pictures in newspapers and on television and computer screens. Scales of measurement are part of the news, no matter what the marketing department believes.

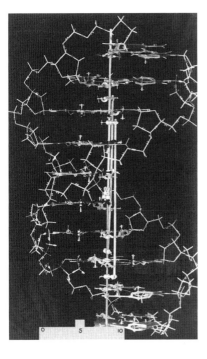

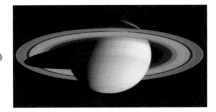

EXPLANATORY, journalistic, and scientific images should nearly always be mapped, contextualized, and placed on the universal grid. *Mapped pictures* combine representational images with scales, diagrams, overlays, numbers, words, images. Good mappings of realistic images have been produced throughout the long history of visual displays, but not often enough. An explanatory image is an explanatory image because it is a *mapped* image. Sensibly mapped pictures nearly always outperform purely pictorial representations for presenting, explaining, and documenting evidence.

Galileo's manuscripts: *Le Opere di Galileo Galilei*, edited by Antonio Favaro (Florence, 1890-1909, 1964-1966), volume 3, part 2. DNA model: James D. Watson, *The Double Helix* (New York, 1968), 206. Image of Saturn: Cassini spacecraft, March 27, 2004, Cassini Imaging Team, SSI, JPL, ESA, NASA. *Wizard of Oz*, Mirko Ilić Corp., for David Kehr, "When a Cyberstar Is Born," *The New York Times* (November 18, 2001), 2-1.

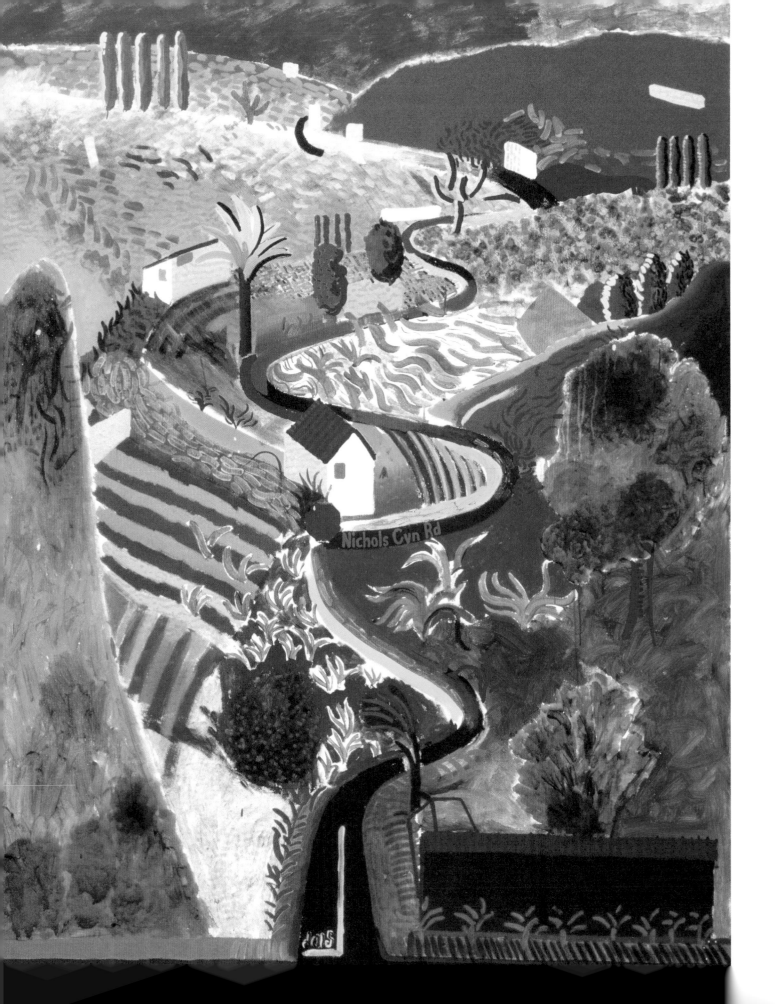

DAVID HOCKNEY'S *Nichols Canyon* shows just about the minimal possible mapping of an image. Placed on the painting is a single non-pictorial detail external to the motif, a road name jauntily mapped onto the road image. Cartographic-style lettering (typeface, abbreviation of "canyon") explicitly expresses the map metaphor. More interplay of word and image takes place on the pavement at the anamorphic ▨, which reads correctly from the foreshortened viewpoint of those on the road. Like many representational images, *Nichols Canyon* is inherently scaled, sort of, since objects of more or less known size appear in the scene.

This cockatoo is mapped by a ruler at lower right ("scale of 6 inches") and by the plant leaves. All other cockatoo data are buried in 6 fat text-only volumes (Latin and French in parallel), linked awkwardly by codes to a separate atlas of 261 fine hand-colored engravings. Perhaps because it is so difficult to coordinate all the heavy books, the text volumes in my set, once part of an ornithological library, reveal no signs of use since their publication 244 years ago. In contrast, the atlas of plates is well-worn.

David Hockney, *Nichols Canyon*, 1980, (214 × 153 cm, 84 × 60 in), acrylic on canvas.

Mathurin Jaques Brisson, *Ornithologie ou méthode contenant la division des oiseaux en ordres, sections, genres, espèces & leurs variétés* (Paris, 1760), engraved by François Nicolas Martinet, atlas plate *Tom. IV, Pl. XXI.*

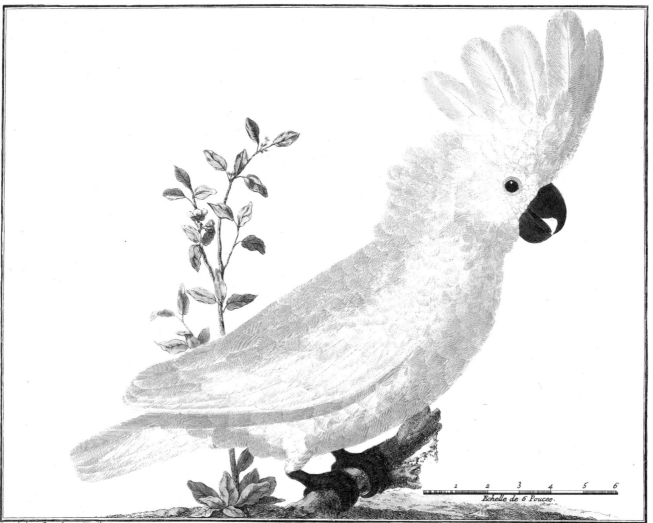

Dessiné et Gravé par Martinet.

Kakatoes.

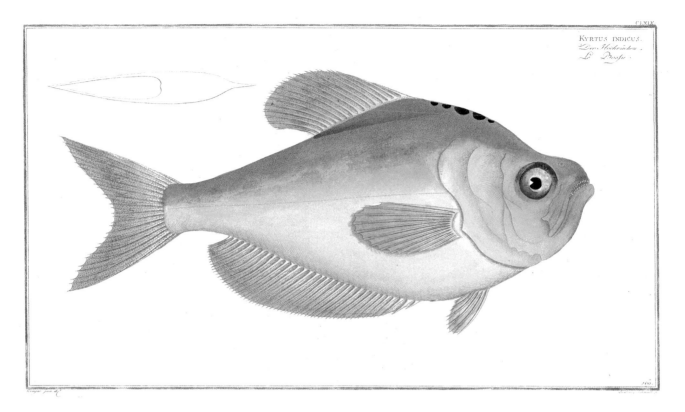

Among the most beautiful natural history books ever, Markus Bloch's *Ichthyologie* presents 216 fishes, from tiny seahorses to large sharks, all drawn to fit exactly into identical boxes framing the images. Thus every fish has both a *different and unknown* scale of measurement.

Markus-Eliezer Bloch, *Ichthyologie, ou Histoire Naturelle, Générale et Particulière des Poissons*, 6 volumes (Berlin, 1795).

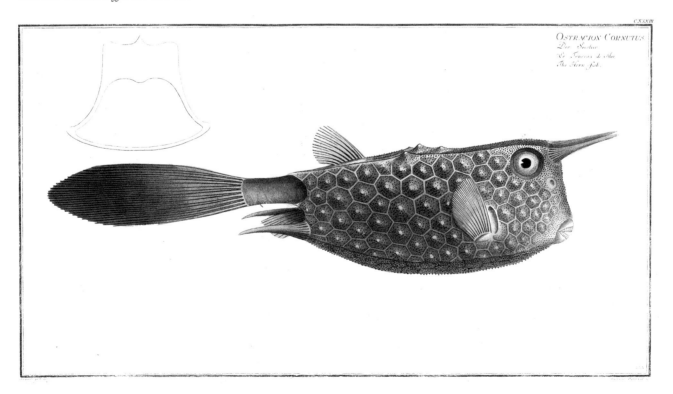

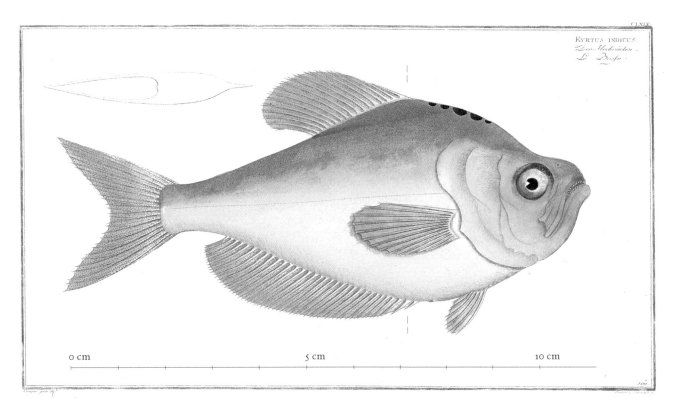

All the more reason to map the images on the universal ruler. Here gentle redesigns show measurement scales and the locations of cross-sections. The original hand-colored engravings at least map the images by means of cross sections and multilingual names.

Above, *Kürtus indicus*, volume 5, 98-99; below, *Ostracion cornutus*, volume 4, at 110-111. Redrawn.

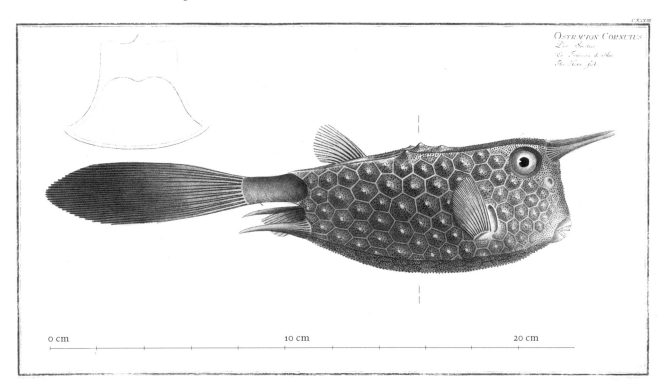

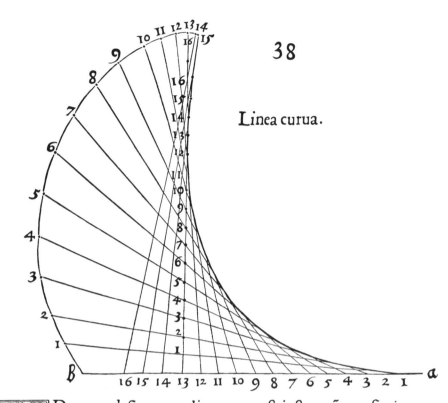

38

Linea curua.

D nuper defignatam lineam poteft inftrumétum fieri per quod ea fa
cile defcribitur, in hunc nempe modum, Præparetur lignŭ quadran
gulum, tantæ longitudinis, quanta opus erit, per tranfuerfum, cuius
principium fit a.& finis b.In eius fuperficie fuprema fac crenã inftar
canalis, tam profundam vt per eam rotula quædam vltro citróque agi commo-
de queat,& diuide lignum illud in tot partes quot volueris, inchoãdo numerum

IN this fine Dürer woodcut, a geometric construction sitting on top of explanatory text, some 48 numbers map out 3 different line traces. In his book published in 1525, Dürer presents 100 such images of geometric, typographical, and architectural constructions. These creative, beautiful diagrams are annotated with words, numbers, and scales—appropriate for a book on applied art called *A Course in the Art of Measurement*.

Marin Mersenne, a French mathematical analyst of music (inventor of equal temperament scale) and a number theorist (Mersenne primes), produced many remarkable mapped images in his 1636 book on musical instruments and harmony. Hand-drawn engravings, with their much greater resolution than woodcuts, make for excellent although costly mapped images. At right, this elegant engraving from Mersenne's *Harmonicorum libri* shows 80 numbers (312 digits) along with intensely detailed drawings of your 19-string lute and 21-string theorbo.

Albrecht Dürer, *Institutiones geometricae* (Paris, 1532), 35, the Latin edition of *Underweysung der Messung* (Nuremberg, 1525).

Marin Mersenne, *Harmonicorum libri: in quibus agitur de Sonorum Natura, Causis, et Effectibus: de Consonantiis, Dissonantiis, Rationibus, Generibus, Modis, Cantibus, Compositione, orbisque totius Harmonicis Instrumentis* (Paris, 1636), liber primus, 10.

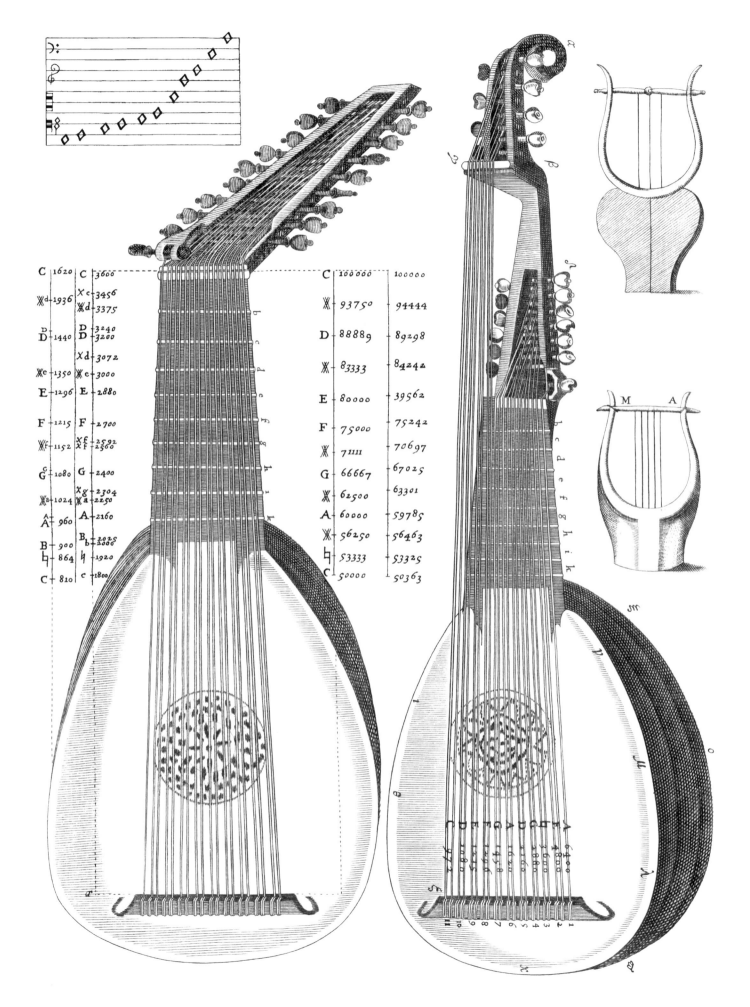

EARLY sky maps aggressively mapped their images. This copper-plate engraving from Johann Bayer's beautiful *Uranometria* published in 1603 identifies stars visible to unaided eyes. Brightness is indicated by star-sizes (like city-sizes on a map) and by Greek letters (a nomenclature used to this day): α is of course the brightest star in the constellation, β the next brightest, and so on. Best of all, stars are located on a measured and labeled two-dimensional grid, yielding

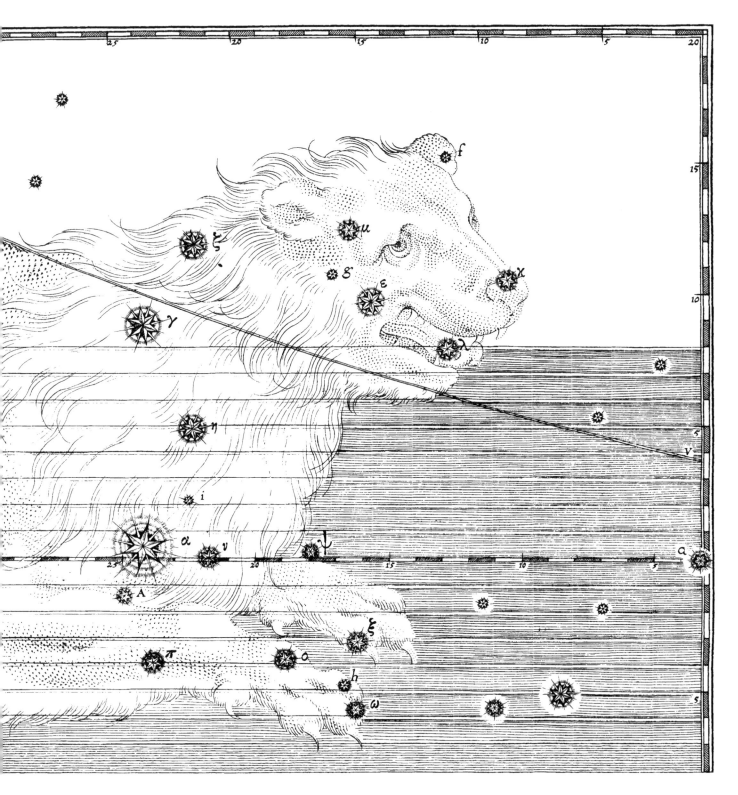

a dual context of universal sky grid *and* neighborhood stars. For showing evidence, the map metaphor suggests that labels belong on images, that external grids help to scale images, and that data are more credible when contextualized. For the want of stars here, the lovely star-myth Leo the lion fills the gaps. Seven years later Galileo's telescope would fill the known sky with innumerable stars, replacing myth with the wonders of nature.

Johann Bayer, *Uranometria* (Augsburg, 1603), plate Bb, engravings by Alexander Mair.

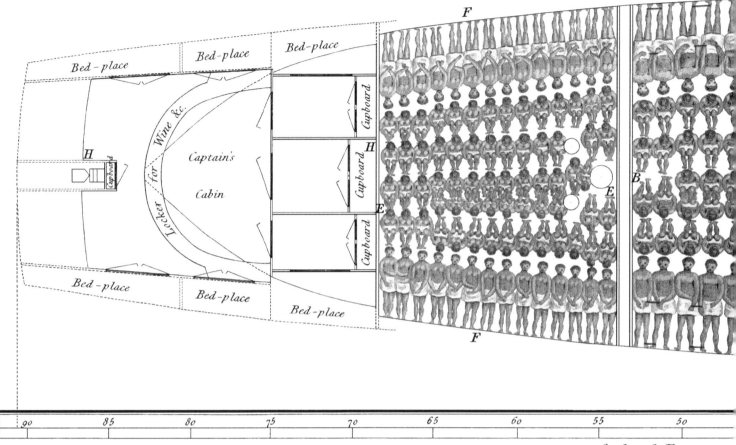

Scale of Feet.

NOT stars but slaves are mapped into the terrible grid of this slave ship, a portrait of individual suffering multiplied by 347 people and then millions. Nearly identical human figures in these cutaway diagrams symbolize how slavery turns individuals into anonymous commodities. Above, in a plan view of *The Vigilante*, a slave ship captured off the African coast in April 1822, human bodies count out the numbers, increased in turn by the double layer of people shown in elevation view at far right. Each detail makes the image more horrifying: men sorted out and ordered by size, shackled in pairs; women gathered at left adjacent to the relatively vast Captain's cabin and wine lockers; the fierce microeconomic optimization in packing a cargo of 227 men and 120 women. These conditions contributed to catastrophic death rates among all those it took to yield the 12,000,000 to 20,000,000 slaves eventually imported into America and the New World.

Like Minard's graphic of Napoleon's invasion of Russia in 1812, this engraving has the straightforward quality and credible precision of an engineering diagram — the facticity, the detail of individuals cumulating into an overview, and the architectural drawing style

Published for the Religious Society of Friends in London, *Case of The Vigilante, A Ship Employed in the Slave-Trade; With Some Reflexions on that Traffic; folding plate engraved by J. Hawkesworth of The Vigilante from the outside, its interior, showing the manner in which the slaves were transported, as well as examples of the irons in which they were bound* (London, 1823).

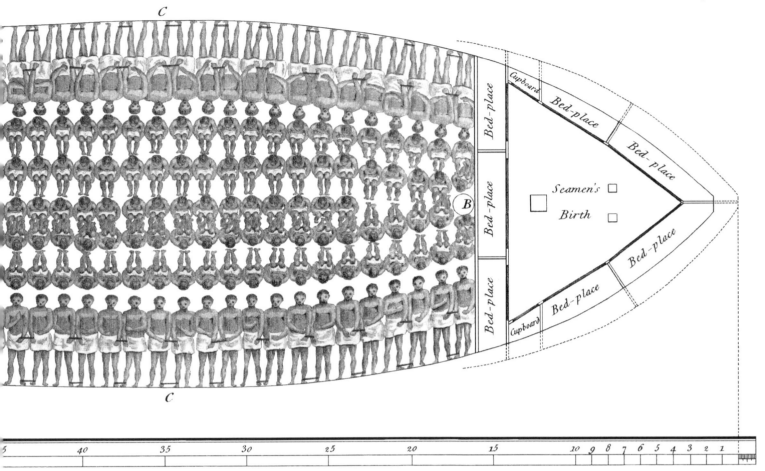

with a measurement scale, hidden lines, plan views, elevations, labels. Indicating the captured ship was examined carefully, such detail adds to the credibility of the image. The transparent view (above) and cross-section (below) reveal the ghastly workings of a slave ship perhaps better than purely representational still-life drawings or photographs. From a powerful anti-slavery tract published by the London Religious Society of Friends in 1823, the engraving is part of a document based on first-hand evidence and a deep caring about the content.

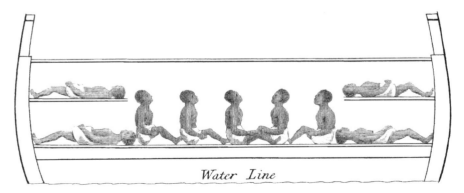

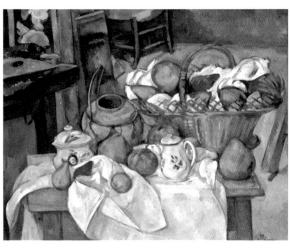

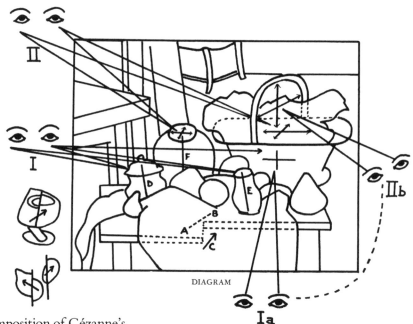

DIAGRAM

To reconstruct the multiple perspectives in the composition of Cézanne's paintings, Erle Loran's insightful book combines explanatory mappings, photographs of the original scene, captions, and descriptive text—all placed adjacent to the art. In *Still Life with Fruit Basket* above, Cézanne depicts objects from varying points of view, which Loran exuberantly illustrates with 4 eye-pairs floating around the perimeter of a map. Fortunately this thick-pencil diagram is adjacent to the painting rather than directly overlaid. Such mappings are often made by tracing over photographs or video stills (as in drawings for technical manuals, magic instruction, cookbooks). For publication, map-tracings can be overlaid on the image, placed adjacent to the image, or even stand alone.

These mappings are insightful if somewhat . . . diagrammatic. Readers of Loran's book will never see Cézanne quite the same way again, which is largely for the good. In both these mappings and paintings, we can see the now-revealed skewed cubist tables, their broken and skewed tops covered by a tactfully placed cloth.

Erle Loran, *Cézanne's Composition: Analysis of His Form with Diagrams and Photographs of His Motifs* (Berkeley, 1943, 1947, 1963), 76-77 (above), and 92-93 (below).

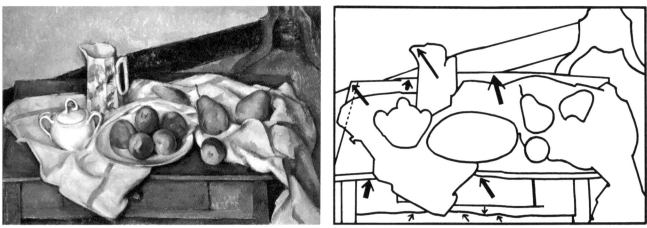

DIAGRAM

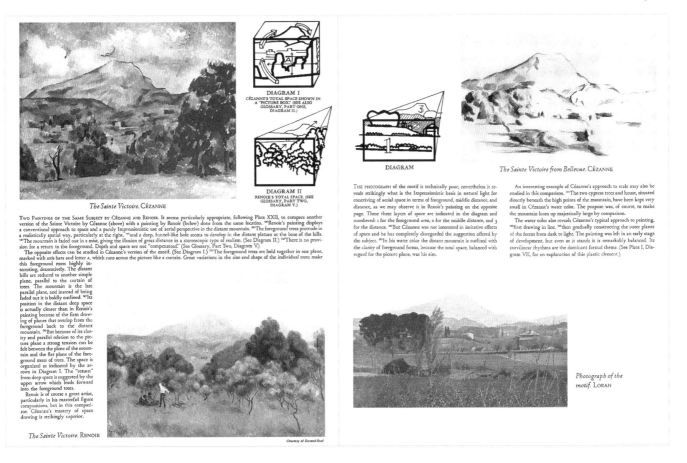

The Sainte Victoire. CÉZANNE

DIAGRAM

The Sainte Victoire from Bellevue. CÉZANNE

The Sainte Victoire. RENOIR

Photograph of the motif. LORAN

In this bright-eyed page layout, Loran places a Cézanne painting in parallel with (1) Renoir's painting of the same motif, (2-3) picture-box mappings of both paintings, (4) Cézanne's watercolor of the same motif, (5) its picture-box mapping, (6) a photograph taken from the vantage point where both Cézanne and Renoir did their paintings. It certainly helps to have good content. The surrounding text integrates, compares, explains this sixfold parallel mapping of Cézanne's *The Sainte Victoire*.

Roy Lichtenstein made a large painting that duplicated Loran's diagram of Cézanne's *Portrait of Madame Cézanne*. Lichtenstein's painting does not include the earnest label DIAGRAM (for those from out of town?) that appears underneath Loran's original mapping at right. Lichtenstein defended his borrowing as ironic commentary on oversimplified A-B-C diagrams to explain art. No doubt irritated by this gratuitous critique of diagrammatic methods and by the outright copying, Loran fired back with an indignant article "Pop Artists or Copy Cats?"[1] Several of Loran's mappings of Cézanne are off-the-wall found art, with a sincere deadpan surreal intensity expressed in the style of workaday technical diagrams. And there is the irony this map of Cézanne structural engineering could show up in a fancy museum as a big painting by a famous artist. More analytical graphics should be viewed as fine art, for real not ironically.

Erle Loran, *Cézanne's Composition*, above, 100-101; below, 85.

[1] Erle Loran, "Pop Artists or Copy Cats?," *ARTnews*, 62 (September 1963), 48-49; and a response in "Talking with Roy Lichtenstein," *Artforum*, 5 (May 1967), 39.

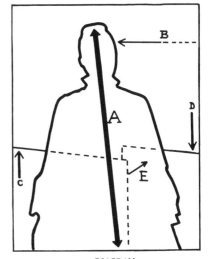

DIAGRAM

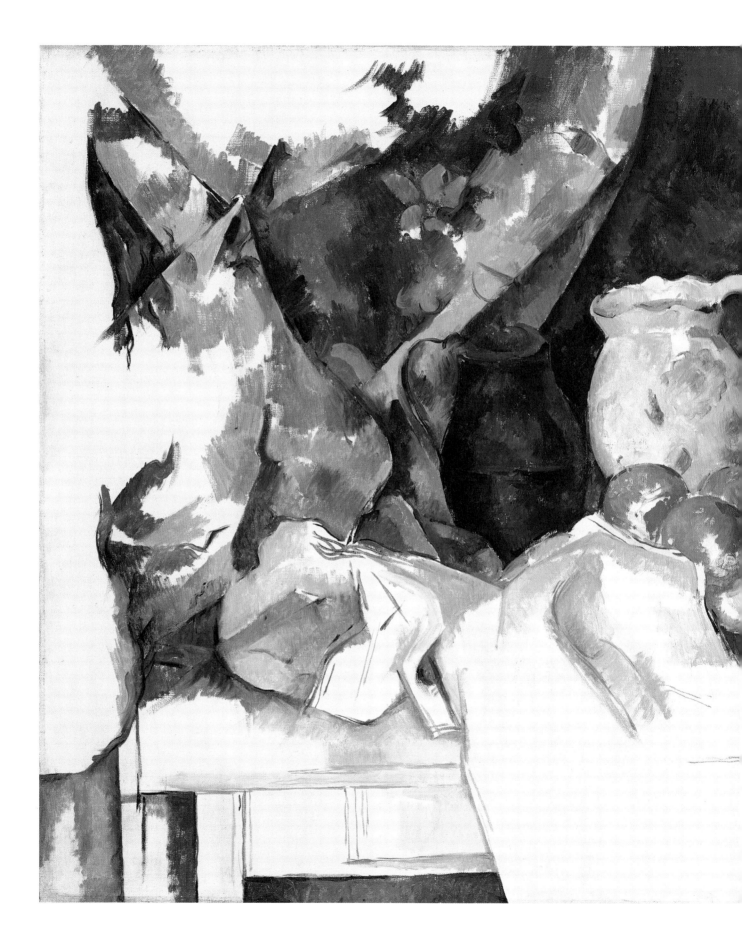

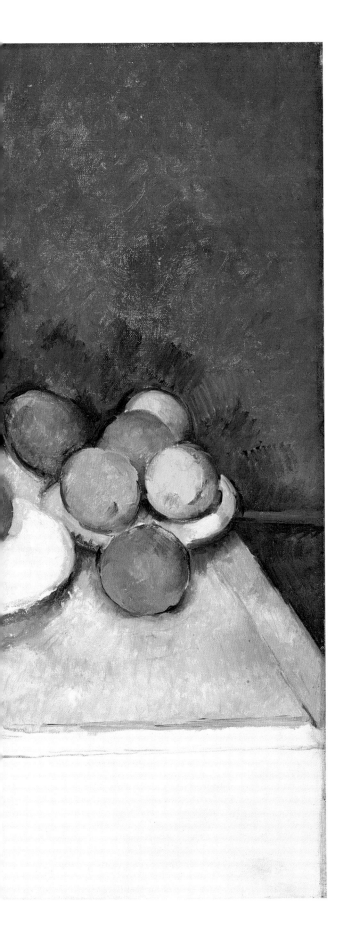

PAUL Cézanne's *Two Pitchers and Fruit* progressively layers 3 mappings of the motif. Revealed are spatial structures and also sequential dynamics in the construction of the painting: (1) the finished areas of fruit and pitchers, characteristically Cézanne; (2) the distributed color tones; and (3) an under-mapped sketch.

The prefatory oil sketch clearly maps out the deliberate construction of a misaligned tabletop as well as the cloth concealing the edge break. Representational paintings have perspectival undermappings, Cézanne's broken-perspectival. The skewed tabletop edges are not parallel to the bottom of the canvas and thus help accent the dynamics of multiple local perspective views.

Some 7 or 8 colors from the finished area are distributed to blocked-in, paint-by-numbers patches in the unfinished area. Similar color patches with the lighter canvas peeking through appear in many Cézanne landscapes, most notably *Garden at Les Lauves* (1906). The work at hand combines Cézanne's still-life and landscape techniques.

Two Pitchers and Fruit is beautiful and different, beautiful because it is different, a surprising Cézanne.

At the Barnes Foundation museum, this painting merits the patient and intense concentration of an observer seated on the bench across the small room where the work resides. Placed by the museum's founder Dr. Albert C. Barnes, that bench greatly improves the view. For, as Paul Klee wrote in *The Thinking Eye*, "Didn't Feuerbach say: For the understanding of a picture, a chair is needed? Why a chair? To prevent the legs, as they tire, from interfering with the mind."

Paul Cézanne, *Two Pitchers and Fruit*, undated (Venturi, Reff, and Rewald in their various catalogues suggest dates from 1892 to 1905), oil on canvas, 63.5 × 79.5 cm, 25 × 31¼ in, The Barnes Foundation, Merion, Pennsylvania.

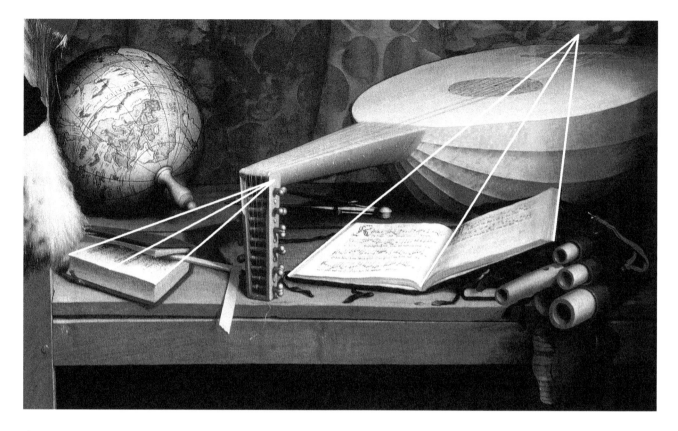

ABOVE, David Hockney drew perspective lines directly onto details from Holbein's *Ambassadors*. These mappings suggest that the 2 books depicted in the painting have divergent vanishing points, which does not mean that cubism developed in 1533, but rather that the books were drawn from different viewpoints. This in turn suggests a mirror lens was used in constructing the painting, since lenses must be moved and refocused for each small element in the physical scene, which produces paintings that consist of an assemblage of elements with varying vanishing points. In an intensely visual book written with images, *Secret Knowledge: Rediscovering the Lost Techniques of the Old Masters*, Hockney mapped works of Dürer, Holbein, Vermeer, and others. These mappings may signal the presence of telltale, unpainterly by-products resulting from the use of optical instruments. Hockney's hypothesis is that mirrors and lenses helped construct complex hyper-realistic perspectives (the globe above, for example); thus the exquisite eye-brain-hand coordination of great artists may have had some technological help.

When mappings become evidence, questions of validity promptly arise. Even the simple registration of a mapping in relation to an image may be dubious, a result of *alignment-to-please*. I once noticed this effect vividly when trying to align the edge of a large plate for a landscape sculpture toward a due-north marker some distance away. It was easy to attain exact alignment simply by tilting my head one way or another, a method

Detail, Hans Holbein the Younger, *The Ambassadors*, 1533, as mapped by David Hockney, *Secret Knowledge: Rediscovering the Lost Techniques of the Old Masters* (London, 2001, 2006), 100. Below, photograph of ET by Philip Greenspun.

of instantaneous adjustment of ±3° without ever having to move the big, heavy plate. Similar parallax effects occur in reading analog gauges. This experience added to my skepticism about the evidence for alleged links between orientations of ancient monuments and astronomical phenomena, *for confirming alignments will pleasingly lock right into place if the desired answer is already known.* Even professional land surveyors, in mapping the same piece of land, sometimes produce divergent results depending upon their client's interests. Mappings become more credible if constructed independently of a favored result. Not all clients, however, wish to finance disinterested measurements and mappings.

A busy bee in mapping artworks is Ernst Mössel, author of the 534-page *Vom Geheimnis der Form und der Urform des Seins,* or *Deep Secrets of Form and the Urforms of Life,* a title eerily similar to Hockney's book.[2] Some 300 mapped images claim to unveil universal and orderly structures that lurk beneath nearly all art (although Mössel takes a skip on cubism). Supposedly symmetries with one geometric property or another appear just about everywhere. Below, white dots position the line-maps on the photographs and also drill holes in Anna, Mary, a tiny Mary, and Jesus. Note the ad hoc and convenient exceptions to symmetry in the add-on triangles accommodating the infant heads. Links between the images and dots here are as fanciful as the links between star-myth images and actual stars on antique constellation maps.

[2] Ernst Mössel, *Vom Geheimnis der Form und der Urform des Seins* (Stuttgart, 1938); images below from page 279.

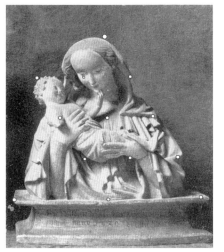

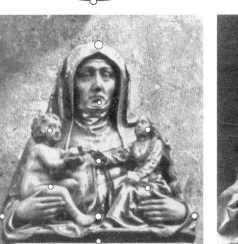

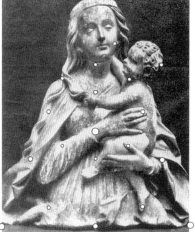

Tafel 190. Von links nach rechts: Maria mit Kind. Arbeit des 15. Jahrhunderts. Im Deutschen Museum zu Berlin. — Mutter Anna selbdritt. Auf dem Marienaltar im Seitenschiff des Domes zu Bamberg. Vom Anfang des 16.Jahrhunderts. — Muttergottes. Vom Anfang des 16.Jahrhunderts. Im Museum der Stadt Ulm

These mappings of nearly every sort of art by means of after-the-fact numerological symmetries have explained nothing much at all. Similar pseudo-explanations arise in the statistical analysis of growth data, where one model appears to fit many varieties of data, at least in the eyes of those researchers already convinced. In a devastating critique of loose mappings of evidence, the mathematician William Feller wrote:

> An unbelievably large literature tried to establish a transcendental "law of logistic growth." Lengthy tables, complete with chi-square tests, supported this thesis for human populations, for bacterial colonies, development of railroads, etc. Both height and weight of plants and animals were found to follow the logistic law even though it is theoretically clear these two variables cannot be subject to the same distribution.... The only trouble with the theory is that not only the logistic distribution, but also the normal, the Cauchy, and other distributions can be fitted to the same material with the *same or better goodness of fit*. In this competition the logistic distribution plays no distinguished role whatever; most theoretical models can be supported by the same observational material. Theories of this nature are short-lived because they open no new ways, and new confirmations of the same old thing soon grow boring. But the naive reasoning has not been superseded by common sense. . .[3]

Perhaps a few Mössel mappings are plausible; all 300, however, are not the replications of scientific research but rather the dotty drawings of a monomaniac. Different maps will fit the same artwork, for many different symmetries and proportions have geometric properties for which aesthetic claims might be made. Within images, dots could fall quite plausibly at places other than those marked, thereby generating contrary mappings. And even if a consensus is reached on dot locations, the same set of dots can be connected in multiple ways.

Then there is the catastrophic mismatch between mapping-space and object-space. Mössel analyzes one-eyed flatland photographs of real 3-dimensional objects. A single *photograph* of an artwork is mapped, not the artwork! Flatland mappings cannot capture spaceland realities. Imagine poor Mössel at the museum pacing around the actual sculpture of this stern and skeptical Anna trying to find some fit for his flatland wire-mesh. No amount of parallax, realigning, or wrapping a grid-net around Anna can save the theory of Ur-Forms.

WHAT separates Erle Loran and David Hockney from crank mappers is an *explanatory tightness of the mapping theory in relation to the image*. Loran and Hockney at least try to explain something; the mappings are *specific, coherent, credible,* and *testable*. In contrast, no possible empirical evidence can ever refute a Mössel, who explains everything and therefore nothing. There is so much wiggle room that the theory turns into unfalsifiable metaphysics and the empirical mappings into mush. When mappings make explanatory interpretations of images, then serious standards of quality for evaluating an explanation become relevant.

Ernst Mössel, *Vom Geheimnis der Form und der Urform des Seins* (Stuttgart, 1938); images opposite (beginning top left) from 283, 283, 299, 288, 307, 380, 273, 253, 304, 181, 163, 210, 159, 197; and below, 279.

[3] William A. Feller, *An Introduction to Probability Theory and Its Applications, II* (New York, 1971, 2nd edition), 52–53. Attempts to demonstrate golden section ubiquity by drawing "fat lines on thin reproductions of Renaissance paintings" are likewise demolished in Martin Kemp, "Divine Proportion and the Holy Grail," *Nature* (25 March 2004), 370.

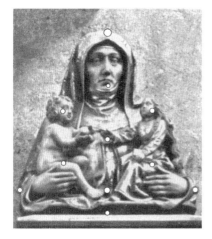

FIGURE DE LA GRIEL

I^{er} Mouvement.

Quatre en avant par deux coupés et Rigaudon en arriere.

2^e M^t.

Les mêmes changent de places avec ceux de vis-à-vis

3^e M^t

La Petite Chaine sur les côtés, puis les 4 autres figurans font à leur tour la même figure que ceux-cy viennent de faire aux I^{er} 2^e et 3^e Mouvem^t.

4^e M^t

Les 4 qui ont agi les premier vont figurer vis-à-vis ceux de leu droite.

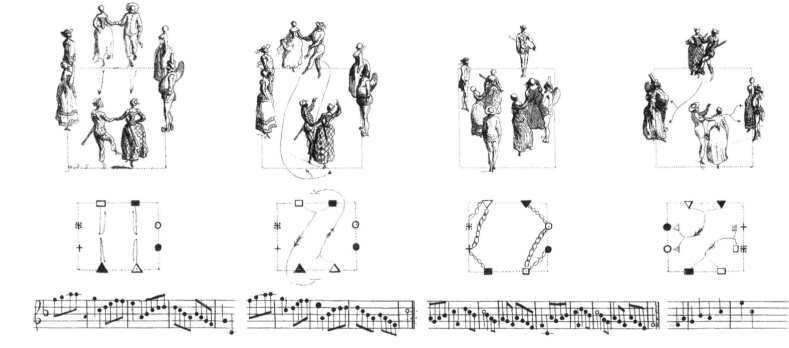

TECHNIQUES for mapping images are transparently useful in describing and explaining motion. Directional arrows, floor plans, trace lines, linked images, and sentences help map out 3-space activities over time in still-land displays of evidence that moves, an inherently difficult display task in flatland. In this section on mapping motion, readers might consider how these still-land examples translate into *movie-land* mappings. Good strategies in analytical design often perform well in both still-land and in movie-land, and mappings may themselves dance along with dancers dancing.

EIGHT sequential mappings choreograph a *contredanse* in this engraving from a 1762 square-dancing instruction pamphlet. A lot is going on here: 4 couples moving about in 3 dimensions as described by words, drawings, 2 floor plans, and music—all multiplied through 8 different

La Cuisse, *Le Répertoire des bals ou théorie-pratique des contredanses décrites d'une manière aisée avec des figures démonstratives pour les pouvioir danser facilement, auxquelles on a ajointé les airs notés* [. . . *Suite du répertoire des bals*], Paris, Cailleau & Mlle Castagnery, 1762-1764 (redrawn).

CONTREDANSE .

5.ͤM.ͭ

L'on prend la Dame qui se trou-
-e vis-à-vis de soy et l'on chasse
nuvert avec elle .

6.ͤM.ͭ

Et sans la quitter on rechasse .

7.ͤM.ͭ

Puis tous huit se faisant face, fi-
gurent en avant et en arriere sans
Rigaudon .

8.ͤM.ͭ

Et reprenant la Dame qui est
vis-à-vis devous, et qui est la
vôtre, vous reprenez vot' place
en faisant un tour avec elle .
 La Main.

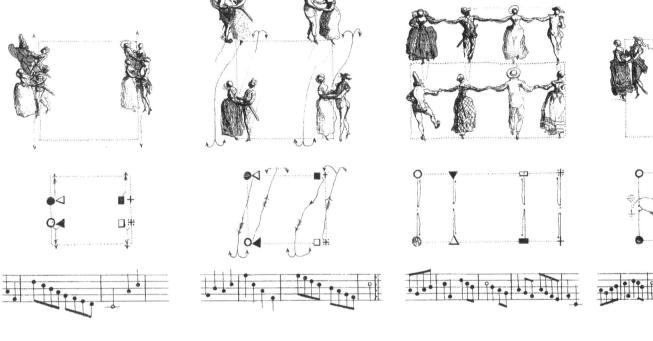

dance patterns. This consistent format portrays 8 movements and also
provides a steady canvas upon which to paint, preserve, and reason about
the changing information, a characteristic strength of small multiples.
Dance-timings are ingeniously arrayed: reading *down* each column describes
sequences *within* a movement; reading *across* describes the sequence of
movements. The diagrams lack an analysis of style. Despite the space-time
complexities of square-dancing, the mapping here is straightforward and
clear—except possibly for the floor-tracks, which lack an explanatory
legend. These encoded dance-steps are consistent with Lincoln Kirstein's
skeptical view of stenochoreography as "provocative diagrams calculated
to fascinate the speculative processes of a chess champion."[4]

[4] Lincoln Kirstein, *Ballet Alphabet* (New
York, 1939), 49-52.

Imagine now the little cartoon figures *moving* on their tracks and the
dancer-symbols moving on their encoded floor-tracks, the musical notes
heard and highlighted as the *contredanse* moves, mapped in movie-land.

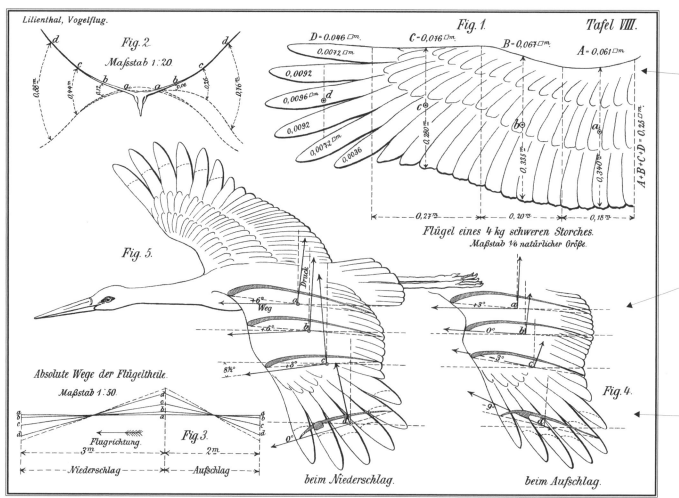

Lilienthal, Vogelflug.

Fig. 2.
Maßstab 1:20.

Fig. 1. Tafel VIII.

D = 0.046 □m. C = 0.076 □m. B = 0.067 □m. A = 0.061 m.

Flügel eines 4 kg schweren Storches.
Maßstab ⅙ natürlicher Größe.

Fig. 5.

Fig. 4.

Absolute Wege der Flügeltheile.
Maßstab 1:50.

Flugrichtung.

3ᵐ 2ᵐ Fig. 3.

— Niederschlag — — Aufschlag —

beim Niederschlag. beim Aufschlag.

Verlag von R. Oldenbourg, München und Berlin.

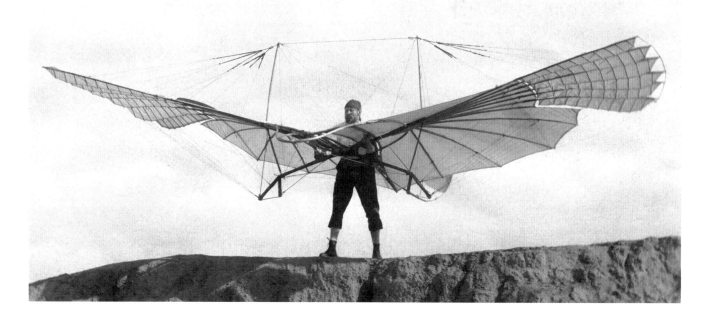

FIVE mapped stork-drawings at left show several of Otto Lilienthal's investigations of bird anatomy and flight. The idea is to construct gliders for piloted flight based in part on principles of bird design; the bigger idea is founding aeronautical engineering.

Figure *1* calculates the wing area of a 4 kg stork, with rectangles and measurements overlaid on the drawing. Lilienthal's scale is ⅙ natural size; as rescaled here, multiply by 9.4 to obtain real stork size. Space-time tracings of flapping wings are shown at upper left in Figure *2* (head-on view) and lower left in Figure *3* (bird-side view); both these drawings provide quantitative scales (½₀ and ½₀).

Lilienthal observed that the top edge of a wing cross-section might well be longer than the bottom. Indeed, these excellent mapped images of wing motion in Figures *4* and *5* resemble modern flight-training manuals that describe such cambered airfoils. Beginning pilots are taught that wings achieve lift because of a longer flow-path (in 2-dimensional cross-section) over the top of an arched wing compared with the bottom. Based on a theory about Bernoulli effects, this popular story would, if true, render inverted flight impossible. A more complete explanation is based directly on Newton's laws and fluid mechanics, with lift resulting from forces generated by a moving wing powered through the air.[5]

Beautiful mappings of the shifting orientations of wing cross-sections (emphasized by shading) show varying angles of attack as flapping wings torque through 3-space in Figures *4* and *5*. This is much richer than the single flatland cross-section of introductory flying manuals; Lilienthal's wings have a fine sense of surface and 3-dimensionality shown by feathers and dynamic multiple cross-sections. Birds are not fixed-wing aircraft.

Although scaled differently, the 5 mappings are thoughtfully integrated. All 5 are linked and oriented by the identical *a b c d* lettercode that marks cross-section locations within each drawing. At far left, Figure *3* shows a side-view of the stork as it flies to the left, in parallel with the adjacent drawings of downward motion (the wing-tip feathers spread) and upward motion in this complex display. Not just a pile of loosely related images, the illustrations add up to a coherent multiple viewpoint.

Alas this excellent plate and 7 others are stuffed away, folded up, in the very back of the book. Some 100 smaller diagrams, charts, and photographs are at least integrated with their relevant text in the book itself (here at right, for example). But the best image of all, this analysis of the stork, is left lonely and abandoned in the back—convenient for printing and binding, inconvenient for seeing and reading.

From 1891 to 1896 Otto Lilienthal built his own conical mountain to launch gliders, piloted 2,000 glider flights, published the findings, created an artificial-stone construction set (*Ankersteinbaukasten*) enjoyed to this day, and took good care of his factory workers. At age 48 he crashed and died while flying an experimental biplane-glider.

Otto Lilienthal, *Der Vogelflug als Grundlage der Fliegekunst* (Munich and Berlin, 1889, 1910), shown opposite is appended plate VIII (red added to figure labels); Lilienthal picture from p. 179; and below from p. 132.

[5] Wolfgang Langewiesche, *Stick and Rudder: An Explanation of the Art of Flying* (New York, 1944, 1972); and David Anderson and Scott Eberhardt, *Understanding Flight* (New York, 2001).

— 132 —

von hinten erblicken. Offenbar geht also die Flügelspitze mit gehobener Vorderkante herauf und mit gesenkter Vorderkante herunter, was beides auf eine ziehende Wirkung hindeutet.

Fig. 68. *Aufschlag*

Fig. 69. *Niederschlag*

Fliegende Möwe.

Auch die an uns vorbeieilende Möwe wird dem geübten Beobachter verraten, welche Rolle die Flügelspitzen bei den Flügelschlägen spielen.

Fig. 70 zeigt eine Möwe beim Flügelniederschlag von der Seite gesehen. Nach der Spitze zu hat der Flügel den nach vorn geneigten Querschnitt *acb*. Der absolute Weg dieser Flügelstelle hat die Richtung *cd*, und *ce* ist der entstandene Luftwiderstand. Man sieht, wie letzterer außer der hebenden gleichzeitig eine vorwärtsziehende Wirkung erhält.

Fig. 70.

Ob aber der Flügel beim Aufschlag in allen Teilen eine ähnliche Rolle übernimmt, also zum Vorwärtsziehen dient, ist nicht ein für allemal ausgemacht. Wäre dieses der Fall, so könnte es unbedingt nur auf Kosten einer gleichzeitig nieder-

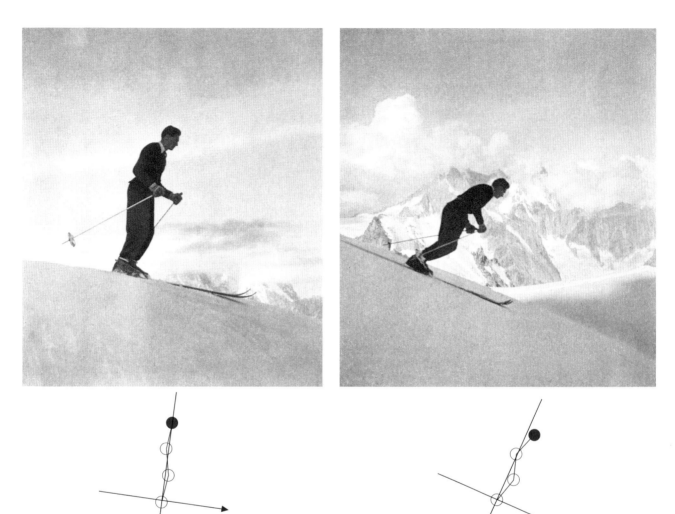

NORMAL POSITION ON GENTLE SLOPE. The body is slightly ahead of an imaginary line which being perpendicular to the slope, passes through the ankles of the skier.

POSITION ON MEDIUM SLOPE. The body is more bent and the hands are further forward.

A BEAUTIFUL instruction manual, *How to Ski by the French Method* presents 200 annotated motion-stopping photographs of ski experts in action. Throughout the book, the technique of information display is the *explanatory mapping of photographs by means of diagrams and text placed in parallel with, or overlaid on, multiple sequential images.* Above, the 2-color diagrams delineate the changing body positions in response to increasingly steep slopes while moving downhill. As images flow left to right, the analytical variable is the passage of time, and, more importantly, the changing grade of slope, gentle to medium to steep.

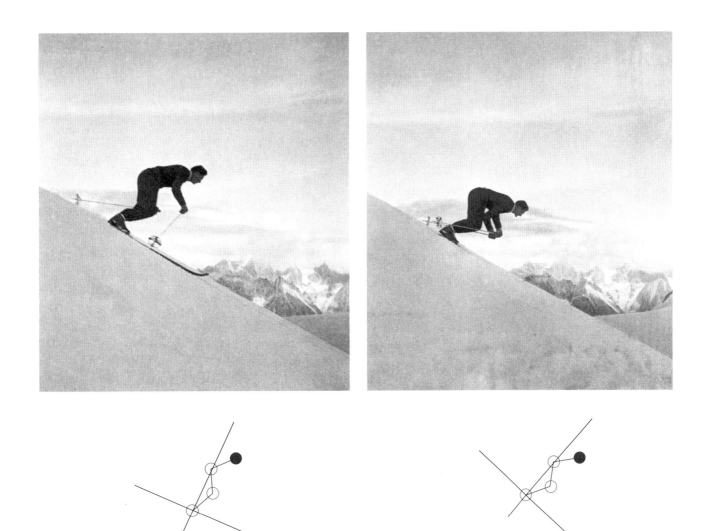

The weight of the body rests on the ball of each foot.

POSITION ON STEEP SLOPE. Greatest possible forward bend of the ankles and upper body.

Pierre Boucher photographed all the action and designed the book, integrating text, diagram, dramatic image. The design style is Classic Modern: sans serif type in red and black; scattered and thin text, poster-like rather than booklike; words as images; spare geometric diagrams; photographs that serve as both content documentation and fluent art. In this applied and practical book, the photographic techniques and layouts resemble an artist's book of great merit, Man Ray's *Facile: Poèms de Paul Éluard* (Paris, 1935). Both books work with multiple, overlapping, double-exposed, negative, solarized photographs. Despite a few design

Émile Allais, *How to Ski by the French Method* (Paris, 1947), 20-21, photographs and design by Pierre Boucher, translated by Agustin Edwards from Émile Allais, *Méthode française de ski* (Paris, 1947).

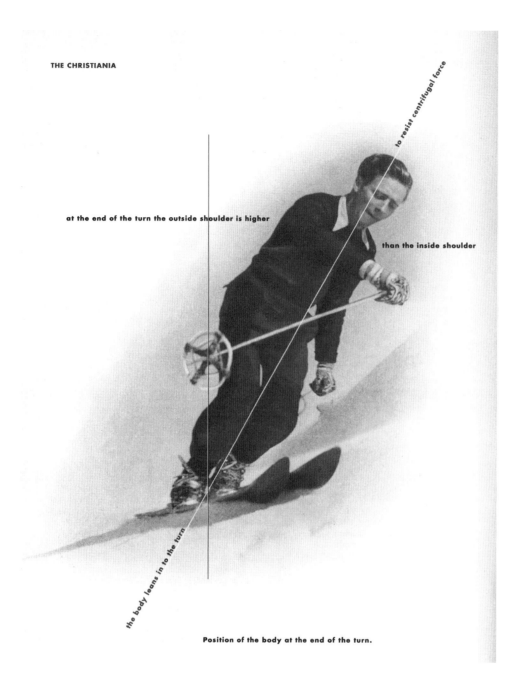

to resist centrifugal force

at the end of the turn the outside shoulder is higher

than the inside shoulder

the body leans in to the turn

Position of the body at the end of the turn.

lapses (ski instructors shown as floating-heads-in-the-sky, like Hollywood stars in movie posters), often the pages of *How to Ski* are as elegant as the great photographic books of the 20th-century.

In this mapped and diagrammatic picture above, the typography brings word-meaning *and* ski geometry-dynamics to photographic still-land. "Outside higher" and "inside lower" shoulders are marked with mapping words. The vertical reference line is squared up by black horizontal type; the body-axis line is extended and labeled by red diagonal type.

Opposite, a self-mapping photograph. Snow-trails, one edge grayed by shadow, the other brightened by reflection, narrate the pattern of tracks. Sunlight maps a dark skier into a long gray shadow projected onto snow.

Émile Allais, *How to Ski by the French Method* (Paris, 1947), 82 (above), 95 (opposite).

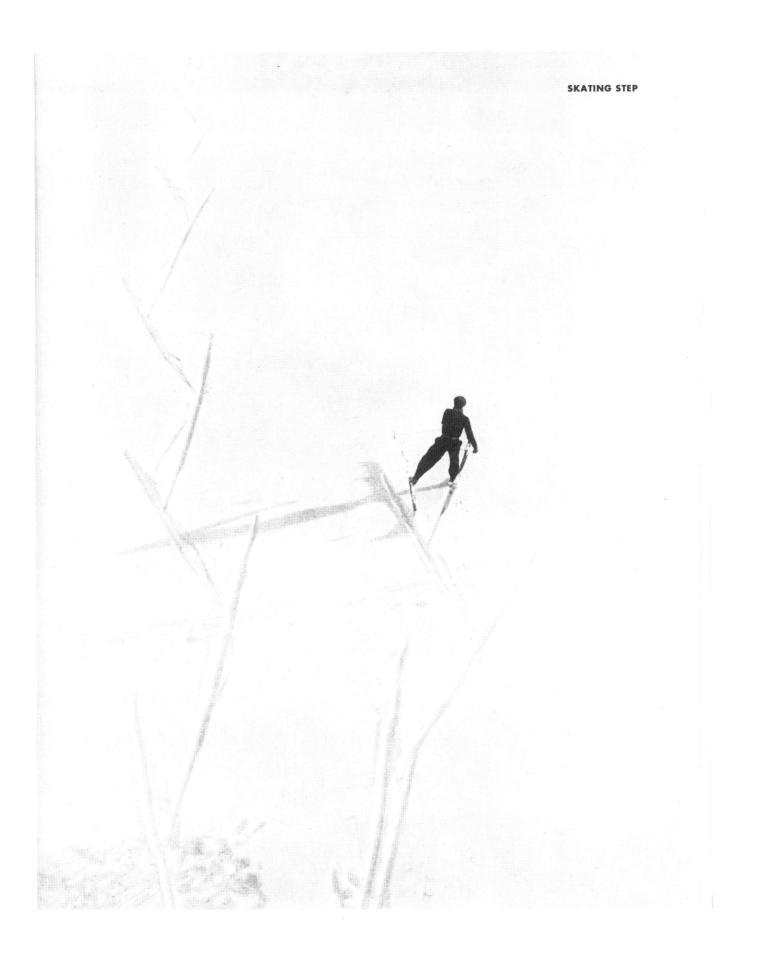

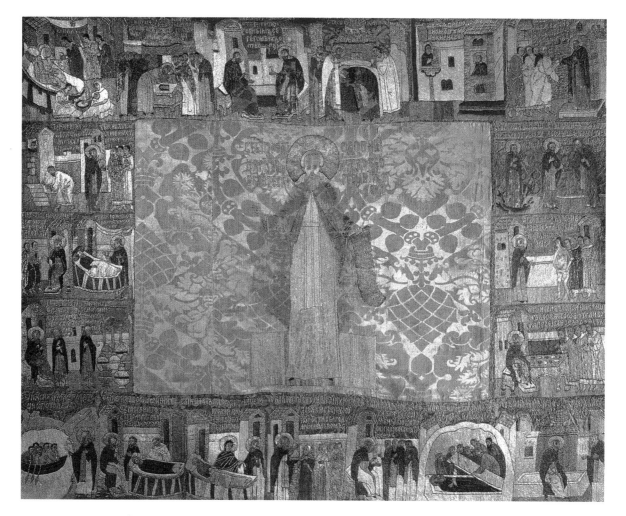

Here are 3 extraordinary mappings, each with 2 scales that show a local and a cosmopolitan view. Above, a 16th-century Russian silk icon cloth describes Saint Kirill in an inscription near his head as the "Wonder Worker, Abbot of White Lake," and shows in the margin 19 wordy small-multiple scenes from his life. At far right, playing against a strong photographic perspective, a map locates Kyoto's School of Floral Art and describes routes from the train station to the flower-arranging school, along with 20 perspective sketches of buildings so that visitors know what to look for on their way. Below, in another superb contextualizing change of scale, a detailed local image is linked to a Japan-wide train map in the margin.

St. Kirill of Belozersk with scenes from his life, cloth, early 16th-century, 99.5 × 118 cm, 39 × 46½ in, State Russian Museum, St. Petersburg. Source: *Russia!*, exhibition catalogue (Guggenheim Museum, New York, 2005), Valerie Hillings essay, 9.

Right: *Ikenobo School of Japanese Floral Art,* edited by T. Nishimura (Kyoto, 1951), 14.

Guide for Visitors to Ise Shrine (Ise, Japan, 1948-1954).

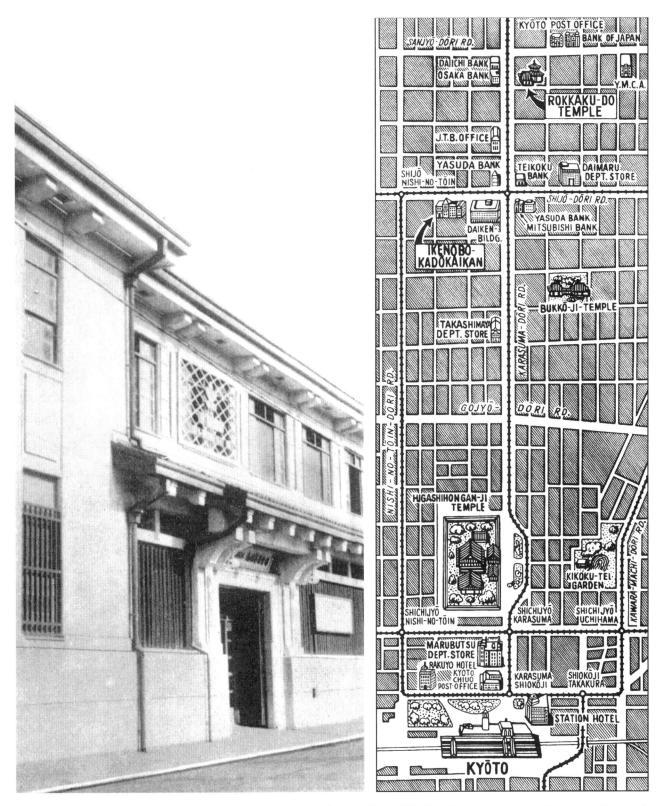

At Muromachi Shijo there stands the Ikenobo-Kadokaikan (Hall), where the researches, meetings of the Kado, and exhibitions of flower arrangements are made. (Left: Its outward appearance)

The right-hand figure shows the route from Kyoto station to the Rokkakudo Ikenobo and the Ikenobo-Kadokaikan (Hall).

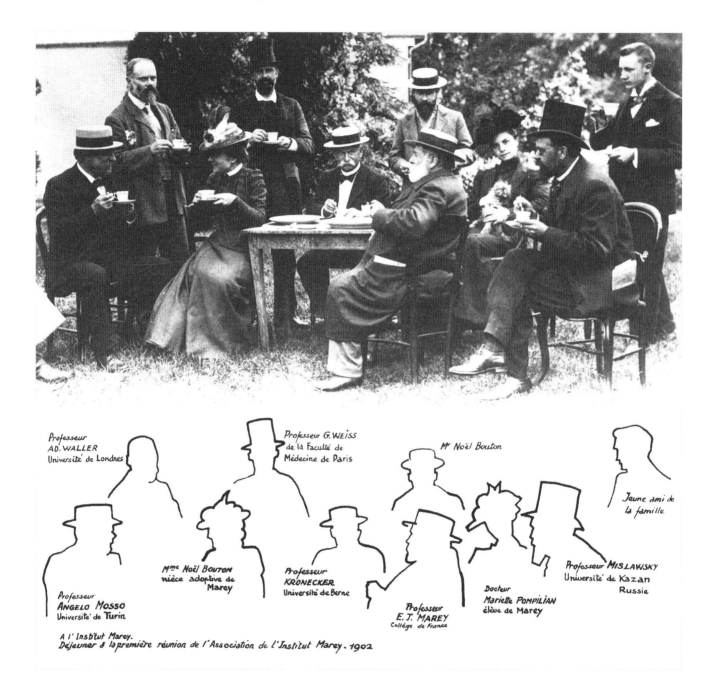

THIS picture and mapping of a 1902 reunion of colleagues of E. J. Marey, the great scientific photographer, provides names and affiliations linked to hat-head outlines that run parallel with the image. The diagram allows label-captions of greater detail than labels placed on the picture itself. There is an engaging quality to the diagrammatic mapping of the picture, and those in the picture can admire their profiles as well as their images. Detailed mappings of this type help to qualify photographs as useful historical documents. Unmapped, however, is the dog in the hands of Docteur Mariette Pompilian.

From Marta Braun, "The Photographic Work of E. J. Marey," *Studies in Visual Communication*, 9 (Fall, 1983), 4.

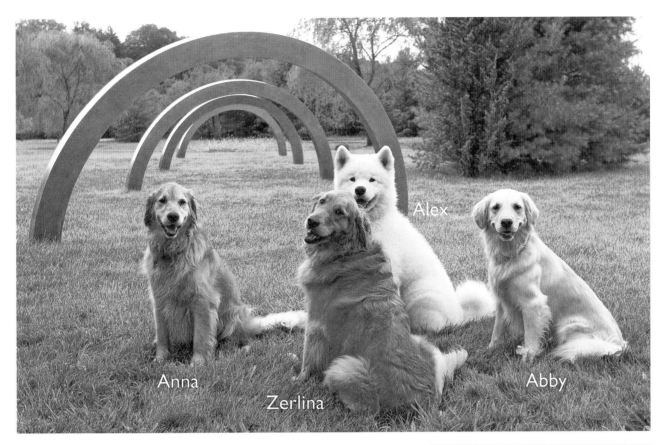

THESE labels are placed directly on the picture, thereby closely tying names to dogs. Again a profile outline provides a charming reinterpretation of the photograph. Such mapping outlines are traditionally at the same scale as the original, but they need not be if there are a relatively small number of dogs in the mapped photograph. This smaller mapping serves as a caption or legend. The dreaded letter code, parodied at right, should be avoided whenever possible.

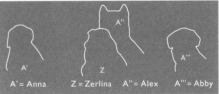

Anna, Zerlina, Alex, Abby, and ET Spring Arcs Sculpture, 2005, photograph by Philip Greenspun. Below, *Bella,* a photographic confection by Nicolas Bissantz.

MAPPED onto a common background by cutting and pasting multiple images, these labeled time-series photographs depict 9 weeks of the growth of a Labrador, Bella. In this home-brew imaging, *measurement labels are placed directly in the photograph where they belong,* in contrast to nearly all published astronomical images from deep space. Those scientific images are notoriously unscaled and dequantified, despite otherwise extensive colorizing, enhancement, and manipulation in image-processing and public relations programs. Science should use Bella reporting standards.

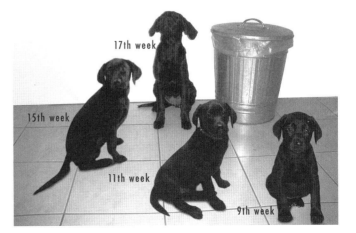

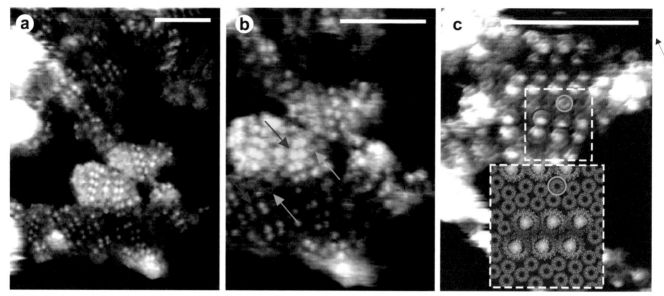

AFM of native photosynthetic membranes. **a**, Large-scale view of several membrane fragments. **b**, Higher-magnification view showing a region of dimeric RC-LH1-PufX core complex arrays (red arrows) and associated LH2 complexes (green arrows). **c**, Three-dimensional view of core complex arrays surrounded by LH2 complexes. The inset at the bottom is a representation of the region denoted by the dashed box in the centre, using model structures derived from atomic resolution data[2-4]. A typical RC-LH1-PufX dimer is delineated in both images by a red outline and a representative LH2 complex by a green circle. Scale bar, 100 nm in all panels. For all images the z range is 6 nm (from darkest to lightest).

IMAGES can map other images, as in a before/after history, or a just–look–at–this comparison of a painting and its forgery, or multiple similar birds in a field guide. Above, scaled (x, y, and z) and mapped images explain the molecular dynamics of photosynthesis. A scale bar at the top of each image shows changing x-y magnification; a color scale shows variation in z (depth). An inset diagram cogently maps the image at upper right.

Below are cubist images, mapping one another. Working on a roadbed, I tossed a rock down, which split open to reveal cubist colors and structure (photograph at left). These Rock/Braque/Picasso mappings flow back and forth, for cubism causes us to see this rock as a motif for a cubist painting. But again, cubism consists of split, fractured, shadowed planes picturing actual 3-dimensional objects, such as fractured rocks.

Svetlana Bahatyrova, *et al.*, "The native architecture of a photosynthetic membrane," *Nature*, 430 (26 August 2004), 1058–1062.

Left, *Braque Rock,* 2004, fractured glacial erratic, Cheshire, Connecticut (detail). Georges Braque, *Les usines du Rio-Tinto à l'Estaque*, 1910, oil on canvas, Centre Pompidou, Paris (detail). Pablo Picasso, *Man with a Violin,* 1912, oil on canvas, Philadelphia Museum of Art (detail).

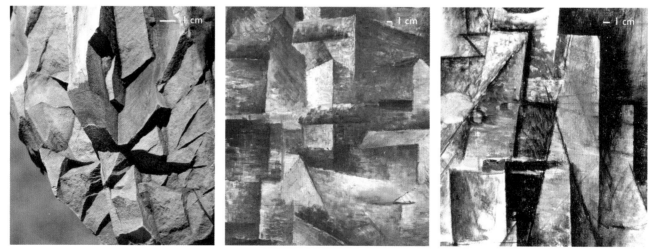

ROCK BRAQUE PICASSO

In adjacent mapped images, large numbers of potential comparisons are sometimes available for alert viewers. What to look at then? Where to compare? For *explanatory* presentations, important comparisons among images should usually be pointed out to viewers by means of annotations, arrows, labels, highlighting, or other method of directing attention. For example, Roger Tory Peterson's *A Field Guide to the Birds* uses pointer-line "keys" to indicate distinctive identifying characteristics among classes of similar birds. In contrast, for *exploratory* image analysis, premature mapping may divert the viewer, foreclose alternative views, and mask subtle detail. Analysts who explore images should try to see with fresh eyes, and to ignore and deflect mind-fogging hints and directives about what is supposed to be seen. Premature closure and viewing-to-please turns exploratory image analysis into advocacy and marketing.

For many presentations, it will be useful to show viewers *both* the unmapped and the mapped images, providing a clean look at the image and then a look at what the mapping has brought to the image. This method should be used much more frequently.

Whether for explanation or exploration, *every image* should always reside on the universal measurement grid of 3-space and time (x, y, z, t). The universal grid should accompany rescaling and zooming in and out, as in the 3-image sequence of photosynthesis at left. And in the classic birdbook at right, scaling birds relative to one another is insufficiently universal; how about some common plants (or, since these are shore-birds, a few clams) to improve the relative scope of relative scaling? Or, much better, a real measurement scale.

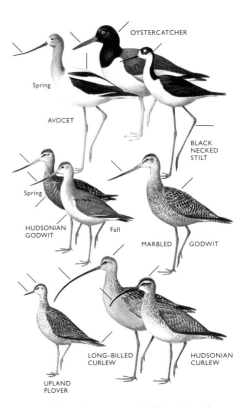

Roger Tory Peterson, *A Field Guide to the Birds* (Boston, 1934, 1939, 1947), plate 23, shore-birds.

WELL-DESIGNED and thoughtfully mapped pictures combine the direct visual evidence of images with the power of diagrams: Image's representational, local, specific, realistic, unique, detailed qualities; Diagram's contextualizing, abstracting, focusing, explanatory qualities.

MOST explanatory and evidential images (presented in scientific research, newspapers, textbooks, technical manuals, legal proceedings, engineering reports, and the like) should be mapped, placed in an appropriate context for comparison, and located on the universal grid of measurement.

MAPPINGS often represent an explanatory theory applied to the visual evidence. Therefore the standards of what constitutes a credible account also apply to mappings.

MAPPINGS help tell why the image matters.

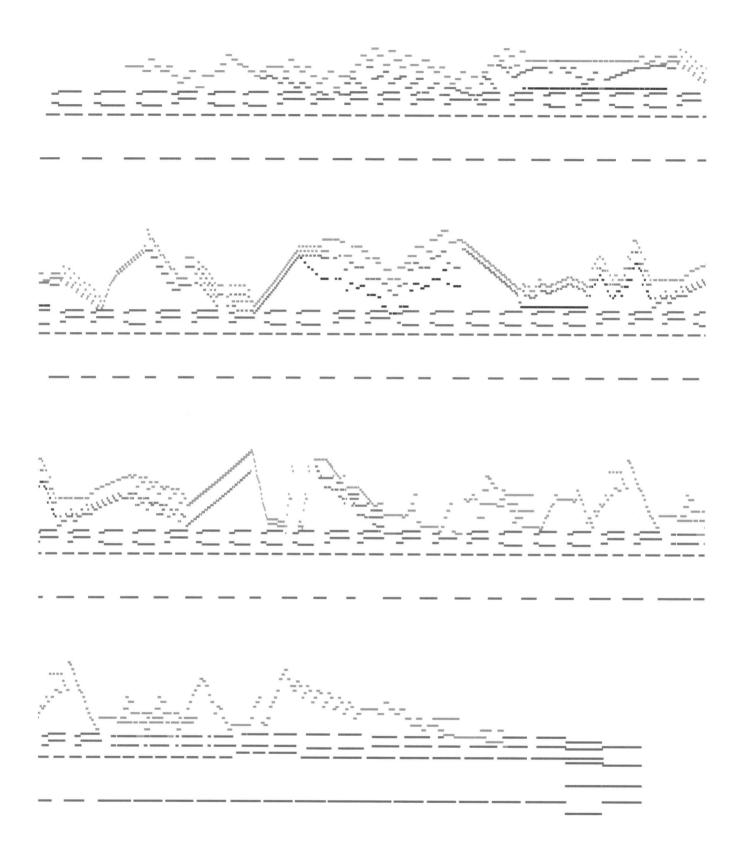

Frédéric Chopin, *Berceuse, opus 57*, depicted
by Stephen Malinowski's excellent Music
Animation Machine

Sparklines: Intense, Simple, Word-Sized Graphics

THE most common data display is a noun accompanied by a number. For example, a medical patient's current level of glucose is reported in a clinical record as a word and number:

glucose 6.6

Placed in the relevant context, a single number gains meaning. Thus the most recent measurement of glucose should be compared with earlier measurements for the patient. This data-line shows the path of the last 80 readings of glucose:

glucose 6.6

Lacking a scale of measurement, this free-floating line is dequantified. At least we do know the value of the line's right-most data point, which corresponds to the most recent value of glucose, the number recorded at far right. Both representations of the most recent reading are tied together with a color accent:

glucose 6.6

Some useful context is provided by showing the *normal range* of glucose, here as a gray band. Compared to normal limits, readings above the band horizon are elevated, those below reduced:

glucose 6.6 or glucose 6.6

For clinical analysis, the task is to detect quickly and assess wayward deviations from normal limits, shown here by visual deviations outside the gray band. Multiplying this format brings in additional data from the medical record; a stack, which can show hundreds of variables and thousands of measurements, allows fast effective parallel comparisons:

glucose 6.6

respiration 12

temperature 37.1 °C

These little data lines, because of their active quality over time, are named *sparklines*—small, high-resolution graphics usually embedded in a full context of words, numbers, images. Sparklines are *datawords*: data-intense, design-simple, word-sized graphics.

Sparklines and sparkline-like graphs can also move within complex multivariate spaces, as in these 9-step sequential results (reading down the columns) in merge-sorting 5 different types of input files. Four variables and 18,000 numbers are depicted in these small multiples.

Below, Robert Sedgewick, *Algorithms in C* (Reading, Massachusetts, 1998), 353.

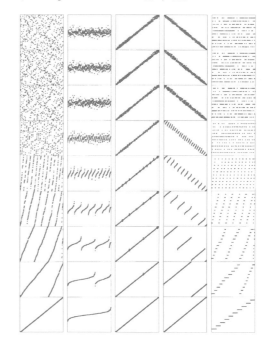

Sᴘᴀʀᴋʟɪɴᴇꜱ are *wordlike* graphics, with an intensity of visual distinctions comparable to words and letters. Letterforms are finely detailed: these constructions indicate the meticulous, detectable, and routine distinctions made for centuries in typography (shown here, a modern bitmap and 10 Renaissance letterforms). Many details are detectable in letterform design, which is why typographers pay close attention to refinements. A single letter set in 11 point type (as is this text) makes 20 to 200 visual distinctions; indeed an informed eye can often uniquely identify one typeface from among thousands by examining a few letters. A single word of 6 or 7 letters, the average English word length, makes 100 to 1,000 visual distinctions. Why not also construct *data graphics* that work at the resolution of routine typography? Thus the idea of sparklines: small, intense, wordlike graphics.

Felice Feliciano,
Città del Vaticano 1460

Damiano Moille, Parma 1480

Hartmann Schedel, Munich 1482

Luca Pacioli, Venezia 1509

Sigismondo Fanti, Venezia 1514

Francesco Torniello, Milano 1517

Albrecht Dürer, Nuremberg 1525

Albrecht Dürer, Nuremberg 1525

Giovam Baptista Verini, Toscolano 1526

Geofroy Tory, Paris 1529

Words visually present both an overall shape and letter-by-letter detail; since most readers have seen the word previously, the visual task is usually one of quick recognition. Sparklines present an overall shape and aggregate pattern along with plenty of local detail. Sparklines are read the same way as words, although much more carefully and slowly. For example, here are the comparative daily performances during a full year for 2 investment funds: Vanguard 500 Index

PIMCO Total Return

Each sparkline tracks some 250 days of prices and thus 249 changes in prices. Narrated above are overall views *and* local details, along with visually parallel comparisons of the daily ups and downs for the 2 funds. At right, 3 years of daily history (2,250 numbers) of stock prices, their changes, and trading volumes for an overly exciting insurance company.

Bitmap of Isadora font by Kris Holmes, "Terpsichore and Typography," *Fine Print on Type* (San Francisco, 1989), 93. Renaissance letterforms, redrawn by Bonnie Scranton: Edward Tufte, *Visual Explanations* (Cheshire, Connecticut, 1993), 113.

68.0 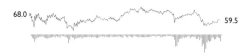 59.5

Wordlike sparklines should often be embedded in text and tables, which provide a helpful context for interpreting otherwise free-floating sparklines. Text and data surrounding quantitatively imprecise sparklines may now and then show more precise numbers and scaling information in an image/text/number format, as we saw for the glucose sparkline: ˄˄˄˄˄. glucose 6.6 . Of course the wordlike qualities of sparklines create the wonderful possibility of *writing with data graphics*. Thus this image "˄˄˄˄˄." depicts like a graph and means like a word: "the last 80 readings of glucose, compared to normal limits, with the most recent reading indicated by a red dot."

Small graphical images have collaborated with text and tables for centuries: sparkline-like space-fillers from a 1400 *Book of Hours* (at right), illuminated initials in medieval manuscripts, emoticons :-) in email, tiny imagelike symbols in railroad time-tables (at right), and Chinese characters combined with English text:

> Traditionally, characters are differentiated into six types. The basic units are pictographs (象形) portraying objects, e.g. tree 木, and ideographs (指事) suggesting abstractions, e.g. one 一. These pictographs and ideographs (collectively known as 文) combine to create two additional types of characters, logical aggregates (會意) and phonetic complexes (形聲). Logical aggregates combine the meanings of different characters to create a new meaning, e.g. a person 人 against a tree 木 means rest 休.

ELEGANTLY integrating words and images within a sentence, Galileo reported his discovery of Saturn's unusual shape as 2 *visual nouns* that compare 2 telescopic views, clear and murky. In Galileo's book *Istoria e dimostrazioni intorno alle macchie solari* (1613), text and image combine to report the evidence:

> ta imperfezzione dello ſtrumento, ò dell'occhio del riguardan-te,perche ſendo la figura di Saturno coſì ⊂○○⊃ ,come moſtra-no alle perfette viſte i perfetti ſtrumenti , doue manca tal perfezzione appariſce coſì ⊂◯⊃ non ſi diſtinguendo perfetta-mente la ſeparazione , e figura delle tre ſtelle ; ma io che mil-le volte in diuerſi tempi con eccellente ſtrumento l'hò riguar-dato, poſſo aſſicurarla , che in eſſo non ſi è ſcorta mutazione⌣ alcuna, e la ragione ſteſſa fondata ſopra l'eſperienze,che hauia-

The shape of Saturn is thus ⊂○○⊃ as shown by perfect vision and perfect instruments, but appears thus ⊂◯⊃ where perfection is lacking, the shape and distinction of the three stars being imperfectly seen.[1]

Placed in the familiar typographic context, these extraordinary images are just another sentence element, with no distinction between text and image. Saturn as evidence, image, drawing, graphic, word, noun. Galileo's word/image sentence is one of the best analytical designs ever. It is a good precedent for integrating small, detailed data-lines in text.

Les Très Belles Heures de Notre-Dame du Duc Jean de Berry (Paris, ~1380-1412). Railroad timetable (USSR, 1950s). Rich Harbaugh, *Chinese Characters: A Genealogy and Dictionary* (Taipei, 1998), iii. Redrawn.

ur qui impleunt dſidium ſuum
n confunctur cum loquetur un
importa. pſalmus.
l omnus qui timent dominum:
ambulant in uys eius.
nannum tuarum quia manon
is es et bene tibi erit.
ſuut nuus labundans in lateub:
.
ſuut nouelle oluarum in cu

🛫 = аэропорт 🚢 = порт
🛏 = спальный вагон или
 гостиница около станции
🚌 = автобусная остановка
🍷 = в графах поездов

[1] Galileo Galilei, *Istoria e dimostrazioni intorno alle macchie solari* (Rome, 1613), 25. *Discoveries and Opinions of Galileo* (New York, 1957), 102, translated by Stillman Drake. Hand-drawn images of Saturn are similarly integrated in the text of 3 letters by Galileo, *Le Opere di Galileo Galilei*, ed. by Antonio Favaro (Florence, 1890-1909), vol. 10, 409-410, 474, 502-504.

SPARKLINES have obvious applications for financial and economic data—by tracking and comparing changes over time, by showing overall trend along with local detail. Embedded in a data table, this sparkline depicts an exchange rate (dollar cost of one euro) for every day for one year:

	2003.4.28	12 months	2004.4.28	low	high
Euro foreign exchange $	1.1025	∿∿∿	1.1907	1.0783	1.2858

Colors help link the sparkline with the numbers: red = the oldest and newest rates in the series; blue = yearly low and high for daily exchange rates. Extending this graphic table is straightforward; here, the price of the euro versus 3 other currencies for 65 months and for 12 months:

	1999.1.1	65 months	2004.4.28	low	high		2003.4.28	12 months	2004.4.28	low	high
Euro foreign exchange $	1.1608	∿∿∿	1.1907	.8252	1.2858	$	1.1025	∿∿∿	1.1907	1.0783	1.2858
Euro foreign exchange ¥	121.32	∿∿∿	130.17	89.30	140.31	¥	132.54	∿∿∿	130.17	124.80	140.31
Euro foreign exchange £	0.7111	∿∿∿	0.6665	.5711	0.7235	£	0.6914	∿∿∿	0.6665	0.6556	0.7235

Daily sparkline data can be standardized and scaled in all sorts of ways depending on the content: by the range of the price, inflation-adjusted price, percent change, percent change off of a market baseline. Thus *multiple sparklines* can describe the same noun, just as multiple columns of numbers report various measures of performance. These sparklines reveal the details of the most recent 12 months in the context of a 65-month daily sequence (shown in the fractal-like structure at right).

Consuming a horizontal length of only 14 letterspaces, each sparkline in the big table above provides a look at the price and the changes in price for every day for years, and the overall time pattern. *This financial table reports 24 numbers accurate to 5 significant digits; the accompanying sparklines show about 14,000 numbers readable from 1 to 2 significant digits. The idea is to be approximately right rather than exactly wrong.*[2]

By showing recent change in relation to many past changes, sparklines provide a context for nuanced analysis—and, one hopes, better decisions. Moreover, the year-long daily history reduces *recency bias,* the persistent and widespread over-weighting of recent events in making decisions. Tables sometimes reinforce recency bias by showing only current levels or recent changes; sparklines improve the attention span of tables.

Tables of numbers attain maximum densities of only 300 characters per square inch or 50 characters per square centimeter. In contrast, graphical displays have far greater resolutions; a cartographer notes "the resolving power of the eye enables it to differentiate to 0.1 mm where provoked to do so."[3] Distinctions at 0.1 mm mean 250 per linear inch, which implies 60,000 per square inch or 10,000 per square centimeter, which is plenty.

[2] On being "approximately right rather than exactly wrong," see John W. Tukey, "The Technical Tools of Statistics," *American Statistician,* 19 (1965), 23-28.

[3] D. P. Bickmore, "The Relevance of Cartography," in J. C. Davis and M. J. McCullagh, eds., *Display and Analysis of Spatial Data* (London, 1975), 331.

Here is a conventional financial table comparing various return rates of 10 popular mutual funds:

"Favorite Funds," *The New York Times*, August 10, 2003, p. 3-1.

Popular mutual funds, based on assets under management.

ASSETS (MIL.)	FUND	RETURN			
		4 WKS.	2003	3-YR.	5-YR.
$64,368	Vanguard Index 500 Index	– 2.0%	+12.2%	– 11.7%	– 0.8%
62,510	Fidelity Magellan	– 2.1	+11.3	– 12.9	– 0.2
50,329	Amer A Invest Co of Am	– 1.2	+09.4	– 3.9	+ 4.0
47,355	Amer A WA Mutual Inv	– 1.5	+09.9	+ 00.8	+ 3.0
40,500	PIMCO Instl Tot Return	– 2.3	+02.4	+ 09.4	+ 7.6
37,641	Amer A Grow Fd of Amer	– 2.9	+14.1	– 11.0	+ 7.4
31,161	Fidelity Contrafund	– 1.0	+10.7	– 6.5	+ 3.0
28,296	Fidelity Growth & Inc	– 1.8	+ 8.2	– 8.7	– 0.1
25,314	Amer A Inc Fund of Amer	– 0.5	+ 9.9	+ 05.5	+ 5.4
24,155	Vanguard Instl Index	– 2.0	+12.3	– 11.6	– 0.7

This is a common display in data analysis: a list of nouns (mutual funds, for example) along with some numbers (assets, changes) that accompany the nouns. The analyst's job is to look over the data matrix and then decide whether or not to go crazy — or at least to make a decision (buy, sell, hold) about the noun based on the data. But along with the summary clumps of tabular data, let us also look at the day-to-day path of prices and their changes for the entire last year. Here is the sparkline table:[4]

[4] In our redesigned table, the typeface Gill Sans does quite well compared to the Helvetica in the original *Times* table. Smaller than the Helvetica, the Gill Sans appears sturdier and more readable, in part because of the increased white space that results from its smaller x-height and reduced size. The data area (without column labels) for our sparkline table is only 21% larger than the original's data area, and yet the sparklines provide an approximate look at 5,000 more numbers.

	$64,368	Vanguard 500 Index	–2.0%	+12.2%	–11.7%	–0.8%
	62,510	Fidelity Magellan	–2.1	+11.3	–12.9	–0.2
	50,329	Amer A Invest Co Am	–1.2	+09.4	–03.9	+4.0
	47,355	Amer A WA Mutual Inv	–1.5	+09.9	+00.8	+3.0
	40,500	PIMCO Instl Tot Return	–2.3	+02.4	+09.4	+7.6
	37,641	Amer A Grow Fd Amer	–2.9	+14.1	–11.0	+7.4
	31,161	Fidelity Contrafund	–1.0	+10.7	–06.5	+3.0
	28,296	Fidelity Growth & Inc	–1.8	+08.2	–08.7	–0.1
	25,314	Amer A Inc Fund Amer	–0.5	+09.9	+05.5	+5.4
	24,155	Vanguard Instl Index	–2.0	+12.3	–11.6	–0.7

Astonishing and disconcerting, the finely detailed similarities of these daily sparkline histories are not all that surprising, after the fact anyway. Several funds use market index-tracking or other copycat strategies, and all the funds are driven daily by the same amalgam of external forces (news, fads, economic policies, panics, bubbles). Of the 10 funds, only the unfortunately named PIMCO, the sole bond fund in the table, diverges from the common pattern of the 9 stock funds, as seen by comparing PIMCO's sparkline with the stacked pile of 9 other sparklines at right.

In newspaper financial tables, down the deep columns of numbers, sparklines can be added to tables set at 8 lines per inch (as in our example above). This yields about 160 sparklines per column, or *400,000 additional daily graphical prices and their changes* per 5-column financial page. Readers can scan the sparkline tables, making simultaneous multiple comparisons, searching for nonrandom patterns in the random walks of prices.

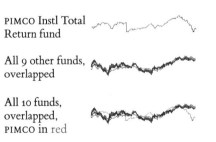

PIMCO Instl Total Return fund

All 9 other funds, overlapped

All 10 funds, overlapped, PIMCO in red

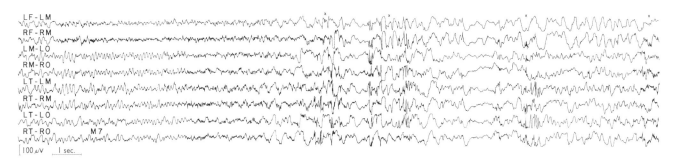

MEDICAL monitoring technologies often produce so much data that sparkline-like graphics are essential to help identify and contextualize clinically relevant events from a torrent of numbers. Above, in this graph of brain waves, 8 tracks (with a scale) of an electroencephalogram begin with calm background activity and then eventually shift into polyspike bursts. At right and below, E. J. Marey, the great French pioneer in creating displays of visual evidence, shows high-resolution physiological data. Depicted are multiple time-traces of empirical measurements, as a pointer scratches data paths onto a smoked carbon plotting field.

Above, Kenneth A. Kooi, *Fundamentals of Electroencephalography* (New York, 1971), 110, redesigned. Below, E. J. Marey, *Du mouvement dans les fonctions de la vie* (Paris, 1868), 118.

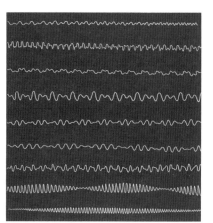

Secousses provoquées par des excitations électriques d'intensité croissante : *a*, origine des secousses ; *h*, parallèle à l'abscisse servant à apprécier les changements d'amplitude des secousses.

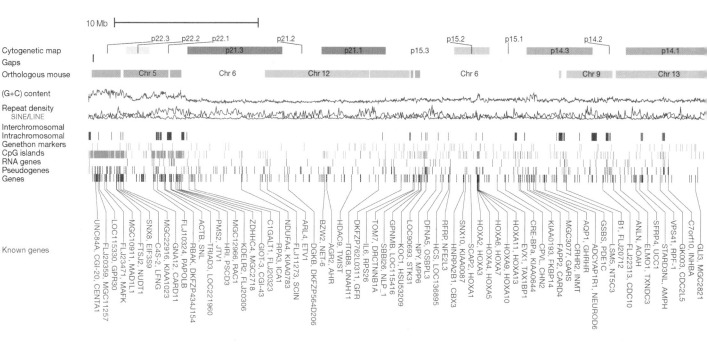

Like cartography, DNA mapping portrays vast amounts of data, for the code of life is very very long. To describe and understand DNA is an inherently high-resolution problem requiring high-resolution displays. Below, in part of human chromosome 7, 10 of 13 data lines operate at sparkline resolutions. The scale distance shown is 10 Mb = 10,000,000 basepairs; the chromosome 7 sequence contains 153,000,000 basepairs. Various patterns in the sequence reveal intriguing changes and stabilities in genetic architecture: "the current configuration and the low degree of sequence similarity among those interchromosomal duplications suggest that the 7q pericentromeric region has been relatively quiescent over the last 25 million years of evolution." To scale 25 million years, contemplate that human language has existed perhaps 1/300th of that time.

LaDeanna W. Hillier, *et al.*, "The DNA sequence of human chromosome 7," *Nature*, 424 (10 July 2003), 157-164; quotation at 162.

Approximately 3% to 5% of the graphics published in major scientific journals depict data with sparkline-like resolutions, as in the chromosome 7 sequence below and the mergesort results at right. There are lots of opportunities to intensify the resolution of scientific data graphics, since many are cartoonish and low-resolution. High-resolution graphics (200 numbers per square centimeter, or 1200 per square inch) help describe, present, and understand really big data sets. By 2006, the median data-graphic published in *Nature* and *Science* presented >1000 numbers. For these journals during the past 10 years, data densities of published graphics have doubled as scientific measurement and resolution have greatly increased. Serious amounts of data—as in science, engineering, medicine, finance, sports, weather—require high-resolution statistical graphics and tables.

Above, Robert Sedgewick, *Algorithms in C* (Reading, Massachusetts, 1998), 350, results of 7 sequential passes to sort a 200 element file in bottom-up mergesort.

Sparklines efficiently display and narrate binary data (presence/absence, occurrence/non-occurrence, win/loss). For baseball, here is the season-long history of wins (upward whisker) and losses (downward) for one team, ⣿⣿⣿⣿⣿⣿ . This 162-game graphical sequence enables sports fans to recall the poor start, the first few scattered wins, another losing streak, and so on through the entire season.

Sparklines that depict on-going sequences can help report all sorts of daily news. This sparkline, embedded in a sentence, is a *dataword* defined as "the win/loss sequence for the season's first 39 games." ──▶ Most sports fans will quickly derive the sparkline's meaning from the context; nearly all readers will understand the meaning the second time a sparkline is published. That's pretty good for a brand new word.

Sparklines can simultaneously accommodate several variables. A team plays on its own field and on opposition fields, a distinction indicated graphically by a horizontal line for home games and no line for away games, ⣿⣿⣿⣿⣿⣿ . The apparent serial correlation (short waves of greater or lesser success) in this time-series is the result of an alternating schedule of home and away games, as teams are more successful at home. A useful strategy for data displays is *to multiply a good design.* These stacked sparklines compare seasons:

New York ⣿⣿⣿⣿⣿⣿ 101-61

Boston ⣿⣿⣿⣿⣿⣿ 98-64

A short red whisker indicates the losing team was held scoreless. These 2 sparklines depict and compare 5 variables (ordered sequence of games, win/loss, home/away, no shutout/shutout, and team) for 162 games.

Below, 6 *paragraphs of sparklines* tell the story of the 2004 season for 6 divisions, showing competitive paths (wins - losses = net games over .500) for 30 baseball teams for all 162 games played by each team. The tables report 500 digits; these sparklines trace out 4,856 win/loss outcomes:

ORIOLES EXTEND WIN STREAK

Yesterday the surging Baltimore Orioles won their fourth exciting game in a row. Still the team has hardly recovered from a poor start, with a season record so far of 8 wins and 31 losses ⣿⣿⣿⣿ , currently the worst in baseball.

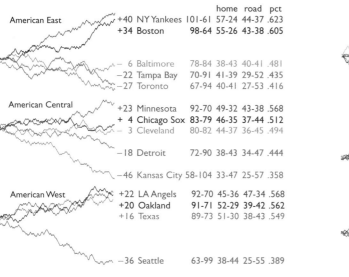

American East		home	road	pct
+40 NY Yankees	101-61	57-24	44-37	.623
+34 Boston	98-64	55-26	43-38	.605
− 6 Baltimore	78-84	38-43	40-41	.481
−22 Tampa Bay	70-91	41-39	29-52	.435
−27 Toronto	67-94	40-41	27-53	.416

American Central		home	road	pct
+23 Minnesota	92-70	49-32	43-38	.568
+ 4 Chicago Sox	83-79	46-35	37-44	.512
− 3 Cleveland	80-82	44-37	36-45	.494
−18 Detroit	72-90	38-43	34-47	.444
−46 Kansas City	58-104	33-47	25-57	.358

American West		home	road	pct
+22 LA Angels	92-70	45-36	47-34	.568
+20 Oakland	91-71	52-29	39-42	.562
+16 Texas	89-73	51-30	38-43	.549
−36 Seattle	63-99	38-44	25-55	.389

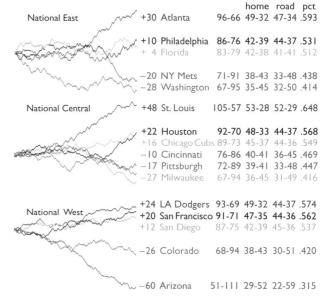

National East		home	road	pct
+30 Atlanta	96-66	49-32	47-34	.593
+10 Philadelphia	86-76	42-39	44-37	.531
+ 4 Florida	83-79	42-38	41-41	.512
−20 NY Mets	71-91	38-43	33-48	.438
−28 Washington	67-95	35-45	32-50	.414

National Central		home	road	pct
+48 St. Louis	105-57	53-28	52-29	.648
+22 Houston	92-70	48-33	44-37	.568
+16 Chicago Cubs	89-73	45-37	44-36	.549
−10 Cincinnati	76-86	40-41	36-45	.469
−17 Pittsburgh	72-89	39-41	33-48	.447
−27 Milwaukee	67-94	36-45	31-49	.416

National West		home	road	pct
+24 LA Dodgers	93-69	49-32	44-37	.574
+20 San Francisco	91-71	47-35	44-36	.562
+12 San Diego	87-75	42-39	45-36	.537
−26 Colorado	68-94	38-43	30-51	.420
−60 Arizona	51-111	29-52	22-59	.315

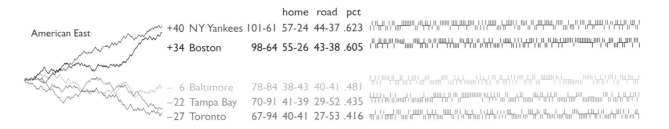

		home	road	pct	
American East	+40 NY Yankees 101-61	57-24	44-37	.623	
	+34 Boston 98-64	55-26	43-38	.605	
	− 6 Baltimore 78-84	38-43	40-41	.481	
	−22 Tampa Bay 70-91	41-39	29-52	.435	
	−27 Toronto 67-94	40-41	27-53	.416	

Above, competitive comparisons *and* win/loss sequences. Instead of simply piles of summary numbers in conventional tables, these sparkline-tables depict game-by-game records. Sparklines can narrate on-going results in detail for any process producing sequential binary outcomes.

Or, for that matter, *measured* outcomes. Data-whiskers can of course vary in length to signal degree of success or intensity of occurrence. For example, as researchers study brains at work, neurons firing, the scientific literature will become filled with sparklines, the way to show such evidence. Here mouse neurons generate multiple sparklines depicted in an auditory stimulus space of intensity/frequency. Note the contour lines mapped in the 3-space of neuron spikes (of variable length), intensity, and frequency:

L. I. Zhang, A. Y. Tan, C. E. Schreiner, M. M. Merzenich, "Topography and synaptic shaping of direction selectivity in primary auditory cortex," *Nature,* 424 (2003 July 10), 201-205.

Below, sparklines report tens of thousands of measurements, a data matrix of routine magnitude for scientific evidence. The marks indicate the visual activities of mice cycling through 19 days for 2 types of mice. Note the subtle duplication of data for each 24-hour period placed in a 48-hour grid in order to show the cyclical activity patterns:

S. Hattar, *et al.*, "Melanopsin and rod-cone photoreceptive systems account for all major accessory visual functions in mice," *Nature,* 424 (2003 July 3), 76-81.

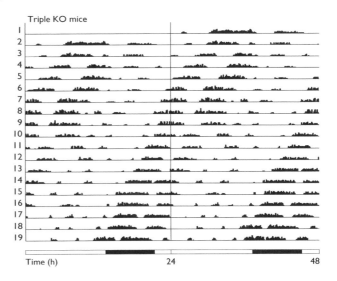

THIS remarkable "bumps chart" shows 800 interwoven sparklines that
tally the results of women's collegiate rowing contests at the University
of Cambridge, England, for 12 seasons each with 4 days of racing by 66+
crews. It all adds up to the outcomes of 3,252 contests. Bumps races come
about because the narrowness of rivers precludes more than 2 crews from
rowing side-by-side. At the beginning of a race, crews are spaced apart at
intervals, the starting gun is fired, and they row like mad trying to catch
the boat immediately in front. When a boat bumps or overtakes another,
as shown by the intersection of 2 diagonals, the crew previously in front
pulls over, bumped down a notch in rank. And so on during all 4 days of
racing, shown by the quarterly structure of each year's contest. Team
standings at season's end carry over to the start of next year's race, thus

Bumps chart by Tim Granger, University
of Cambridge.

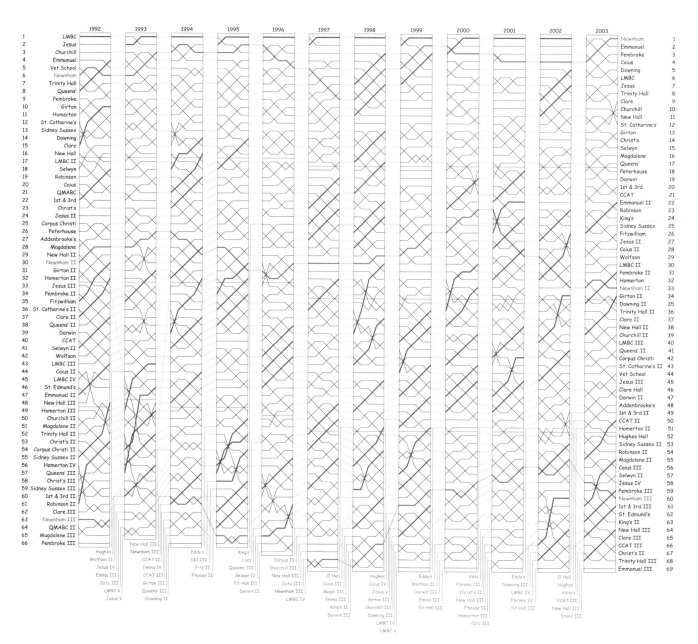

maintaining a continuous thread for the 12-year history of every team's performance. This beautiful web of data contains 800 threadlike graphs, arrayed on a grid of 800 little cells of ordered nouns and years locating each team's performance for any year. Diagonal red lines within a year show crews awarded "blades," when a team bumps up 4 times during that year's race. Dark blue lines narrate 12 years of racing for one recent leader, Newnham, a choice for highlighting that is no accident since the creator of this chart also coaches Newnham women's crew.

SPARKLINES can improve conventional statistical graphics. At right, a *dotdashplot,* a redesign of the standard scatterplot, turns the *frames* into data by projecting the bivariate scatter into univariate distributions, shown as sparklines. Such simultaneous displays of marginal and joint distributions help identify extreme observations as outliers in either one or two dimensions. Obviously different 2-D scatters are consistent with given X and Y univariate distributions; dotdashplots remind viewers that knowledge of the X and Y *univariate* distributions fails to provide full knowledge about their joint *bivariate* distribution.

More generally, *n-1* dimensional scenes are mere shadows of *n*-space activities, precisely the plight of residents of Abbott's *Flatland* and even, at times, residents of Nature's spaceland. Below, in this 3-dimensional dotdashplot, the 3 bivariate scatterplots (XY, XZ, YZ) provide few hints of the saddle-shape of the 3-D distribution (XYZ), yet all the data points in the 3-D scatter lie on the surface of a hyperbolic paraboloid. The 3-D scatter is boxed in by the univariate and bivariate marginal distributions, as the folded univariate sparklines link up 2-D plots and define axes:

Above, dotdashplot: Edward Tufte, *The Visual Display of Quantitative Information* (1983, 2001), 133–135. Below, 3-D scatterplot where *all* 3-D points lie on the surface of a hyperbolic paraboloid, constructed by Professor Alex Kandel, University of Notre Dame.

SPARKLINE-LIKE performances are seen in cartography, brain research, molecular biology, 16th-century engravings, and other data-intense, high-resolution fields. In the exquisite national maps of Switzerland, finely detailed contour lines indicating constant elevations flow over a surface covered with nouns (places) and numbers (mountain heights), a context of visual images, numbers, and words. Sparklines should be so good; indeed all serious analytical graphics should be so good.

 For centuries, artists have used an extremely high-resolution precise line varying in response to changes in *3-dimensional* visual information: the engraving line, so fine and subtle that it is sometimes difficult to reproduce cleanly by advanced printing methods even today. At far right, Albrecht Dürer's 1514 engraving of Saint Jerome shows the extraordinary detail available in the reproduction of visual information 500 years ago. Here at immediate right, enlarged 4 times the area of Dürer's original, the lion's face reveals the detailed intensity of engraving lines.

Matterhorn, Landeskarte der Schweiz, 1347, Bundesamt für Landestopographie (Wabern, 1983), scale 1:25,000. Albrecht Dürer, *Saint Jerome in His Cell,* 1514, 247 by 188 mm.

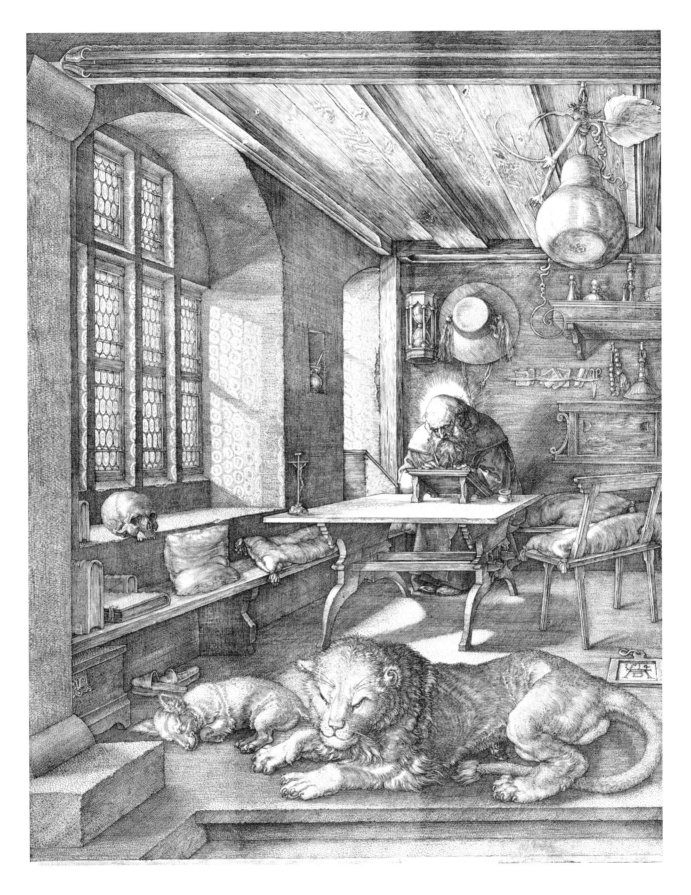

FINALLY, the practical construction of sparklines requires thinking about their design and production:

Aspect ratio A graphic's width/height ratio makes a big difference in displaying data. For *all* types of statistical graphics, the data-shape varies as the aspect ratio varies. At right, for 6 sparklines all showing the same data, note the substantial changes in shape as the y-scale increases by 25% for each line while the x-scale is held constant. How should a sparkline aspect ratio be chosen? Like a narrow ribbon, sparklines have one long dimension and one short, as their wordlike shapes constrain their aspect ratios. This financial sparkline ⁓⁓⁓⁓ is 5 to 1; the full baseball season ⁓⁓⁓⁓⁓⁓ is 20 to 1; the DNA chromosome sparklines run about 300 to 1.

In general, statistical graphics should be moderately greater in length than in height. And, as William Cleveland discovered, for judging slopes and velocities up and down the hills in time-series, best is an aspect ratio that yields hill-slopes averaging 45°, over every cycle in the time-series. Variations in slopes are best detected when the slopes are around 45°, uphill or downhill.[5] To put this idea informally, aspect ratios should be such that time-series graphics tend toward a *lumpy* profile (below) rather than a spiky profile (at right) or a flat profile. Both graphs here show the same data. The aspect ratio for this lumpy graphic is chosen in accord with the 45° rule.

Number of sunspots each year, 1749–1924

Number of sunspots each year, 1749–1924

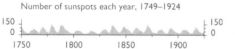

[5] William S. Cleveland, *Visualizing Data* (Summit, New Jersey, 1993), 87-91, 218-227; William S. Cleveland, *The Elements of Graphing Data* (Summit, New Jersey, revised edition, 1994), 66-79.

The lumpy graphic reveals that sunspot cycles tend to rise rapidly and decline slowly, a behavior strongest for cycles with high sharp peaks, less strong for medium peaks, and absent for cycles with small low peaks. None of this is visible in the graph of spikes! Cleveland's idea is essential for sparkline displays of high-resolution time-series, such as in acoustics, medicine, science, engineering, finance. For multiple sparklines, as in the mutual fund data at right, a global aspect ratio is obtained by averaging over the relevant data-lines to yield an overall lumpy quality.

These considerations yield practical advice for choosing aspect ratios for sparklines: use the *maximum* reasonable vertical space available under the word-like constraint, then adjust the horizontal stretch of the time-scale to meet the lumpy criterion. Occasionally the analytical task or character of the data may suggest a better alternative.

Vanguard 500 Index
Fidelity Magellan
Amer A Invest Co Am
Amer A WA Mutual Inv
PIMCO Instl Tot Return
Amer A Grow Fd Amer
Fidelity Contrafund
Fidelity Growth & Inc
Amer A Inc Fund Amer
Vanguard Instl Index

Dequantification In exchange for an enormous increase in graphical resolving power, the wordlike size of sparklines precludes the overt labels and scaling of conventional statistical displays. Most of our examples have, however, depicted *contextual methods* for quantifying sparklines: the gray bar for normal limits and the red encoding to link data points in sparklines to exact numbers ⁓⌁⌁, glucose 6.6 ; global scale bars and labels for sparkline clusters; and, probably best of all, surrounding a sparkline with an implicit data-scaling box formed by nearby numbers that label key data points (such as beginning/end, high/low) 1.1025 ⌁ 1.1907 1.0783 1.2858. And now and then sparklines might be scaled by very small type:

Production methods Data lines produced by conventional statistical graphics programs must be gathered together, rescaled, and resized into sparklines. Sometimes this can be quickly done by cutting and pasting data lines, then resizing the printed output to sparkline resolutions. To produce and display really elegant sparklines, however, currently requires elaborate software: (1) a *page layout* program, (2) a *graphic design* program that gives complete control over type, tables, linework, and (3) a *statistical analysis* program to generate hundreds of chartjunk-free sparklines for export into design and layout operations. Once the basic templates for sparklines are worked out, then ongoing production and display can be placed on automatic pilot. But why is the software for producing high-quality sparklines so contraptionary and so contrary to the display and analysis of high-resolution statistical data?

By segregating evidence by mode (word, number, image, graph), the current-day computer approach contradicts the spirit of sparklines, a spirit that makes no distinction among words, numbers, graphics, images. It is all evidence, after all. A good system for evidence display should be centered on *evidence*, not on a collection of application programs each devoted to a single mode of information. Rather than wandering around a bureaucracy of operating systems and applications, analysts should work entirely with evidence-documents. Long ago such was the case: in the original graphical user interface (developed in the 1970s at Xerox Parc), users saw *only* documents—and *never* saw an operating system or a free-standing application. Text, graphics, tables, and mathematical formulas were all edited *inside of documents*, not inside of separate application programs.[6] Why go to a special place to construct a data graphic? To lay out a report? Segregating information by its mode of production, convenient and profitable for software houses, too often becomes a corrupting metaphor for evidence presentations. Why should the intellectual architecture of our reports and our evidence reflect the chaos of software bureaucracies producing those reports?

[6] Jeff Johnson, Teresa L. Roberts, William Verplank, David C. Smith, Charles H. Irby, Marian Beard, and Kevin Mackey, "The Xerox Star: A Retrospective," *IEEE Computer,* 22 (September 1989), 11-29. This is the classic paper on interface design.

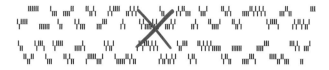

Unintentional optical clutter Above left, these binary-outcome sparklines mainly show accidental arrangements of white space rather than binary outcomes. Then, above right, a less cluttered version of the same data. Closely spaced lines produce moiré vibration, usually at its worst when data-lines (the figure) and spaces (the ground) between data-lines are approximately equal in size, and also when figure and ground contrast strongly in color value. The result is hyperactive optical clutter—for example, at the immediate right. In contrast, note the serene and cleanly differentiated lines on this spring's new bamboo culm at far right.

Changing the relative weight of the data-lines and also muting the contrast between data and background reduces optical noise, as these before/after designs of sparklines suggest:

The standard method for printing color (4-color process) sometimes produces unintentional noise when printing finely detailed material, such as type and sparklines. In 4-color printing (cyan, magenta, yellow, black), tiny dots of color mix together to make the desired color (for example, cyan dots + yellow dots = apparent green). These color dots do not align perfectly, and both type and thin lines can become gritty when printed by conventional 4-color process, shown at right. High-quality maps avoid color dot combinations, as a close look at the Swiss mountain map will indicate. Sparklines should be printed in a single color, or by a judicious mix of 2 colors (magenta + yellow = red), or in flat color (the ink itself is the desired color), or by stochastic color methods.

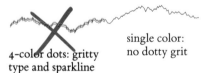

4-color dots: gritty type and sparkline

single color: no dotty grit

Areas surrounding data-lines may generate unintentional optical clutter. Strong frames produce melodramatic but content-diminishing visual effects. At left, the dominant visual elements are, of all things, the strong stripes of the negative spaces between the heavy frames:

A good way to assess a display for unintentional optical clutter is to ask "Do the prominent visual effects convey relevant content?" In the exhibits above earning the unfortunate ✕, the most prominent visual effect is usually the clutter produced by activated negative space.

Resolution of sparklines Sparklines work at intense resolutions, at the level of good typography and cartography. Currently such intensities can be found only on paper, film, and metal—where resolutions >1,200 dpi are easily and inexpensively achieved. Today's computer monitors operate at about 10% of paper's resolution, producing coarse typography in the smaller point sizes as well as sparklines lacking in fine detail. Of course sparklines can be displayed on computer screens but for serious work, sparklines should be printed on paper. Combining paper's resolution with the computer screen's interactivity is often effective.

Resolution of layouts of multiple sparklines For monitoring processes that produce lots of data (financial trading, sporting events, control rooms, scientific and medical analysis, system administration), sparklines should be printed and viewed at a density of 500 sparklines on A3 size paper (about 25 × 45 cm, or 11 × 17 in). This is the data-equivalent of about 15 large computer screens or 300 PowerPoint slides. Unlike relentlessly sequential screens and slides, 500 sparklines on a large piece of paper are *adjacent in space* rather than *stacked in time*. By showing vast amounts of data within the eyespan, spatial adjacency assists comparison, search, pattern-finding, exploration, replication, review.

Just as sparklines are like *words*, so then distributions of sparklines on a page are like *sentences and paragraphs*. The graphical idea here is *make it wordlike and typographic*—an idea that leads to reasonable answers for most questions about sparkline arrangements.

IMAGINE new software or a new computer display that enormously improved the resolution of data graphics. How wonderful and valuable that would be. Sparklines provide such improvements *by design*, by direct, public, open-source methods.

Sparklines vastly increase the amount of data within our eyespan and intensify statistical graphics up to the everyday routine capabilities of the human eye-brain system for reasoning about visual evidence, seeing distinctions, and making comparisons. And data graphics are no longer a special occasion in a separate place with a frame on some slide with a label "Fig. 17-B". Sparklines are everywhere. With resolutions 5 to 100 times conventional graphics and tables, sparklines can help us learn from the flood of numbers produced by modern measurement, monitoring, and surveillance technologies. Providing a straightforward and contextual look at intense evidence, sparkline graphics give us some chance to be approximately right rather than exactly wrong.

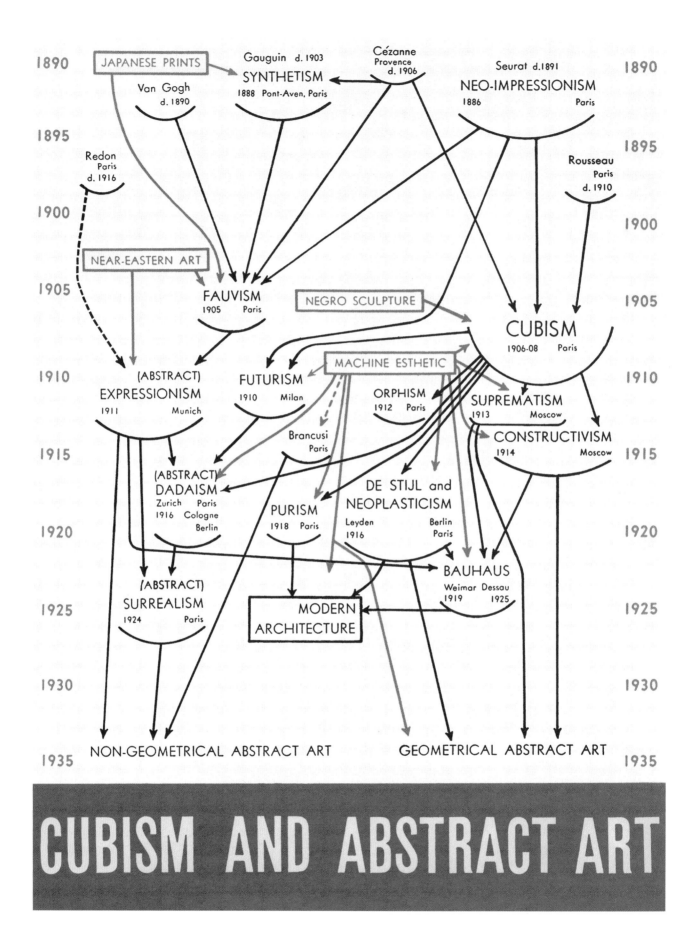

CUBISM AND ABSTRACT ART

Links and Causal Arrows: Ambiguity in Action

ARRAYING words and arrows in art historical 2-space, Alfred Barr's famous diagram illuminated the influential 1936 exhibition *Cubism and Abstract Art*.[1] Set in appropriately modern Vogue (similar to Futura) type, the art chart simultaneously served as a remarkable catalog cover, a table of contents for the show, an organizing history of the art displayed at the museum, and a symbol of the entire enterprise. Barr, then Director of the Museum of Modern Art, imaginatively replaced the conventional typographic catalog cover with a provocative flow chart, a didactic art history genealogy of interacting isms.

Nouns (mainly styles, a few artists and places) are mapped on a grid of *time* (1890-1935, flowing down) and *type of art* (less geometrical at far left, more so at right). Colors distinguish between neighboring and **internal** influences on cubism and abstract art. Like the names of cities of different sizes on maps, the names of iconic styles of art vary in size proportionate to historic relevance: ORPHISM SUPREMATISM CUBISM.

A graphic summarizing 45 years of radical change with 80 words and 51 arrows will necessarily operate at a high level of generality and omit relevant variables. This history of styles does not recognize living artists, except for a lonely Brancusi, who was reportedly delighted to learn that his sculpture did not fit into any of the 13 isms. The only other artists mentioned are 6 deceased greats, Redon, Van Gogh, Gauguin, Cézanne, Seurat, Rousseau. Also the chart shows only those influences *internal* to art, even though work may be shaped by *external* ideas or metaphors from science, technology, architecture, philosophy, literature, current events.

Paths of artistic influence — the verbs of the analysis — are depicted by 51 arrows. Each arrow represents some kind of causal claim concerning the existence, direction, and timing of influence. Nearly all arrows run between style-clumps; no arrows link one individual artist to another. *Absent arrows* between noun-pairs make implicit claims of non-influence; why only one arrow emanating from FUTURISM, and none from BAUHAUS to GEOMETRICAL ABSTRACT ART? It would require many industrious scholars and curators to evaluate all 51 causal links and the many absent links.

But what precisely do the arrows mean? This is the profound analytical and evidential issue for all sorts of diagrams that use links and arrows — flow charts, networks, webs, influence patterns, project management charts, trees of origin and development, parse trees, Feynman diagrams. What do all those lines stand for? Where are their dictionaries? How might connecting lines carry more informative and precise meanings?

[1] Alfred H. Barr, Jr, *Cubism and Abstract Art* (New York, 1936), book jacket, with 8 arrows here revised in accord with Barr's 1941 unpublished manuscript on the chart in *Defining Modern Art: Selected Writings of Alfred H. Barr, Jr,* ed. Irving Sandler and Amy Newman (New York, 1986), 92. On Barr's exhibition, see Susan Noyes Platt, "Modernism, Formalism, and Politics: The 'Cubism and Abstract Art' Exhibition of 1936 at The Museum of Modern Art," *Art Journal,* 47 (1988), 284-295; Sybil Gordon Kantor, *Alfred H. Barr, Jr and the Intellectual Origins of the Museum of Modern Art* (Cambridge, 2002), 21-26, 325-328; and Astrit Schmidt-Burkhardt, *Stammbäume der Kunst: Zur Genealogie der Avantgarde* (Berlin, 2005), 114-184. For comparison, here is a classical typographic catalog cover, for the 1918 Guillaume show:

CATALOGUE DES ŒUVRES

de

MATISSE

et de

PICASSO

Exposées

Galerie Paul Guillaume

108, Faubourg Saint-Honoré

à Paris

Du 23 JANVIER au 15 FÉVRIER 1918

Prix : 2 Francs.

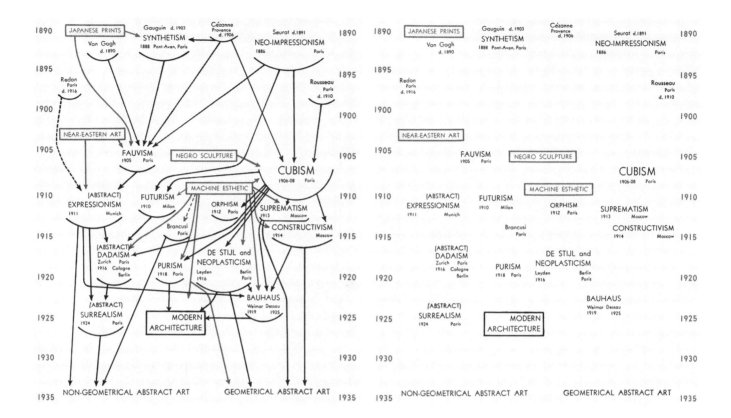

Marked off by dates resembling film-sprocket holes, time flows down in the art chart march of time, avoiding hints of upward progress in art or a growing tree. Instead the idea is a curatorial map of historically ordered rooms in a metaphorical museum, as art-historical time subtly shifts into museum space. Consider all the arrows flowing in and out of CUBISM, a huge room with the largest label: 5 entries from earlier rooms, then 7 exits to styles presented later. FAUVISM has 6 entrances and a single exit—a premature (1910) announcement of ABSTRACT EXPRESSIONISM. A complex of rooms fills the years covered by the exhibition (1905-1925), contrasting with a visual and analytic thinness in the chart during the decades before and after the period covered by the exhibition.

At upper right, erasing the network of 51 arrows (as well as the 19 bowl-like boundary lines beneath each style) takes much of the life out of the original chart. Left behind are scattered nouns, a map with erased roads. Without arrows and brackets, the art chart begins to resemble the spatially dislocated Cubist-influenced poetry of Guillaume Apollinaire's *Calligrammes*. Breaking the putative linearity of conventional text, the 2-dimensional typography of Barr and Apollinaire allows a multiplicity of more or less simultaneous narrative sequences and readings. Of course map-makers have serenely distributed all sorts of words in 2-dimensional spaces for 6,000 years.

Guillaume Apollinaire, *Calligrammes: Poems of Peace and War (1913-1916)*, translation by Anne Hyde Greet (Berkeley, 1980), 92, the first page of the poem "Voyage," redrawn.

Although the causal paths in the art chart are complex, the *idea* of causality is simplistic. Depicted by single-headed arrows, causality flows just one way without the back-and-forth possibilities of *mutual influence* in art. Such arrows represent a major and sometimes false assumption about the allowable scope of causal mechanisms. There are no paired arrows ⇄ or double-headed arrows ⟷ , which would signal contemporaneous influence and feedback among art styles and artists— for example, intense interplay of Braque, Picasso, and Matisse within CUBISM. Indeed Barr, creator of the art chart, published an essay on the Matisse-Picasso relationship.[2] The chart's one-directional arrows have unnecessarily narrowed and foreshortened the history of modern art.

In assessing causal linking lines, the claim that "X acts on Y" should be tested against competing alternatives, such as the paired arrows of interplay. Another check is to *reverse* the claim: "Might it be instead that Y acts on X?" Are there difficulties with concepts of artistic influence? Could Barr's arrowheads ever be at the wrong end of the linking lines? Art historian Michael Baxandall makes a brilliant argument:

> 'Influence' is a curse of art criticism primarily because of its wrong-headed grammatical prejudice about who is the agent and who is the patient: it seems to reverse the active/passive relation which the historical actor experiences and the inferential beholder will wish to take into account. If one says that X influenced Y it does seem that one is saying that X did something to Y rather than that Y did something to X. But in the consideration of good pictures and painters the second is always the more lively reality. It is very strange that a term with such an incongruous astral background has come to play such a role, because it is right against the real energy of the lexicon. If we think of Y rather than X as the agent, the vocabulary is much richer and more attractively diversified: *drawn on, resort to, avail oneself of, appropriate from, have recourse to, adapt, misunderstand, refer to, pick up, take on, engage with, react to, quote, differentiate oneself from, assimilate oneself to, assimilate, align oneself with, copy, address, paraphrase, absorb, make a variation on, revive, continue, remodel, ape, emulate, travesty, parody, extract from, distort, attend to, resist, simplify, reconstitute, elaborate on, develop, face up to, master, subvert, perpetuate, reduce, promote, respond to, transform, tackle*... everyone will be able to think of others. Most of these relations just cannot be stated the other way round—in terms of X acting on Y rather than Y acting on X. To think in terms of influence blunts thought by impoverishing the means of differentiation.[3]

This subtle analysis of studies of reconstructed one-directional influence suggests that many linking arrows may rely too much on assumption and too little on evidence. In the art chart, the common direction of 51 arrows impoverishes explanation, at times prematurely foreclosing an analysis of the capacities of those at the wrong end of the arrows. Also arrows are *identical generic links rather than specific verbs* reflecting artistic activities. Baxandall's list shows that a vivid language of differentiated verbs is available to characterize relationships among art and artists.

[2] Alfred H. Barr, Jr, "Matisse, Picasso, and the Crisis of 1907," in *Defining Modern Art: Selected Writings of Alfred H. Barr, Jr*, ed. by Irving Sandler and Amy Newman (New York, 1986), 192-201.

[3] Michael Baxandall, *Patterns of Intention: On the Historical Explanation of Pictures* (London, 1985), 58-59, italics added.

The Barr art chart is an imaginative, important diagram. It also illustrates the implicit but powerful assumptions of visual summaries, and the importance of presenting evidence about the *specific character of relationships* among verbal elements. Many diagrammatic links and arrows assume too much and explain too little, an ambiguity in action. The more generic the arrows and lines, the greater the ambiguity.

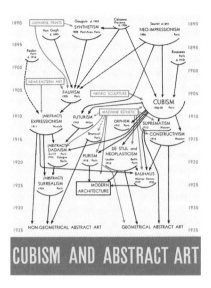

CUBISM AND ABSTRACT ART

INSPIRED by the art chart, Ad Reinhardt, the great color field painter, published this large satirical cartoon in 1946. Like Barr, Reinhardt arrays nouns (artists, influences, styles) over a spatial field generated by 2 variables: *time* (growing up from historical roots) and *type of art* (pure abstract paintings at left and figurative illustration at right). Tiny type at bottom of the cartoon notes "Art is long, and (space)-time is fleeting." Both art charts use rough bipolar scales, dividing artwork into a world of 2 contrasting categories. Reinhardt's horizontal scale sorts out *pure art from ever more wretched and corrupt art* in moving left to right! Representational art grows from a rotten broken branch; down below, commercial art fertilizes the corn:

Here's a guide to the galleries—the art world in a nutshell—a tree of contemporary art from pure (abstract) "paintings" (on your left) to pure (illustrative) "pictures" (down on your right). If you know what you like but don't know anything about art, you'll find the artists on the left hardest to understand, and the names on the right easiest and most familiar (famous). You can start in the cornfields, where no demand is made on you and work your way up and around.

As tabulated below, what Barr ignores (living artists, American art, representational art, Pepsi-Cola contest winners), Reinhardt berates. The Museum of Modern Art chart was reprinted in art history books; the newspaper cartoon was "pinned to the studio walls of artists all over America for years."[4]

[4] Ad Reinhardt, "How to Look at Modern Art in America," *P.M.*, June 2, 1946. See Thomas B. Hess, *The Art Comics and Satires of Ad Reinhardt* (Rome, 1975), for all of Reinhardt's comics and the history of the tree shown at right.

BARR, MODERN ART CHART	REINHARDT, HOW TO LOOK AT MODERN ART IN AMERICA
Information space Art-historical two-space, spatially locating nouns.	**Information space** Art-historical two-space, spatially locating nouns.
Design style Modern, spare, schematic, simple, high art, Futura type.	**Design style** Newspaper cartoon, textured, detailed, thick, passionate, low art, hand-lettering.
Intellectual approach Didactic, synoptic, celebrates modern art, international, cosmopolitan, definitive (provides no extra causal arrows for the reader).	**Intellectual approach** Critical, satirical, prankish, jokey, insider, local, personal. Strongly favors pure abstract art, denounces figurative art and illustration. Not definitive; indeed provides blank leaves for overlooked artists:
Data 673 characters of text; 7 names of artists; 51 influences (all artistic), 23 European and Russian place-names.	**Data** 3,160 characters of text; 263 names of artists, illustrators, friends; 36 influences, styles, genres, corporations, corruptions.
Pepsi-Cola contest winners: 0.	**Pepsi-Cola contest winners**: 18. This art contest gave prizes to representational artists. Reinhardt mocked the winners by marking their names with a bottle:

HOW TO LOOK AT MODERN ART IN AMERICA

by Ad Reinhardt

Here's a guide to the galleries—the art world in a nutshell—a tree of contemporary art from pure (abstract) "paintings" (on your left) to pure (illustrative) "pictures" (down on your right). If you know what you like but don't know anything about art, you'll find the artists on the left hardest to understand, and the names on the right easiest and most familiar (famous). You can start in the cornfields, where no demand is made on you and work your way up and around. Be especially careful of those curious schools situated on that overloaded section of the tree, which somehow think of themselves as being both abstract and pictorial (as if they could be both today). The best way to escape from all this is to paint yourself. If you have any friends that we overlooked, here are some extra leaves. Fill in and paste up...

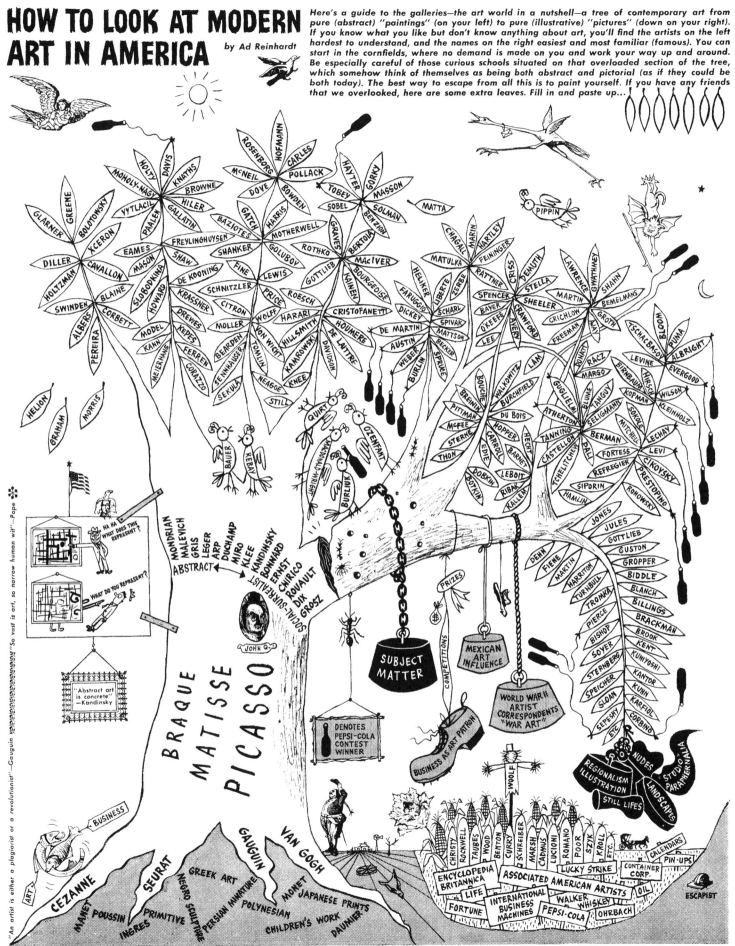

WHEN nouns are linked together by arrows or lines, a change in the level of analysis often takes place. *Nouns name a specific something; arrows and links are too often non-specific, generic, identical, undifferentiated, and ambiguous.* Sameness of a visual element implies sameness of what the visual element represents, as if the identical process operated between every pair of connected nouns. Perhaps information concerning links between nouns is more speculative and uncertain than the nouns, but that does not justify know-nothing designs that make all links identical. At least Ad Reinhardt vividly distinguishes between what he considers fruitful and decayed branches of art in this detail at right.

For most graphics involving nouns connected up by arrows or links, the evidence for variation in connections is stronger than evidence for sameness. It would be astonishing if the contrary were true. To express such variation, arrows, links, and other connectors should become more articulate, more differentiated, less generic. For example, the artist Mark Lombardi deploys a variety of links in network drawings that suggest, at least to the already-convinced, vast political-economic conspiracies:

—————— Some type of influence or control

——————▶ Some type of mutual relationship or association

– – – – – Flow of money, loans or credits

—ⱮⱮ—◀ Sale or transfer of an asset

– – – – – – Blocked or incomplete transaction

ℓℓℓℓℓ The sale or spin-off of a property

Legend (revised) from Robert Hobbs, *Mark Lombardi Global Networks* (New York 2003), 52. Detail below (words enlarged) from Mark Lombardi, *George W. Bush, Harken Energy, and Jackson Stephens, ca. 1979-90*, fifth version, 1999.

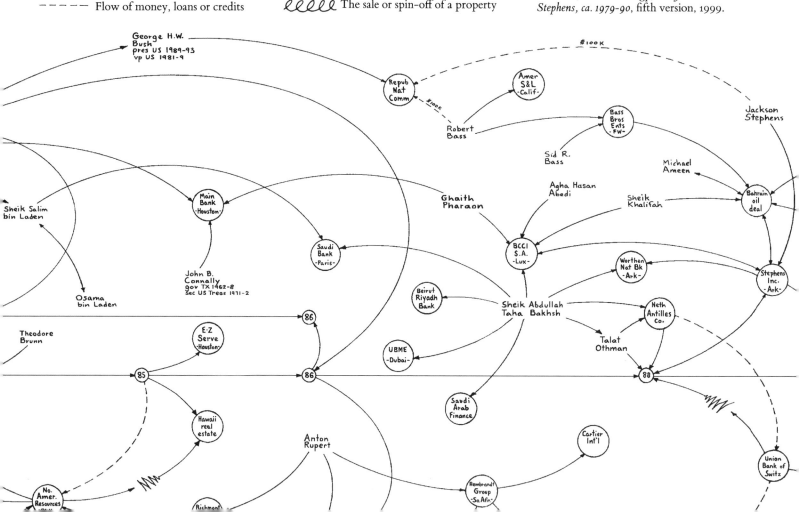

Maps show information with differentiated lines all the time, with greater richness than art history charts and network drawings. These 3 cartographic legends make 34, 15, and 17 distinctions in line meaning. So many distinctions requires contemplation of the detailed encodings in the legend—although the correct reading of many lines on maps, like words in sentences, is often clear from the context.

Main road, sealed surface; Built-up area

Minor road, sealed surface; Road bridge;
Distance marker: Kilometre; Mile

Motorable track; Buildings

Foot path; Foot bridge

Railway, double track; Station; Halt

Railway, single track; Road over;
Road under; Level crossing

Light railway, single track

Embankment; Cutting

International boundary

District boundary

Mukim boundary

Nature reserve boundary

Vegetation limit

Power transmission line

Contours; Supplementary contours

River and stream; River and Shoreline indefinite

Pond; Bund; Sluice; Underground stream

Reservoir; Dam; Water pipe line

Service reservoir; Canal

有料の部分 幅員11.0ᵐ以上の道路
幅員5.5ᵐ以上の道路
国道番号 幅員2.5ᵐ以上の道路
幅員1.5ᵐ以上の道路
小　　　　道
国　有　鉄　道
民　営　鉄　道
森　林　軌　道　等
索　　　　道
堤　　　　防
都・府・県　界
支　庁　　界
国　　　　界
郡・市・都内の区界
区・町・村界

Main Road, with Bridge
Secondary Road, with Culvert
Other Road or Track
(Impassable in Wet Season)
Footpath
Boundaries :- International
" Divisional
" District
KEREWAN Divisional Headquarters
BWIAM District Headquarters
Telegraph or Telephone Line
(Along Road)
Power Line
Watercourse
Steep Slopes

Cartographic lines have a high-resolution lightness and clarity, similar to typography. Finely textured lines avoid the optical clutter and moiré vibration of heavy links, which appear at lower left in a small segment of a tree of life. At right a redesign calms down the clunky connectors. But the links remain uncartographic and uninformative; why should they all look alike, even though the histories they summarize differ?

Top left, *Singapore, 1:50,000 topographical map*, Ministry of Defence, 1983; top right, *The National Atlas of Japan, 1:25,000 maps* (Tokyo, 1984); and *Kau-Ur, The Gambia, 1:50,000,* The Gambia Government (1975).

Manilkara zapota
Impatiens palida
Clethra alnifolia
Pyrola picta
Styrax americana
Pterospora andromedea
Sarcodes sanguinea
Monotropa uniflora
Sarracenia purpurea
Cyrilla racemiflora
Symplocos paniculata
Diospyros virginiana
Camellia japonica

Manilkara zapota
Impatiens palida
Clethra alnifolia
Pyrola picta
Styrax americana
Pterospora andromedea
Sarcodes sanguinea
Monotropa uniflora
Sarracenia purpurea
Cyrilla racemiflora
Symplocos paniculata
Diospyros virginiana
Camellia japonica

At left, a few of the 3,000 species shown in a 1.5 meter diameter circular tree of life by David Hillis. See Elizabeth Pennisi, "Modernizing the Tree of Life," *Science*, 300 (13 June 2003), 1692-1697.

Waste Tech Inc.

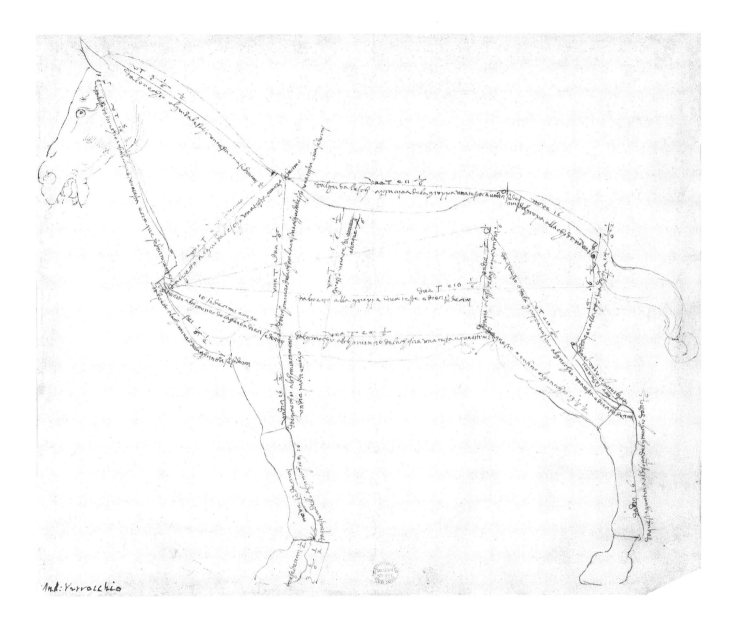

Andrea del verrocchio's dimension lines proportionally measure horse dimensions in terms of 1/16 horsehead units (written incorrectly here, art historians suggest, as "1/6" rather than "1/16"). Most lines are numerically labeled by the proportional units and are also annotated by words describing the line endpoints—for example, "from top of front leg bone to top of back leg bone." The drawing exemplifies the use of multiple labels (both words and numbers here) for linking lines.

Verrocchio's annotated lines hint that *sparklines* might now and then simultaneously serve as linking lines, conveying detailed statistical data about the character of the link (variation over time? frequency of contact? strength of link? reliability? back-and-forth influence?).

Andrea del Verrocchio, *Measured Drawing of a Horse in Profile Facing to the Left*, 1483–1488, pen and ink with traces of black chalk, 249 by 298 mm, as described and translated in Carmen C. Bambach's essay in *Leonardo da Vinci: Master Draftsman*, edited by Carmen C. Bambach (The Metropolitan Museum of Art, New York, 2003), 268–270.

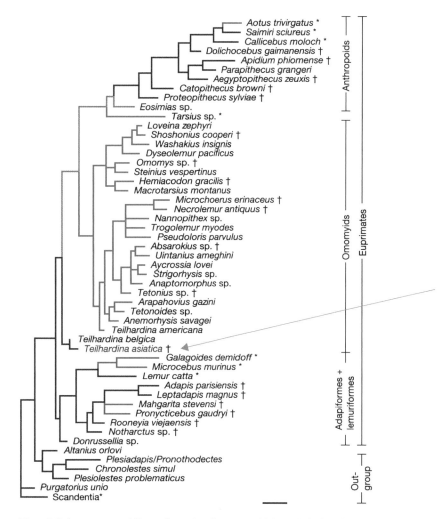

The skull of *Teilhardina asiatica* sp. nov. (IVPP V12357). Reconstruction of the skull based on IVPP V12357, with grey shadow indicating the missing parts. Scale bar, 5 mm.

Figure 3 Strict consensus of 33 equally parsimonious trees with the optimization of activity patterns. Tree length = 2,076, Consistency index (CI) = 0.3685, Retention index (RI) = 0.5519. Asterisks denote extant taxa. Daggers denote the terminal taxa presenting reconstructions of activity patterns (data are from refs 7, 23, 30). Blue, diurnal; green, nocturnal; orange, equivocal. Scale bar, 30 characters.

THIS cladogram (*klados* is Greek for branch or twig) locates the earliest modern primate *Teilhardina asiatica*, "a small, diurnal, visually oriented predator." Recently dug up in Hunan Province, China, the *T. asiatica* skull apparently dates back 55 million years. In this branch from the tree of life, colors add meaning to the lines: blue = diurnal, green = nocturnal, orange = equivocal, but why not the more obvious black for nocturnal? Higher-level categories are shown in the right margin of the tree

similar to the categories along the bottom margin of the Barr art chart

Several good design techniques for trees are at work here: scaled linking lines, color-coded links, and also the multiple classification of nouns by means of color links, typographic symbols († *), marginal annotation, and local position among sequentially splitting branches. Multiple splits indicate uncertain evidence, not simultaneous biological events.

Xijun Ni, Yuanqing Wang, Yaoming Hu, and Chuankui Li, "A euprimate skull from the early Eocene of China," *Nature* 427 (1 January 2004), 65–68 (images here combined and redrawn).

Evolutionary trees describe a causal mechanism: changes over time in organisms take place as a result of descent from ancestors. Thus names closer to one another have more in common than names further apart.

Reasoning about tree diagrams evokes not only specifics about the content at hand but also more general issues about analytical credibility. What causal mechanisms are assumed or described by the tree? In what space does the tree reside? What does the data matrix behind the tree look like? Can we see that matrix? What is the interplay of evidence and assumption in generating the results? Do alternative trees fit the data? How many? Can the published tree be distinguished from alternatives? Does the tree reflect good practice in reporting evidence?

This tree is derived from statistically crunching a data set of 15,000 numbers. Such intense summarizing inevitably requires strong editorial judgments and statistical assumptions. Here the evidence needed extra boiling down because the tree does not report all that much data (lots of empty space, no numbers in the display itself, coarse linking lines).

In what 2-space does the cladogram reside? Scaled by a scale bar, the horizontal line-lengths show the number of features measured for the taxa.[5] Thus the horizontal dimension is not a time-scale (indeed dates of organism existence are often uncertain or absent); some nouns on the right in one part of the tree may pre-date nouns on the left elsewhere. Likewise, the tree's vertical dimension has little meaning, as indirectly indicated by the lack of a scale. Vertical line-length simply reflects the number of typographic lines and their leading for taxa names.[6]

Among a variety of trees, published here is the "most parsimonious" tree, with the *smallest* number of changes in animal features (hairy/smooth, diurnal/nocturnal, and so on) over time. Does Nature generate efficient trees? At *every* branch? Is parsimony a proven biological phenomenon or merely a statistical modeling assumption? Yet the assumption does not identify a unique tree; this cladogram is a "consensus tree" based on 33 equally parsimonious trees, with some *nearly* parsimonious trees hanging around. Sorting among many plausible candidate models often leads to publishing a brittle, over-fitted model. Thus these leaves may tremble.

The statistical methodology for calculating published trees is described by feel-good pitch words. Readers are presented with a "strict consensus of parsimonious trees" based on "optimization of activity patterns." Who could object to a consensus, let alone a strict one, both optimal and parsimonious? Like puns, these words have a duplicity of meaning, with narrow technical and broad cheerleading meanings.

Several numbers also overreach. Indices accurate to 4 significant digits are reported in the diagram's caption, although these calculations are based on crude measurements of animal features that are arbitrarily quantified (1 = smooth, 2 = furry). And the recently discovered skull is reported to be "54.97" million years old, a suspiciously precise estimate. Fossil evidence is probably a 1 or 2 digit science much of the time.

[5] Instead of placing unlabeled scale bars up in the illustrations (cladogram and skull) and units of measurement down in the captions, *direct* labeling for the scale bars would be much better:

30 characters 5 mm

[6] Several of these authors later published this helpful illustration of relationships among early mammals, for Cenozoic taxa (jaw shown in outline) and Mesozoic taxa (solid), with the scale bar now built in. Yaoming Hu, Jin Meng, Yuanqing Wang, and Chuankui Li, "Large Mesozoic mammals fed on young dinosaurs," *Nature,* 433 (13 January 2005), 149-152, redrawn:

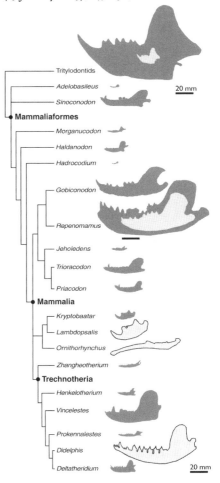

W ITH differentiated lines similar to maps and old electronic schematics, Richard Feynman's famous diagrams for quantum electrodynamics depict complex ideas. Based on a dictionary and elaborate syntax, the diagrams portray interactions of photons, electrons, positrons, their many colleagues and anti-colleagues by means of visual reasoning, logical enumeration, and mathematical operations. Behind the scenes, extensive calculations are at work; in 1983, the magnetic moment of an electron was computed to 12 significant digits using 900 diagrams with 100,000 terms.

Serving simultaneously as images, equations, and verbal summaries, Feynman diagrams are multimodal and thus, in practice, often modeless. For example, this double-page layout below from Martinus Veltman's *Diagrammatica: The Path to Feynman Diagrams* combines diagrams, their parallel mathematical equations, and a verbal narrative. Veltman points out that the "situation in quantum electrodynamics is more complicated," which we knew before we started. These pages below have an elegant

Illustration by Roger Hayward, in C. L. Stong, *The Amateur Scientist* (New York, 1960), 287.

Martinus Veltman, *Diagrammatica: The Path to Feynman Diagrams* (Cambridge, 1994), 150–151.

Now the infinity of the one loop σ self-energy diagram was absorbed in the σ mass m. That means that the σ mass is now given by $m^2 + \delta_m$. With this choice for the σ mass however there is a contribution of order g^4 hidden in the one loop diagram, see figure, where the dot signifies that for the σ mass one must take $m^2 + \delta_m$. To order g^2 one has:

$$\frac{1}{Q^2 + m^2 + \delta_m - i\epsilon} = \frac{1}{Q^2 + m^2 - i\epsilon}$$
$$- \frac{1}{Q^2 + m^2 - i\epsilon} \delta_m \frac{1}{Q^2 + m^2 - i\epsilon}$$

which can be pictured as shown.

Selecting then from this one loop diagram the part proportional to g^4 leads to the diagram shown, where now the cross stands for a factor $-\delta_m$.

In other words, having absorbed the one loop infinity in the σ mass means that at the g^4 level we find in fact two diagrams:

The cross equals precisely minus the infinite part of the σ self-energy insertion in the first diagram. Together then they are finite; in fact, the self-energy diagram was computed before, and together the result is finite and of the form

$$F(Q) = C + \int_0^1 dx \, \ln\left(x(1-x)Q^2 + M^2\right)$$

where C is a constant. For large Q that behaves as $\ln Q^2$. The remaining integral

$$\int d_4 Q \, \frac{F(Q)}{\left((Q-k)^2 + M^2\right)\left(Q^2 + m^2\right)^2} \sim \int d_4 Q \, \frac{\ln Q^2}{Q^6}$$

is convergent.

In other theories, such as for example quantum electrodynamics, this is not that simple. The remaining integral is usually

divergent, and one must show that the remaining infinity is such that it can be absorbed again in the parameters of the theory, i.e., it must be a linear combination of a constant and a constant times momentum squared but nothing else.

Disentangling infinities is a rather complicated affair. One speaks of overlapping divergencies.

6.5 Quantum Electrodynamics

The situation in quantum electrodynamics is more complicated. The reason is that the electron propagator behaves as $1/k$ for large momentum rather than $1/k^2$ as the π and σ propagators in the foregoing. The divergent diagrams at the one loop level are:

Electron self-energy, Λ

Photon self-energy, Λ^2

Electron–photon vertex, $\ln \Lambda$

Photon scattering, $\ln \Lambda$

Exercise 6.5 Verify this.

The tadpole diagram is zero. The corresponding expression is:

$$\int d_4 p \, \frac{\text{Tr}\{\gamma^\mu(-i\gamma p + m)\}}{p^2 + m^2 - i\epsilon}.$$

The trace gives $-4ip_\mu$, the resulting integral is:

$$\int d_4 p \, \frac{-4ip_\mu}{p^2 + m^2 - i\epsilon}.$$

All p-integrations are symmetric and go from $-\infty$ to $+\infty$, but the integrand is odd in p and the integral is therefore zero.

visual precision, similar to John Cage's artistic musical scores. Veltman introduces *Diagrammatica* with a note indicating that behind the graceful page layout is a thoughtful mathematical physicist and book designer: "This book is somewhat unusual in that I have tried very hard to avoid numbering the equations and figures. This [keeps] all derivations and arguments closed in themselves, and the reader needs not to have fingers at eleven places to follow an argument."[7]

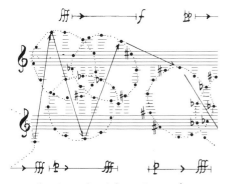

John Cage, detail from *Concert for piano and orchestra, 1958*, solo for piano, 9.

Produced by mechanical drawing, the first published Feynman diagram (above left) commits the classic design error of *equal line weight for all visual elements*. In the original at left, naive arrows serve as pointer lines *and* as traces of quantum dynamics, just as dimension lines sometimes get mixed up with object lines in architectural and engineering drawings. In our redesign adjacent to the original, pointer lines prove unnecessary, other than for time's arrow. Recently published Feynman diagrams use color lines similar to road maps.

A consistently helpful strategy in analytical design is to extend the scope of a good design element — by increasing the dimensionality of the space the element resides in, enhancing resolution of the element, multiplying elements, and integrating the element into various displays. Such is the history of Feynman diagrams, as below on 2 space-time grids multiple quantum dancers move around, described by Feynman's words beneath:

[7] Veltman, *Diagrammatica*, xii.

Far left: R. P. Feynman, "Space-time approach to quantum electrodynamics," *Physical Review,* 76 (1949), 776. Color diagrams: DØ Collaboration, "A precision measurement of the mass of the top quark," *Nature,* 429 (10 June 2004), 638-641. Below: Richard P. Feynman, *QED: The Strange Theory of Light and Matter* (Princeton, 1985), 117-118. For history, see David Kaiser, *Drawing Theories Apart: The Dispersion of Feynman Diagrams in Postwar Physics* (Chicago, 2005).

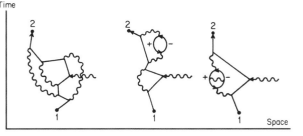

Laboratory experiments became so accurate that further alternatives, involving four extra couplings (over all possible intermediate points in space-time), had to be calculated, some of which are shown here. The alternative on the right involves a photon disintegrating into a positron-electron pair, which annihilates to form a new photon, which is ultimately absorbed by the electron.

Calculations are presently going on to make the theoretical value even more accurate. The next contribution to the amplitude, which represents all possibilities with six extra couplings, involves something like 70 diagrams, three of which are shown here. As of 1983, the theoretical number was 1.00115965246, with an uncertainty of about 20 in the last two digits; the experimental number was 1.00115965221, with an uncertainty of about 4 in the last digit.

THIS molecular-epidemiological diagram tracks the rapid spread of virus isolates of severe acute respiratory syndrome (SARS) that caused disease outbreaks in many countries. Beginning with the unfortunate Patient number 1, some 20 arrows track key SARS patients, from Guangdong in China to Hong Kong to Vietnam, Singapore, and Canada (and then eventually to 30 other countries). The key index cases above (with their virus designations in parentheses) apparently "caused a disproportionate number of secondary cases, the so-called super-spreading incidents."

This practical, workaday diagram demonstrates excellent analytical practices for displays that use links and arrows to tie nouns together: timelines, trees, networks, organization charts, project management charts, and the like. These practices are:

Focus on causality The SARS graphic attempts to describe the *causal mechanisms* of disease transmission, as is nearly always the case in epidemiology. For SARS, the causal issues are fairly straightforward, compared with the complexities of our earlier examples tracing out creative influences in art or linking up 55 million years of ancestral evolution. Uncertainties in causal links can sometimes be shown graphically; the SARS diagram indicates uncertain transmission routes with dotted arrows.

Multiple sources and levels of data The SARS graphic presents evidence from molecular isolates, clinical observations, epidemiological detective work, and worldwide public health statistics—*whatever evidence it takes to understand what is going on.* Too often diagrams instead rely solely on one type of data or stay at one level of analysis.

Y. Guan, J. S. M. Peiris, B. Zheng, L. L. M. Poon, K. H. Chan, F. Y. Zeng, C. W. M. Chan, M. N. Chan, J. D. Chen, K. Y. C. Chow, C. C. Hon, K. H. Hui, J. Li, V. Y. Y. Li, Y. Wang, S. W. Leung, K. Y. Yuen, and F. C. Leung, "Molecular epidemiology of the novel coronavirus that causes severe acute respiratory syndrome," *The Lancet*, 363 (10 January 2004), 99–104; diagram at 100, quotation at 103.

Annotated linking lines Links and arrows should provide specifics: when and how the link operates, its strength and persistence, credibility of evidence for the link. Identical links should be used only if identical processes operate everywhere. The SARS graphic distinguishes between more and less certain links, and also annotates several links.

Annotated nouns Like linking lines and causal arrows, nouns in diagrams should be labeled, annotated, explained, described. The SARS analysis shows patient names with virus strain identification, description, travels. Annotated nouns combine with annotated arrows to help narrate the epidemic. The graphic begins by describing *Patient 1* in Hong Kong, not *Patient 0* in Guangdong, since the Chinese government suppressed information about the epidemic in China.

Efficiency of design Like a good map, the SARS graphic is straightforward, direct, with no unnecessary elements. In contrast, clunky boxes, cartoony arrows, amateur typography, and colorful chartjunk degrade diagrams. If your display looks like a knock-off from a corporate annual report or a PowerPoint pitch, start over. *Designs* for analytical diagrams should be clear, efficient, undecorated, maplike; the *content* should be intense, explanatory, evidential, maplike. The metaphor is the map, not stupidity.

Thus, for example, the omnipresent boxes of organization charts are rarely needed. If every name is highlighted, no name is. Maps don't put boxes around city names. The location of the typography *alone* indicates the 2-dimensional location of each bureaucrat; the space gained by the absence of all those little boxes can then provide additional information, such as the salary equivalents of the now-unboxed bureaucrats. Omitting boxes increases explanatory resolution.

Credibility An analytical graphic should provide reasons to believe. The SARS chart presents a coherent story, diverse data, knowledgeable detail. Published in *The Lancet*, a leading international, peer-reviewed medical journal, the article reports explanatory detective work rather than marketing products for commercial clients or covering up for governments. Most of the 18 authors work at public health organizations. All this helps add up to a credible diagram, at least until better evidence or alternative explanations come along.

Alternative diagrams test the credibility of the favored diagram. What are the competing diagrams and alternative assumptions? Are the links credible, documented, explained, quantified? Does the published diagram ignore relevant variables? Consumers of presentations should take causal diagrams and linking lines seriously, just like real evidence.

Patient 2C ——— Travel to Vietnam (Admitted to French Hospital, Hanoi) →

Patient 2E (SIN–2500) ——— Travel to Singapore → (Singapore index case)

Patient 2D ——— Travel to Canada → (Canada index case)

Patient 1 (HKU–33) Hong Kong index case, travel from Guangdong

Patient 2A (HKU–39849) Shopping, sightseeing with patient 1

Patient 3B (HKU–56) Hospital X health-care workers

Urbani French hospital health-care worker

Disaster at the Federal Emergency Management Agency, www.fema.gov.

Don't do this.

Instead, do this.

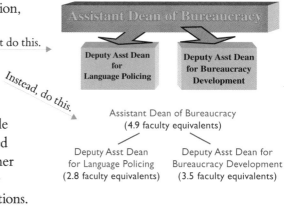

Assistant Dean of Bureaucracy (4.9 faculty equivalents)

Deputy Asst Dean for Language Policing (2.8 faculty equivalents)

Deputy Asst Dean for Bureaucracy Development (3.5 faculty equivalents)

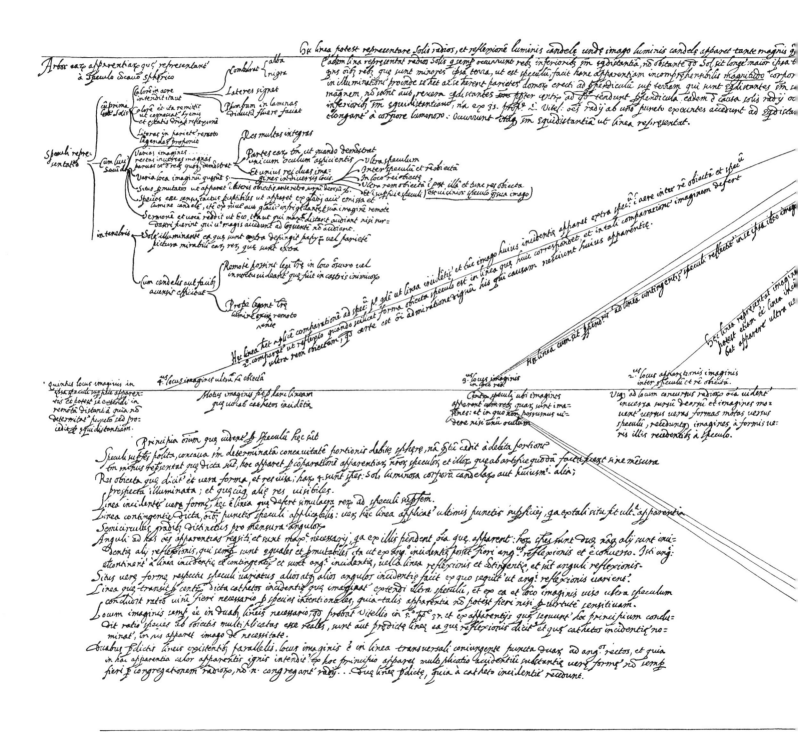

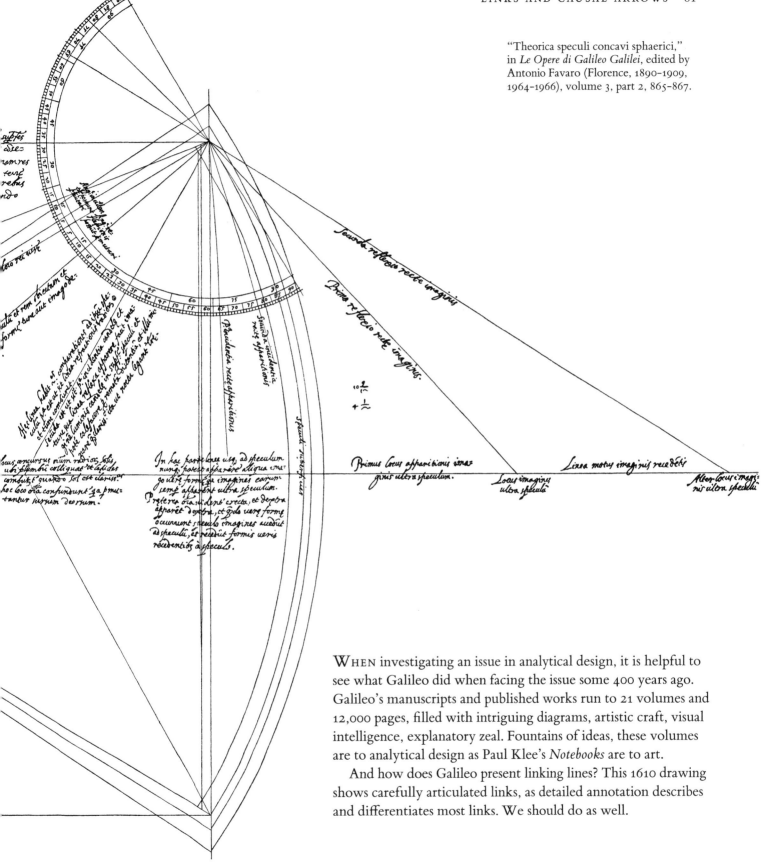

"Theorica speculi concavi sphaerici,"
in *Le Opere di Galileo Galilei*, edited by
Antonio Favaro (Florence, 1890-1909,
1964-1966), volume 3, part 2, 865-867.

WHEN investigating an issue in analytical design, it is helpful to
see what Galileo did when facing the issue some 400 years ago.
Galileo's manuscripts and published works run to 21 volumes and
12,000 pages, filled with intriguing diagrams, artistic craft, visual
intelligence, explanatory zeal. Fountains of ideas, these volumes
are to analytical design as Paul Klee's *Notebooks* are to art.

And how does Galileo present linking lines? This 1610 drawing
shows carefully articulated links, as detailed annotation describes
and differentiates most links. We should do as well.

Words, Numbers, Images — Together

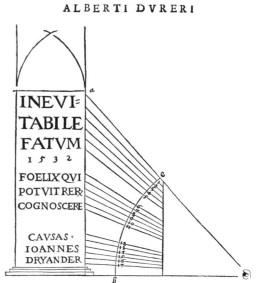

EVIDENCE that bears on questions of any complexity typically involves multiple forms of discourse. In modern scientific research, for example, 25% of published materials are graphs, tables, diagrams, and images; the other 75% are words (in 2,850 articles we randomly sampled from the 10 most-cited scientific journals, 1951-2000). Or, consider a more selective sample from 1610: Galileo's *Starry Messenger* is 30% images and diagrams, all integrated within the text. Or, for a more visual subject, the aesthetic theory and practical geometry of art, architecture, letterforms: Albrecht Dürer's *A Course in the Art of Measurement* (1525) consists of 52% drawings and 48% text, with woodcuts and words combined throughout the book.[1]

Evidence is evidence, whether words, numbers, images, diagrams, still or moving. It is all information after all. For readers and viewers, the intellectual task remains constant regardless of the particular mode of evidence: to understand and to reason about the materials at hand, and to appraise their quality, relevance, and integrity.

Most techniques for displaying evidence are inherently multimodal, bringing verbal, visual, and quantitative elements together. Statistical graphics and maps are visual-numerical fields labeled with words and framed by numbers. Even an austere image may evoke other images, new or remembered narrative, and perhaps a sense of scale and quantity. Words can simultaneously convey semantic and visual content, as the nouns on a map both name places and locate them in the two-space of latitude and longitude (here at right on a 1923 postcard).

Like Galileo and Dürer, those who reason about evidence often seek to place different forms of information within a common visual field and to treat all forms—verbal or nonverbal—as colleagues in explanation. At left, a manuscript of Leonardo da Vinci reveals intense unification of word and image characteristic of deep evidence-reasoning and evidence-presenting. How could it be otherwise? Leonardo's analysis combines text, beautiful drawings, engineering diagrams, annotation of local detail, and scales of measurement—whatever it takes—to illustrate the anatomy of the arm including such subtleties as the slight contraction in arm length upon turning the hand flat down and crossing the radius and ulna.[2]

YET this bond between verbal and nonverbal evidence has sometimes come undone in the process of *publishing,* as the assorted technologies of reproduction and presentation have segregated information by the accident of its mode of production. What has happened during 1,200 years of presenting text and images on paper and computer screens— and what can be done about it?

[1] Albrecht Dürer, *Institutiones geometricae* (Paris, 1532), 116, Latin edition of *Underweysung der Messung* (Nuremberg, 1525). A woodcut with text explains how to equalize the apparent size of inscriptional lettering on tall monuments as viewed by the eye (lower right of diagram).

Kurt Schmidt, postcard announcing the 1923 Bauhaus show in Weimar.

[2] Leonardo da Vinci, *The Bones and Muscles of the Arm* (1510-1511), pen and ink with wash, 29.3 × 20.1 cm or 11½ × 7⅞ in.

CONSIDER the word/image relationships in this remarkable manuscript from the ninth century. In manuscripts, as the word suggests (*manus*, hand + *scriptus*, write), the common source of all marks is a handheld pen, pencil, brush. Thus the hand directly integrates word and image, as in Leonardo's drawings of anatomy, nature, and engineering projects; Galileo's manuscripts on astronomy and physics; ordinary notebooks, today's comics. And especially the centaur at left.

A triumph of multi-functioning signs, and of unification of text and image, this splendid zodiacal word-centaur is from a Carolingian manuscript portraying many constellations as word-pictures. Written in Rustic script, the Latin words "form wavy tracks, and through that curvature they model the form, giving it the fullness and convexity of the flank and rear of a horse."[3] Words begin and end so as to outline the legs and body, and the resulting perimeter links 44 star-dots that more or less form the southern constellation of Centaurus (the text mentions 24 stars). The words of the body are based on *De Astronomia* of Hyginus (2nd century AD); the block of words upon which the centaur stands is from Cicero's Latin translation of a Greek poem, *Phaenomena*, written around 275 BC by Aratus.

A variety of centaurs, some facing left and others right, all except this nearly wordless, have wandered through 2,000 years of celestial charts. Same stars, many centaurs. For a long time the amazing reality of the stars has been caught up in a thick mythology-astrology of constellation maps, elaborate stories (at left, 1,320 characters), and ambiguous images imposed upon the starry sky. Along with providing cues for recalling classical mythology, star-myths help us organize and remember the spatial locations of some stars. The centaur-words also describe nearby constellations, linking star stories across the sky.

By outlining *two*-space projections of the stars, constellation maps create an illusory flatland out of what are in fact non-adjacent stars residing in *three*-space. Now that astronomers can accurately measure the distance of many stars from Earth, perhaps it is time to draw three-space celestial maps with new visual-verbal geometries and narratives that will show where stars reside in the depths of space. Of course the Centaur is constructed only from stars visible to the unassisted eye. Galileo's telescope changed all that.

Although the original Latin is incomprehensible to most modern eyes, indeed to most eyes for all time nearly everywhere, today we easily grasp the *visual* meaning of this centaur drawn 1200 years ago: stars, real and imaginary objects, contoured shape reading as three-space, an outline map in two-space, a narrative metaphor grouping the stars into a constellation. For all kinds of images, there is similar continuity of showing and seeing. Chiron the centaur exemplifies the universality of images—and the stupefying locality of languages.

Centaur. Harley ms 647, Aratus, folio 12, ninth century, British Library, London, 20.6 × 21.9 cm, or 8⅛ × 8⅝ in.

[3] Meyer Schapiro, *Words, Script, and Pictures: Semiotics of Visual Language* (New York, 1966), 147.

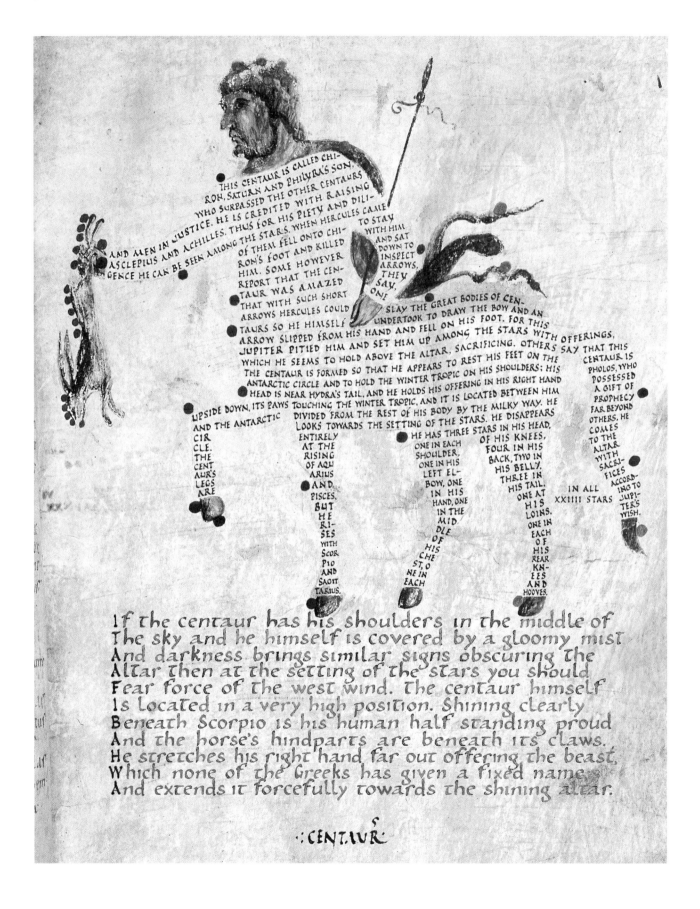

Our previous double-page spread reproduced the original centaur in Latin. Shown at left, Chiron the centaur is translated and reconstructed in English. First Latin, now English, only a few thousand more languages to go. Written in English with the letterforms of the original Rustic script, the poem recalls the harrowing career, noble exploits, and excellent character of the centaur, this fine cartoon animal, half human, half horse. A few words even describe the stars.

Elaine Morse of Graphics Press redrew the centaur; Kenneth Lapatin of Boston University translated the Latin.

JUST as in manuscripts, early printing routinely combined text and image. During the first 800 years of printing with moveable reusable type—from the 600s in Korea, Japan, and China and finally in the 1400s in Europe—text and image were printed by the same method: the information to be reproduced was cut in relief in mirror-image reverse on woodblocks by carving away areas to be absent of ink. The information to be printed thus stood proud—like a mountain, in relief—on the woodblock. The wrong-reading raised wood was then inked and pressed onto the paper, leaving a correct-reading copy of the original. Since this method works for any mark, *text and image can be printed simultaneously and integrated on printed sheet without special intervention.* For example, here below is a splendid integration of text and image from the *Diamond Sutra*, printed by woodblock in 868, and according to the British Library catalog, "the world's earliest complete survival of a dated printed book."

Diamond Sutra (AD 868), Dunhuang, China. Ink on paper printed by wooden blocks.

HYPNEROTOMACHIA POLIPHILI, VBI HV
MANA OMNIA NON NISISOMNIVM
ESSE DOCET. ATQVE OBITER
PLVRIMA SCITV SANE
QVAM DIGNA COM
MEMORAT.

✳ ✳ ✳
✳ ✳
✳

Hypnerotomachia Poliphili was probably written by Francesco Colonna, a worldly monk, and was undoubtedly published by the Venetian printer Aldus Manutius in 1499. Although the drawings are often artful, and the typography splendid and influential to this day, *Hypnerotomachia* is a forever beauty because of its harmonious whole combining type and woodcut illustrations.

A long elegy to the reader opens the book. The elegy concludes with confident humanistic exuberance (no humble servant dedicating the work to royalty or religion) and expresses sentiments no doubt felt by other authors since 1499:

> *Receive what this great cornucopia has offered,*
> *Behold a useful and profitable book. If you think otherwise,*
> *Do not lay the blame on the book, but on yourself.*[4]

Here at right is a fine page from *Hypnerotomachia*: generous margins, a narrative drawing, a title-summary in capital letters, floriated initial capital letters, and the similar visual texture of all elements. Shown is one of many parade scenes, a rowdy party of nymphs and lions. Some 30 to 40 pages of the book reach this high level of visual eloquence.

Hypnerotomachia has been studied for centuries by design students as an aesthetic exemplar of printing, layout, and typography—and *only* that, since few could read the original words, a unique confected Italian-Latin-Greek hybrid language. Unreadable classics teach that some books are beautiful simply as pure amazing art objects. Unfortunately they also teach *content indifference*: in text/image relations, designers need only consider aesthetic effects. Of course such effects are central to decorative and commercial art. But for serious work in reasoning about evidence, *the essential test of text/image relations is how well they assist understanding of the content*, not how perfectly stylish the pages look. To make this test, one must know *what the words mean in their relation to the images, and what the images mean in relation to the words*. Recall Eric Gill's point:

> *If you look after truth and goodness,*
> *Beauty looks after herself.*

Francesco Colonna, *Hypnerotomachia Poliphili* (Venice, 1499), at left, title; at right, l5.

[4] *Hypnerotomachia Poliphili: The Strife of Love in a Dream* (New York, 1999), translated by Joscelyn Godwin, 5.

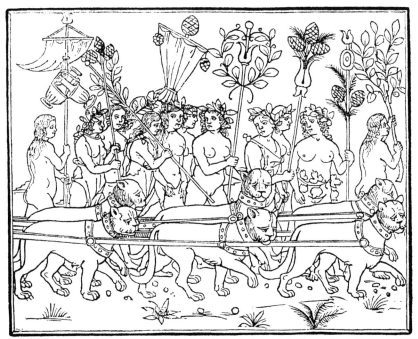

LA MVLTITVDINE DEGLI AMANTI GIOVENI, ET
DILLE DIVE AMOROSE PVELLE LA NYMPHA APOLI
PHILO FACVNDAMENTE DECHIARA, CHI FVRO·
NO ET COMEDAGLI DII AMATE. ET GLI CHORI DE
GLI DIVI VATICANTANTI VIDE.

 LCVNO MAI DIT ANTO INDEFESSO ELO
quio aptamente se accommodarebbe, che gli diuini ar
chani disertando copioso & pienamente potesse euade
re & uscire·Et expressamente narrare, & cum quanto di
ua pompa, indesinenti Triumphi, perenne gloria, festi
ua lætitia, & fœlice tripudio, circa a queste quatro iuisi
tateseiuge de memorando spectamine cum parole sufficientemente ex-
primere ualesse. Oltragli inclyti adolescentuli & stipante agmine di inu-
mere & periucunde Nymphe, piu che la tenerecia degli anni sui elle pru-
dente & graue & astutule cum gli acceptissimi amanti de pubescente
& depile gene. Ad alcuni la primula lanugine splendescéte le male in-
ferpiua delitiose alacremente festigiauano. Molte hauendo le facole sue
accense & ardente. Alcune uidi Pastophore. . Altre cum drite haste
adornate de prische spolie. Et tali di uarii Trophæi optimaméte ordinate

retico basamento in circuito inscalpto digniffimaméte tali hieraglyphi. Primo uno capitale offo cornato di boue, cum dui instrumenti agricultorii, alle corne innodati, & una Ara fundata sopra dui pedi hircini, cum una ardente fiammula, Nella facia dellaquale era uno ochio, & uno uulture. Dapofcia uno Malluuio, & uno uaso Gutturnio, fequédo uno Glomo di filo, ifixo i uno Pyrono, & uno Antiquario uafo cu lorificio obturato,. Vna Solea cum uno ochio, cum due fronde intranfuerfate, luna di oliua & laltra di palma politaméte lorate. Vna ancora, & uno anfere. Vna Antiquaria lucerna, cum una mano tenente. Vno Temone antico, cum uno ramo di fructigera Olea circunfafciato·pofcia dui Harpaguli. Vno Delphino·& ultimo una Arca reclufa· Erano quefti hieraglyphi optima Scalptura in quefti graphiamenti·

Lequale uetuftiffime & facrefcripture penficulante, cufi io le interpretai.

EX LABORE DEO NATVRAE SACRIFICA LIBERA LITER, PAVLATIM REDVCES ANIMVM DEO SVBIECTVM. FIRMAM CVSTODIAM VITAE TVAE MISERICORDITER GVBERNANDO TENEBIT, INCOLVMEM QVE SERVABIT.

the piazza, I saw the following hieroglyphs engraved in suitable style around the porphyry base. First, the horned skull of a bull with two agricultural tools tied to the horns; then an altar resting on two goat's feet, with a burning flame and, on its face, an eye and a vulture. Next, a washing basin and a ewer; then a ball of string transfixed by a spindle, and an antique vase with its mouth stopped. There was a sole with an eye, crossed by two branches, one of laurel and the other of palm, neatly tied; an anchor, and a goose; an antique lantern, with a hand holding it; an ancient rudder, bound up together with a fruited olive-branch; then two hooks, a dolphin, and lastly a closed coffer. These hieroglyphs were well carved in the following graphic form:

After thinking over these ancient and sacred writings, I interpreted them thus:

FROM YOUR LABOUR TO THE GOD OF NATURE SACRIFICE FREELY. GRADUALLY YOU WILL MAKE YOUR SOUL SUBJECT TO GOD. HE WILL HOLD THE FIRM GUIDANCE OF YOUR LIFE, MERCIFULLY GOVERNING YOU, AND WILL PRESERVE YOU UN-HARMED.

IN 1999, Joscelyn Godwin published the first complete English translation of *Hypnerotomachia*, which revealed an intense language of superabundant imagery, a text as visual as a text can be. Above, we see the same page from the 1499 original and the 1999 English translation, as words track detailed little images in a rebus. Surely these words were written with a sketch at hand. The rebus woodcut, a verbal / visual confection, itself becomes a sentence element, as the text introduces the rebus image with the phrase "in the following graphic form." Continuing interplay-multiplicity of text / image / text / image carries on to the end of the page.

To see the cognitive (as well as optical) relationships between words and images in *Hypnerotomachia*, I have read the English text surrounding each of 170 woodcuts in the book and then collated the English against the original book of 1499. Nearly always, the words closely follow the images—and the images closely follow the words—as in the rebus page. Here are the details of all the content-links between words and images.

Left, Francisco Colonna, *Hypnerotomachia Poliphili* (Venice, 1499), c1; and, at right, *Hypnerotomachia Poliphili: The Strife of Love in a Dream* (New York, 1999), translated by Joscelyn Godwin, 41.

Of the 170 woodcuts in *Hypnerotomachia,* fully 73% have *all* their relevant words within the common visual field of the same double-page spread of the open book. At right, for example, a double-page spread shows all the words (highlighted) belonging to an image (highlighted). Indeed, for this example, text and image are unified not merely on the spread but on *each page.* On the left page, the text applies fully to the image below; on the right page, the relevant text surrounds its image.

Sometimes the appropriate words and images are not fully within our eyespan all at once, as the words narrating the image-scene begin on the page *before* the spread containing the image. In this sequential pair of double-page spreads at right, the relevant words begin on the second page of the first spread (4 highlighted lines at the bottom) and then flow on over to the next spread where the image resides. Found in 21% of the 170 images, this arrangement usually maintains a reasonable unity of narrative.

Then, for 4% of the woodcuts, the words spill over *after* the relevant image, as we see now at right. The relevant (highlighted) words and image begin together, but then the relevant words continue on over to the next double-page spread. In this event, it might be helpful at times to repeat the same image near the spilled-over text.

Only 2.4% of all the woodcuts (4 of 170) are not directly adjacent to any of their words. At right, for example, the relevant text ends on the first double-page spread, then the relevant image appears on the next. At least this is a *local* non-adjacency, for the image is not distantly appended somewhere at the back of the book.

Overall, the design of *Hypnerotomachia* tightly integrates the relevant text with the relevant image, a *cognitive integration* along with the celebrated optical integration. Again it is likely that Aldus Manutius and his colleagues were guided by image-sketches placed within the original manuscript itself.

The pages reproduced from *Hypnerotomachia,* 1499 (with corresponding pages in Godwin, 1999) are: *top:* l3'- l4 (174-175); *row 2:* b4'- b6 (32-35); *row 3:* c5'- c7 (422-425); and *bottom:* k7'- l1 (166-169).

Poliphili briefly dies.

Polia drags Poliphili out by his feet.

At the temple, Polia revives Poliphili.

P & P amorously embrace, but then . . .

P & P are chased away by the High Priestess.

Later, back at the temple, all is well.

ALONG with placing the right words next to the right images, the book unifies the verbal-visual story by linked temporal images that thread through long textual passages. This narrative sequence above illustrates the 40-page love story of Polia and Poliphili. Brought together, these woodcuts provide a crisp visual summary of a distinctly wordy account, a *storyboard* (a powerful analytical and narrative display method) that sets and links scenes, locates and animates characters. The *Hypnerotomachia* sequence resembles a modern movie storyboard; for example, the scary cornfield sequence in Alfred Hitchcock's *North by Northwest* (1959):

Hypnerotomachia, 1499, a8', b1, c5, c5', c6, d1.

Compared with Leonardo's anatomical drawings of 1510 and movie storyboards of 1959, the *Hypnerotomachia* woodcuts are flat, medieval. And unintentionally humorous, as Polia drags out a temporarily deceased Poliphili by his feet, greatly elongating him in the process.

palmiạtro. Nelạle in una faeie, dal frõte dila fractura era iſcripto, & ſi-
milmẽte oue era rupto pidicio di alcune litere pte fragmẽtate, & itegre,
parte rimaſte. Poſcia nella ſubiecta corpulẽtia dalla circinante cinctu-
ra uerſo el fondo, nellaquale erano appacte le anſe, nel fronte dilla fra-
ctura era queſta præſtante ſcriptura.

Relicti queſti rupti monumenti, ad una deſtructa tribuna deue-
ni nellaquale alquanto fragmento di muſeo ſi comprendeua. Oue
picto mirai uno homo affligente una damicella. Et uno naufragio. Et
uno adoleſcétulo ſopra il ſuo dorſo equitante una fanciulla, nataua ad
uno littore deſerto. Et parte uedeuaſi di uno leone. Et quegli dui in una
nauicula remiganti. Il ſequente diſtructo. Et ancora queſta parte era in
molti lochi lacerata, Non ualeua intendere totalmente la hiſtoria. Ma
nel pariete cruſtato marmoreo, era interſepta una tabula ænea, cum ma
iuſcule græcæ. Tale epigramma inſcripto haueua. Ilquale nel pro-
prio Idiomate in táta pietate me prouocaua legendo
ſi miſerando caſo, che di lachryme conte-
nirme non potui, dánando la rea for
tuna. Ilquale ſæpicule perle
gendo, quanto io ho
potuto cuſi il ſe
ce latino.

Conſequente era uno altro nobiliſſimo
trophæo baiulato. Nel ſublime haſtile una
pila ſopra uno pyrronio promineua tra uno
iflexo lunario di due pinne ſubtilmẽte di bra
ctea doro foliate, uno folio paginataméte ſo
pra laltro ſoppſ
ſo. Ilreſiduo dil
lequale in circi
naméto coacto
rendeua una co
rona cũ faſceo-
la detenta, p me
dio la haſta exi-
guaméte balau
ſtata traiectan-
do perpendicu
larmẽte. Sotto la
corona una pi-
leta, cum il fun
do di uno gut-
turnio uaſo de-
ſcendéte ſopra
il fmigiodi due
coniuncteale-
dapofcia una fi
gura ouolata cũ
una bulla byſſi
na nel umbili-
co corruſcante. Sotto queſta infixa era una
pila peponaceamte ſcindulata, cum uolan-
te faſcicule opportunamte inſtricte-
 Molti altri diplixo narrato gli ſtyracide-
liquali alcuni di Hebeno, altri di fandalo ru
bente citrino & bianco, & di candidiſſimo Ebure, & aurati, & di argen-
to contecti, & di altri pretioſilignamini. Omni coſa fabre deformata di
tenuiſſimo oro, argento, & di leuigata materia, & di ſeta uirente formati &
di omni altra gratioſa coloratione, cum iucunda floratura. Cum gemme
multiplicemente ornati agli congruenti lochi omni coſa harmonicamé
te deſtinata & conſpicuamente applicata, cum præpendenti ſpondili, o-
x

ſtatua ſupra ſtante di tutto, quale laltra, Senõche era regina, Laquale ſub-
leuato il dextro bracio cum lindice ſignaua la parte retro le ſue ſpalle, &
cum laltro teniua una tabella ritinuta cum il coperto & cum la mano ſua
indiuiſa. Nella ạle etiam iſcripto era tale epigramma in tri idiomi.

Di tanta nouitate digna di relato mirabondo, & degli ænigmati præle
gendoli ſæpicule, dil tutto io reſtai ignaro, & dilla iterpretatione & ſophiſ
mo ſignificato molto ambiguo. Non era auſo percio alcuna coſa perten
tare. Ma quaſi inculſo da timore in queſto loco tetro & illumino, quan-
tunque gli fuſſe il lucernale lume. Niente di manco il ſolicito deſiderio
di contemplare la triumphante porta ſtimulante, piu legitima cauſa fue
che quiui non dimoraſſe, che altro. Dique ſencia altro fare, cum penſie-
ro & propoſito per omni modo dapo la contemplatione di eſſa porta mi
rabile, unaltra fiata quiui ritornare. Et piu tranquillamẽte ſpeculareteale
magnificentia de inuento dagli humani ingegni, citiſſimo allapertura
perueni. Et deſcendando uſciui fora dil exuiſcerato monſtro. Inuentio-
ne inexcogitabile, & ſencia exiſtimatione, exceſſo di faticha, & temerario
auſo humano, quale. Trepano terebrare tanta durecia & contumacia di
petra, & euacuaretanta durítudine di materia, ouero altre fabrile machi-
ne poteron? Concordemente conuenendo il cauato introrſo cum la for
ma exteriore. Finalmẽte ſopra la piacia ritornato, uidi in queſto porphy-
retico

WORDS decorate many of the illustrations. Some 57 concocted Latin and
Greek inscriptions (2,300 words in English translation) show up on pots,
boxes, tablets, architecture, and in a garden with letterforms constructed
from marjoram plants. At left, an inscribed pot sits on a pedestal of shaped
type. In the center image above, the text flows around the objects described,
a nearly too-clever layout perhaps disconcerting to those actually reading
the text. At right, a woman standing on a tomb holds a tablet with Hebrew,
Greek, and Latin words—real show-off typography for 1499.

 The typography of *Hypnerotomachia* is imaginative, confident, and
self-conscious. Words run around images, words generate shaped patterns.
Now done easily on the computer, such practices have recently produced
a lot of annoying designer typography and unread words, as well some
beautiful poetic designs, especially for books with modest verbal content.

 Hypnerotomachia is lusciously visual, and its 468 pages conjure up ancient
architecture, stupendously elaborate gardens, an operatic love story, and 4
parades. Love, landscape, and architecture are described in a lush sensual
language of dreamy impossibility. Although 94% of the book consists of
text (the remaining 6% images), the words themselves are intensely visual,
a thesaurus of fantasized obsessive detail.

 All those visual words enrich reading of the woodcuts. Viewed without
the adjacent text, the drawings evoke mixed evaluations: heavy-handed,
naive, charming, thin, cartoonish. Certainly not Dürer woodcuts or fine art.
It is the drawings *together* with the words that make a beautiful book.

Hypnerotomachia, 1499, q5, x1, b8'.

POLIPHILO QVIVI NARRA,CHE GLI PARVE AN-
CORA DI DORMIRE, ET ALTRONDE IN SOMNO
RITROVARSE IN VNA CONVALLE, LAQVALE NEL
FINE ER A SER ATA DE VNA MIR ABILECLÁVSVRA
CVM VNA PORTENTOSA PYRAMIDE, DE ADMI-
RATIONE DIGNA, ET VNO EXCELSOOBELISCO DE
SOPRA. LAQVALE CVM DILIGENTIA ET PIACERE
SVBTILMENTE LA CONSIDEROE.

A SPAVENTEVOLE SILVA, ET CONSTI-
pato Nemore euaso,& gli primi altri lochi per el dolce
somno che se hauea per le fesse & prosternate mébre dif-
fuso relicti,me ritrouai di nouo in uno piu delectabile
sito assai piu che el præcedente.Elqual non era de mon
ti horridi, & crepidinose rupe intorniato, ne falcato di
strumosi iugi. Ma compositamente de grate montagniole di non tro-
po altecia. Siluose di giouani quercioli, di roburi, fraxini & Carpi-
ni, & di frondosi Esculi, & Ilice, & di teneri Coryli, & di Alni, & di Ti-
lie, & di Opio, & de infructuosi Oleastri, disposti secondo laspecto de
gli arboriferi Colli. Et giu al piano erano grate siluule di altri siluatici

Hypnerotomachia Poliphili (Venice, 1499), a6'.

LIVRE PREMIER DE

*Poliphile racompte comme il luy fut aduis en songe qu'il dormoit, & en
dormant se trouuoit en une uallee fermee d'une grand closture en for-
me de pyramide, sur laquelle estoit asis un obelisque de merueilleuse
haulteur, qu'il regarda songneusement, & par grande admiration.*

A forest espouentable aiant esté par moy passee,
& apres auoir delaisse ceste premiere region par
le doulx sommeil qui m'auoit lors espris, ie me
trouuay tout de nouueau en vn lieu beaucoup
plus delectable que ie premier, car il estoit bordé
& enuironné de plaisans cotaulx verdoians, &
peuplez de diuerses manieres d'arbres, comme
chesnes, faux, planes, ormes, fraisnes, charmes,
tilleulz,& autres,plantez selon l'aspect du lieu. &
abas atrauers la plaine, y auoit de petitz buys-
fons d'arbrisseaux sauluaiges,côme genestz, geneuriers, bruyeres, & tama-
rins, chargez de fleurs. parmy les prez croissoient les herbes medicinales, a
scauoir les trois consolides, enule, cheurefueil, branque vrsine, liuesche, per-
sil de macedoine, piuoyne, guymauues, plantain, betoyne, & autres simples
de toutes sortes & especes, plusieurs desquelles m'estoient incôgneues. Vn
peu plus auant que le mylieu de ceste plaine, y auoit vne sablonniere meslee
de petites mottes verdes, & pleine d'herbe menuette, & vn petit boys de
palmiers, esquelz les Egyptiés cueillent pain,vin,huille,vestement, & mef-
rain pour bastir.leurs fueilles sembloient lames d'espees, & estoiét chargées
de fruict.il y en auoit de grandes, moiennes,& petites,& leur ont les anciens
donnée

*Hypnerotomachie, ov Discours du songe de
Poliphile* (Paris, 1546), a3'.

POLIPHILO TELLS THAT HE SEEMED TO SLEEP
AGAIN, AND TO FIND HIMSELF SOMEWHERE ELSE
IN A DREAM. HE WAS IN A VALLEY, BLOCKED AT
THE END BY A MARVELLOUS ENCLOSURE, WITH
A MIGHTY AND ADMIRABLE PYRAMID AND A
TALL OBELISK ABOVE IT. HE STUDIED THIS CARE-
FULLY, WITH DILIGENCE AND ENJOYMENT.

LEAVING BEHIND THE TERRIBLE FOREST,
the dense woodland and the other previous places,
thanks to the sweet sleep that had bathed my tired and
prostrate members, I now found myself in a much
more agreable region. It was not hemmed in by dread
mountains and cloven rocks, nor encircled by craggy peaks, but by
pleasant hills of no great height. These were wooded with young oaks,
roburs, ash and hornbeam; with leafy winter-oaks, holm-oaks and
tender hazels; with alders, limes, maples and wild olives, disposed
according to the aspect of the forested slopes. Even on the plain there
were pleasant copses of other wild shrubs and flowering brooms, and

20

*Hypnerotomachia Poliphili: The Strife of Love
in a Dream* (New York, 1999), 20.

FOR 500 years, the integration of words and images in *Hypnerotomachia*
has persisted in most editions. The original edition of 1499 illustrates the
beginning of Poliphilo's book-long dream. The elegant French edition of
1546 redid the illustrations and typography (large initial capitals 10 lines
deep; chapter summaries placed above the images and set in italics rather
than capital letters). At right, in the complete English edition published
in 1999, *Hypnerotomachia Poliphili: The Strife of Love in a Dream,* the
page layouts and illustrations closely follow the 1499 original. How could
words and images not be unified in such a book?

LIKE *Hypnerotomachia,* the legal document excerpted at right integrates
text and image in a farcical narrative and thesaurus of grotesque luxury.
Government prosecutors, by means of images of incriminating documents
and color pictures of the loot (cash, boats, antiques, a "Dream Home"),
enumerate the bribes received by a corrupt and acquisitive politician,
Randy "Duke" Cunningham. In American courts, the standard format
for legal documents yields thin information densities (is productivity
measured by the page?) induced by excessively leaded-out type. Here,
however, the adroit use of visual evidence intensifies the prosecutorial
advocacy, reveals the scope of corruption, and mocks the attempts at
evidence fabrication, making the Duke's criminality appear ludicrous
and, 507 years later, nearly as fantastical as *Hypnerotomachia Poliphili.*

Carol C. Lam, Sanjay B. Bhandari, Jason A.
Forge, Phillip L. B. Halpern, "Government
Sentencing Memorandum," *United States
of America v. Randall Harold Cunningham,
aka Randy "Duke" Cunningham,* United
States District Court, Southern District
of California, March 3, 2006. Redrawn.

In this "bribe menu," the left column represented the millions in government contracts that could be "ordered" from Cunningham. The right column was the amount of the bribes that the Congressman was demanding in exchange for the contracts. For example, Cunningham's menu offered $16 million to Coconspirator No. 2 in government contracts in exchange for the contractor giving up his title to a boat ("BT") for which Coconspirator No. 2 had initially paid $140,000 ("140"). The next four rows indicate that an additional million dollars in funding was "for sale" in exchange for every additional $50,000 that Coconspirator No. 2 was willing to pay Cunningham. Once Coconspirator No. 2 had paid Cunningham $340,000 in bribes, the rates dropped; and, as the final five rows reflect, Cunningham would charge only $25,000 for each additional million dollars that was awarded in additional government contracts.

Between September 2000 and April 2001, this co-conspirator paid $11,116.50 for Cunningham's yacht mortgage. Despite this "purported sale," the yacht remained with Cunningham throughout this entire time period.

Towards the end of July or the beginning of August, Cunningham mentioned to the realtor that because he had a million dollars to spend, perhaps he would simply sell his home at 13832 Mercado Drive in Del Mar for $1.5 million and use the million dollars netted from that sale to purchase a bigger house for himself. Cunningham said that his partner (whom he had identified as Coconspirator No. 2) could simply have an office in Cunningham's bigger home. The next day, the realtor asked Cunningham if she could handle the listing for his Del Mar home. Cunningham replied that he already had a buyer for it. Thereafter, the realtor and Cunningham began looking at a number of homes that Cunningham picked out of a magazine featuring "Dream Homes" in the San Diego area. Cunningham's plan turned out to be to use the profits from the sale of his Del Mar home (pictured below left) to purchase a Spanish style mansion located at 7094 Via Del Charro in Rancho Santa Fe, California (pictured below right).

On or about October 28, 2003, Cunningham instructed the realtor to submit an offer on the 7094 Via Del Charro house. Eventually, the Cunninghams and the sellers agreed on a purchase price of $2,550,000.

When Cunningham eventually sold the Arlington, Virginia condominium (in August 2004), it was literally stuffed with furniture, including the many antiques and rugs given to Cunningham as bribes. Cunningham shipped all of these items (some of which are pictured below) to his Rancho Santa Fe mansion. Among other things, the shipping manifest that Cunningham signed included: (1) two Bejar Rugs valued at $40,000 a piece; (2) a corner lead glass armoire valued at $5,200; (3) a large lead glass armoire valued at $4,500; (4) a small lead glass armoire valued at $2,700; (5) a china hutch circa 1890 valued at $24,000; (6) two candelabras valued at $1,400; (7)

two smoking tables valued at $2,000; (8) a French lamp shade valued at $3,500; (9) three smoking tables valued at $2,000; (10) cobalt blue lamps valued at $300 a piece; (11) a cut glass floor piece valued at $1,200; (12) a Tiffany statue valued at $2,000; (13) an Erte statue valued at $12,000; (14) four crystal lamps valued at $2,800; (15) a cut glass lamp valued at $2,400; (16) an eagle ceramic valued at $500; (17) three cut glass doors valued at $5,000; (18) glass armoire valued at $5,400; (19) a French bedroom armoire valued at $5,200; (20) three marble top French dressers valued at $12,600; (21) a marble top mirrored vanity valued at $2,200; (22) an antique mirror valued at $1,200; (23) a living room armoire valued at $5,200; (24) a marble top / marble fold shelf valued at $4,200; (25) a hall tree valued at $3,700; (26) small bedroom armoire valued at $2,700; (27) an armoire valued at $3,200; (28) an antique secretary valued at $4,200; (29) two German antique bars valued at $6,400; and (30) two silver candle sticks valued at $5,600.

Fabrication of Evidence – Rug Dealer

Cunningham's attempts to tamper with evidence were not limited to individuals with whom he had a personal relationship. After the *Union-Tribune* story broke in June 2005, Cunningham sent a handwritten note and a $16,500 check to the rug dealer from whom Coconspirator No. 2 had purchased the $15,200 worth of rugs that were shipped to Cunningham in May 2005 (see above). In the note, reproduced at right, Cunningham concocted a story about having looked in vain for an invoice or address to send payment when the rugs arrived at his Escondido office. He then preposterously suggested that he had previously sent a check for the rugs that had been returned because he had the wrong address.

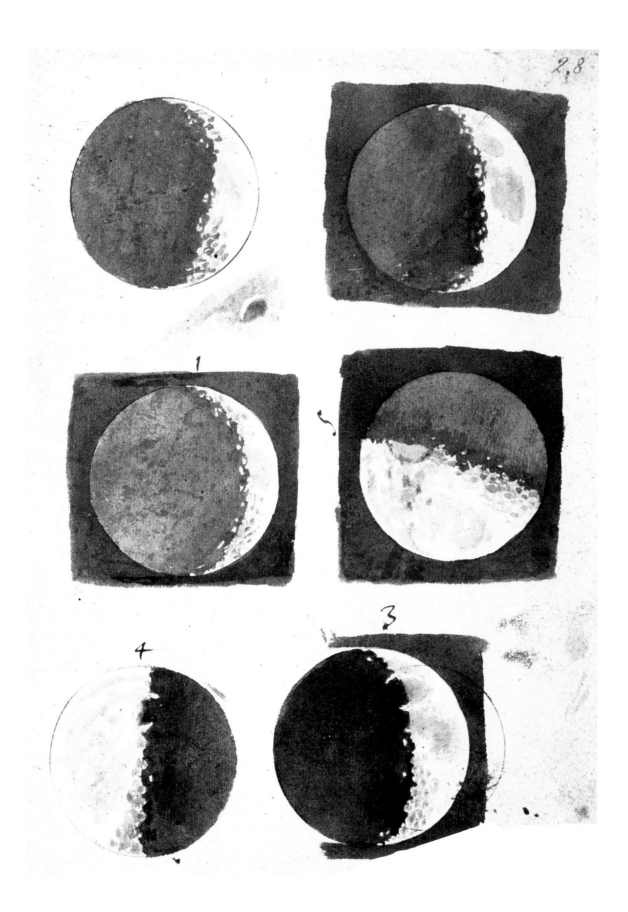

Galileo's Evidence: "The Wonder of the Spectacle and the Accuracy of the Expression"

WHAT *Hypnerotomachia* (1499) is to the design of word-image narrative in fiction, Galileo's *Sidereus Nuncius* [*The Starry Messenger*] (1610) is to nonfiction. Both books describe wonderful new objects and narrate complex events; both weave words and images together in elegant and vivid arrangements. Of course the substance differs: *Hypnerotomachia* is limited because the stuff must be made up; *The Starry Messenger* adds several orders of magnitude to understanding Nature's amazing reality.

In late 1609, Galileo constructed a telescope and soon "made more discoveries that changed the world than anyone has ever made before or since."[5] *The Starry Messenger*, published in March 1610, announced discovery of craters on the moon, a multitude of stars beyond those few seen by unaided eyes, and the 4 satellites of Jupiter. More importantly, the book "told the learned community that a new age had begun and that the universe and the way in which it was studied would never be the same."[6] From then on, theories about the universe had to be tested against the visual evidence of empirical observation. This is the forever idea in Galileo's book. And so armchair speculation, parsing Aristotle and religious doctrine, and philosophizing were no longer good enough. Evidence became decisive in understanding Nature.

Sidereus Nuncius presents its evidence in 78 images and drawings, all tightly integrated within their explanatory text, that cover 30% of the printed area in the book's 60 pages. Galileo observed lunar mountains, plains, craters, earthshine—in a delicate play of light and shadow near the terminator between the illuminated and unilluminated parts of the moon. Galileo made these beautiful ink and watercolor drawings of his observations.[7] Peaks of mountains appear as bright spots on the dark edge of the terminator (see drawing 3, where the lighted mountain peaks extend deep into the dark side). As on Earth, a rising sun catches the tops of higher peaks; and on the bright side of the terminator, shadow and sunlight fill the crater basins.

To depict this level of detail, Galileo personally financed the copper engravings for his images of the moon that appeared in *Sidereus Nuncius*.[8] Engravings were considerably more expensive and difficult to print than woodcuts; also, to combine word and image on the same page, the paper had to pass through two different presses, one to print the type (relief) and another to print the high-resolution engravings (intaglio). These complexities yielded some copies of Galileo's *Starry Messenger* that omit the engravings, causing auction houses 395 years later to note dutifully that their copy at auction is the "issue without the 5 text engravings BUT these supplied in facsimile printed directly on the original leaves . . . an extraordinary hybrid copy."[9]

[5] Noel W. Swerdlow, "Galileo's discoveries with the telescope and their evidence for the Copernican theory," in *The Cambridge Companion to Galileo*, ed. Peter Machamer (Cambridge, 1998), 245.

[6] Albert Van Helden, "Preface," *Sidereus Nuncius*, translated by Albert Van Helden (Chicago, 1989), vii.

[7] Source: Biblioteca Nazionale Centrale, Florence. All 6 drawings show bright spots on the terminator's dark edge, as the sun catches the tops of higher peaks. These bright spots can be seen today with >15× stabilized binoculars or telescope.

[8] Detailed accounts of Galileo's 2 books on astronomy are Owen Gingerich and Albert Van Helden, "From *Occhiale* to Printed Page: The Making of Galileo's *Sidereus Nuncius*," *Journal for the History of Astronomy*, 24 (2003), 251-267; and Albert Van Helden and Mary G. Winkler, "Representing the Heavens: Galileo and Visual Astronomy," *Isis*, 83 (1992),195-217.

[9] Sotheby's New York, *Fine books and Manuscripts*, November 30, 2005, item 44.

&tum daturam. Depreſſiores inſuper in Luna cernuntur magnæ maculæ, quàm clariores plagæ; in illa enim tam creſcente, quam decreſcente ſemper in lucis tenebrarúmque confinio, prominente hincindè circa ipſas magnas maculas contermini partís lucidioris; veluti in deſcribendis figuris obſeruauimus; neque depreſſiores tantummodo ſunt dictarum macularum termini, ſed æquabiliores, nec rugis, aut aſperitatibus interrupti. Lucidior verò pars maximè propè maculas eminet; adeò vt, & ante quadraturam primam, & in ipſa ſermè ſecunda circa maculam quandam, ſupcriorem, borealem nempè Lunę plagam occupantem valdè attollantur tam ſupra illam, quàm intra ingentes quæda eminentiæ, veluti appoſitæ præſeferunt delineationes.

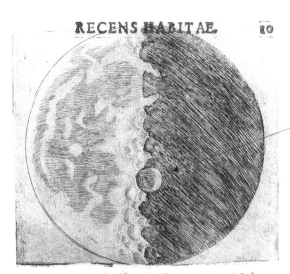

Hæc eadem mácula ante ſecundam quadràturam nigrioribus quibuſdam terminis circumuallata conſpicitur; qui tanquam altiſſima montium iuga ex parte Soli auerſa obſcuriores apparent, quà verò Solem reſpiciunt lucidiores extant; cuius oppoſitum in cauitatibus accidit, quarum pars Soli auerſa ſplendens apparet, obſcura verò, ac vmbroſa, quæ ex parte Solis ſita eſt. Imminuta deinde luminoſa ſuperficie, cum primum tota ſermè dicta macula tenebris eſt obducta, clariora mõtium dorſa eminenter tenebras ſcandunt. Hanc duplicem apparentiam ſequentes figuræ commoſtrant.

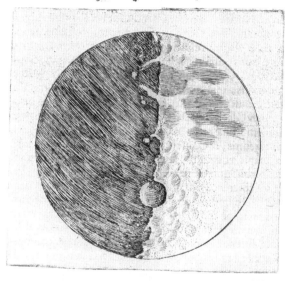

Hæc

C 2 Vnum

Sidereus Nuncius presents 5 engraved images of the moon (4 unique and 1 repeat), the first astronomical pictures ever printed. A major scientific finding is that the moon

> [is] not smooth, even, and perfectly spherical, as the great crowd of philosophers have believed about this and other heavenly bodies, but, on the contrary, [is] uneven, rough, and crowded with depressions and bulges. And it is like the face of the Earth itself, which is marked here and there with chains of mountains and depths of valleys.[10]

In 1610 the discovery of such surface irregularities was significant because Aristotle had claimed that all celestial bodies were perfect, smooth, and without blemish (unlike the wretched Earth). This evidence-free fancy had become religious doctrine before being demolished by 10 pages of visual observations reported in *Sidereus Nuncius*. Galileo later questioned why religious faith need depend on the presence or absence of craters on the moon or, indeed, other astronomical observations.

Galileo Galilei, *Sidereus Nuncius* (Venice, 1610), 9V–10R.

[10] *Sidereus Nuncius*, translated by Albert Van Helden (Chicago, 1989), 40.

Scholars have compared Galileo's images with modern photographs.[11] The 1610 engravings *qualitatively* picture the actual moon, except the big crater is way too big, a deliberate local enlargement designed to portray operative details of light and shadow. At this huge size in the original pages at left, the crater would have been visible to unaided eyes on the Earth, deterring the smooth-moon doctrine forever. The gigantic generic crater contradicts the rest of the image, a realistic representation of the moon's surface. For presenting evidence about light and shadow, it is far better to show the generic crater in a *separate* image as Galileo did in his original watercolor (here at right), similar to an artist showing an enlarged detail in a sketchbook. Unlike the book engravings, the watercolor images do not place the big generic crater on the moon itself, since the separate callout shows details of light and shadow.

Accompanying the astronomical pictures of *Sidereus Nuncius* is an intensely visual language describing the surface of the moon. Nearly half of that text describes *visual variation over time*, systematic changes in the appearance of the surface resulting from changes in the sun's elevation:

> Not only are the boundaries between light and dark on the Moon perceived to be uneven and sinuous, but, what causes even greater wonder, is that very many bright points appear within the dark part of the Moon, entirely separated and removed from the illuminated region and located no small distance from it. Gradually, after a small period of time, these are increased in size and brightness. Indeed, after 2 or 3 hours they are joined with the rest of the bright part, which has now become larger. In the meantime, more and more bright points light up, as if they are sprouting, in the dark part, grow, and are connected at length with that bright surface as it extends farther in this direction. [When] the bright surface has decreased in size, as soon as almost this entire spot is covered in darkness, brighter ridges of mountains rise loftily out of the darkness [Change] of shapes [is] caused by the changing illumination of the Sun's rays as it regards the Moon from different positions . . .[12]

Although Galileo's words describe change, the images are frozen in time. The pictures of *Sidereus Nuncius* present *spatial comparisons* of various craters under the same sunlight, rather than *temporal comparisons* of varying sunlight on the same crater. Below, modern photographs now show the changing appearance of a single crater, as the sun's angle of elevation gradually moves from 0° to 43°. In this fine sequence of 7 images, direct temporal comparisons now make the visual evidence, formerly static, as dynamic as Galileo's eloquent text. Shifting crescents of light play in and out of a crater over time in a narrative of surface and shadow. The lack of a light–scattering atmosphere produces intensely dark Moon shadows.

[11] See Ewan A. Whitaker, "Galileo's Lunar Observations and the Dating of the Composition of *Sidereus Nuncius,*" *Journal for the History of Astronomy*, 9 (October 1978), 155-179.

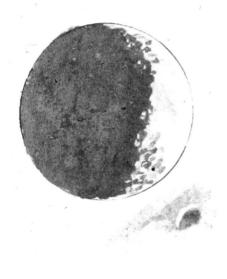

[12] *Sidereus Nuncius*, translated by Albert Van Helden (Chicago, 1989), 42, 45, 47.

John E. Westfall, *Atlas of the Lunar Terminator* (Cambridge, 2000), 32; images from the Apollo-15 Mapping Camera.

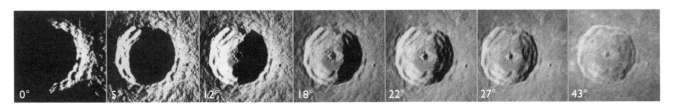

0° 5° 12° 18° 22° 27° 43°

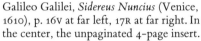

page 16v *page 1 of insert* *page 2* *(double-page spread of insert)* *page 3* *page 4 of insert* *page 17R*

A FEW days before *Sidereus Nuncius* was published in March 1610, Galileo added 4 new unnumbered pages (above in yellow), inserted between pages 16v and 17R. Half text and half image, these pages report the astounding discovery of vast numbers of stars far beyond those seen by unaided eyes. Preparing readers for the images to come, the insert's first page uses words and numbers to announce the findings:

> But in order that you may see one or two illustrations of the almost inconceivable crowd of [stars], and from their example form a judgment about the rest of [the stars], I decided to reproduce two star groups. In the first I had decided to depict the entire constellation of Orion there are more than five hundred new stars around the old ones, spread over a space of 1 or 2 degrees. . . .[To] the three in Orion's belt and the six in his sword that were observed long ago, I have added eighty others seen recently, and I have retained their separations as accurately as possible. . . . In the second example we have depicted the six stars of the Bull called the Pleiades. . . . Near these lie more than forty other invisible stars, none of which is farther removed from the aforementioned six than scarcely half a degree. We have marked down only thirty-six of these, preserving their mutual distances, sizes, and the distinction between old and new ones, as in the case of Orion.[13]

Then a glorious double-page layout *shows* the evidence. Reproduced above in the context of surrounding material and on our righthand page at medium size (and at original size to follow), this triumph of scientific discovery *and* of information design depicts the visible stars of brighter magnitude ✳ seen by unaided eyes for centuries, as well as innumerable "invisible stars" now seen by the telescope ∗ ✱ ✳. Symbolizing the cosmic vastness, printed stars flow into the margins and then off the pages into an unbounded void, breaking out of the book's typographic grid (for Nature is nowhere rectangular) and breaking the limits of past knowledge.

A ghostly word-impression lurks in the background of these 2 starry pages, as the rectangular typographic grids of words show through from opposite sides of the not entirely opaque paper. Show-through goes both ways: on the insert's first page, the stars printed on its backside push the paper up, making little braille-like bumps that anticipate the sky map about to appear. These star bumps, a byproduct of letterpress printing of isolated elements (such as page numbers or stars) that tend to punch through, are shown at near right.[14] The raking light and consequent shadows are similar to, say, the play of sunlight on lunar mountains.

Galileo Galilei, *Sidereus Nuncius* (Venice, 1610), p. 16v at far left, 17R at far right. In the center, the unpaginated 4-page insert.

[13] *Sidereus Nuncius*, translated by Albert Van Helden (Chicago, 1989), 59–62.

[14] On the first page of the insert (above left), a red box locates the enlarged detail below:

Quòd tertio loco à nobis fuit obferuatum, eft ipfiuf-
met LACTEI Circuli effentia, feu materies, quam Per-
fpicilli beneficio adeò ad fenfum licet intueri, vt & alter-
cationes omnes, quæ per tot fæcula Philofophos excrucia
runt ab oculata certitudine dirimantur, nosque à verbofis
difputationibus liberemur. Eft enim G A L A X Y A nihil
aliud, quam innumerarum Stellarum coaceruatim confi-
tarum congeries; in quamcunq; enim regionem illius Per-
fpicillum dirigas, ftatim Stellarum ingens frequentia fe fe
in confpectum profert, quarum complures fatis magnæ, ac
valde confpicuæ videntur; fed exiguarum multitudo pror-
fus inexplorabilis eft.
 At cum non tantum in GALAXYA lacteus ille candor,
veluti albicantis nubis fpectetur, fed complures confimilis
coloris areolæ fparfim per æthera fubfulgeant, fi in illarum
quamlibet Specillum conuertas Stellarum conftipatarum
 cętum

Describing the innumerable stars, Galileo distinguishes between word and image in reasoning about celestial objects. Before 1610 astronomy had largely been verbal gymnastics, speculation, philosophizing, disputation. In contrast, these new telescopic images are the direct, visible, decisive testimony of Nature herself. In the Latin text accompanying the stars scattered across the pages, Galileo makes the key link between empirical observation and credibility with the phrase "visible certainty," oculata certitudine. And that is the grand, forever consequence of *Sidereus Nuncius*: from then on, all science, to be credible, had to be based on publicly displayed evidence of seeing and reasoning, and not merely on wordy arguments. Galileo wrote:

> What was observed by us in the third place is the nature or matter of the Milky Way itself, which, with the aid of the spyglass, may be observed so well that all the disputes that for so many generations have vexed philosophers are destroyed by visible certainty, and we are liberated from wordy arguments. For the Galaxy is nothing else than a congeries of innumerable stars distributed in clusters. To whatever region you direct your spyglass, an immense number of stars immediately offer themselves to view, of which very many appear rather large and very conspicuous but the multitude of small ones is truly unfathomable.
>
> And since that milky luster, like whitish clouds, is seen not only in the Milky Way, but dispersed through the ether, many similarly colored patches shine weakly; if you direct a glass to any of them, you will meet with a dense crowd of stars.[15]

Galileo Galilei, *Sidereus Nuncius* (Venice, 1610), middle 2 pages of the unpaginated 4-page insert between pages 16v and 17R. Color added.

[15] *Sidereus Nuncius*, translated by Albert Van Helden (Chicago, 1989), 62.

PLEIADVM CONSTELLATIO.

Quòd tertio loco à nobis fuit obſeruatum, eſt ipſiuſ-
met LACTEI Circuli eſſentia, ſeu materies, quam Per-
ſpicilli beneficio adeò ad ſenſum licet intueri, vt & alter-
cationes omnes,quæ per tot ſæcula Philoſophos excrucia
runt ab oculata certitudine dirimantur,noſque à verboſis
diſputationibus liberemur. Eſt enim GALAXYA nihil
aliud, quam innumerarum Stellarum coaceruatim conſi-
tarum congeries; in quamcunq; enim regionem illius Per-
ſpicillum dirigas,ſtatim Stellarum ingens frequentia ſe ſe
in conſpectum profert,quarum complures ſatis magnæ,ac
valde conſpicuæ videntur;ſed exiguarum multitudo pror-
ſus inexplorabilis eſt.

At cum non tantum in GALAXYA lacteus ille candor,
veluti albicantis nubis ſpectetur,ſed complures conſimilis
coloris areolæ ſparſim per æthera ſubfulgeant,ſi in illarum
quamlibet Specillum conuertas Stellarum conſtipatarum
<div align="right">cętum</div>

THIS double-page spread is from Henri Matisse's *Poésies*, one of the finest artists' books of the 20th-century. Like Galileo's page layout in *The Starry Messenger* showing the innumerable stars, the Matisse drawings break out of the typographic grid. As Matisse wrote: "The design fills the unmargined page, for the design is not, as usual, massed toward the center, but radiating over the whole sheet. The problem was then to balance the two pages—one white, that of the etching,

LE GUIGNON

Au-dessus du bétail ahuri des humains
Bondissaient en clartés les sauvages crinières
Des mendieurs d'azur le pied dans nos chemins.

Un noir vent sur leur marche éployé pour bannières
La flagellait de froid tel jusque dans la chair,
Qu'il y creusait aussi d'irritables ornières.

and one relatively black, that of the typography. I obtained my result by modifying my arabesque so that the attention of the spectator would be drawn again to the white page as much as to the promise of reading the text."
This parallelism of Galileo and Matisse reflects the one deep communality of science and art: to show the results of intense seeing.

After describing the innumerable stars, *Sidereus Nuncius* then reports the discovery of Jupiter's 4 satellites. Published data begin January 7 and conclude March 2, 1610, just 10 days before the book came off the press. Early March was a busy time for Galileo and the woodcut artist, copper engraver, typesetter, and printer—as they quickly produced 550 copies of their book, which immediately sold out.

A visual/verbal narrative presents the evidence: sequential images of Jupiter (the capital letter O) and the moons (✳✳ ·✳) accompanied by words that record the time and date of observation, estimated distances of the moons from Jupiter, and Galileo's reasoning. An original page in Latin from *Sidereus Nuncius* is shown below at left, with a translation at right. This narrative sequence, a detective story of discovery, resembles a handwritten notebook that completely integrates words, drawings, data. Enormous detail is provided in 24 pages showing 65 annotated little drawings of Jupiter and its satellites; every image is introduced by text

Illustration, previous page: Henri Matisse, etchings for "Le Gaugnon" in Stéphane Mallarmé, *Poésies* (Lausanne, 1932), 8–9. Henri Matisse, "Comment j'ai fait mes livres," in Albert Skira, *Anthologie du livre illustré par les peintres et sculpteurs de l'école de Paris* (Geneva, 1946), in Philip Hofer and Eleanor M. Garvey, *The Artist and the Book 1860-1960* (Boston, 1961), 138.

At left, Galileo Galilei, *Sidereus Nuncius* (Venice, 1610), 18v; at right, *Sidereus Nuncius*, translated by Albert Van Helden (Chicago, 1989), 67-68.

OBSERVAT. SIDEREAE

Ori.　　　　　✳ ✳O ✳　　　Occ.

Stella occidentaliori maior, ambæ tamen valdè conspicuæ, ac fplendidæ : vtra quæ diftabat à Ioue fcrupulis primis duobus; tertia quoque Stellula apparere cœpit hora tertia prius minimè confpecta, quæ ex parte orientali Iouem ferè tangebat, eratque admodum exigua. Omnes fuerunt in eadem recta, & fecundum Eclypticæ longitudinem coordinatæ.

Die decimatertia primum à me quatuor confpectæ fuerunt Stellulæ in hac ad Iouem conftitutione. Erant tres occidentales, & vna orientalis; lineam proximè

Ori.　　　　✳ O·✳ ✳　　　Occ.

Iectam conftituebant; media enim occidétalium paululum à recta Septentrionem verfus deflectebat. Aberat orientalior à Ioue minuta duo : reliquarum, & Iouis intercapedines erant fingulæ vnius tantum minuti. Stellæ omnes eandem præ fe ferebant magnitudinem; ac licet exiguam, lucidiffimæ tamen erant, ac fixis eiufdem magnitudinis longe fplendidiores.

Die decimaquarta nubilofa fuit tempeftas.

Die decimaquinta, hora noctis tertia in proximè depicta fuerunt habitudine quatuor Stellæ ad Iouem;

Ori.　　　O · ✳ ✳　　✳　　　Occ.

occidentales omnes: ac in eadem proxim recta linea difpofitæ; quæ enim tertia à Ioue numerabatur paululum

Thus, on the twelfth, at the first hour of the following night, I saw the stars arranged in this manner. The more

East　　　✳ ✳O ✳　　　West

eastern star was larger than the western one, but both were very conspicuous and bright. Both were two minutes distant from Jupiter. In the third hour a third little star, not at all seen earlier, also began to appear. This almost touched Jupiter on the eastern side and was very small. All were in the same straight line and aligned along the ecliptic.

On the thirteenth, for the first time four little stars were seen by me in this formation with respect to Jupiter. Three were on the west and one on the east. They formed a very nearly straight line, but the middle star of the

East　　　✳ O·✳ ✳　　　West

western ones was displaced a little to the north from the straight line. The more eastern one was 2 minutes distant from Jupiter; the intervals between the remaining ones and Jupiter were only 1 minute. All these stars displayed the same size, and although small they were nevertheless very brilliant and much brighter than fixed stars of the same size.

On the fourteenth, the weather was cloudy.

On the fifteenth, in the third hour of the night, the four stars were positioned with respect to Jupiter as shown

East　　　O · ✳ ✳　　✳　　　West

in the next figure. They were all to the west and arranged very nearly in a straight line, except that the third one from Jupiter was raised a little bit to the north.

describing how the satellites changed position over the hours and days. Shown in full above, this lengthy, detailed, enthusiastic narrative adds up— on and on and on—to a convincing, overwhelming scientific presentation.

Nonetheless 24 consecutive pages of 65 annotated observations break the visual evidence up into stupefying fragments. Although an excellent design for a diary of discovery, this sequential text/image arrangement is not good for Jupiter. Barricades of words disrupt the visual continuity of the evidence. How might the evidence of *Sidereus Nuncius* be redesigned to show the swift and elegant motion of the Galilean satellites?

Galileo Galilei, *Sidereus Nuncius* (Venice, 1610), 17R-28R.

At right, this redesign brings together all 65 of Galileo's published observations of Jupiter and its satellites that we saw earlier. When the intervening text is omitted, the visual evidence becomes adjacent, linked, sequential, moving. No longer a choppy series of 65 little anecdotes spread over 24 pages, the observations flow more or less continuously. This graph provides the first evidence of the "corkscrew" structure that lay behind the nightly movements of the points of light of Jupiter's moons observed by Galileo.

The nightly images are properly located relative to one another, placed on a vertical time-scale showing the date and hour of observation. The capital letter ○ representing Jupiter is now scaled down to its correct relative size (to the diameter of the orbit of the outer satellite) from the over-large original in *Sidereus Nuncius*. Some nights have no data; the gap near the top of the chart, for example, indicates that it was a cloudy evening in Padua on January 9, 1610. Overlapping Jupiters ⊖ show multiple viewings made by Galileo during a single night; the changing positions of the moons can be detected hour by hour.

Jupiter and its satellites reside in 4 dimensions: 3-space and the 4th dimension of time. Yet in the graph at right, as in nearly all displays of the motion of Jupiter's satellites, the 3 spatial dimensions are compressed into one-dimensional lineland. Then these linelands are stacked in time, which flows downward instead of the customary left-to-right. This curious and imaginative design is the direct consequence of the special arrangement of Jupiter and its satellites, all of which revolve in nearly the *same* orbital plane as Earth and the other planets. Thus we see the orbits approximately on edge, parallel to the ecliptic, as the points of light of Jupiter's satellites appear to move back and forth along a straight line. This stack of linelands is an unconventional design; usually in plotting data with strong periodicities, time flows horizontally from left to right. The arrangement here, however, elegantly reflects the nightly views seen through the telescope and recorded sequentially in a scientific notebook.

These 2 different presentations—the original verbal/visual diary of discovery *and* this new graphic of stacked observations at right—tell the story of Jupiter's satellites. *Both arrangements are necessary to analyze the evidence*; each independently contributes to understanding the satellites.

Assorted views of the same underlying data are often helpful. Multiple portrayals may reveal multiple stories, or demonstrate that inferences are coherent, or that findings survive various looks at the evidence in a kind of internal replication. Both Galileo's diary of discovery and the stacked lineland sequence here use the same 65 images—a repetition of data, but not design, which yields new knowledge and enhances the credibility of both images. Graphical displays used in scientific reports and exploratory data analysis should not be afraid to repeat themselves, and to play some visual variations around the main evidence.

	Date
	7 January 1610
	8
	9
	10
	11
	12
	13
	14
	15
	16
	17
	18
	19
	20
	21
	22
	23
	24
	25
	26
	27
	28
	29
	30
	31
	1 February 1610
	2
	3
	4
	5
	6
	7
	8
	9
	10
	11
	12
	13
	14
	15
	16
	17
	18
	19
	20
	21
	22
	23
	24
	25
	26
	27
	28
	1 March 1610
	2

Still another redesign serves to combine Galileo's verbal narrative of discovery and the 65 little images by replacing the original *serial* arrangement of text/image/text/image/text . . . with *parallel* sequences of words and images now moving together night after night. Below, in this parallel design, words from Galileo's diary (compressed and paraphrased) annotate each observation during the first 11 days of observation:

January 7	✳ ✳ ○ ✳	*With my new telescope, I saw 3 stars around Jupiter in a straight line parallel to the ecliptic.*
8	○ ✳ ✳ ✳	*Provoked by curiosity, tonight I viewed Jupiter again; now 3 stars were all west of Jupiter.*
9	cloudy	*Unfortunately tonight the sky was covered everywhere with clouds.*
10	✳ ✳ ○	*Only 2 stars, to the east! Is a third hiding behind Jupiter? Jupiter can't move that fast; thus the stars must move.*
11	✳ ✳ ○	*It appears that 3 stars wander around Jupiter, like Venus and Mercury around the Sun.*
12	✳ ✳○ ✳	*As I watched, a third star appeared nearest to Jupiter. All 3 little stars were straight on the ecliptic.*
13	✳ ○ ✳✳ ✳	*For the first time I saw 4 separate stars near Jupiter. The eastern star was 2 minutes from Jupiter,*
14	cloudy	*and the 3 other stars apart at about 1 minute intervals. But now, on the 14th, the weather was cloudy.*
15	◉ ✳ ✳ ✳✳ ✳✳	*About 3 hours after sunset, 4 stars appeared; at 7 hours after, only 3 were in the same straight line.*
16	✳ ○ ✳ ✳	*Then 2 stars appeared within a distance of 40 seconds of Jupiter with 1 star 8 minutes from J in the west.*
17	✳✳ ◉ ✳ ✳	*Again 2 stars; 4 hours later another emerged, which, I suspect, had been united with the first one.*

FOR the *Starry Messenger,* with its tone and velocity of a news report, the pages were quickly produced by following the layout of Galileo's handwritten scientific journals. In his journals and letters, and thus in his book, Galileo makes no distinction among words, diagrams, images. Evidence is evidence. The similar treatment of text, diagrams, and images suggests to readers that images are as relevant and credible as words and diagrams. A book design that treats all modes of information alike reinforces the point. Galileo's images of course earned specific credibility for substantive reasons: their precise detail and sheer number, their depiction of Jupiter's moons in systematic motion, their narrative of discovery of an intriguing reality beyond imagination. This evidence was contested by a critic who proposed an alternative explanation: the images might simply be optical illusions induced by the telescope rather than actual satellites moving. In response, a characteristically sharp and sardonic Galileo offered a large reward to anyone who could construct a telescope that would create illusory satellites around one planet but not others![16]

[16] *Le Opere di Galileo Galilei,* edited by Antonio Favaro (Florence, 1890-1909, 1964-1966), volume XI, 107, as cited by Stillman Drake, *Galileo At Work: His Scientific Biography* (Chicago, 1978), 166.

AFTER Galileo, Newton. In 1687 Isaac Newton published the *Principia,* or the *Mathematical Principles of Natural Philosophy.* At the beginning of the book, Edmund Halley wrote a celebratory ode on this "Mathematico-Physical Treatise," which included this Galilean echo:

> *The things that so often vexed the minds of the ancient philosophers*
> *And fruitlessly disturb the schools with noisy debate*
> *We see right before our eyes, since mathematics drives away the cloud.*

tum *D* ob proportionales *C S, C D* defcribet Ellipfin confimilem, e regione. Corpora autem *T* & *L* viribus motricibus *S D* x *T* & *S D* x *L*, (prius priore, pofterius pofteriore) æqualiter & fecundum lineas parallelas *T I* & *L K* (ut dictum eft) attracta, pergent (per Legum Corollarium quintum & fextum) circa centrum mobile *D* Ellipfes fuas defcribendo, ut prius. Q. E. I.

Addatur jam corpus quartum *V*, & fimili argumento concludetur hoc & punctum *C* Ellipfes circa omnium commune centrum gravitatis *B* defcribere; manentibus motibus priorum corporum *T*, *L* & *S* circa centra *D* & *C*, fed paulo acceleratis. Et eadem methodo corpora plura adjungere licebit. Q. E. I.

Hæc ita fe habent ubi corpora *T* & *L* trahunt fe mutuo viribus acceleratricibus majoribus vel minoribus quam trahunt corpo-

tur: fitq; major femper ubi trium commune illud centrum, minuendo motum corporis *S*, moveri incipit & magis deinceps magifq; agitatur.

Corol. Et hinc fi corpora plura minora revolvantur circa maximum, colligere licet quod Orbitæ defcriptæ propius accedent ad Ellipticas, & arearum defcriptiones fient magis æquabiles, fi corpora omnia viribus acceleratricibus, quæ

funt ut eorum vires abfolutæ directe & quadrata diftantiarum inverfe, fe mutuo trahent agitentq;, & Orbitæ cujufq; umbilicus collocetur in communi centro gravitatis corporum omnium interiorum (nimirum umbilicus Orbitæ primæ & intimæ in centro gravitatis corporis maximi & intimi; ille Orbitæ fecundæ, in communi centro gravitatis corporum duorum intimorum; ifte

NEWTON's *Principia* (1687) integrates hundreds of physics diagrams so as to fall properly in the text. This serves the convenience and understanding of readers, who can view a diagram and its relevant text together. The first edition helpfully repeats the *same* diagram (above right) in position on 4 double-page layouts and, in the third edition, on 7 consecutive layouts. This technique of relevant repetition was also used (with 11 repeats) in the first edition of Descartes' *Principia* (1644).

This fine integration of text and image in Newton's *Principia* resulted because (1) the book was printed in relief, so words and woodcut images printed simultaneously in one pass through the press; (2) the excellent Edmund Halley, an intensely visual scientist and cartographer, financed the publication and watched over the process of book production along with Newton. In this collaboration of two very bright, content-oriented book designers, Halley wrote to Newton on June 29, 1686:

> Now you approve of the Character and Paper, I will push on the Edition
> Vigorously. I have sometimes had thoughts of having the Cutts neatly
> done in Wood, so as to stand in the page, with the demonstrations,
> it will be more convenient, and not much more charge, if it please you
> to have it so, I will trie how well it can be done . . .

Newton replied on July 14, 1686:

> I have considered your proposal about wooden cuts & beleive it will
> be much convenienter for ye Reader & may be sufficiently handsome.[17]

NEITHER Halley nor woodcuts, however, were deployed in publication of Newton's *Opticks* (1704), a book reporting fundamental discoveries: interference effects, the color composition of sunlight, Newton's rings, and design of the Newtonian reflector telescope still used to this day. All, indeed, rather visual topics; one-third of Newton's text directly addresses 55 diagrams that show light in action. Troubles began when *the diagrams were printed as free-standing engravings, completely separate from the text.*

Isaac Newton, *Principia* (London, 1687), illustrations at 170, 189.

[17] *The Correspondence of Isaac Newton,* 7 volumes edited by H. W. Turnbull, J. F. Scott, A. Rupert Hall, Laura Tilling (Cambridge, 1959-1977), letters 289 and 290, quotations at pages 443, 444.

Isaac Newton, *Opticks: or, A Treatise of the Reflections, Refractions, Inflections, and Colours of Light* (London, 1704), at left pages 24-25 with the flaps "Book I. Plate I. Part I., Fig. 2., Fig. 3., Fig. 5., Fig. 7."and "Book I. Plate III. Part I., Fig. 13., Fig. 14., Fig. 15., Fig. 16." Below, page 25.

Newton's 55 original drawings were sent to an engraver, who ganged and printed them on 12 pages of flaps bound into 4 clusters variously inserted into the book. Each cluster opens out sideways and dangles from the book, as shown above. All this printing and binding yields an ingenious but contraptionary collation of *Opticks*:

> 80 pages of pure text, followed by 5 dangling flaps with 29 ganged figures
>
> 84 pages of pure text, followed by 4 dangling flaps with 16 ganged figures
>
> 48 pages of pure text, followed by 2 dangling flaps with 7 ganged figures
>
> 90 pages of pure text, followed by 1 dangling flap with 3 ganged figures.

To link some text to some distant flap diagram requires 5 hierarchical levels of flap label codes. For example, the phrase "Prism DEGdeg" in the text is illustrated elsewhere on the flap page with the address "Book I. Part II. Plate IV. Fig. 16," where the visual version of "Prism DEGdeg" unhappily resides. The first 80 text pages of *Opticks* contain 6,300 letter-codes (at right, a grim sample) that refer to illustrations stashed away after page 80. To read the book requires an enormous back and forth between the text and the enflapped diagrams, between a book of words and 4 parallel booklets of illustrations. This is a competent design for comparing or admiring diagrams, or handwaving over a famous book by Newton, but a poor design for learning about light and optics.

Ganged and segregated engravings have proved convenient to certain nonreaders. A common fate of separate pages of engravings in old books has been for some dealers in antiquarian prints to slice the engravings out of the original book, frame them, and sell them off — in the ultimate segregation of image and text. It is fine to appreciate physics drawings as art objects. It is even finer to know what they mean and who thought them up, and to keep the relevant images with the relevant words forever.

For Newton's *Opticks*, bureaucracies of presentation and mechanical reproduction corrupted the understanding of the content. You're lucky if they don't.

THIS big table reports the dreary history of text/image segregation for the 23 editions in 5 languages of Newton's *Opticks* published since 1704. Several of these books are elegant examples of fine printing, others are heavy-handed. Nearly all are quite difficult to read, since only 2 of the 23 editions completely integrate Newton's images with his words! To top it off, a 1964 volume stuffed the 55 images into a little pocket attached to the inside back cover. Nearly all the 23 published editions of *Opticks* can only be admired, for they can hardly be understood.

With 19th-century lithography allowing text and image to be simultaneously printed on the same page, publishers finally produced integrated editions of *Opticks* in 1898, 1931, and 1952. At right, Newton's words and images are together for the first time, 194 years late, on a page reporting the invention of the Newtonian telescope. But, as our table shows, the ghost of the original segregation haunts the 5 most recent versions, including an elegant digital reproduction that first replicates and then multiplies all the problems of the original Opticks.

Few editors, translators, and publishers of *Opticks* overcame the segregation of word and image that started in 1704; nearly all appear unaware of the inherently visual and explanatory quality of the content. The initial book design tends to persist, whether good (*Hypnerotomachia*) or bad (*Opticks*). It is worthwhile to get the original right.

If Newton's great work can be disrupted and rendered substantially incoherent by the technologies of reproduction for some 300 years, then no work with visual elements is safe.

Sir Isaac Newton's Optik, oder Abhandlung über Spiegelungen, Brechungen, Beugungen und Farben des Lichts, translated by William Abendroth (Leipzig, 1898), 72.

A dismal history: Text and image in the 23 published editions, from 1704 to 1998,
Isaac Newton, *Opticks: or, A Treatise of the Reflections, Refractions, Inflections, and Colours of Light*

EDITIONS	TEXT AND IMAGE: INTEGRATED OR SEGREGATED?
First English edition (London, 1704)	**Segregated.** 12 fold-out flaps show 55 figures. These flaps are grouped in 4 clusters, and each flap-cluster is bound into the book at the end of each of the 4 sections of *Opticks*. This format was used in most editions of *Opticks* for the next 300 years.
First Latin edition (London, 1706)	**Segregated.** Grouped in 4 clusters, 12 fold-out flaps show 55 figures.
Second English edition (London, 1717)	**Segregated.** Grouped in 4 clusters, 12 fold-out flaps show 55 figures.
Second Latin edition (London, 1719)	**Segregated.** Grouped in 4 clusters, 12 fold-out flaps show 55 figures.
First French edition (Amsterdam, 1720)	**Segregated in a new way, even more.** All figures placed at *back* of book, where 12 fold-out flaps show 55 figures. Now the illustrations are even further from their text.
Third English edition (London, 1721)	**Segregated.** Grouped in 4 clusters, 12 fold-out flaps show 55 figures.
Second French edition (Paris, 1722)	**Segregated.** Grouped in 4 clusters, 12 fold-out flaps show 55 figures. Each of the 4 sections begins with a new, identical engraving of one of Newton's experiments. This is the most beautifully designed and printed of all editions of *Opticks*, but just as disorganized.

Text and image in Newton's *Opticks* (dismal table continued)

EDITIONS	TEXT AND IMAGE: INTEGRATED OR SEGREGATED?
Fourth ("deathbed") English edition (London, 1730)	**Segregated**. Grouped in 4 clusters, 12 fold-out flaps show 55 figures. Newton made changes in this edition shortly before his death.
Third Latin edition (Lausanne, 1740)	**Segregated even more**. All figures at *back* of book, 12 fold-out flaps show 55 figures.
Latin edition (Graz, 1747) Latin edition (Padua, 1749) Latin edition (Padua, 1773)	**Segregated in a different way**. For all 3 of these Latin editions, 40 plates are at the end of the book. The first 28 plates are from earlier works on optics by Newton bound in the same volume; the last 12 plates show the usual 55 figures for *Opticks*.
Collected works, *Isaaci Newtoni opera quae exstant omnia,* ed. S. Horsley (London, 1779-1785), 5 volumes	**Segregated in still another way**. All figures placed at end of text of *Opticks*, where 12 pages show 55 figures. These drawings are no longer on fold-out flaps, so it is nearly impossible to view the figures and text simultaneously. These are *the collected works,* volumes that should celebrate rather than dismantle Newton's thought.
Third French edition (Paris, 1787)	**Segregated**. Grouped in 4 clusters, 12 fold-out flaps show 55 figures.
First German edition (Leipzig, 1898), 2 volumes	Completely integrated! All figures are correctly placed with their accompanying text throughout the 2 volumes of the German translation. Text often fitted around figures. This is the first edition in any language to combine Newton's words and images, 194 years after *Opticks* was first published. Sample page shown at far upper left.
Reprint of fourth English edition of 1730 (London, 1931); this in turn reprinted in paperback (New York: Dover, 1952, in print as of 2006)	Partly integrated. 28 figures are placed with their accompanying text; the remaining 27 figures are alas turned sideways (for rotating readers) and placed on separate pages within 1 to 5 pages of their textual reference. Sometimes awkward and inconvenient, but the only in-print edition for reading Newton. Introduction by Albert Einstein.
Reprint of second English edition 1717 (Chicago, 1952)	Completely integrated! At last, in English, all of Newton's words and images brought together. All figures are appropriately placed with their accompanying text. Published as volume 34, *The Great Books of the Western World,* of all places. It took 248 years to combine word and image in the original English.
Reprint of second French edition (Paris, 1955)	**Segregated**. Grouped in 4 clusters, 12 fold-out flaps show 55 figures.
Reprint edition of Newton's collected works, edited by S. Horsley, 1779-1785 (Stuttgart-Bad Cannstatt,1964), 5 volumes	**Segregated in another way**. Newton's 55 illustrations are reproduced on 12 separate folded sheets stuffed into a pocket affixed to the inside back cover. A jumble, making for extremely awkward, inconvenient reading.
Reprint of first English edition of 1704 (Brussels, 1966)	**Segregated in a new way**. The 12 plates, usually folded and placed in clusters at end of the 4 sections of *Opticks* have now been redistributed throughout the book, placing some figures closer to the accompanying text; many figures, however, are 5 to 10 pages arbitrarily distant from their text. In this edition, the plates are no longer mounted on fold-out flaps, making it impossible to view the figures and text simultaneously.
First Romanian edition (Bucharest, 1970)	**Segregated**. All figures placed at end.
Digital reproduction for computer, high-resolution photographs of first edition of 1704 (Oakland, California: Octavo, 1998)	**Segregated in the newest way**. As usual, words and images are separated, but now we're on the computer: 4 clusters of 12 plates show 55 figures. Integrating words and images on the screen demands complex efforts by computer users; it is perhaps easier to read through nearly any printed edition, even those segregating text and image. In an inexpensive format, this superb digital reproduction does provide a good sense of the character of the very rare first edition of Newton's *Opticks*.

RECENTLY some book publishers have required authors to place their images but not their text on the internet. Segregation of text and image requires text/image linkage codes of the sort that we saw in *Opticks*— "Book I. Part II. Plate IV. Fig. 16. Prism DEG deg." [18] Modern graphic designers, buttressed by semiotics mumbo-jumbo and compromised by commercial expediency, have styled new linkage systems that have proved as inconvenient and annoying as those of the 1704 *Opticks*. Here is a sandwich collation for a modern designer field guide to the weather:

176 pages of black-only type and a few diagrams printed on bible paper
96 pages of color pictures each with a few words printed on glossy paper
212 pages of black-only type and a few diagrams printed on bible paper

Icon-symbol thumbtabs then link up the segregated words and images. All this stuff turns into a Book Operating System, which requires 570 words of preposterous documentation. A sample:

20 *How to Use This Guide*

Example 2 You are visiting friends in Kansas who
A small funnel live just a few miles from your house,
forming at the and you have heard on the radio that a
base of a cloud tornado watch has been issued.
 You scan the sky and notice that a
 small funnel has formed at the base of a
 thick thunderstorm cloud overhead.
1. Turn to the Thumb Tab Guide. There
 you find a vortex-shaped silhouette,
 standing for the group Tornadoes and
 Other Whirls. The symbol refers you to
 the color plates 207–230.
2. You look at the color plates and quickly
 surmise that the funnel shape in the sky
 overhead may be the beginning stage of
 a tornado. The captions refer you to
 the text on pages 511–522.
3. Reading the text, you become
 convinced that there is a tornado
 forming. You and your friends
 immediately seek the storm shelter and
 wait for the threat to pass.

Following an Icon Learning Experience, readers must search for 3 links in 3 separate clusters of 6, 24, and 12 pages. The computer-interface metaphor extends to the presentation style, which emulates an inept technical manual: the second person that soon becomes cloying from overuse (11 uses of *you* and *your* in 9 sentences); the lame humor (tornado, Kansas); the tone that suggests the reader is an idiot; the clunky typography (double spaces after a period, and the narrow columns and failure to hyphenate that produce wildly varying line lengths and a hyper-active right rag with the lonely letter "a" floating off the end of 3 lines). Like a technical manual, the book's actual subject—the weather—is not mentioned until the last word of a 9 word insecure bureaucracy of a book title.

[18] In the Case of the Disappearing Diagrams of Descartes, the beautifully integrated text and image of the first edition was promptly dismantled by the bureaucracies of secondary production: "In the first Latin edition of the *Principia philosophiae* of 1644, illustrations are incorporated into the main body of the text... These illustrations are appended to the end of the text in the French edition of 1647 prepared by Abbé Picot, Charles Adam and Paul Tannery—the editors of the canonical edition of Descartes's works—followed the practice of Picot, which in turn means that they were compelled to add a number of awkward footnotes that link the pictures to the appropriate bits of text. Though the editors of the recent English edition—Miller and Miller (1983)—maintain that their edition is based on the original Latin text, this edition adopts Picot's practice of placing the pictures at the end of the text. Numerous annotations of phrases and passages are added in footnotes that are often helpful with the text, *but not one reference to the illustrations is offered that is not to be found in Descartes's original text. It is as though these illustrations do not exist.*" Brian Baigrie, "Descartes's Scientific Illustrations and *la grande mécanique de la nature*," in *Picturing Knowledge: Historical and Philosophical Problems Concerning the Use of Art in Science* (Toronto, 1996), 87 (italics added).

National Audubon Society Field Guide to North American Weather (New York, 1991, 1998), 20.

208

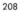

JAYS, MAGPIES, AND CROWS (*Family* Corvidae) are medium to large, gregarious, omnivorous birds with heavy bills. Wings of jays and magpies are short and rounded, reaching only to the base of the long rounded tail. Wings of crows and ravens are long and rounded, extending nearly to the tail tip. Sexes are similar. Often scolded and chased by smaller birds in nesting season. Songs are poor, mostly raucous. Eggs, 3-6 (magpies, 5-9), are colored and speckled.

BLUE JAY ✓ *Cyanocitta cristáta*
Common in oak and pine woods. The only eastern jay except in central Fla. and Far North, and the only blue-winged jay with white on wings and tail. Conspicuously crested in all plumages. Migrates by day in loose flocks of 5-50. Common call is a loud *jay, jay,* 10-20 pairs/min.

STELLER'S JAY *Cyanocitta stélleri*
Common in coniferous forests. The only crested jay in and west of the Rockies; dark crest is always present. Calls are low-pitched, raucous, and varied, often in series of 3. Like the Blue Jay, Steller's imitates hawks expertly.

SCRUB JAY *Aphelócoma coeruléscens*
Locally common, especially in scrub oaks, where it skillfully remains out of sight. This crestless jay is best told by its white throat, outlined in blue. The sharp contrast between blue crown and olive-gray back also separates it from the other jays. Flights are short, ending with a sweeping glide. Calls, similar to Steller's, are higher and often in ones or twos.

MEXICAN JAY *Aphelócoma ultramarina*
Common in oak and oak-pine forests, 2,000-8,000'. Looks like a faded Scrub Jay with a uniformly gray throat and breast. Calls, less raucous than other jays', are slurred upward; frequently repeated.

PINYON JAY *Gymnorhinus cyanocéphalus*
Short-tailed, crow-like in flight and habits; common in arid regions. Nests in pinyon pines and junipers; is often seen on the ground around sagebrush. In winter it wanders erratically to farmlands. Told from other jays by its uniform steel-blue color, short tail, and long beak. Compare with Mountain Bluebird (p. 234). Has a high mewing call in flight; when perched, a *queh queh queh.*

SOMETIMES metaphors or analogies, at least other than basing field guides on computer interfaces, assist reasoning about analytical design. *But usually the metaphors for analytical design should be the content and the reasoning associated with the content.* For example, the purpose of a field guide is to combine visual recognition of physical objects with new verbal, geographic, and graphical information. And so for the birds above, we are provided with their images, shape comparisons for 7 birds in profile at the top, location maps, song scores, description, and identifying keys. Location maps are particularly helpful in avoiding ridiculous identifications, such as apparently observing a bird in Montreal that in fact resides exclusively in Acapulco. In this classic Golden Field Guide, there is a sense of craft, detail, and credibility that comes from gathering and displaying good evidence all together.

Chandler S. Robbins, Bertel Bruun, and Herbert S. Zim, illustrated by Arthur Singer, *Birds of North America: A Guide to Field Identification* (New York, 1966), 208-209.

Spotting a hidden handgun

ASYMMETRICAL GAIT

A gun in a right-hand pocket or tucked into the right side of a waistband may hinder leg movement on that side, making the right stride shorter than the left.

A slightly clipped arm swing may also signal a hidden gun: the forearm on the gun side will tend to stay close to the body, instinctively guarding the weapon.

UPPER BODY SHIFT

When approached from the front, a person with a hidden gun will instinctively turn the gun side of his body away from the person approaching, and may veer to that side to avoid a face-to-face encounter. He is also likely to pull his arm in toward his body on the gun side.

Short stride on gun side

Short arm swing on gun side

L R RIGHT STRIDE

R L LEFT STRIDE

A QUICK ADJUSTMENT

A gun's weight is distributed unevenly, with more of its weight in the grip than in the barrel. Vertical motion — like descending stairs or stepping onto a curb — tends to shift the barrel upward. A quick, circular movement of the hand or forearm adjusts the gun's position.

Gun's original position in waistband

Weighted grip slips downward; barrel rises

HAND REPOSITIONS GUN

GUN HIDDEN UNDER JACKET

RUNNING FROM THE RAIN

When running toward shelter from rain, or across a busy street, a person concealing a gun is likely to brace the weapon with an arm or hand.

CONSPICUOUS CLOTHING

Garments worn to conceal weapons often appear odd, mismatched, or out of season, and can actually draw attention to a person trying to avoid scrutiny. A closer look may reveal movements or other characteristic signs of a hidden handgun.

JACKET FITS UNEVENLY
One side hangs lower than the other, and swings like a pendulum with each step

HAND RESTS ON GUN
Hand constantly feels for gun through clothing

HOLSTER BULGES
A holstered gun appears as a lump when arms are extended or when the body bends at the waist

STYLES DON'T MATCH
Oversized or mismatched coat seems incompatible with other clothing

CLOTHES DON'T SUIT WEATHER
A coat is open in cold weather, for quick access to a gunor closed in hot weather, to conceal one

Source: Robert T. Gallagher, former detective, Anti-Robbery Tactical Unit, New York City Police Department

Megan Jaegerman

THIS excellent report describes clues to detect hidden handguns carried on the street and also for meeting the standards of evidence necessary to obtain a conviction. Somewhat like the 18th-century dance annotation we saw earlier, the various scenes here choreograph movement in 3-space by means of sequences, call-outs, parallelism, motion arrows, mappings, multiple viewpoints (silhouette, 3-dimensional, flatland footprints), and particularly words and images working together to describe an extended causal sequence. To create this display, Megan Jaegerman did *both* the research and the design, breaking their common alienation. This design amplifies the content, because the designer created the content. Her backup documentation, at a level demanded by editors at high-quality newspapers, indicates the care and craft of the work:

Parts of this graphic appeared in *The New York Times,* May 26, 1992. The graphic here is greatly expanded and redrawn for this book. Research and artwork for both graphics are based on interviews with Robert T. Gallagher of the New York City Police Department, and were done by Megan Jaegerman, who worked at the *Times* news graphics department from 1990 to 1998. Her email of March 2005, reproduced in the text, describes the interviews with Detective Gallagher.

> I confirmed his ID as Detective Robert T. Gallagher of the NYC Police Dept. at criminaljustice.state.ny.us/ops/staff/index.htm. Also lists his award (see below).

> From my notes: He was a New York City policeman for 18 years, who for much [unknown] of that time worked as a plain-clothes undercover detective [anti-robbery tactical unit, confiscating illegal firearms], in Bronx & Manhattan, 6pm to 2am shift. He got very good at picking out people carrying weapons. So good that he received [not sure of exact terminology] 1984 Governor's Police Officer of the Year Award. The great achievement was not just making gun arrests (1,200 of them), but making them stick. The letter nominating him said he had "an almost flawless conviction rate." I believe he put it at "99.99."

> That's the whole point of his observation—not just to get a gun off the street, and then maybe have the arrest thrown out, which apparently happens too often—but to get from arrest to conviction and jail time. It's all about probable cause, he explained. First identify suspicious demeanor, appearance, behavior (which don't qualify as grounds for arrest), and then wait for probable cause, or legal grounds for frisking and/or arresting someone. He pretty much had to watch for enough clues to justify suspicion, which would allow him to stop a suspect. Then he'd identify himself as a policeman, and THEN he'd watch for the hand reaching toward the waistband, or the guy instinctively turning away, and pulling his arm in to his side. That would combine to give probable cause for a frisk. And when there's a frisk and a weapon, there's an arrest, and apparently with Gallagher, very often a conviction. The sequence is necessary, in the context of suspects' rights and legal requirements for arrest—evidence must exist that rises above suspicion to probable cause.

> The tell-tale signs are those in the graphic—slight asymmetries in gait, odd clothing combinations or styles or misfits, instinctive evasive moves when confronted, constant hand-to-gun, holding gun while running, visible bulges or irregularities in the way clothing fits or hangs . . . etc. Source for gun art is a photo from Gallagher of three kinds of revolvers, all looking about the same.

> He did act out the motions for me, with guns hidden in all the usual places, and demonstrations of grabbing and frisking and all of that. And he let me do some of the gun handling and role playing. So I'm confident in the graphic.

WHEN and how should data points in statistical graphics be labeled with words? In a classic book, *The Elements of Graphing Data,* William Cleveland suggests that word-labels on data may well "interfere with our assessment of the overall pattern of quantitative data."[19] Several examples then show interfering labels within data fields, including this

[19] William S. Cleveland, *The Elements of Graphing Data* (Monterey, California, 1985), 46.

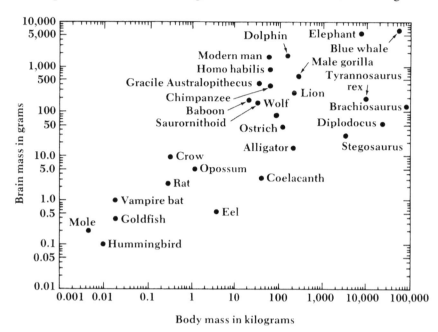

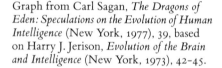

Graph from Carl Sagan, *The Dragons of Eden: Speculations on the Evolution of Human Intelligence* (New York, 1977), 39, based on Harry J. Jerison, *Evolution of the Brain and Intelligence* (New York, 1973), 42-45.

noisy, cluttered scatterplot of the empirical relationship between body mass and brain mass for 26 animals. Cleveland's analysis suggests these imperatives for putting words on data points:

> Do not allow data labels in the data region to interfere with the quantitative data or to clutter the graphs. Avoid putting notes, keys, and markers in the data region. Put keys and markers just outside the data region and put notes in the legend or in the text.[20]

[20] Cleveland, *The Elements of Graphing Data,* 44-47.

Conflicting with the idea of integrating evidence regardless of its mode, these guidelines provoke several issues:

First, labels *are* data, even intriguing data. For example, among the really big animals, relatively smaller brains are found in the prehistoric tyrannosaurus rex, brachiosaurus, diplodocus, stegosaurus — a result that emerges from seeing data dots linked to their names. Or, why is the hummingbird shown as heavier than the mole, the wolf than humans? Such plotting errors can be more easily detected when data points are named. And where would the gnat, mosquito, cat, hammerhead shark, or centaur appear on the graph? Just like numbers, nouns are evidence.

Second, when labels abandon the data points, then a code is often needed to relink names to numbers. Such codes, keys, and legends are impediments to learning, causing the reader's brow to furrow.

Third, segregating nouns from data-dots breaks up evidence on the basis of mode (verbal vs. nonverbal), a distinction lacking substantive relevance. Such separation is uncartographic; contradicting the methods of map design often causes trouble for any type of graphical display.

Fourth, design strategies that reduce data-resolution take evidence displays in the wrong direction.

Fifth, what clutter? Even this supposedly cluttered graph clearly shows the main ideas: brain and body mass are roughly linear in logarithms, and as both variables increase, this linearity becomes less tight.

But verbal arguments do not resolve design questions. Visual evidence decides visual issues. And it turns out that Cleveland has a strong point. The 26 labels do in fact clutter up the graph, obscuring relations among the data. Perhaps something will show up if all the words disappear:

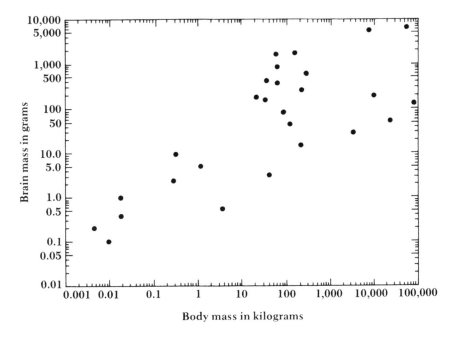

Without the dark typography of the labels, we see very differently: the big blob of words in the top half of the original graph inflates the visual variability of body mass for heavier animals. Thus one possible solution for label-clutter, particularly in exploratory data analysis, is to examine *both* scatterplots, with and without labels.

Good design, however, can dispose of clutter *and* show all the data points and their names. To repair this graphic, the data-dots need to gather themselves together on a *different visual level* from their labels. And the labels need to calm down. Like good maps, statistical graphics should have a layered depth of reading. Not a hierarchy of importance for verbal versus quantitative information, but rather a pluralism of distinctions. This suggests a redesign.

In this revised graph, *red* helps to cluster 26 data-dots now placed in a quiet field of grayed-down words. *Label clutter has vanished, but the labels are still there.* Clutter calls for a design solution, not a content reduction.

At lower left, this chart on the varying viscosity of glass in relation to temperature has an overall sameness of texture and color. Administrative elements (frames, grids, pointer lines, tick marks) are as visually active as the evidence curve itself. At right, the red color pulls out the curve from the graphic debris, while maintaining a unity of text and linework by means of the cartographic strategy of layering and separation.

Roger Hayward in John Strong, *Procedures in Experimental Physics* (New York, 1938), 6.

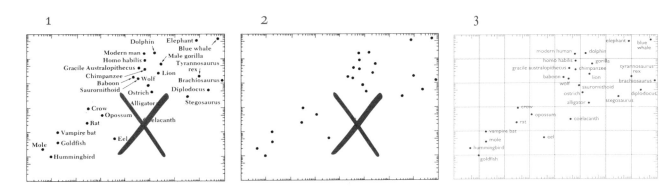

The redesign sequence reflects these fundamental principles: 1. Clutter is a failure of design, not an attribute of information. 2. Visual problems should not be fixed by reducing content-resolution (such as, for example, discarding words that label data). 3. Instead, fix the design.

Words and data-dots are abstracted representations of actual animals and body/brain masses. In a spirit of seeking visual solutions for visual problems, let each animal represent *itself* at its two-space location in the scatterplot below. Image sizes are proportional only to space available— except for the big brachiosaurus and tiny humans, shown together here at right, whose amazing relative sizes are approximately correct. Other details below repay study.

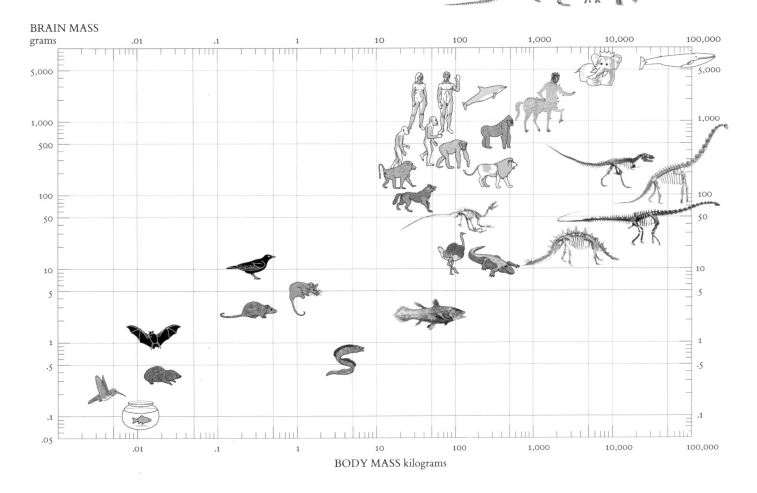

The Fundamental Principles of Analytical Design

Categories such as time, space, cause, and number represent the most general relations which exist between things; surpassing all our other ideas in extension, they dominate all the details of our intellectual life. If humankind did not agree upon these essential ideas at every moment, if they did not have the same conception of time, space, cause, and number, all contact between their minds would be impossible. . . .

Émile Durkheim, *Les formes élémentaires de la vie religieuse*
(Paris, 1912), 22-23.

I do not paint things, I paint only the differences between things.

Henri Matisse, *Henri Matisse Dessins: thèmes et variations*
(Paris, 1943), 37.

EXCELLENT graphics exemplify the deep fundamental principles of analytical design in action. If this were not the case, then something might well be wrong with the principles.

Charles Joseph Minard's data-map describes the successive losses in men of the French army during the French invasion of Russia in 1812. Vivid historical content and brilliant design combine to make this one of the best statistical graphics ever. Carefully study Minard's graphic, shown in our English translation at right. A title announces the design method (figurative map) and subject (what befell the French army in Russia). Minard identifies himself and provides a credential. A paragraph of text explains the color code, the 3 scales of measurement, and the methods. Five data sources are acknowledged.

Then the Russian campaign of 1812-1813 begins.

At right, English translation of item 28 in Charles Joseph Minard, *Tableaux Graphiques et Cartes Figuratives de M. Minard, 1845-1869*, a portfolio of Minard's statistical maps at the Bibliothèque de l'École Nationale des Ponts et Chaussées, Paris, 62 × 30 cm, or 25 × 12 in. This 1869 map is the last sheet in Minard's lifetime portfolio. English translation by Dawn Finley, redrawing by Elaine Morse.

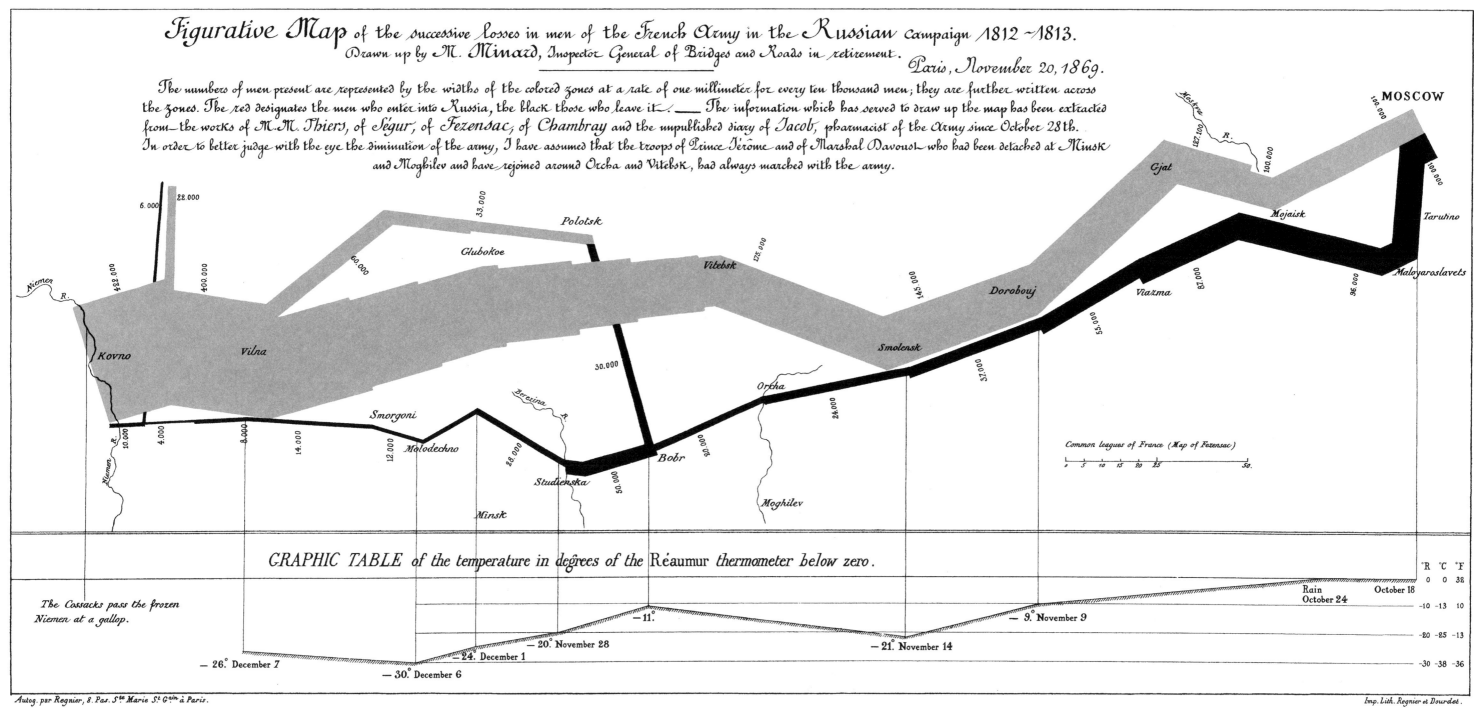

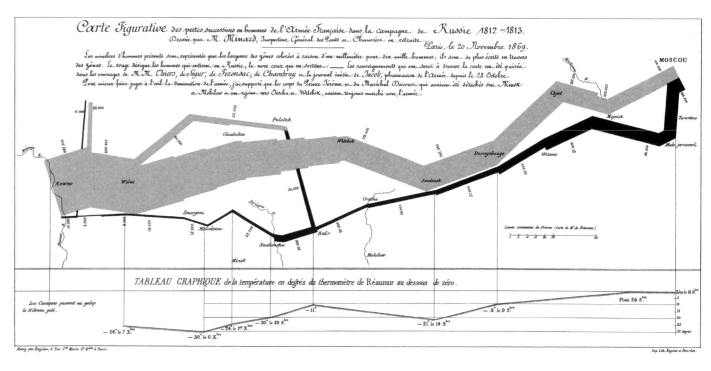

Above, the original French version. This statistical map portrays the successive losses of the French Army in Napoleon's Russian campaign of 1812. The *overall* toll, French and Russian, was approximately 700,000 to 1,000,000. Described by E. J. Marey as seeming to defy the pen of the historian by its brutal eloquence,[1] Minard's map exemplifies many of the fundamental principles of analytical design.

Principle 1: Comparisons

Beginning at the left, on the Polish-Russian border near the Niemen River, the thick tan line shows the size of the Grand Army (422,000 men, drawn from all Europe) as it invaded Russia in June 1812, as well as the army's path. As the soldiers die, the line narrows; the flow-line indicates the number of remaining soldiers at each position on the map. Also shown are movements of auxiliary troops, who sought to protect the rear and flank of the advancing army.

In September, the 100,000 surviving troops reached Moscow, which was by then sacked, deserted, on fire. The departure from Moscow is depicted by the dark lower line, in turn linked to a temperature scale and dates in the statistical graphic at the bottom of the chart. During the retreat, it was bitterly cold and many soldiers froze and starved. Crossing back over the Niemen River with 10,000 survivors, the army struggled out of Russia. At the end, the map notes: "The Cossacks [Russian horsemen] pass the frozen Niemen at a gallop," driving out the scattered remnants of Napoleon's Grand Army.

[1] E. J. Marey, *La méthode graphique dans les sciences expérimentales* (Paris, 1878), 73: "Toujours il arrive à des effets saisissants, mais nulle part la représentation graphique de la marche des armées n'atteint ce degré de brutale éloquence qui semble défier la plume de l'historien."

Les Cosaques passent au galop le Niémen gelé.

And it is at the Niemen River, where the invasion began and ended, that we see a small but poignant illustration of the *First Principle for the analysis and presentation of data:*

Show comparisons, contrasts, differences.

The fundamental analytical act in statistical reasoning is to answer the question "Compared with what?" Whether we are evaluating changes over space or time, searching big data bases, adjusting and controlling for variables, designing experiments, specifying multiple regressions, or doing just about any kind of evidence-based reasoning, the essential point is to make intelligent and appropriate comparisons. Thus visual displays, if they are to assist thinking, should show comparisons.

Minard makes several vivid comparisons, some over many months, others during the course of a few days. At the war's beginning, the army crossed the Niemen River with 422,000 soldiers, shown by the number itself and represented by the width of the tan line. At the end, 10,000 soldiers returned back across the Niemen, as indicated by the number itself and the thin black line concluding the retreat. Only 1 soldier in 42 survived this futile campaign (the widths of the black / tan lines at the Niemen River were inaccurately constructed in a ratio of 1 to 28). This graphic comparison at the Niemen summarizes the slaughter, 6 months from start to finish.

At the Berezina River, another comparison. During the retreat (west-ward, to the left), the black line crossing the river abruptly diminishes— from 50,000 to 28,000 soldiers, as 22,000 died in 2 days. This change in line weight represents, in a blunt and incomplete way, the terrible events at the Berezina, described by Philippe-Paul de Ségur (*aide de camp* to Napoleon, and a source cited by Minard):

> It was the twenty-eighth of November. The Grand Army had had two whole days and nights in which to effect the crossing, and it should have been too late for the Russians to do any harm. But chaos reigned in our midst....an immense confused mass of men, horses, and vehicles besieged the narrow entrances to the bridges and began to flow over them. Those in front, pushed by the weight of those behind or halted by the river, were crushed, trampled on, or forced into the ice-filled water of the Berezina. From the horrible, formless mob there arose a sort of dull murmur which swelled at times to a wild clamor mingled with groans and awful imprecations....The confusion was so great that when Napoleon himself wished to cross at two o'clock, it was necessary to use force to clear a passage for him....Then, as in all extreme situations, hearts were laid bare, and both infamous and sublime actions were witnessed. Some there were who, determined to pass at all costs, cut a horrible way for themselves with their swords. Others opened an even crueler road for their carriages, driving them pitilessly through the helpless crowd, crushing men and women, in their odious greed sacrificing their companions in misery to save their possessions.[2]

[2] Count Philippe-Paul de Ségur, *Napoleon's Russian Campaign* (New York, 1958), 246, 249; translated by J. David Townsend from *Campagne de Russie, Mémoires d'un Aide de Camp de Napoléon* (Paris, 1824).

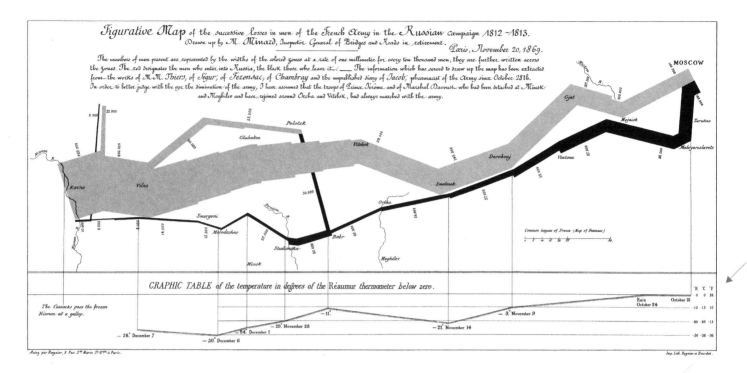

Principle 2: Causality, Mechanism, Structure, Explanation

How did nearly everyone in the Grand Army die? The mapped routes of invasion / retreat show the *location* of the bad news but do not explain what *caused* the deaths. Yet often the reason that we examine evidence is to understand causality, mechanism, dynamics, process, or systematic structure. Scientific research involves causal thinking, for Nature's laws are causal laws. Medical analysis—prevention, diagnosis, intervention— requires causal analysis. Reasoning about reforms and making decisions also demands causal logic. To produce the desired effects, we need to know about and govern the causes; thus "policy-thinking is and must be causality-thinking."[3]

Simply collecting data may provoke thoughts about cause and effect: measurements are inherently comparative, and comparisons promptly lead to reasoning about various sources of differences and variability. A vivid statement about epidemiological evidence by the distinguished medical pathologist Rudolf Virchow exemplifies this logic: "Medical statistics will be our standard of measurement: we will weigh life for life and see where the dead lie thicker, among the workers or among the privileged."[4]

Principles of design should attend to the fundamental intellectual tasks in the analysis of evidence; thus we have the *Second Principle for the analysis and presentation of data:*

Show causality, mechanism, explanation, systematic structure.

[3] Robert A. Dahl, "Cause and Effect in the Study of Politics," in Daniel Lerner, *Cause and Effect* (New York, 1965), 88.

[4] Rudolf Virchow, *Die Medizinische Reform* (Berlin, 1848), no. 1, 182; as quoted in Paul Farmer, *Infections and Inequalities: The Modern Plagues* (Berkeley, 1999), 1.

Minard depicted a possible causal variable by means of a graph of temperatures during the retreat—for Napoleon was defeated not only by the Russian Army but also by General Winter. Temperature is measured on a Réaumur scale, with the freezing point of water equated to 0° and boiling point of water to 80°. This is converted to the nearly universal Celsius (0° and 100°) and to Fahrenheit (32° and 212°) in scales on our English translation of Minard's graphic at left. Note that the scale starts at freezing; the *warmest* reading is 0°C or 32°F. It was very cold in Russia during November and December of 1812. The statistical graphic then brings in an another variable, *time*. Each temperature during the retreat is dated, from the rainy October departure from Moscow to the bitter cold on December 7th near the end.

The map's causal analysis is thin, merely a reminder of intense cold. Although the path of the retreating army loosely parallels the line of falling temperatures, this symbolic parallelism has no evidential value. The link between very cold temperatures and deaths is, however, made explicit in Minard's 5 historical sources that contain eye-witness accounts of the ghastly frozen soldiers. And in the striking visual-quantitative imagery of Victor Hugo's poem *L'Expiation* (at right) describing the retreat from Moscow.

Snow, in what was left of the city behind them,
drifted into the smoke and flames.
In their retreat, the army did not know
one white field from another,
or the left flank from the right or center.
Ensigns whited out, the voices of commanders
lost, what had been an army was a herd. . . .

The sky made turbid snow,
over the largest army ever,
an immeasurable shroud. Each of the soldiers fell
alone, struck by raiding troops,
or by the deadlier North.
They junked the cannon to burn the carriage.
Whoever slept for a moment died. The wasteland
swallowed them whole, regiments at a time,
visible now, where they lay down to rest,
as undulations in the anonymous snow.
Fugitives, wounded men, and dying,
in caissons, stretchers, and sleds, overloading
the bridges, falling asleep by the ten thousand,
woke up, hundreds, or less.

Selected Poems by Victor Hugo (New York, 2002), 14-17, translated by Brooks Haxton.

Principle 3: Multivariate Analysis

Minard delineates the war of 1812 by means of 6 variables: the *size* of the army, its *two-dimensional location* (latitude and longitude), the *direction* of the army's movement, and *temperature* on various *dates* during the retreat from Moscow. These 6 dimensions are shown with distinct clarity. There is no instruction manual, nor a jargon fog about a spatial-temporal hyper-space focus group executive dashboard web-based keystone methodology. Instead it is *War and Peace* as told by a visual Tolstoy.

Accounts of Napoleon's invasion of Russia are *multivariate* (that is, involving 3 or more variables). How could it be otherwise? Nearly all the interesting worlds (physical, biological, imaginary, human) we seek to understand are inevitably multivariate in nature. Simple navigational instructions reflect up to 4 dimensions, describing routes through the 3-space in which we live over the 4th dimension, time. Current-day cosmological theories claim an 11-dimensional universe. The analysis of cause and effect, initially bivariate, quickly becomes multivariate through such necessary elaborations as the conditions under which the causal relation holds, interaction effects, multiple causes, multiple effects, causal sequences, sources of bias, spurious correlation, sources of measurement error, competing variables, and whether the alleged cause is merely a proxy or a marker variable.[5]

[5] On multivariate subtleties of evidence for causality, Austin Bradford Hill, "The Environment and Disease: Association or Causation?," *Proceedings of the Royal Society of Medicine*, 58 (1965), 295-300; posted at www.edwardtufte.com

The only thing that is 2-dimensional about evidence is the physical flatland of paper and computer screen. Flatlandy technologies of display encourage flatlandy thinking. Reasoning about evidence should not be stuck in 2 dimensions, for the world we seek to understand is profoundly multivariate. Strategies of design should make multivariateness routine, nothing out of the ordinary. To think multivariate, show multivariate; the *Third Principle for the analysis and presentation of data:*

Show multivariate data; that is, show more than 1 or 2 variables.

Principle 4: Integration of Evidence

Minard brings together various modes of information in order to describe troop movements and the war's consequences: a paragraph of words, a map with narrating flow-lines, and a statistical graphic dangling from the map. In particular, at the Niemen River where the invasion began and ended, these modes of information are simultaneously mobilized: the number of troops before and after the campaign, mapped flow-lines moving in 2-space, temperature and dates, and the mocking words describing the Cossack horsemen. Contrast this graceful integration with books where all the images are collected into one big pile, printed and positioned far from their relevant text. Or those awful reports consisting entirely of words, except for all the data tables segregated and appended at the back, in organizational and intellectual disarray. Or computer applications that deal with only one type of information at a time. The evidence doesn't care what it is—whether word, number, image. In reasoning about substantive problems, what matters entirely is the *evidence,* not *particular modes* of evidence.

To integrate word and diagram, Minard uses a light unsaturated tan color to depict the invasion flow-line, which allows the place-names to show through. The tan's transparency has little visual effect on the typography for the place-names inside the flow-line, so those names belong with names *outside* the flowline, maintaining the map's surface

coherence as the army passes over the land.[6] In 20 different figurative maps, Minard uses transparent overlays to combine words, numbers, and flow-maps within a common visual field. Cartographers have long used this technique of layering and separation, which can increase the informational depth of flatland by additional dimensions and possibly by several multiples of data density.

Words, numbers, pictures, diagrams, graphics, charts, tables belong together. Excellent maps, which are the heart and soul of good practices in analytical graphics, routinely integrate words, numbers, line-art, grids, measurement scales. Rarely is a distinction among the different modes of evidence useful for making sound inferences. It is all information after all. Thus the *Fourth Principle for the analysis and presentation of data:*

Completely integrate words, numbers, images, diagrams.

Thus tables of data might be thought of as paragraphs of numbers, tightly integrated with the text for convenience of reading rather than segregated at the back of a report. Most images and tables used in public presentations should be annotated with words explaining what is going on. In exploratory data analysis, however, the integration of evidence needs to be thought through. Perhaps the numbers or data points may stand alone for a while, so we can get a clean look at the data, although techniques of layering and separation may simultaneously allow a clean look as well as bringing other information into the scene.

More generally, the principle of information integration points to a philosophy of inquiry: a broad, pluralistic, problem-directed view of what constitutes the scope of relevant evidence. Too often in scholarly research, in social science at least, there is a certain narrowness in the choice and use of evidence. Thus many investigations of, say, political economy rely exclusively on a *single* mode of evidence: statistical data, or wordy memoirs of policy-makers, or anecdotes, or mathematical models, or metaphor, or economic or political ideology, or newspaper clippings. Research questions are framed along the lines of "How can one type of information or one particular approach be used to explain something?" rather than "How can something be explained?"[7]

Pre-specifying the mode of relevant information or the explanatory method may produce a tendentious misalignment of evidence in relation to substantive matters under investigation. The world to be explained is indifferent to scholarly specialization by type of evidence, methodology, or disciplinary field. A deeper understanding of human behavior may well result from integrating a diversity of evidence, *whatever it takes to explain something.* Like good information displays, explanatory investigations, if they are to be honest and genuine, must seek out and present all relevant evidence regardless of mode.

[6] The text accompanying the map describes the invasion line as *rouge* or red. It appears the line never was red, even when freshly printed in 1869. Although red pigments are degraded by light, Minard's maps are in fact bound in a non-circulating portfolio with no light exposure at the Bibliothèque de l'École Nationale des Ponts et Chaussées. Today the invasion-line color is as exactly as shown in this chapter (confirmed by color control bars in our direct photograph of Minard's original map), with no signs of color fading. In another map by Minard (below), bright red ink has now survived 148 years, again suggesting that today's tan invasion line was not yesterday's *rouge:*

Detail from Charles Joseph Minard, *Carte figurative et approximative des quantités de viandes de boucherie envoyées sur pied par les départements et consommées à Paris,* 1858.

[7] See Donald P. Green and Ian Shapiro, *Pathologies of Rational Choice Theory* (New Haven, 1996). Amusing parodies of *a priori* method-driven approaches are found in C. Wright Mills, *The Sociological Imagination* (New York, 1959) on the social sciences; Frederick C. Crews, *The Pooh Perplex* (New York, 1963) and *Postmodern Pooh* (New York, 2001) on literary criticism; *The Sokal Hoax,* compiled by the editors of *Lingua Franca* (Lincoln, Nebraska, 2000) on literary-sociological studies of science.

Principle 5: Documentation

The credibility of an evidence presentation depends significantly on the quality and integrity of the authors and their data sources. Documentation is an essential mechanism of quality control for displays of evidence. Thus authors must be named, sponsors revealed, their interests and agendas unveiled, sources described, scales labeled, details enumerated. Thorough documentation is a good sign that a report was constructed with at least some care and craft.

Minard documents his data-map of Napoleon's Russian campaign at a level of detail remarkable for 19th-century graphics and in ways appropriate to nearly all visual presentations of information:

What is the display about? losses in men of the French Army in the Russian Campaign 1812–1813.

Who did the work? Drawn up by M. Minard

Who's that? Inspector General of Bridges and Roads in retirement.

Where and when was the work done? Paris, November 20, 1869.

What are the data sources? The information which has served to draw up the map has been extracted from the works of M.M. Thiers, of Ségur, of Fezensac, of Chambray and the unpublished diary of Jacob, the pharmacist of the Army since October 28th.

Any assumptions? In order to better judge with the eye the diminution of the army, I have assumed that the troops of Prince Jérôme and of Marshal Davoust who had been detached at Minsk and Moghilev and have rejoined around Orcha and Vitebsk, had always marched with the army.

What are the scales of measurement?

 for invasion and retreat flow-lines: one millimeter for every ten thousand men

 for the underlying map: Common leagues of France (Map of Fezensac)

 | | | | | | | | |
 | 0 | 5 | 10 | 15 | 20 | 25 | | 50. |

The French "lieue" is of variable length, approximately 2.5 miles or 4 kilometers (historically varying by up to 10%).

 for the temperature: degrees of the Réaumur thermometer below zero

Who published and printed the work? Autog. par Regnier, 8. Pas. S.te Marie S.t G.ain à Paris. Imp. Lith. Regnier et Dourdet.

Publicly attributed authorship indicates to readers that someone is taking responsibility for the analysis; conversely, the absence of names signals an evasion of responsibility. Readers can follow up and communicate with named sources. Also, names may have reputations for credibility — or not.

Authorship credit is too often absent from corporate and government reports; we should remember that *people* do things, not agencies, bureaus, departments, divisions. People may do better work when they receive public acknowledgement and take public responsibility for their work. The good Minard put his name on nearly all his work and personally signed with pen and ink (at right) some of the figurative maps.

Displays should name their data sources. Minard names 5 sources.[8] Information comes from somewhere; the audience should be told where. Undocumented displays are inherently suspect. For example, opaque, vague, and undocumented accounting statements are leading indicators of financial corruption.

Data graphics are data graphics because they have *scales of measurement*. Viewers should be told about measurements. Minard provides 3 scales. Many modern graphics are undocumented: in 13 computer-science books on technical visualizations, only 20% of the published images had complete scales and labels, 60% had *no* scales or labeled dimensions at all.[9] Even in real science, images sometimes forget about measurement scales: the astronomical pictures from the Hubble Space Telescope are usually published without indications of distance, size, or location. In business and financial displays, the common errors and lies involve corrupt measurement scales: absence of labels, undefined or imprecise measurements, tendentiously chosen base-years, excessively short time-series, inflated rather than inflation-adjusted monetary units, and time-shifting of data (such as the notorious premature revenue recognition).

Finally, for many presentations, there are issues of research integrity provoked by financial sponsorship, advocacy position, and potential conflicts of interest. Students of bureaucracy have long noted that where people stand depends upon where they sit. In medical research, the published findings are too often predictably related to the interests of the financial sponsors of the research. To assess the credibility of a report, the audience must know who paid for the study, why they paid for it, and possible conflicts of interest of the authors. High-quality medical journals now require from authors a detailed statement about financial sponsorship and possible conflicts of interest, which is then published along with the research article.[10] Public documentation of sponsorship will not end corrupt presentations, but at least it alerts everyone to possibilities of bias. As J. P. Donleavy said about expecting fair play in high places: "You'll get it if enough folk are watching."[11]

Documentation allows more effective watching, and we have the *Fifth Principle for the analysis and presentation of data:*

> Thoroughly describe the evidence. Provide a detailed title, indicate the authors and sponsors, document the data sources, show complete measurement scales, point out relevant issues.

représentées par des zônes maritimes vertes entre des lignes t dont les largeurs indiquent les tonnages d'après l'Echelle.

Paris, le 14 Juillet 1855.

Ch. Jo. Minard

Detail from *Carte figurative et approximative de céréales qui ont circulé en 1853 sur les voies d'eau et de fer de l'Empire français, 1855.*

[8] Minard provides last names; his 5 sources are very likely Adolphe Thiers, *Histoire du Consulat et de l'Empire* (Paris, 1862); Philippe-Paul de Ségur, *Campagne de Russie, Mémoires d'un Aide de Camp de Napoléon* (Paris,1824); M. de Fezensac, *Journal de la campagne de Russie en 1812* (Paris, 1849) and *Souvenirs militaires* (Paris, 1863); Georges, Marquis de Chambray (anonymously published) *Histoire de l'expedition de Russie* (Paris, 1823); Pierre-Irénée Jacob's long unpublished journal, which eventually appeared in *Revue d'Histoire de la Pharmacie,* XVIII (1966), numbers 189-191.

[9] Data in Edward Tufte, *Visual Explanations* (Cheshire, Connecticut, 1997), 21-25.

[10] For example, this statement below from Wayne A. Ray, *et al.,* "cox-2 selective non-steroidal anti-inflammatory drugs and risk of serious coronary heart disease," *The Lancet,* 360 (October 5, 2002), 1073:

Contributors
W. A. Ray, M. R. Griffin, C. M. Stein, and P. G. Arbogast designed the study and wrote the protocol. W. A. Ray and P. G. Arbogast did statistical analyses. J. R. Daugherty and K. Hall contributed to the protocol and computer programming. W. A. Ray wrote the initial draft of the report, then revised by M. R. Griffin, C. M. Stein, and P. G. Arbogast.

Conflict of interest statement
W. A. Ray has worked as a consultant for Merck Research Laboratories within the past 3 years, but not within the past year. M. R. Griffin is a consultant for Merck. No funding for this study was provided by any pharmaceutical company.

Acknowledgments
The work was supported in part by the Agency for Healthcare Research and Quality, Center for Education and Research on Therapeutics cooperative agreement (grant HS1-0384), US Public Health Service grant HL 67964, and a cooperative agreement with the Food and Drug Administration (FD-U-001641). Study sponsors had no role in study design, data collection and analysis, interpretation, or writing the report.

[11] J. P. Donleavy, *The Unexpurgated Code: A Complete Manual of Survival and Manners* (New York, 1975), 279.

Principle 6: Content Counts Most of All

How Charles Joseph Minard (1781-1870) came to construct the map of the French invasion of Russia tells us about the spirit behind one of the best graphics ever. Minard was a renowned engineer, who managed large public works projects and designed bridges, canals, docks, and roads. He had the technical skills to construct good data graphics; he could draw and see and count all at a high level; he had developed the flow-map, an architecture exactly right for depicting losses in military campaigns. But at the heart of the work was Minard's passion about the substantive content.

At age 70 Minard retired from engineering. During the next 18 years, he produced 50 maps depicting statistical data describing spatial flows and distributions of French wine, ancient languages, railroads, cotton, migration, and the military strategies of Charlemagne and Napoleon. These "figurative maps" represent Minard's substantial contribution to the practice and theory of analytical graphics.[12]

In November 1869 at age 88, Minard published his last figurative map, the extraordinary 2-color lithograph at right. Two maps are printed on a poster-sized piece of paper. Both maps have the same theme, human losses in war. The upper map recounts the diminishing army of Hannibal and his elephants wandering around the Alps into northern Italy 2,200 years ago. This account of Hannibal's unhappy adventure makes comparisons over space and time with a narrative flow-line, uses multivariate data, has a north-arrow (documentation that should appear on every map), and indicates data sources. But this story lacks the narrative power of the Russian invasion map.

Minard had seen the horrors of war. Several of his public works projects had repaired wartime destruction. Then, while planning and managing construction in 1813, he was confined in besieged Antwerp:

> Minard always retained a sharp impression of some bloody episodes of the bombardment; and these are some memories which had made him leave Paris last year at the approach of the Prussians.[13]

Minard's last work is an anti-war poster. A memoir by his son-in-law, Minard's only biographer, describes the map of Napoleon's invasion:

> He emphasized the losses of men which had been caused by two grand captains, Hannibal and Napoleon 1st, the one in his expedition across Spain, Gaul, and Italy, the other in the fatal Russian campaign. The armies in their march are represented as currents which, broad initially, become successively thinner. The army of Hannibal shrunk from 96,000 men to 26,000, and our grand army from 422,000 combatants to only 10,000. The image is gripping; and, especially today, it inspires bitter reflections on the cost to humanity of the madnesses of conquerors and the merciless thirst for military glory.[14]

[12] Minard's work is catalogued in Arthur H. Robinson, "The Thematic Maps of Charles Joseph Minard," *Imago Mundi*, 21 (1967), 95-108; Gilles Palsky, *Des chiffres et des cartes: Naissance et développment de la cartographie quantitative française au XIXe siècle* (Paris, 1996); and Michael Friendly, "The Graphic Works of Charles Joseph Minard," posted on the internet. Reproductions of Minard's maps and other graphics are in Arthur H. Robinson, *Early Thematic Mapping in the History of Cartography* (Chicago, 1982); Edward Tufte, *The Visual Display of Quantitative Information* (Cheshire, Connecticut, 1983, 2001); and Gilles Palsky, *Des chiffres et des cartes . . .* (Paris, 1996).

[13] V. Chevallier, "Notice nécrologique sur M. Minard, inspecteur général des ponts et chaussées, en retraite," *Annales des ponts et chaussées*, 2 (1871), 1-22, quotation at 6-7. Translation by Dawn Finley. A translation of this 22-page biography of Minard at www.edwardtufte.com.

[14] V. Chevallier, "Notice nécrologique sur M. Minard. . .," 17-18.

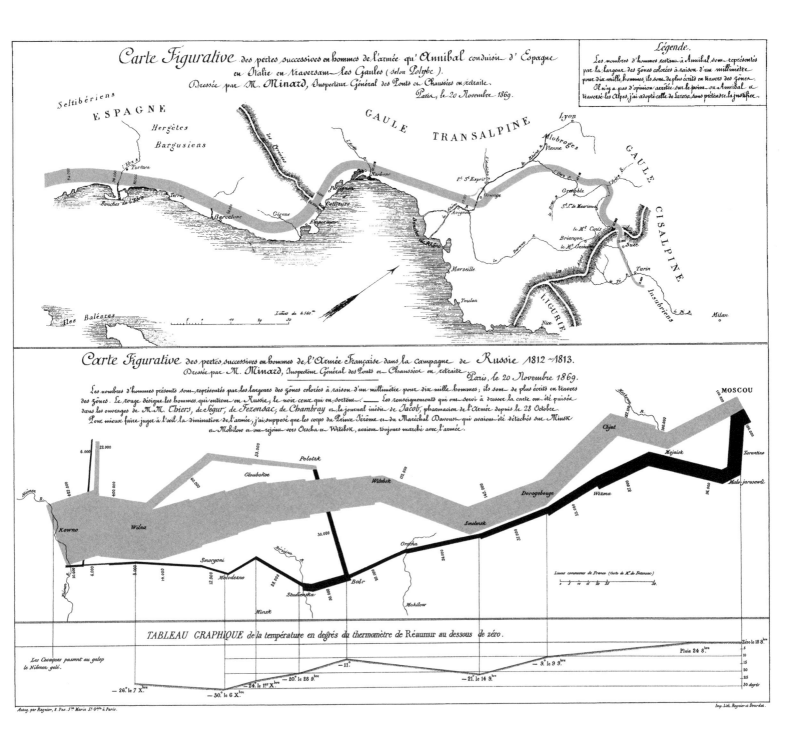

Charles Joseph Minard, *Tableaux Graphiques
et Cartes Figuratives de M. Minard, 1845-1869,*
item 28 in a portfolio of Minard's statistical
maps at the Bibliothèque de l'École Nationale
des Ponts et Chaussées, Paris. 62 × 54 cm,
or 25 × 21 in, redrawn.

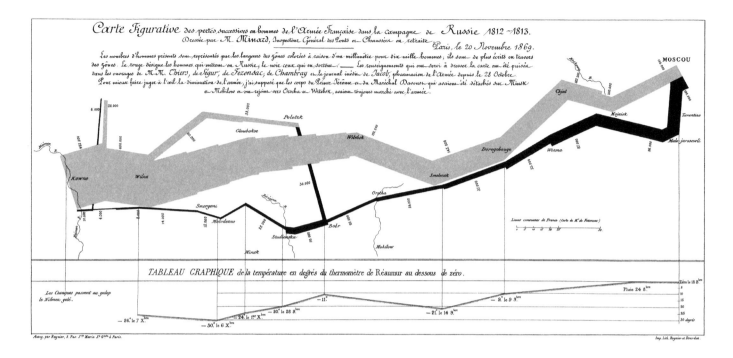

Minard's focus on the human costs of war is subtly reinforced by his choice of content. *Minard never mentions Napoleon.* That the word "Napoleon" does not appear on the map of Napoleon's march indicates here at least full attention is to be given to memorializing the dead soldiers rather than celebrating the surviving celebrity.

Minard's work exemplifies the spirit behind excellent analytical graphics: a good knowledge of the content and a deep caring about the substance. *The Sixth Principle for the analysis and display of data:*

> Analytical presentations ultimately stand or fall depending
> on the quality, relevance, and integrity of their content.

This suggests that the most effective way to improve a presentation is to get better content. It also suggests that design devices and gimmicks cannot salvage failed content.

The content principle points to priorities in analytical design work: this is a content-driven craft, to be evaluated by its success in assisting thinking about the substance. Thus the first questions in constructing analytical displays are not "How can this presentation use the color purple?" Not "How large must the logotype be?" Not "How can this presentation use the Interactive Virtual Cyberspace Protocol Display Technology?" Not decoration, not production technology. The first question is *What are the content-reasoning tasks that this display is supposed to help with?* Answering this question will suggest choices for content elements, design architectures, and presentation technologies.

Relevance of Principles of Analytical Design

THE purpose of an evidence presentation is to assist thinking. Thus presentations should be constructed so as to assist with the fundamental intellectual tasks in reasoning about evidence: describing the data, making multivariate comparisons, understanding causality, integrating a diversity of evidence, and documenting the analysis. Thus the Grand Principle of analytical design: *The principles of analytical design are derived from the principles of analytical thinking.* Cognitive tasks are turned into principles of evidence presentation and design.

If the intellectual task is to make comparisons, as it is in nearly all data analysis, then "Show comparisons" is the design principle. If the intellectual task is to understand causality, then the design principle is to use architectures and data elements that show causality. The Grand Principle helps answer the most difficult question of all in the theory of analytical design: *How are principles of design derived?*

THE fundamental principles of analytical design apply broadly, and are indifferent to language or culture or century or the technology of information display. Nearly everyone everywhere, one way or another, reasons about causality, makes comparisons, navigates through 3-space and time. The principles are applicable to the design of the first map scratched into stone 6,000 years ago, and also to modern scientific displays. On both that stone and that computer screen, it is necessary to escape the flatland surface to compare multivariate data, to integrate and document evidence, to reason about dynamics, mechanism, causality.

No doubt these intellectual tasks and their consequent design principles have a grander universality: if we ever see the analytical presentations of intelligent beings from other planetary systems, those designs will make multivariate causal comparisons. Competence in these fundamental intellectual tasks is what it takes for sentient and communicating beings to survive, thrive, and evolve in a world governed by the universal laws of Nature — for the character of Nature's laws is that they are causal, operate at every multivariate space-time point, reveal themselves by difference and comparison, and, indeed, are utterly indifferent to what particular sentient beings think about those laws. The unique universal character of physical laws provokes certain universal analytical tasks, here turned into the principles for the presentation of evidence.

Because these principles are rooted in fundamental cognitive tasks, they are relevant for *producing presentations* and for *consuming presentations*. Thus consumers of evidence presentations should look for appropriate comparisons, assessments of causality, multivariateness, use of relevant data, credible documentation, content-reasoning. There is a symmetry of thinking in the wise production and the wise consumption of evidence. At a good evidence presentation, we're all in it together.

What about analytical displays of evidence involving *human behavior,* often so distant from any kind of lawlike understanding? Social science lacks the wonderfully convenient simplifying guarantee of the physical sciences that empirical observations are always somehow the expression of knowable invariant laws that operate at every space-time point. Lacking this mind-focusing guarantee, the study of human behavior is sometimes overwhelmed with multivariate uncertainties about causality, as analysis of after-the-fact historical patterns yields loose, fragile, poorly resolved explanations. Consider medical research seeking to identify successful treatments, a field advantaged by a wealth of resources and rewards, by clear explanatory goals, by the capacity to conduct randomized controlled experiments, and by a basis in universal physical laws. Even with such advantages, the substantive results in medical research tend toward the marginal and unsatisfying ("21% of the treatment group survived compared to 15% of the controls") rather than the certain ("this treatment always produces a cure").

Indeed, perhaps the single most important finding of social science— the unanticipated consequences of human action—is a finding about the impediments in predicting consequences of human behavior.[15] Such uncertainty is epidemic because people can act on the basis of knowledge about patterns of human behavior, and thereby modify (uncertainly, to be sure) those patterns. Many investigations of human activities seek to unveil particular historical experiences in order to alter, avoid, or continue those experiences in the future. Thus the hope of Minard in making his anti-war poster.

Compared to evidence presentations about *nature* (physical science), presentations about *human behavior* (medicine and social science) are more descriptive, more verbal, less visual, less quantitative. For example, the physical and biological sciences publish statistical graphics that depict a median > 1,000 numbers (data for *Nature* and *Science,* 2006). In contrast, for applied research in medicine, statistical displays show an average 45 numbers per graphic (data for *The Lancet,* 2006). Also evidence published in major scientific journals such as *Nature* and *Science* is distinctly more visual and nonverbal than the evidence published in major journals in medicine and social science.

Despite such differences in modes of evidence and in explanatory style, physical science and studies of human behavior share some key underlying explanatory and intellectual patterns. To this point, the editor-compiler of 1,045 grand summary findings about human behavior that had some reasonable supporting evidence offered a threefold grander summary of social science knowledge:

> (1) Some do, some don't.
>
> (2) The differences aren't very great.
>
> (3) It's more complicated than that.[16]

[15] Robert K. Merton, "The Unanticipated Consequences of Social Action," *American Sociological Review,* 1 (December 1936), 894-904.

[16] Bernard Berelson, "Citation Classic: Bernard Berelson and Gary Steiner, *Human Behavior: An Inventory of Scientific Findings* (New York, 1964)," in Neil J. Smelser, ed., *Contemporary Classics in the Social and Behavioral Sciences* (Philadelphia, 1987), 335.

These summary statements reflect the universal analytic issues of (1) causality, (2) comparison, and (3) multivariate complexity. Human activities, after all, take place in intensely comparative and multivariate contexts filled with causal ideas: intervention, purpose, responsibility, consequence, explanation, intention, action, prevention, diagnosis, strategy, decision, influence, planning. Thus the fundamental principles of analytical design are relevant for displays of evidence describing human behavior, as we have seen in Minard's *French Invasion of Russia*.

It is a principle that shines impartially on the just and the unjust that once you have a point of view all history will back you up.

Van Wyck Brooks, *America's Coming-of-Age* (New York, 1915), 20.

The rage for wanting to conclude is one of the most deadly and most fruitless manias to befall humanity. Each religion and each philosophy has pretended to have God to itself, to measure the infinite, and to know the recipe for happiness. What arrogance and what nonsense! I see, to the contrary, that the greatest geniuses and the greatest works have never concluded.

Gustave Flaubert, *Correspondance* (Paris, 1929), vol. v, 111.

[The anthropological idea of "culture" is] so diffuse and all-embracing as to seem like an all-seasons explanation for anything human beings might contrive to do, imagine, say, be, or believe. . . . We were condemned, it seemed, to working with a logic and a language in which concept, cause, form, and outcome had the same name.

Clifford Geertz, *Available Light* (Princeton, 2000), 12–13.

Words strain,
Crack and sometimes break, under the burden,
Under the tension, slip, slide, perish,
Decay with imprecision, will not stay in place,
Will not stay still.

T. S. Eliot, "Burnt Norton," *Four Quartets* (London, 1943).

First you establish the traditional "two views" of the question. You then put forward a common-sensical justification of the one, only to refute it by the other. Finally, you send them both packing by the use of a third interpretation, in which both the others are shown to be equally unsatisfactory. Certain verbal maneuvers enable you to line up the traditional "antitheses" as complementary aspects of a single reality: form and substance, content and container, appearance and reality, essence and existence, continuity and discontinuity, and so on. Before long the exercise becomes the merest verbalizing, reflection gives place to a kind of superior punning, and the "accomplished philosopher" may be recognized by the ingenuity with which he makes ever-bolder play with assonance, ambiguity, and the use of those words which sound alike and yet bear quite different meanings.

Claude Lévi-Strauss, *Tristes Tropiques* (Paris, 1955; London, 1961), 54.

Corruption in Evidence Presentations: Effects Without Causes, Cherry-Picking, Overreaching, Chartjunk, and the Rage to Conclude

MAKING a presentation is a moral act as well as an intellectual activity. The use of corrupt manipulations and blatant rhetorical ploys in a report or presentation—outright lying, flagwaving, personal attacks, setting up phony alternatives, misdirection, jargon-mongering, evading key issues, feigning disinterested objectivity, willful misunderstanding of other points of view—suggests that the presenter lacks both credibility and evidence. To maintain standards of quality, relevance, and integrity for evidence, consumers of presentations should insist that presenters be held intellectually and ethically responsible for what they show and tell. Thus *consuming* a presentation is also an intellectual and a moral activity.

THESE 2 chapters describe widely used presentation methods that are enemies of the truth, that corrupt reasoning, that produce unbeautiful anti-evidence. Rather than blatant, the methods described are subtle, the more dangerous for being so. These maneuvers often distort evidence, deceive the audience, and exploit the bond of trust necessary for reliable and intelligent communication.

CORRUPT maneuvers, blatant or subtle, are epidemic in political speeches, marketing, internet rants, and PowerPoint pitches. Less often, perhaps, corruptions of reasoning and evidence show up in serious presentations: our examples in these 2 chapters include strategic plans in business, a report of a presidential commission, economics, engineering analysis during a crisis, certain data analysis techniques, public health, medical research, and social science.

DESPITE the threat of corruption, a consumer of presentations should try to be hopeful and curious, avoid premature skepticism, and maintain an open mind but not an empty head. After all, many presentations are not corrupt. Furthermore, a presenter engaging in corrupt maneuvers might be reporting what eventually turn out to be accurate and truthful conclusions. A particular danger, then, of corrupt maneuvers is not only that they enable lying but also that they place the truth in disrepute. From scientific reports to political speeches, few things are more appalling than listening to inept and specious arguments made by one's allies.

Effects Without Causes and The Evasion of Responsibility

The *Report* of the 9/11 Commission describes major lapses in security and missed opportunities that may have allowed the attacks to take place:

> [Despite the CIA's numerous warnings, America's] domestic agencies never mobilized in response to the threat. They did not have direction, and did not have a plan to institute. The borders were not hardened. Transportation systems were not fortified. Electronic surveillance was not targeted against a domestic threat. State and local law enforcement were not marshaled to augment the FBI's efforts. The public was not warned.[1]

Here and elsewhere in the *Report*, conspicuously absent is the agent of inaction. Above, 5 verbs are passive. The 3 active verbs take the utterly vague subject "domestic agencies." Exactly *who* did not make a plan, *who* did not follow up, *who* failed to warn the public? "These things that were not done must have been not done by somebody, and the somebodies reporting to him."[2] By means of the passive voice, the 9/11 Commission evades attributing responsibility for security lapses. Of course, if the passive didn't exist, they would have done it some other way.

Although often a useful writing technique, passive verbs also advance *effects without causes*, an immaculate conception. To speak of ends without means, agency without agents, actions without actors is contrary to clear thinking. If the issues at hand involve responsibilities or decisions or plans, causal reasoning is necessary. The logic of decisions is "If we do such-and-such [cause], then we hope this-and-that will happen [desired effect]." And the logic of responsibility is the logic of the active voice: *someone did* or *did not do* something. Alert audiences should watch out for causality from nowhere and its sometime assistant, the passive voice.

The technique of evasion by passive voice is well-known and widely noted—and yet some reviewers of *The 9/11 Commission Report* failed to detect its overt evasive deflections of responsibility. What is obvious, and perhaps even tiresome to the sophisticated, is not so obvious in serious action. Why should we fail to be vigilant and rigorous about the quality of evidence and its presentation just because a report is part of a public dialogue, or is meant for the news media, or is from the government, or concerns an important matter?

WHAT the passive voice can be for verbal reasoning, certain statistical methods are for data reasoning: anti-causal, a jumble of effects without causes. In particular, the methodologies of *data mining, factor analysis,* and *multidimensional scaling* crunch and grind vast data matrices down into smaller lumps. These methodologies, however, fail to testify about causal models. Such techniques are perhaps useful for those who have lots of data but no ideas, to those otherwise clueless about causality. To be relevant for decisions and actions, whatever emerges from data crunching must somehow turn into real evidence about causal processes.

[1] *The 9/11 Commission Report: Final Report of the National Commission on Terrorist Attacks Upon the United States* (New York, 2004), 265.

[2] Thomas Powers, "How Bush Got It Wrong," *The New York Review of Books*, 60 (September 23, 2004), 87.

LIKE the passive voice, the *bullet-list format* collaborates with evasive presenters to promote effects without causes, as in the fragmented generic points of cheerleading strategic plans and the dreaded mission statement:

★ *Accelerate The Introduction Of New Products!!!*
★ *Accelerate Revenue Recognition!!!*

Better to say *who* will accelerate, and *what, how, when,* and *where* they will accelerate. An effective methodology for making such statements is the *sentence*, with subjects and predicates, nouns and verbs, agents and their effects. Identifying specific agents of action may also eventually help forensic accountants and prosecutors target those responsible for excessively accelerated recognition of revenue.

In presentations of plans, schemes, and strategies, bullet outlines get all confused even about simple, one-way causal models. Here, from the *Harvard Business Review,* a deep analysis of bullets for business plans:

> Bullets leave critical assumptions about how the business works unstated. Consider these major objectives from a standard five-year strategic plan
>
> - Increase market share by 25%.
> - Increase profits by 30%.
> - Increase new-product introductions to ten a year.
>
> Implicit in this plan is a complex but unexplained vision of the organization, the market, and the customer. However, we cannot extrapolate that vision from the bullet list. The plan does not tell us how these objectives tie together and, in fact, many radically different strategies could be represented by these three simple points. Does improved marketing increase market share, which results in increased profits (perhaps from economies of scale), thus providing funds for increased new-product development?
>
> Market share ⟶ Profits ⟶ New-product development
>
> Or maybe new-product development will result in both increased profits and market share at once:
>
> New-product development ⟶ Market share
> ⟶ Profits
>
> Alternatively, perhaps windfall profits will let us just buy market share by stepping up advertising and new-product development:
>
> Profits ⟶ New-product development ⟶ Market share.[3]

[3] Gordon Shaw, Robert Brown, Philip Bromiley, "Strategic Stories: How 3M is Rewriting Business Planning," *Harvard Business Review*, 76 (May-June, 1998), 44.

It follows that more complex and realistic multivariate causal models are way over the head of the simplistic bullet-list format.

To identify and critique assertions of effects without causes, consumers of presentations should sketch out the causal models lurking within the analysis, assess how the evidence links up to the theories, draw diagrams with arrows, label alleged causes and effects, contemplate the meaning of arrows, and do what the presenter should have done in the first place.

Cherry-Picking, Evidence Selection, Culled Data

THE most widespread and serious obstacle to learning the truth from an evidence-based report is *cherry-picking,* as presenters pick and choose, select and reveal only the evidence that advances their point of view. "It is a principle that shines impartially on the just and unjust that once you have a point of view all history will back you up."[4]

Few presenters are saintly enough to provide their audience with competing explanations, contrary evidence, or an accounting of the full pool of evidence tapped to construct the presentation. But thoughtful presenters might at least privately test their analysis: *Has evidence been filtered or culled in a biased manner? Do the findings grow from evidence or from evidence selection? Would the findings survive the scrutiny of a skeptic or investigator of research fraud? What would Richard Feynman think?* Such questions may help presenters get it right before enthusiasm for their own work takes over. To avoid being fooled, consumers of presentations must ask these questions as well.

It is idle, however, for skeptics to claim that the evidence presented in a report has been selected. Of course there is more evidence than that published. The key issue is whether evidence selection has compromised the true account—if we only knew what it was—of the underlying data.

A CLEAR sign of cherry-picking is that a report appears *too good to be true,* provoking consumers of the report to mutter "*It's more complicated than that.*" But unless the back-office operations in preparing a report are known, it is difficult to identify the specific effects of evidence selection for any *single* report. A *series* of reports, however, can decisively reveal corrupt practices. It is perhaps merely a happy coincidence when the reported quarterly earnings for one corporation exceed its forecasted earnings by exactly one penny; but if this miracle occurs in 20% of all corporations, it is a sign of systematic manipulation of financial data.[5]

In medical research, too often the *first published study* testing a new treatment provides the *strongest evidence that will ever be found* for that treatment. As better controlled studies—less vulnerable to the enthusiasms of researchers and their sponsors—are then conducted, the treatment's reported efficacy declines. Years after the initial study, as the Evidence Decay Cycle plays out, sometimes the only remaining issue is whether the treatment is in fact harmful. Lack of disciplined comparisons, which gives free play to cherry-picking, erodes the credibility of early reports of enthusiasts, no matter how authoritative their sales pitch:

> One day when I was a junior medical student, a very important Boston surgeon visited the school and delivered a great treatise on a large number of patients who had undergone successful operations for vascular reconstruction. At the end of the lecture, a young student at the back of the room timidly asked, "Do you have any controls?" Well, the great surgeon drew himself

[4] Van Wyck Brooks, *America's Coming-of-Age* (New York, 1915), 20. Or, as Nero Wolfe remarks, "Once the fabric is woven it may be embellished at will." Rex Stout, *The Golden Spiders* (New York, 1955), 85.

[5] The distribution of published test statistics over a *series* of papers may reveal culling of evidence. Consider a research issue between those who believe there is no relationship between 2 variables (call this hypothesis H_0) and those who believe there is a relationship (H_A). Advocates of H_0 and H_A gather data, run many multiple regressions, and examine the *t*-statistics on the relevant regression coefficients. Both schools of advocates seek to publish decisive results; and both seek to avoid ambiguous results. Such advocacy may lead to evidence selection, resulting in a peculiar distribution of all published test statistics: a heaping of results that strongly favor *either* H_0 *or* H_A, and *fewer* results in the dreaded *Zone of Boredom, Ambiguity, and Unpublishability,* the zone of non-results. For *t*-tests on regression coefficients, the ZBAU values fall between 1.6 to 2.0, where the choice between H_0 and H_A is a close call. For my book *Political Control of the Economy* (Princeton, 1978), I compiled the distribution of the 248 published *t*-statistics from all 17 of the then-published studies of election year macroeconomic conditions and the U.S. national vote for the political party of the incumbent president. Both the H_0 and the H_A heapings, as well as the *Zone of Boredom, Ambiguity, and Unpublishability,* are seen below in the distribution of *published* *t*-statistics:

values of published *t*-statistics for 248 regression coefficients in all 17 published studies of economic conditions and election outcomes

CORRUPT TECHNIQUES IN EVIDENCE PRESENTATIONS 145

up to his full height, hit the desk, and said, "Do you mean did I not operate on half of the patients?" The hall grew very quiet then. The voice at the back of the room very hesitantly replied, "Yes, that's what I had in mind." Then the visitor's fist really came down as he thundered, "Of course not. That would have doomed half of them to their death." God, it was quiet then, and one could scarcely hear the small voice ask, "Which half?"[6]

[6] Dr. E. E. Peacock, Jr., University of Arizona College of Medicine; quoted in *Medical World News* (September 1, 1972), 45.

THOMAS CHALMERS, a founder of evidence-based medicine, repeatedly demonstrated that the more susceptible a research design is to evidence selection and bias, the more enthusiastic the evidence becomes for favored treatments. For example, Chalmers and colleagues examined 53 published reports evaluating a surgical procedure, a portcaval shunt for esophageal bleeding.[7] All studies were rated on (1) *enthusiasm* of the findings for the surgery, (2) *quality of the research design* (good design = random assignment of patients to treatment or control groups; bad = treatment group not compared with any proper control). The gold standard of research designs is the randomized controlled trial (RCT), which assigns patients randomly to the treatment or the control group (assuring within chance limits that both groups are identical in all respects, known and unknown, thereby avoiding, for example, selection of more promising patients to favored treatments). Of the 53 published studies, only 6 were well-designed (RCT). And their findings were clear: none of the 6 well-designed studies were markedly enthusiastic about the operation:

[7] N. D. Grace, H. Muench, T. C. Chalmers, "The Present Status of Shunts for Portal Hypertension in Cirrhosis," *Gastroenterology* 50 (1966), 684-691; table shown here as updated by Chalmers in John P. Gilbert, Richard J. Light, and Frederick Mosteller, "How Well Do Social Innovations Work?" in Judith Tanur, *et al., Statistics: A Guide to the Unknown* (San Francisco, 1978), 135.

Quality of research design versus degree of investigator enthusiasm for the portcaval shunt surgical procedure, 53 published studies

	MARKED ENTHUSIASM	MODERATE ENTHUSIASM	NO ENTHUSIASM
RESULTS OF 6 WELL-DESIGNED (RCT) STUDIES:	0	3	3
RESULTS OF 47 POORLY DESIGNED STUDIES:	34	10	3

In contrast, for 47 studies lacking valid controls, 34 expressed marked enthusiasm for the surgery. Thus 72% (34 of 47) of the poorly controlled studies got it wrong, endorsing a surgical procedure unwarranted by the RCT gold standard. This link between lousy research designs and wrongly enthusiastic reports has been replicated again and again for all too many drugs and surgical procedures (some eventually abandoned thanks to the meta-analysis of evidence similar to the table above).

Loosely designed studies allow the underlying medical reality to be filtered and cherry-picked so as to reliably produce unreliable evidence for favored treatments. Discovery of this persistent bias led to regulatory and scientific standards requiring that research on medical treatments use randomized controlled trials. These requirements, alas, have in turn fostered imaginative new methods for cherry-picking the data of medical research in favor of good news.[8]

[8] An-Wen Chan, Asbjørn Hróbjartsson, Mette T. Haahr, Peter C. Gøtzsche, Douglas G. Altman, "Empirical Evidence for Selective Reporting of Outcomes in Randomized Trials: Comparison of Protocols to Published Articles," *Journal of the American Medical Association*, 291 (May 26, 2004), 2457-2465.

Controlled trials are *prospective:* a possible cause-effect relationship is identified, an intervention made, future outcomes observed. In contrast, evidence for many phenomena—weather, politics, geology, economics, art history, business—largely comes from *retrospective,* nonexperimental observation. In such after-the-fact studies, researchers and presenters have a good many opportunities to decide *what counts as relevant evidence,* which are also terrific opportunities for cherry-picking.

Consider a standard methodology in economics, finance, and political economy: explanations are empirically generated or perhaps evaluated by means of fitted models. Such multiple regression analyses of historical data seek to account for the past and to predict the future. In theory, perfectly reasonable; in practice, these efforts may be compromised by a certain slackness of theory and method:

(1) *Imprecise theories* Some theories suggest what variables might be related. But the theories tend to be vague and broad, hinting at perhaps 5 to 10 relevant effects, and 5 to 100 candidate causal variables.

(2) *Many "notions"* Researchers hold a variety of sub-theoretical ideas, or notions, that are employed in the course of data analysis: trying out variables not explicitly justified by the theory; excluding part of the data or mixing in *ad hoc* dummy variables to re-estimate the model; taking logarithms and other transforms; fitting innumerable lag structures to time-series. Researchers may have 5 to 100 notion options available.

(3) *Many different operational measures for the same concept* Consider the variety of plausible empirical measures of economic growth, social status, cultural norms, educational achievement, political competition.

(4) *Data slack* In conducting data analysis, researchers decide many details: treatment of missing data, reconciliation of discrepant sources, construction of classifications, choice of the beginning/ending points in time-series (a notorious cheat in financial data), choice of category cut-points, and so on. Not all these decisions are necessarily made innocent of the favored result, and a few small tilts in the same direction soon add up to a finding.[9]

All told, many plausible models result. For k explanatory variables, there are $2^k - 1$ possible fitted models, then multiplied by notions and on through the rest of the slack. Routinely 10^4 to 10^7 fitted models are available; all can be quickly computed and sorted over. These models are not independent and many look pretty much alike, but which few to publish from millions of possibilities? This latitude for evidence selection makes it difficult to distinguish between reliable findings and cherry-pickings. Now and then it may matter.

Such model-searching might find something new and true. Or merely something brittle and over-fitted, a model that collapses when used for prediction.[10] Found models (possibly from among millions searched) must be replicated afresh on innocent data—for how can models produced

[9] "Exercising the right of occasional suppression and slight modification, it is truly absurd to see how plastic a limited number of observations become in the hands of men with preconceived ideas." Francis Galton, *Meteorographica* (London, 1863), 5.

[10] C. M. Bishop's diagram mocks a fussy over-fitted model (the red line) wandering around the data space picking up every little piece of stray variation. Built on the quicksand of idiosyncratic and random variation rather than the rock of predictive causal theory, over-fitted models shrink when applied to new data. Indeed, the decline in explained variance for a found model compared with that model applied to new data is appropriately called, in the jargon of model-building, "shrinkage".

by massive searches then be confirmed by reference to the same material? This circularity of stale testing of cherry-picked data-generated models leaves researchers and their findings no more secure than Ignorance's justification for hope in *The Pilgrim's Progress*:

> Ignorance: But my heart and life agree together, and therefore my
> hope is well grounded.
>
> Christian: Who told thee that thy heart and life agree together?
>
> Ignorance: My heart tells me so.[11]

[11] John Bunyan, *The Pilgrim's Progress* (1678), chapter 15.

Credible explanations grow from the combined testimony of 3 more or less independent, mutually reinforcing sources—explanatory theory, empirical evidence, and rejection of competing alternative explanations. Cherry-picking dilutes and confounds these 3 sources into the wishful circular thinking and just-so stories of Ignorance.

BETWEEN the initial data collection and the final published report falls the shadow of the *evidence reduction, construction, and representation process:* data are selected, sorted, edited, summarized, massaged, and arranged into published graphs, diagrams, images, charts, tables, numbers, words. In this sequence of representation, a report represents some data which represents the physical world:

raw data: observations, measurements	→	evidence reduction, construction, and representation	→	the report or presentation: findings represented by graphs, tables, diagrams, images, numbers, words

This process of evidence construction and representation, though not a black box but certainly a gray area, consists of all the decisions that *cause* the published findings of a report. These decisions are made, to varying degrees, both in the spirit of doing analytical detective work to discover what is going on *and* in the spirit of advancing a favored point of view. Thus the integrity of a report depends in part on the *integrity of the process* of evidence construction; alert consumers of a report must seek some kind of assurance that the process was sensible and honest.[12]

Given the persistent threat of cherry-picking and aggressive advocacy, consumers of reports and presentations might well ask: *Do the report's findings grow from the evidence or from the process of evidence construction? Would that process survive the scrutiny of a research audit? Does the presenter have a reputation for cherry-picking? Is the particular field of inquiry notorious for advocacy and evidence corruption (investment analysis, land development, new drug research, sales reports)? Are the findings too good to be true? Have the report's findings been independently replicated? How much does the decision to be made depend on the evidence in the report at hand? Who paid for the work?*

[12] John Ioannidis, "Why Most Published Research Findings Are False," *Public Library of Science,* 2 (August 2005), e124, a paper with a distinctly provocative title, suggests that in medical research: "A research finding is less likely to be true when the studies conducted in a field are smaller; when effect sizes are smaller; when there is a greater number and lesser preselection of tested relationships; where there is greater flexibility in designs, definitions, outcomes, and analytical modes; when there is greater financial and other interest and prejudice; and when more teams are involved in a scientific field in chase of statistical significance." Ioannidis's collection of references provides a summary of the considerable evidence on evidence corruption.

Punning, Overreaching, and Economisting

The book *Painting Outside the Lines: Patterns of Creativity in Modern Art* by David Galenson begins with an intellectual history of the work, disarmingly written in the first-person singular with 35 self-references in the first 2 pages. At right, the second page of the introduction. In the first paragraph here, *value* clearly refers not to merits but to *prices* of paintings, as art dealers, market transactions, and results of art auctions are mentioned. Described is a 2-variable study: the *price* of a painting in relation to the *age* of the artist when the painting was made. Fair enough, but why should anyone care about this correlation? Thus the key problem of the preface: can what might appear to be dustbowl empiricism be parlayed into an interesting book? And, if interesting, true?

Subtle shifts in language broaden the study's conceptual scope, although the underlying evidence remains unchanged. The word *value* migrates into the comparative, as high-priced paintings are described as the "most valuable work" of an artist. This comes close to a pun, since the dictionary meanings of *valuable* are (1) monetary worth and (2) meritorious, admirable, esteemed qualities. The paragraph's final sentence completes the punning equation, as a rhetorical maneuver turns auction prices into "*importance* of artistic work" via the intermediate term of "most valuable work."

The intermediate link "most valuable work" now blithely converts auction prices into a measure of "best work" of an artist. Views on this matter differ. "The present commercialization of the art world, at its top end, is a cultural obscenity," said Robert Hughes, an expert on art and art markets, "When you have the super-rich paying for an immature Rose Period Picasso $104 million [in 2004], close to the GNP of some Caribbean or African states, something is rotten. Such gestures do no honor to art; they debase it making the desire for it pathological." Can rarely-auctioned paintings be understood as commodities? Perhaps the auction price for a painting also reflects previous prices (statistically adjusted for inflation), trends in economic conditions, varying fashions for artists, dealer and auction-house marketing, commission price-fixing, changes in the number of customers for pricey art, provenance of paintings, and gullibility of art-collecting *nouveau riche* adjusted for trendy. Variations in auction prices result in part from distinctive characteristics of art markets (see, for example, 2 recent books: Meryle Secrest, *Duveen: A Life in Art* and Christopher Mason, *The Art of the Steal: Inside the Sotheby's-Christie's Auction House Scandal*).

But wait: the book is also about the life cycle of *artistic productivity*, measured in part by . . . *auction prices*. There's more: auction prices help explain how *artists think and work*. Just imagine that. How does today's price at Christie's or Sotheby's explain how Cézanne "planned and executed his work" 120 years ago? Backward run the inferences until reels the mind.

Since my college course I had r[...]
spring of 1997, in talking with seve[...]
the value of a particular contemp[...]
course of his career. Wondering h[...]
find out systematically, in much t[...]
my earlier work: I could use mar[...]
tions—to estimate the relationship[...]
and the artist's age at the time of th[...]
mer I collected the appropriate da[...]
prominent American painters of t[...]
and their successors.

The results were startling. T[...]
Mark Rothko, and the other Abstr[...]
done late in their careers, but just[...]
ert Rauschenberg, and the other ma[...]
emphasis of my college course on [...]
and Stella had therefore not been [...]
generation almost all produced th[...]

Curious whether these results w[...]
1960s, I then made a similar study[...]
who dominated the first century of [...]
evidence of a shift over time. Mod[...]
cluding Manet and Cézanne, norm[...]
in their careers, but the leading arti[...]
Gauguin and van Gogh through Pi[...]
work when they were much young[...]

This book presents the results[...]
tween age and productivity, toget[...]
those results and consideration of so[...]
research, I found the same exciteme[...]
patterns in the history of art that I h[...]
problems in economic and social hi[...]
of quantitative analysis, whether [...]
could lead to accurate predictions ab[...]
their enterprise as artists, and ev[...]
executing their work. But I was also [...]
art historians have neglected quanti[...]
work can offer new insights into t[...]
adds another dimension to existi[...]

Above, David Galenson, *Painting Outside the Lines: Patterns of Creativity in Modern Art* (Cambridge, Massachusetts, 2001), xiv. Quotation at left: Robert Hughes, "A Bastion Against Cultural Obscenity," *The Guardian*, June 3, 2004.

ied interested in modern art. In the
t dealers, I was intrigued to learn that
artist's work had declined over the
mmon this was, I realized that I could
me way I had measured age effects in
nsactions—the results of recent auc-
een the value of an artist's paintings
ecution. During the following sum-
d made these estimates for the most
nerations, the Abstract Expressionists

ost valuable work of Jackson Pollock,
pressionists was almost invariably
posite was true for Jasper Johns, Rob-
inters of the next generation. The
nportance of the early work of Johns
cident, for the leading artists of their
ost valuable work at early ages.
nique to New York in the 1950s and
e careers of the great French painters
rn art. To my surprise, I again found
inters in France born before 1850, in-
oduced their most valuable work late
the generations that followed, from
and Braque, typically did their best

ese two studies of the relationship be-
th my interpretation of the causes of
their consequences. In doing this
identifying and explaining systematic
ways found in doing similar work on
I was amazed how often the results
ction prices or textbook illustrations,
w individual painters conceived of
ut how they went about planning and
pointed to discover how completely
approaches to their discipline. Such
story of modern art, and in so doing
rk based on traditional approaches.

Quotations at right: David Hackett Fischer, *Historians' Fallacies* (New York, 1970), 274; Clifford Geertz, *Available Light: Anthropological Reflections on Philosophical Topics* (Princeton, 2000), 12–13.

Fischer's *Historians' Fallacies* describes the punning multiplicity of meaning as "*the fallacy of equivocation . . . whenever a term is used in two or more senses within a single argument, so that a conclusion appears to follow when in fact it does not.*" Auction prices allegedly carry enormous information, relevant one way or another to all the following: (1) the most valuable, meaning both price and merit, work of an artist, (2) historical importance, (3) best artistic work, (4) artistic productivity, (5) creativity, (6) how artists conceive their works, (7) how artists paint their works. Consider a thought experiment: *Do our theories about (1), (2), (3), (4), (5), (6), and (7) change when new data (say, in 2010-2020) for auction prices become available?* If yes, how and why should art history be rewritten? If no, what exactly is the relevance of auction prices for understanding "patterns of creativity in modern art"?

Concepts that explain everything explain nothing. Such concepts deny distinctions between cause and effect, theory and evidence, explanation and correlation. Here the explanatory meaning of "price" in economic history is as mushy as the meaning of "culture" in anthropology, which Clifford Geertz devastatingly describes as "so diffuse and all-embracing as to seem like an all-seasons explanation for anything human beings might contrive to do, imagine, say, be, or believe. . . . We were condemned, it seemed, to working with a logic and a language in which concept, cause, form, and outcome had the same name."

The artist's *age* at the time a painting was painted, the other key variable, also has a multiplicity of meanings. When Picasso was 26, it was *also* 1907, a magical year, the beginning of Cubism. Thus an artist's *age* is confounded with the *year* the painting was created and everything going on during that moment in art. Thus for some artists at some times, age is a *proxy* (statistical jargon for "pun") for art history.

At least Professor Galenson is satisfied. "Systematic" analysis has produced "startling" findings, which create "surprise," "excitement," "new insights." He is "amazed how often [his] results lead to accurate predictions" although "also disappointed how completely art historians have neglected" his approach. The problem here is not the self-congratulation, but rather that *self-reported self-astonishment is presented as evidence for the credibility of one's own research.*

Slippery language, stupendous conclusions. This syndrome of overreaching is economically described by a new word: *economisting,* with accents on *con* and *mist:*

economisting (e kon´o mist´ing) 1. The act or process of converting limited evidence into grand claims by means of punning, multiplicity of meaning, and over-reaching. 2. The belief or practice that empirical evidence can only confirm and never disconfirm a favored theory. 3. Conclusions that are theory-driven, not evidence-based. See also *confirmation bias, painting with a broad brush, Iraqi weapons of mass destruction, marketing, post-modern critical theory, German meaning of "mist".*

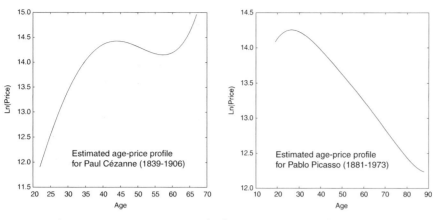

David Galenson, *Painting Outside the Lines: Patterns of Creativity in Modern Art* (Cambridge, Massachusetts, 2001), 15, figures 2.1 and 2.2.

The puns in *Painting Outside the Lines* nearly make some empirically testable claims about the extraordinary explanatory powers of auction prices. What then is provided in the way of *evidence* about artists, paintings, and prices? For one thing, the book presents 15 data tables with 2,029 entries (artists' birthdates, deathdates, ages, and frequency of appearances in exhibitions and art history textbooks)—but *not a single auction price or price index or anything else that might measure an economic transaction for a particular painting.* Likewise for the text in the 265-page book: no prices. The book's 2 graphs show a vertical axis, Ln(Price) = the natural logarithm of prices, along with age/price curves for Cézanne and Picasso. These 2 tidy curves, without any actual data points, are the *only* quantitative evidence about auction prices in the book. Readers are not even told the number of paintings plotted graphically. The Cézanne age/price curve shown above are consistent with all sorts of underlying data:

What information is necessary to assess the credibility of the book's 2 graphs? Here is a checklist, familiar to students of research methods:

Number (*n*) of paintings in the analysis.
The data matrix (auction price and age of artist, for the *n* paintings).
Equations of the fitted models, and plotted curves accompanied by the data.
Quality of fit of the estimated models.
The substantive meaning, quantitatively expressed, of the estimated models.[13]

Thoroughly dequantified, *Painting Outside the Lines* provides *none* of this information. Elementary standards of statistical evidence are not met by the book's notable publisher (Harvard University Press) or the notable author (Professor of Economics, University of Chicago). The economisting puns are unsupported by the economisting evidence.

[13] The 2-dimensional space for these graphs can yield intriguing quantitative interpretations, a point missed by the fitted polynomial curves at left (which use t^0, t^1, t^2, t^3, t^4, t^5 terms to fit auction prices). Instead, consider an exponential model, where *p = auction price* and *t = age of the artist*:

$$p = ae^{bt}$$

Taking natural logarithms and then letting $c = \log_e a$ allows the model to be estimated by ordinary least squares (OLS). Conveniently, this is also the 2-space of the graphs above:

$$\log_e p = c + bt$$

The regression coefficient, *b*, has a useful substantive interpretation: in the model $p = ae^{bt}$, $b \times 100$ is equal to the percent increase in *p* per unit increase in *t*, if *b* is small (say, less than 0.25). The proportional increase in *p*, per unit increase in *t*, is

$$= \frac{\frac{\Delta p}{p}}{\Delta t} = \frac{p_2 - p_1}{p_1} \quad (\text{since } \Delta t = t_2 - t_1 = 1)$$

$$= \frac{ae^{bt_2} - ae^{bt_1}}{ae^{bt_1}} = e^b - 1$$

$$= \left(1 + b + \frac{1}{2!}b^2 + \frac{1}{3!}b^3 + \dots\right) - 1$$

by the series expansion of e^b. If *b* is small, then higher-order terms can be dropped

$$\approx (1 + b) - 1 = b$$

the OLS slope in the $\log_e price$ by *age* space. Another possibility is to estimate elasticities by taking the logarithm of both variables. As insiders know, however, the resulting R^2 will be much smaller compared to letting 6 polynomial age terms bend and wander around to fit auction prices. What theory of markets—other than barefoot empiricism—specifies such a model? Higher powers of an artist's age make no *substantive* sense; at a vigorous 80, Picasso's age to the fifth is a stupefying 3,276,800,000. What then can the regression coefficient on t^5 mean: "A 100,000,000 quintic-year change in *artist age* explains a β_5 change in $\log_e prices$"?!

IN REPORTS on quantitative work, frequent puns involve the language of mathematical statistics: *significance, confidence, maximum likelihood, bias, standard errors, optimal.* (Recall the "strict consensus of parsimonious trees with optimized activity patterns" in our earlier example of fitted cladograms.) In statistics, these words have clearly defined technical meanings. The everyday meanings of these words, however, resonate far beyond their narrow technical usage.

Statistical tests against the null hypothesis allow some researchers to make punning claims about the significance (everyday meaning) of their findings. Statistical significance (technical meaning) derives from the ridiculousness of the null hypothesis, sample size, fateful and usually false assumptions about independence of observations, assumptions about the sampling distribution under the null hypothesis, and, yes, size of the effect. Thoughtful researchers will report content-relevant measures of effects and not confound those measures with tests against the null hypothesis. Insiders already know this, but the punning problems persist in workaday research practice. Such puns identify mediocrities.

Puns from microeconomics and mathematical statistics—and, for that matter, quantum mechanics, evolutionary theory, fractals, chaos theory— claim unmerited credibility by trading on the authority and sometimes the jargon of the original narrow technical achievement. Puns enable *overreaching*, as previously bright ideas sprawl, grow mushy, and collapse into vague metaphors when extended outside their original domain. Steven Weinberg describes the breakdown in logic when once-precise concepts overreach:

> Quantum mechanics has been variously cited as giving support to mysticism, or free will, or the decline of quantitative rationality. Now, I would agree that any-one is entitled to draw any inspiration he or she can from quantum mechanics, or from anything else. This is what I meant when I wrote that I had nothing to say against the use of science as metaphor. But there is a difference between inspiration and implication, and in talking of the "telling cultural implications" of quantum mechanics, Professor Levine may be confusing the two. There is simply no way that any cultural consequences can be *implied* by quantum mechanics. It is true that quantum mechanics does "apply always and every-where," but what applies is not a proverb about diverse points of view but a precise mathematical formalism, which among other things tells us that the difference between the predictions of quantum mechanics and pre-quantum classical mechanics, which is so important for the behavior of atoms, becomes negligible at the scale of human affairs.[14]

[14] Steven Weinberg, *Facing Up: Science and Its Cultural Adversaries* (Cambridge, Massachusetts, 2001), 156-157.

WHEN a precise, narrowly focused technical idea becomes metaphor and sprawls globally, *its credibility must be earned afresh locally by means of specific evidence demonstrating the relevance and explanatory power of the idea in its new application.* It is not enough for presenters to make ever-bolder puns, as meaning drifts into duplicity. Something has to be explained.

Chartjunk: Content-Free Stuff Replaces Evidence

For consumers of presentations, gratuitous and cartoonish decoration of
statistical graphics provides evidence about the presenter's integrity and
statistical skills: little integrity, no statistical skills. Imagine the quality
of analysis behind this chart: a fanciful 3-fold change in revenue growth
is depicted by a 7-fold change in bar *area* and an immense change in the
apparent *volume* of the guy in the track suit. And who would believe in
revenue growth projections for some 4 years?

 For cynical or malicious presenters, chartjunk decoration reflects their
contempt for evidence and for their audience. Chartjunk flows from the
premise that audiences can be charmed, distracted, or fooled by means of
content-free misdirection: garish colors, designer colors, corny clip-art,
generic decoration, phony dimensionality. For decoration, it sure is ugly.

 Audience members at a presentation featuring chartjunk rather than
evidence should ask themselves "Is this the quality of analysis that we
are relying on to understand a problem or to make a decision? Why
should we trust this presenter? Just how high can the presenter count?
Does the presenter think we're fools? Why are we having this meeting?"

Microsoft Excel and PowerPoint produce, ineptly, many of the data graphics and tables used in presentations today. Filled with chartjunk, the default graph templates in these programs are useful for constructing deceptive investment and weight-loss pitches. Excel chartjunk can sometimes be finessed by skilled users; PowerPoint graph templates are broken beyond repair. For preparing data presentations other than ads in tabloid newspapers, a professional statistical graphics program is essential.

(Experiment B64 conducted under the supervision of a physician and a court bailiff)

ALONG with the *chartjunk of garish decoration*, there is also the *chartjunk of graph bureaucracy*: useless or optically active grids, boxes and frames around graphs, redundant representations of data, cross-hatched bars. In this spreadsheet assessing the danger to the Columbia space shuttle, the most prominent visual activities are the vast empty framing areas and the grid prisons that surround the unexplained and unreadable numbers.

Very little chartjunk appears in the sports, weather, and financial tables in newspapers, or in the tables and graphs published in major scientific journals—since the content is too important and too complex for fooling around with chartjunk.[15]

[15] On chartjunk, see Edward Tufte, *The Visual Display of Quantitative Information* (Cheshire, Connecticut, 1983, 2001), chapter 5.

Results of Impact Analysis for particle size = 20" x 10" x 6"

XT	YT	ZT	VMAX (ft/sec.)	VX (ft/sec.)	VY (ft/sec.)	VZ (ft/sec.)	IMPANG (degrees)
1755	193	625	690	682	104	20	9.0
1759	194	630	689	680	107	25	9.4
1744	190	637	693	683	107	36	8.7
1755	191	641	698	689	107	41	7.8
1800	197	648	702	693	105	46	8.8
1747	190	626	686	677	104	21	7.0
1769	192	629	682	674	105	23	7.1
1751	188	637	685	676	105	35	10.4
1754	188	641	690	681	104	40	7.8
1754	187	644	694	684	103	44	6.6
1755	197	627	693	684	107	23	11.9
1748	195	630	691	682	107	27	13.3
1756	194	638	699	689	109	37	8.9
1806	202	645	712	703	109	42	11.3
1788	199	647	711	701	109	46	10.4
1762	200	627	700	691	109	24	21.5
1833	211	633	707	698	110	28	9.6
1802	204	641	713	703	110	38	12.8
1790	202	644	711	702	110	42	11.3
1781	200	647	712	703	108	46	11.1
1744	186	625	683	675	102	18	6.5
1718	181	627	673	665	101	22	6.0
1742	184	636	653	645	98	30	2.0
1652	169	635	635	627	96	32	0.4
1593	159	634	611	603	92	34	2.0
1786	198	621	705	697	104	15	7.5
1799	201	624	702	694	105	18	7.7
1758	194	624	691	683	104	20	9.1
1830	210	617	723	715	106	12	5.4
1799	205	620	710	702	106	15	7.9
1790	202	623	707	699	106	17	8.1
1762	198	625	694	686	107	21	11.8
1788	196	620	705	697	102	14	7.0
1798	198	623	698	691	103	17	7.2
1755	191	624	687	679	103	19	6.8
2023	238	615	762	755	103	7	1.1
1830	210	617	723	715	106	12	5.4

STS-107 Debris Impacting Orbiter Wing

When Evidence is Mediated and Marketed: Pitching Out Corrupts Within

EVIDENCE-BASED reports are repackaged and marketed by *bureaucracies of secondary presentations*: public relations, advertising, programs for public outreach, schoolbook publishing, journalism, and the vast government Ministries of Propaganda. Soon enough, tertiary presentations pitch recaps of opinions about a summary of some evidence somewhere.

In repackagings, a persistent *rage to conclude* denies the implications, complexities, and uncertainties of primary evidence.[16] A strong selection bias typically operates: news wins out over olds, recency rather than the quality of evidence decides the relevance of evidence.

Secondary re-presentations have much larger audiences than primary reports. Rarely read, the original report blurs and fades away. A handful of technical reviewers might examine the complete set of evidence for a new drug; possibly 500 people read medical journal articles about the drug and 5,000 peruse medical abstracts; 500,000 might see news reports and millions advertisements for the drug, as the original evidence has ultimately passed through 3 or 4 repackagings on the way to market. Or consider textbooks: a successful college text is assigned to 200,000 students, some of whom read it; the primary works summarized by the textbook are read by a few researchers. For reports of government commissions, for *each* reader of the original, there are perhaps 100,000 readers of mediated secondary versions. Sometimes, actually reading a government report constitutes original research.

Substantial resources are devoted to repackaging: pharmaceutical companies spend more on marketing than on drug research, schoolbook publishers more on lobbying textbook selection committees than on writing books, financial firms more on promoting investment products than on discovering them.

In repackaging and commodifying evidence-based material for wider distribution, the bureaucracies of secondary presentation get their whack at the primary report: they edit, clarify, interpret, summarize, simplify, over-simplify, spin, tart up, mess up. And they make errors. If you worry about evidence corruption in primary reports, secondary presentations will give you a lot more to worry about. Repackaging adds its own special interpretative filter to the critical process of learning from evidence:

[16] Flaubert's phrase *"la rage de vouloir conclure"* occurs in his letter to Mlle Leroyer de Chantepie, October 23, 1863, here translated: "The rage for wanting to conclude is one of the most deadly and most fruitless manias to befall humanity. Each religion and each philosophy has pretended to have God to itself, to measure the infinite, and to know the recipe for happiness. What arrogance and what nonsense! I see, to the contrary, that the greatest geniuses and the greatest works have never concluded." Gustave Flaubert, *Correspondance* (Paris, 1929), vol. v, 111.

| raw data: observations, measurements | → | evidence reduction, construction, and representation | → | the primary report: findings represented by graphs, tables, diagrams, images, numbers, words | → | reports produced by the bureaucracies of secondary and tertiary presentations |

corrupting feedback, as bureaucracies of presentation undermine the integrity of evidence and analysis

Secondary bureaucracies of presentation may lack the technical skills and substantive knowledge to detect their mistakes. In the sausage-making, chop-shop production of many secondary and tertiary presentations, absent are methods that routinely help enforce the intellectual quality

and integrity in primary work: external review and final approval by content experts, professional standards of evidence, skeptical intelligence. And then, to impede direct communication between originators and audiences, bureaucracies of secondary presentation may limit access to the primary report through copyrights, inconvenient or costly subscriptions, and overreaching claims of corporate privilege or government secrecy.

PRODUCERS of primary reports may console themselves about distortions in mediated versions of their work by recalling the words of the noted marketeer P. T. Barnum: "Without publicity a terrible thing happens—nothing." Evidence cannot become relevant if no one knows about it.

How can creators of evidence-based reports defend the integrity of their work against repackaging mischief? To start with, primary reports should be inexpensively and directly available (internet, self-publishing, leaks to journalists), short-circuiting the bureaucracies of secondary presentation. Creators of original material should never surrender rights to their work. They should prepare their own secondary reports to replace repackagings. They should police secondary mediated versions of their work, and turn the mistakes of the easily mocked pitch culture into notorious examples.

And *consumers* of evidence should stay reasonably close to primary sources and to evidence-interpreters who provide honest unbiased readings. There's almost always something to learn from a first-rate primary source (for example, that secondary versions incorrectly interpret the primary). For consumers, an indicator of an untrustworthy presentation bureaucracy is its denial of access to primary evidence (for example, by requiring that all publications be pre-approved by the PR department). Another sign is that repackagings always manage, somehow, to support a predetermined line. Wise consumers should keep in mind that reports from an unbiased interpreter will not always agree with their own prior views. And that one's allies are not all that less likely to corrupt evidence than one's opponents.[17]

[17] A good guide for assessing the quality and the credibility of nonfiction reports is Sarah Harrison Smith, *The Fact Checker's Bible: A Guide to Getting It Right* (New York, 2004).

BY generating corrupt repackagings, an organization's bureaucracy of secondary presentations may come to corrupt the integrity of work *within* the organization. Compromised external communications promote compromised internal communications, as *pitching out corrupts within.* If a corporation distorts evidence presented to consumers, stockholders, and journalists, then it may soon lie to itself. Or, similarly, the chronic problem of government intelligence agencies: once the collection and selection of evidence starts to become fixed around a pre-determined policy line, intelligence agencies may become perpetually unintelligent, confused about the differences between detective work and marketing. Or, even in writing novels: "Cliché spreads inwards from the language of the book to its heart. Cliché always does."[18] Nowadays the common tool for pitching out—and corrupting evidence within—is PowerPoint.

[18] Martin Amis, *The War Against Cliché* (New York, 2001), p. 137.

The English language . . . becomes ugly and inaccurate because our thoughts are foolish, but the slovenliness of our language makes it easier for us to have foolish thoughts.

George Orwell, "Politics and the English Language"

For a successful technology, reality must take precedence over public relations, for Nature cannot be fooled.

Richard P. Feynman, *"What Do You Care What Other People Think?"*

And not waving but drowning.

Stevie Smith, poem, "Not Waving But Drowning"

Sweet songs never last too long on broken radios.

John Prine, "Sam Stone"

The Cognitive Style of PowerPoint: Pitching Out Corrupts Within

IN corporate and government bureaucracies, the standard method for making a presentation is to talk about a list of points organized onto stylized slides projected up on the wall. For years, before computerized presentations, those giving a talk used transparencies for projected images. Now presenters use a slideware program, Microsoft PowerPoint, which turns out billions and billions of presentation slides each year.

This chapter provides evidence that *compares PowerPoint with alternative methods for presenting information*: 10 case studies, an unbiased collection of 2,000 PP slides, and 32 control samples from non-PP presentations.

The evidence indicates that PowerPoint, compared to other common presentation tools, reduces the analytical quality of serious presentations of evidence. This is especially the case for the PowerPoint ready-made templates, which corrupt statistical reasoning, and often weaken verbal and spatial thinking. What is the problem with PowerPoint? How can we improve our presentations? And what specific sorts of corruptions of evidence and analysis should *consumers* of PowerPoint presentations look out for?

WHEN Louis Gerstner became president of IBM, he encountered a big company caught up in ritualistic slideware-style presentations:

> One of the first meetings I asked for was a briefing on the state of the [mainframe computer] business. I remember at least two things about that first meeting with Nick Donofrio, who was then running the System/390 business

> At that time, the standard format of any important IBM meeting was a presentation using overhead projectors and graphics that IBMers called "foils" [projected transparencies]. Nick was on his second foil when I stepped to the table and, as politely as I could in front of his team, switched off the projector. After a long moment of awkward silence, I simply said, "Let's just talk about your business."

> I mention this episode because it had an unintended, but terribly powerful ripple effect. By that afternoon an email about my hitting the Off button on the overhead projector was crisscrossing the world. Talk about consternation! It was as if the President of the United States had banned the use of English at White House meetings.[1]

[1] Louis V. Gerstner, Jr., *Who Says Elephants Can't Dance? Inside IBM's Historic Turnaround* (2002), 43.

The Cognitive Style of PowerPoint

GERSTNER'S blunt action shutting down the projector suggests there are better tools for doing business analysis than reading aloud from bullet lists: *"Let's just talk about your business."* Indeed, Gerstner later asked IBM executives to write out their business strategies in longhand using the presentation methodology of *sentences*, with subjects and predicates, nouns and verbs, which then combine sequentially to form *paragraphs*, an analytic tool demonstratively better than slideware bullet lists.[2]

"Let's just talk about your business" indicates a thoughtful exchange of information, a mutual interplay between speaker and audience, rather than a pitch made by a power pointer pointing to bullets. PowerPoint is *presenter-oriented, not content-oriented, not audience-oriented.* PP advertising is not about content quality, but rather presenter therapy: "A cure for the presentation jitters." "Get yourself organized." "Use the AutoContent Wizard to figure out what you want to say."

PowerPoint's convenience for some presenters is costly to the content and the audience. These costs arise from the *cognitive style characteristic of the standard default PP presentation: foreshortening of evidence and thought, low spatial resolution, an intensely hierarchical single-path structure as the model for organizing every type of content, breaking up narratives and data into slides and minimal fragments, rapid temporal sequencing of thin information rather than focused spatial analysis, conspicuous chartjunk and PP Phluff, branding of slides with logotypes, a preoccupation with format not content, incompetent designs for data graphics and tables, and a smirky commercialism that turns information into a sales pitch and presenters into marketeers.* This cognitive style harms the quality of thought for the producers and the consumers of presentations.

PowerPoint comes with a big attitude. Other than video games, not many computer programs have attitudes. Effective tools such as web browsers, Word, Excel, Photoshop, and Illustrator are not accompanied by distinctive cognitive styles that reduce the intellectual level of the content passing through the program.

Nonetheless, PowerPoint may benefit the bottom 10% of all presenters. PP forces them to have *points*, some points, any points. Slideware perhaps helps inept speakers get their act together, outline talks, retrieve visual materials, present slides. Furthermore, PP probably doesn't cause much damage to really first-rate presenters, say the top 10%, who have strong content, self-awareness, and their own analytical style that avoids or neutralizes the PP style. This leaves 80%, workaday presenters, for whom the PP cognitive style causes trouble.

In practice, PP slides are very low resolution compared to paper, most computer screens, and the immense visual capacities of the human eye-brain system. With little information per slide, many many slides are needed. Audiences endure a relentless sequentiality, one damn slide after

[2] Gordon Shaw, Robert Brown, Philip Bromiley, "Strategic Stories: How 3M is Rewriting Business Planning," *Harvard Business Review*, 76 (May–June, 1998), 42–44.

another. Information stacked in time makes it difficult to understand context and evaluate relationships. Visual reasoning usually works more effectively when the relevant evidence is shown *adjacent in space* within our eyespan. This is especially the case for statistical data, where the fundamental analytical task is to make comparisons.

The statistical graphics produced by PowerPoint are astonishingly thin, nearly content-free. In 28 books on PP templates, the 217 model statistical graphics depict an average of 12 numbers each (as do the PP data-table templates). Compared to the worldwide publications shown here, the PP statistical graphics are the thinnest of all, except for those in *Pravda* in 1982, back when that newspaper operated as the major propaganda instrument of the Soviet communist party and a totalitarian government.[3] Doing a bit better than *Pravda* is not good enough:

MEDIAN NUMBER OF ENTRIES IN DATA MATRICES FOR
STATISTICAL GRAPHICS IN VARIOUS PUBLICATIONS, 2003

Science	> 1,000
Nature	> 700
New York Times	120
Wall Street Journal	112
Frankfurter Allgemeine Zeitung	98
New England Journal of Medicine	53
Asahi	40
Financial Times	40
The Economist	32
Le Monde	28
28 books on PowerPoint presentations (1997-2003)	12
Pravda (1982)	5

[3] In this table, the medians are based on at least 20 statistical graphics and at least one full issue of each publication. These publications, except for scientific journals, tend to use the same graph designs issue after issue; thus replications of several of the counts were within 10% of the original result. Data for other publications (*Pravda*, for example) are reported in Edward R. Tufte, *The Visual Display of Quantitative Information* (1983, 2001), 167.

Pravda, May 24, 1982.

These PP graph templates are particularly unfortunate for students, since for all too many their *first* experience in presenting statistical evidence is via PP designs, which create the impression that data graphics are for propaganda and advertisements and not for reasoning about information.

And, in presenting *words*, impoverished space encourages imprecise statements, slogans, abrupt and thinly-argued claims. For example, this slide from a statistics course shows a seriously incomplete cliché. In fact, probably the *shortest true statement* that can be made about causality and correlation is "*Empirically observed covariation is a necessary but not sufficient condition for causality.*" Or perhaps "*Correlation is not causation but it sure is a hint.*" Many true statements are too long to fit on a PP slide, but this does not mean we should abbreviate the truth to make the words fit. It means we should find a better tool to make presentations.

Sequentiality of the Slide Format

WITH information quickly appearing and disappearing, the slide transition is an event that attracts attention to the presentation's compositional methods. Slides serve up small chunks of promptly vanishing information in a restless one-way sequence. It is not a contemplative analytical method; it is like television, or a movie with over-frequent random jump cuts. Sometimes quick chunks of thin data may be useful (flash-card memorizing), other times not (comparisons, links, explanations). *But formats, sequencing, and cognitive approach should be decided by the character of the content and what is to be explained, not by the limitations of the presentation technology.* The talk that accompanies PP slides may overcome the noise and clutter that results from slideville's arbitrary partitioning of data, but why disrupt the signal in the first place? And why should we need to recover from a technology that is supposed to help our presentations?

Obnoxious transitions and partitions occur not only slide-by-slide but also line-by-line, as in the dreaded slow reveal (at right). Beginning with a title slide, the presenter unveils and reads aloud the single line on the slide, then reveals the next line, reads that aloud, on and on, as the stupefied audience impatiently awaits the end of the talk.

It is helpful to provide audience members with at least one mode of information that allows *them* to control the order and pace of learning—unlike slides and unlike talk. Paper handouts for talks will help provide a permanent record for review—again unlike projected images and talk. Another way to break free of low-resolution temporal comparisons is to show multiple slides, several images at once within the common view. Spatial parallelism takes advantage of our notable capacity to reason about multiple images that appear simultaneously within our eyespan. We are able to select, sort, edit, reconnoiter, review—ways of seeing quickened and sharpened by direct spatial adjacency of evidence.

Now and then the narrow bandwidth and relentless sequencing of PP slides are said to be virtues, a claim justified by loose reference to George Miller's classic 1956 paper "The Magical Number Seven, Plus or Minus Two." That essay reviews psychological experiments that discovered people had a hard time remembering more than about 7 unrelated pieces of really dull data all at once. These studies on memorizing nonsense then led some interface designers, as well as PP guideline writers seeking to make a virtue of a necessity, to conclude that only 7 items belong on a list or a slide, a conclusion that can only be reached by not reading Miller's paper. In fact the paper neither states nor implies rules for the amount of information shown on a slide (except for those presentations consisting of nonsense syllables that the audience must memorize and repeat back to a psychologist). On the contrary, the deep point of Miller's work is to suggest strategies, such as placing evidence within a context, that extend the reach of memory beyond tiny clumps of data.[4]

[THE AUDIENCE FLEES]

[4] George A. Miller, "The Magical Number Seven, Plus or Minus Two: Some Limits on Our Capacity for Processing Information," *Psychological Review,* 63 (1956), 81–97 (and widely posted on the internet). At Williams College in September 2000, I saw George Miller give a presentation that used the optimal number of bullet points on the optimal number of slides— zero in both cases. Just a straightforward talk with a long narrative structure.

Metaphors for Presentations and Conway's Law

THE metaphor of PowerPoint is *the software corporation itself.* To describe a software house is to describe the PP cognitive style: a big bureaucracy engaged in *computer programming* (deep hierarchical structures, relentlessly sequential, nested, one-short-line-at-a-time) and in *marketing* (advocacy not analysis, more style than substance, misdirection, slogan thinking, fast pace, branding, exaggerated claims, marketplace ethics). That the PP cognitive style mimics a software house exemplifies *Conway's Law:*

> Any organization which designs a system . . . will inevitably produce a design whose structure is a copy of the organization's communication structure.[5]

Why should the structure, activities, and values of a large commercial bureaucracy be a useful metaphor for our presentations? Are there worse metaphors? Voice-mail menu systems? Billboards? Television? Stalin?

The pushy PP style tends to set up a dominance relationship between speaker and audience, as the speaker makes power points with hierarchical bullets to passive followers. Such aggressive, stereotyped, over-managed presentations—the Great Leader up on the pedestal—are characteristic of hegemonic systems *and of Conway's Law again in operation:*

> The Roman state bolstered its authority and legitimacy with the trappings of ceremony. . . . Power is a far more complex and mysterious quality than any apparently simple manifestation of it would appear. It is as much a matter of impression, of theatre, of persuading those over whom authority is wielded to collude in their subjugation. Insofar as power is a matter of presentation, its cultural currency in antiquity (and still today) was the creation, manipulation, and display of images. In the propagation of the imperial office, at any rate, art was power.[6]

A BETTER metaphor for presentations is *good teaching.* Practical teaching techniques are very helpful for presentations in general. Teachers seek to explain something with credibility, which is what many presentations are trying to do. The core ideas of teaching—*explanation, reasoning, finding things out, questioning, content, evidence, credible authority not patronizing authoritarianism*—are contrary to the cognitive style of PowerPoint. And the ethical values of teachers differ from those engaged in marketing.[7]

Especially disturbing is the introduction of PowerPoint into schools. Instead of writing a report using sentences, children learn how to decorate client pitches and infomercials, which is better than encouraging children to smoke. Student PP exercises (as seen in teachers' guides, and in student work posted on the internet) typically show 5 to 20 words and a piece of clip art on each slide in a presentation consisting of 3 to 6 slides—a total of perhaps 80 words (20 seconds of silent reading) for a week of work. Rather than being trained as mini-bureaucrats in the pitch culture, students would be better off if schools closed down on PP days and everyone went to The Exploratorium. Or wrote an illustrated essay explaining something.

[5] Melvin E. Conway, "How Do Committees Invent?," *Datamation,* April 1968, 28-31. The law's "inevitably" overreaches. Frederick P. Brooks, Jr., in *The Mythical Man-Month: Essays on Software Engineering* (1975), famously describes the interplay between system design and bureaucracy.

[6] Jás Elsner, *Imperial Rome and Christian Triumph: The Art of the Roman Empire AD 100-450* (Oxford, 1998), 53.

[7] On teaching, see Joseph Lowman, *Mastering the Techniques of Teaching* (San Francisco, 1995); Wilbert McKeachie and Barbara K. Hofer, *McKeachie's Teaching Tips* (New York, 2001); Frederick Mosteller, "Classroom and Platform Performance," *The American Statistician,* 34 (1980), 11-17 (posted at www.edwardtufte.com).

PowerPoint Does Rocket Science: Assessing the Quality and Credibility of Technical Reports

NEARLY all engineering presentations at NASA are made in PowerPoint. Is this a product endorsement or a big mistake? Does PP's cognitive style affect the quality of engineering analysis? How does PP compare with alternative methods of technical presentation? Some answers come from the evidence of NASA PowerPoint in action: (1) hundreds of PP technical presentations experienced in 2003 by the Columbia Accident Investigation Board and in 2005 by the Return to Flight Task Group, (2) a case study of the PP presentations for NASA officials making life-and-death decisions during the final flight of Columbia, (3) observations by Richard Feynman who saw a lot of slideware-style presentations in his NASA work on the 1986 Challenger accident, (4) my observations as a NASA consultant on technical presentations for shuttle risk assessments, shuttle engineering, and deep spaceflight trajectories.

DURING the January 2003 spaceflight of shuttle Columbia, 82 seconds after liftoff, a 1.67 pound (760 grams) piece of foam insulation broke off from the liquid fuel tank, hit the left wing, and broke through the wing's thermal protection. After orbiting the Earth for 2 weeks with an undetected hole in its wing, Columbia burned up during re-entry because the compromised thermal protection was unable to withstand the intense temperatures that occur upon atmosphere re-entry. The 7 astronauts on board died. The only evidence of a possible problem was a brief video sequence showing that something hit the wing somewhere. Here are 2 video frame-captures at 82 seconds after Columbia's launch:

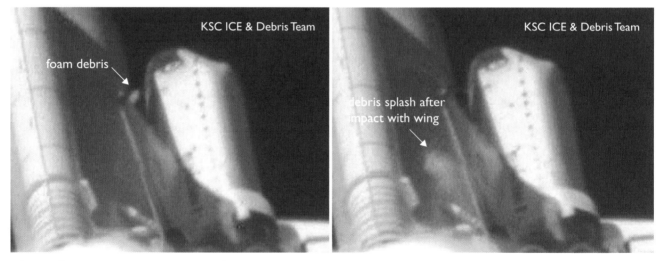

The rapidly accelerating Columbia in effect ran into the foam debris. Post-accident frame-by-frame analysis yields the impact velocity of the foam, 600 miles or 970 km per hour, the speed of sound. Since kinetic energy $= \frac{1}{2}mv^2$, the velocity-squared contribution is substantial.

In the video, 2 relevant variables are indeterminate: impact *angle of incidence* and impact *location*. Did the debris hit the insulation tiles on the left wing, or the reinforced carbon-carbon (RCC) on the leading edge of the wing? Post-accident investigation established that the foam hit the especially vulnerable RCC.

What to make of this video? How serious is the threat? What actions should be taken in response? A quick, smart analysis is needed, since Columbia will re-enter the atmosphere in about 12 days. Although the evidence is uncertain and thin, for only a single camera showed debris impact, the logical structure of the engineering analysis is straightforward:

debris *kinetic energy* (function of mass, velocity, and angle of incidence)	+	debris hits locations of *varying vulnerability* on left wing	\longrightarrow	*level of threat* to the Columbia during re-entry heating of wing

Angle of incidence is uncertain; *location of impact* is uncertain (wing tiles? leading edge of the wing?); *mass* and *velocity* of the foam debris can be calculated. Profoundly relevant is the *difference in velocity* between the shuttle and the piece of free-floating foam, since the kinetic energy of the foam impact is proportional to that *velocity squared*. Even though the errant foam was lightweight (1.67 lb), it was moving fast (600 mph) relative to the shuttle. Velocity squared is like shipping and handling: it will get you every time.

To help NASA officials assess the threat, Boeing Corporation engineers quickly prepared 3 reports, a total of 28 PowerPoint slides, dealing with the debris impact.[8] These reports provided mixed readings of the threat to the spacecraft; the lower-level bullets often mentioned doubts and uncertainties, but the highlighted executive summaries and big-bullet conclusions were quite optimistic. Convinced that the reports indicated no problem rather than uncertain knowledge, high-level NASA officials decided that the Columbia was safe and, furthermore, that no additional investigations were necessary. Several NASA engineers had hoped that the military would photograph the shuttle in orbit with high-resolution spy cameras, which would have easily detected the damage, but even that checkup was thought unnecessary given the optimism of the 3 Boeing reports. And so the Columbia orbited for 16 days with a big undetected hole in its wing.

ON the next page, I examine a key slide in the PP reports made while Columbia was damaged but still flying. The analysis suggests methods for how not to get fooled while consuming a presentation. Imagine that you are a high-level NASA decision-maker receiving a pitch about threats to the spacecraft. You must learn 2 things: Exactly what is the presenter's story? And, can you *believe* the presenter's story? A close reading of a presentation will help gauge the quality of intellect, the knowledge, and the credibility of presenters. To be effective, close readings must be based on *universal* standards of evidence quality, which are not necessarily those standards that operate locally.

[8] C. Ortiz, A. Green, J. McClymonds, J. Stone, A. Khodadoust, "Preliminary Debris Transport Assessment of Debris Impacting Orbiter Lower Surface in STS-107 Mission," January 21, 2003; P. Parker, D. Chao, I. Norman, M. Dunham, "Orbiter Assessment of STS-107 ET Bipod Insulation Ramp Impact," January 23, 2003; C. Ortiz, "Debris Transport Assessment of Debris Impacting Orbiter Lower Surface in STS-107 Mission," January 24, 2003. These reports were published in records of the CAIB and at NASA websites.

Summary and Conclusion

- Impact analysis ("Crater") indicates potential for large TPS damage
 - Review of test data shows wide variation in impact response
 - RCC damage limited to coating based on soft SOFI
- Thermal analysis of wing with missing tile is in work
 - Single tile missing shows local structural damage is possible, but no burn through
 - Multiple tile missing analysis is on-going
- M/OD criteria used to assess structural impacts of tile loss
 - Allows significant temperature exceedance, even some burn through
 - Impact to vehicle turnaround possible, but maintains safe return capability

Conclusion
- Contingent on multiple tile loss thermal analysis showing no violation of M/OD criteria, safe return indicated even with significant tile damage

BOEING 13

On this one Columbia slide, a PowerPoint festival of bureaucratic hyper-rationalism, 6 different levels of hierarchy are used to display, classify, and arrange 11 phrases:

Level 1 Title of Slide
Level 2 ● Very Big Bullet
Level 3 — big dash
Level 4 ◆ medium–small diamond
Level 5 • tiny bullet
Level 6 () parentheses ending level 5

The analysis begins with the dreaded Executive Summary, with a conclusion presented as a headline: "Test Data Indicates Conservatism for Tile Penetration." This turns out to be unmerited reassurance. Executives, at least those who don't want to get fooled, had better read far beyond the title.

The "conservatism" concerns the *choice of models* used to predict damage. But why, after 112 flights, are foam–debris models being calibrated during a crisis? How can "conservatism" be inferred from a loose comparison of a spreadsheet model and some thin data? Divergent evidence means divergent evidence, not inferential security. Claims of analytic "conservatism" should be viewed with skepticism by presentation consumers. Such claims are often a rhetorical tactic that substitutes verbal fudge factors for quantitative assessments.

As the bullet points march on, the seemingly reassuring headline fades away. Lower-level bullets at the end of the slide undermine the executive summary. This third-level point notes that "Flight condition [that is, the debris hit on the Columbia] is significantly outside of test database." How far outside? The final bullet will tell us.

This fourth-level bullet concluding the slide reports that the debris hitting the Columbia is estimated to be 1920/3 = 640 times larger than data used in the tests of the model! The correct headline should be "Review of Test Data Indicates Irrelevance of Two Models." This is a powerful conclusion, indicating that pre-launch safety standards no longer hold. The original optimistic headline has been eviscerated by the lower-level bullets. Note how close attentive readings can help consumers of presentations evaluate the presenter's reasoning and credibility.

The Very-Big-Bullet phrase fragment does not seem to make sense. No other VBBs appear in the rest of the slide, so this VBB is not necessary.

Spray On Foam Insulation, a fragment of which caused the hole in the wing

Here "ramp" refers to foam debris (from the bipod ramp) that hit Columbia. Instead of the cryptic "Volume of ramp," say "estimated volume of foam debris that hit the wing." Such clarifying phrases, which may help upper level executives understand what is going on, are too long to fit on low-resolution bullet outline formats. PP demands a shorthand of acronyms, phrase fragments, clipped jargon, and vague pronoun references in order to get at least some information into the tight format.

A model to estimate damage to
the tiles protecting flat surfaces
of the wing

es Conservatism for Tile
ation

ata used to create Crater
7 Southwest Research data
ation of tile coating

ped by normal velocity
of projectile (e.g., 200ft/sec for

ed for the softer SOFI particle
ard tile coating
at it is possible at sufficient mass

enetrated SOFI can cause

ergy (above penetration level)
e damage

ntly outside of test database
vs 3 cu in for test

The vigorous but vaguely quantitative words "significant" and "significantly" are used five times on this slide, with meanings ranging from "detectable in a perhaps irrelevant calibration case study" to "an amount of damage so that everyone dies" to "a difference of 640-fold." The five "significants" cannot refer to statistical significance, for no formal statistical analysis has been done.

Note the analysis is about *tile* penetration. But what about RCC penetration? As investigators later demonstrated, the foam did not hit the tiles on the wing surface, but instead the delicate reinforced-carbon-carbon (RCC) protecting the wing leading edge. Alert consumers should carefully watch how presenters delineate *the scope of their analysis,* a profound and sometimes decisive matter.

?

Slideville's low resolution and large type generate space-wasting typographic orphans, lonely words dangling on 4 separate lines:

Penetration **significantly** 3cu. In and velocity

The really vague pronoun reference "it" refers to *damage to the left wing,* which ultimately destroyed Columbia (although the slide here deals with tile, not RCC damage). Low-resolution presentation formats encourage vague references because there isn't enough space for specific and precise phrases.

The same unit of measurement for volume (cubic inches) is shown in a slightly different way every time

3cu. In **1920cu in** **3 cu in**

rather than in clear and tidy exponential form 1920 in^3. Shakiness in conventions for units of measurement should always provoke concern, as it does in grading the problem sets of sophomore engineering students.* PowerPoint is not good at math and science; here at NASA, engineers are using a presentation tool that apparently makes it difficult to write scientific notation. The pitch-style typography of PP is hopeless for science and engineering, yet this important analysis relied on PP. Technical articles are not published in PP; why then should PP be used for serious technical analysis, such as diagnosing the threat to Columbia?

*The Columbia Accident Investigation Board (final report, p. 191) referred to this point about units of measurement: "While such inconsistencies might seem minor, in highly technical fields like aerospace engineering a misplaced decimal point or mistaken unit of measurement can easily engender inconsistencies and inaccuracies." The phrase "mistaken unit of measurement" is an unkind veiled reference to a government agency that had crashed $250 million of spacecraft into Mars because of a mix-up between metric and non-metric units of measurement.

In the reports, *every single text-slide* uses bullet-outlines with 4 to 6 levels of hierarchy. Then another multi-level list, another bureaucracy of bullets, *starts afresh* for a new slide. How is it that each elaborate architecture of thought always fits *exactly* on one slide? The rigid slide-by-slide hierarchies, indifferent to content, slice and dice the evidence into arbitrary compartments, producing an anti-narrative with choppy continuity. Medieval in its preoccupation with hierarchical distinctions, the PowerPoint format signals every bullet's status in 4 or 5 different simultaneous ways: by the order in sequence, extent of indent, size of bullet, style of bullet, and size of type associated with various bullets. This is a lot of insecure format for a simple engineering problem. The format reflects a common conceptual error in analytic design: information architectures mimic the hierarchical structure of large bureaucracies pitching the information. Conway's Law again. In their report, the Columbia Accident Investigation Board (CAIB) found that the distinctive cognitive style of PowerPoint interacted with the biases and hierarchical filtering of the bureaucracy during the crucial period when the spacecraft was damaged but still functioning:

> The Mission Management Team Chair's position in the hierarchy governed what information she would or would not receive. Information was lost as it traveled up the hierarchy. A demoralized Debris Assessment Team did not include a slide about the need for better imagery in their presentation to the Mission Evaluation Room. Their presentation included the Crater analysis, which they reported as incomplete and uncertain. However, the Mission Evaluation Room manager perceived the Boeing analysis as rigorous and quantitative. The choice of headings, arrangement of information, and size of bullets on the key chart served to highlight what management already believed. The uncertainties and assumptions that signaled danger dropped out of the information chain when the Mission Evaluation Room manager condensed the Debris Assessment Team's formal presentation to an informal verbal brief at the Mission Management Team meeting.[9]

[9] Columbia Accident Investigation Board, *Report*, volume 1 (August 2003), 201.

At about the same time, lower-level NASA engineers were writing about possible dangers to Columbia in several hundred emails, with the Boeing reports in PP format sometimes attached. The text of about 90% of these emails simply used *sentences* sequentially ordered into *paragraphs*; 10% used bullet lists with 2 or 3 levels. These engineers were able to reason about the issues without employing the endless hierarchical outlines of the original PP pitches. Good for them.

Several of these emails referred to the 3 PP reports as the "Boeing PowerPoint Pitch." This is astonishing language. The WhatPoint Pitch? The PowerWhat Pitch? The PowerPoint What? *The language, attitude, and presentation tool of the pitch culture had penetrated throughout the NASA organization, even into the most serious technical work, a real-time engineering analysis of threats to the survival of the shuttle.*

The analysis of the key Columbia slide on the preceding pages was posted at my website.[10] Much of this material was then later included in the final report of Columbia Accident Investigation Board. In their discussion of "Engineering by Viewgraphs," the Board went far beyond my case study of the Columbia slide in these extraordinary remarks about PowerPoint:

> As information gets passed up an organization hierarchy, from people who do analysis to mid-level managers to high-level leadership, key explanations and supporting information are filtered out. In this context, it is easy to understand how a senior manager might read this PowerPoint slide and not realize that it addresses a life-threatening situation.
>
> At many points during its investigation, the Board was surprised to receive similar presentation slides from NASA officials in place of technical reports. The Board views the endemic use of PowerPoint briefing slides instead of technical papers as an illustration of the problematic methods of technical communication at NASA.[11]

The Board makes an explicit comparison: some tools are better than others for engineering, and technical reports are better than PowerPoint.

THEN, 2 years later, 7 members of the Return to Flight Task Group, a powerful external review group created by NASA to monitor the post-Columbia repairs of the shuttle, had something to say about engineering by PowerPoint. After seeing hundreds of PP decks from NASA and its contractors, the Task Group made direct comparisons of alternative presentation tools for engineering analysis and documentation:

> We also observed that instead of concise engineering reports, decisions and their associated rationale are often contained solely within Microsoft Power-Point charts or emails. The CAIB report (vol. 1, pp. 182 and 191) criticized the use of PowerPoint as an engineering tool, and other professional organizations have also noted the increased use of this presentation software as a substitute for technical reports and other meaningful documentation. PowerPoint (and similar products by other vendors), as a method to provide talking points and present limited data to assembled groups, has its place in the engineering community; however, these presentations should never be allowed to replace, or even supplement, formal documentation.
>
> Several members of the Task Group noted, as had CAIB before them, that many of the engineering packages brought before formal control boards were documented *only* in PowerPoint presentations. In some instances, requirements are defined in presentations, approved with a cover letter, and never transferred to formal documentation. Similarly, in many instances when data was requested by the Task Group, a PowerPoint presentation would be delivered without supporting engineering documentation. It appears that many young engineers do not understand the need for, or know how to prepare, formal engineering documents such as reports, white papers, or analyses.[12]

[10] "Columbia Evidence—Analysis of Key Slide," March 18, 2003, Ask E.T. forum, www.edwardtufte.com

[11] Columbia Accident Investigation Board, *Report*, vol. 1 (August 2003), 191.

[12] Dan L. Crippen, Charles C. Daniel, Amy K. Donahue, Susan J. Helms, Susan Morrisey Livingstone, Rosemary O'Leary, William Wegner, "A.2, Observations," in *Final Report of the Return to Flight Task Group* (July 2005), 190.

The Return to Flight Task Group made their evaluations and decisions based on closure packages that described the post-Columbia shuttle repairs. In the final report, 7 Task Group members reported that these "inadequate and disorganized" packages, often huge decks of PP slides, provoked "our frustration."[13]

> Closure packages, which should have represented the auditable, documented status of the NASA implementation of the CAIB recommendations, tended to rely on mass, rather than accuracy, as proof of closure. The closure packages showed an organization that apparently still believes PowerPoint presentations adequately explain work and document accomplishments.[14]

In an example of the pitch culture in action, some closure packages were provided prematurely to the Return to Flight Task Group in apparent behind-the-scenes maneuvers to discover just what it might take to get approval for the post-accident shuttle repairs. The idea might have been that if it is too late to change the engineering, then change the pitch about the engineering. The Task Group thus found it necessary to repeat Richard Feynman's famous conclusion to his report on the first shuttle accident, the 1986 loss of the Challenger: "For a successful technology, reality must take precedence over public relations, for Nature cannot be fooled."[15]

By using PP to report technical work, presenters quickly damage their credibility—as was the case for NASA administrators and engineers pitching their usual PP decks to these 2 very serious review boards.

Both the Columbia Accident Investigation Board and the Return to Flight Task Group were filled with smart experienced people with spectacular credentials. These review boards examined what is probably the best evidence available on PP for technical work: hundreds of PP decks from a high-IQ government agency thoroughly practiced in PP. Both review boards concluded that (1) PowerPoint is an inappropriate tool for engineering reports, presentations, documentation and (2) the technical report is superior to PP. Matched up against alternative tools, PowerPoint lost.

Serious problems require a serious tool: written reports. For nearly all engineering and scientific communication, instead of PowerPoint, *the presentation and reporting software should be a word-processing program* capable of capturing, editing, and publishing text, tables, data graphics, images, and scientific notation. Replacing PowerPoint with Microsoft Word (or, better, a tool with non-proprietary universal formats) will make presentations and their audiences smarter. Of course full-screen projected images and videos are necessary; that is the one harmless use of PP. Meetings should center on concisely written reports on paper, not fragmented bulleted talking points projected up on the wall. A good model for the technical report is a scientific paper or commentary on a paper published in substantial scientific journals such as *Nature* or *Science*.

[13] *Final Report of the Return to Flight Task Group* (July 2005) 195.

[14] *Final Report of the Return to Flight Task Group* (July 2005), 195.

[15] Richard P. Feynman, *"What Do You Care What Other People Think? Further Adventures of a Curious Character* (New York, 1988), 237; and quoted by the *Final Report of the Return to Flight Task Group* (July 2005), 194.

High-Resolution Visual Channels Are Compromised by PowerPoint

A TALK, which proceeds at a pace of 100 to 160 spoken words per minute, is not an especially high-resolution method of data transmission. Rates of transmitting *visual* evidence can be far higher. The artist Ad Reinhardt said, "As for a picture, if it isn't worth a thousand words, the hell with it." People can quickly look over tables with hundreds of numbers in the financial or sports pages in newspapers. People read 300 to 1,000 printed words a minute, and find their way around a printed map or a 35 mm slide displaying 5 to 40 MB in the visual field. Often the visual channel is an intensely high-resolution channel.

Yet, in a strange reversal, nearly all PowerPoint slides that accompany talks have much *lower* rates of information transmission than the talk itself. Too often the images are content-free clip art, the statistical graphics don't show data, and the text is grossly impoverished. As shown in this table, *the PowerPoint slide typically shows 40 words, which is about 8 seconds of silent reading material.* The example slides in PP textbooks are particularly disturbing: in 28 books, which should use first-rate examples, the median number of words per slide is 15, worthy of billboards, about 3 or 4 seconds of silent reading material.

This poverty of content has several sources. *The PP design style,* which uses about 40% to 60% of the space available on a slide to show unique content, with remaining space devoted to Phluff, bullets, frames, and branding. The *slide projection of text,* which requires very large type so the audience can see the words. Most importantly, *presenters who don't have all that much to say* (for example, among the 2,140 slides reported in this table, the really lightweight slides are found in the presentations made by educational administrators and their PR staff).

A vicious circle results. Thin content leads to boring presentations. To make them unboring, PP Phluff is added, damaging the content, making the presentation even more boring, requiring more Phluff

What to do? For serious presentations, it will be useful to replace PowerPoint slides with paper handouts showing words, numbers, data graphics, images together. High-resolution handouts allow viewers to contextualize, compare, narrate, and recast evidence. In contrast, data-thin, forgetful displays tend to make audiences ignorant and passive, and also to diminish the credibility of the presenter. Thin visual content prompts suspicions: "What are they leaving out? Is that all they know? Does the speaker think we're stupid?" "What are they hiding?" Sometimes PowerPoint's low resolution is said to promote a clarity of reading and thinking. Yet in visual reasoning, art, typography, cartography, even sculpture, *the quantity of detail is an issue completely separate from the difficulty of reading.*[16] Indeed, quite often, the more intense the detail, the *greater* the clarity and understanding—because meaning and reasoning are relentlessly *contextual.* Less is a bore.

WORDS ON TEXT-ONLY POWERPOINT SLIDES	
26 slides in the 3 Columbia reports by Boeing, median number of words per slide	97
1,460 text-only slides in 189 PP reports posted on the internet and top-ranked by Google, March 2003, median number of words per slide	40
654 slides in 28 PowerPoint textbooks, published 1997-2003, median number of words per slide	15

[16] Edward Tufte, *Envisioning Information* (Cheshire, Connecticut, 1990), 36-51.

Sentences Are Smarter Than The Grunts of Bullet Lists

LISTS often serve well for prompts, reminders, outlines, filing, and possibly for quick no-fooling-around messages. Lists have diverse architectures: elaborately ordered to disordered, linearly sequential to drifting in 2-space, and highly calibrated hierarchies of typographic dingbats to free-wheeling dingbat dingbats. In the construction of lists, a certain convenience derives from their lack of syntactic and intellectual discipline, as each element simply consists of scattered words in fragmented pre-sentence grunts.

PowerPoint promotes the hierarchical bullet list, as exemplified in the Columbia slides. The hierarchical bullet list is surely the most widely used format in corporate and government presentations. Slides are filled with over-twiddly structures with some space left over for content. Sometimes the hierarchies are so complex and intensely nested that they resemble computer code, a lousy metaphor for presentations. These formats usually require deeply indented lines for elements consisting of a few words, the power points. The more elaborate the hierarchy, the greater the loss of explanatory resolution, as the container dominates the thing contained.

It is thoughtless and arrogant to replace the sentence as the basic unit for explaining something. Especially as the byproduct of some marketing presentation software.

For the naive, bullet lists may create the appearance of hard-headed organized thought. But in the reality of day-to-day practice, the PP cognitive style is faux-analytical, with a bias towards promoting effects without causes. A study in the *Harvard Business Review* found generic, superficial, simplistic thinking in bullet lists widely used in business planning and corporate strategy:

> In every company we know, planning follows the standard format of the bullet outline... [But] bullet lists encourage us to be lazy ...
>
> **Bullet lists are typically too generic.** They offer a series of things to do that could apply to any business. . . .
>
> **Bullets leave critical relationships unspecified.** Lists can communicate only three logical relationships: sequence (first to last in time); priority (least to most important or vice versa); or simple membership in a set (these items relate to one another in some way, but the nature of that relationship remains unstated). And a list can show only one of those relationships at a time.[17]

[17] Gordon Shaw, Robert Brown, Philip Bromiley, "Strategic Stories: How 3M is Rewriting Business Planning," *Harvard Business Review*, 76 (May-June, 1998), 44.

Shaw, Brown, and Bromiley found bullets leave "critical assumptions about how the business works unstated," and also displace narratives, an effective tool for thinking and for presentations. They describe, as we saw in the previous chapter on evidence corruption, the weakness of bullet outlines for thinking about causality, the fundamental idea behind strategic planning and, indeed, analytical thinking in general.

For scientists and engineers, a good way to help raise the quality of an analysis is to ask "What would Richard Feynman do?" The Feynman Principle can help with the presentation of scientific and engineering results. Feynman experienced the intense bullet outline style in his work on the first shuttle accident, the Challenger in 1986. He expressed his views clearly:

> Then we learned about "bullets"—little black circles in front of phrases that were supposed to summarize things. There was one after another of these little goddamn bullets in our briefing books and on slides.[18]

As analysis becomes more causal, multivariate, comparative, evidence-based, and resolution-intense, the more damaging the bullet list becomes. Scientists and engineers have communicated about complex matters for centuries without bullets and without PP. Richard Feynman wrote about much of physics—from classical mechanics to quantum electrodynamics—in 3 textbook volumes totalling 1,800 pages. These books use no bullets and only 2 levels of hierarchy, chapters and subheads within chapters:

[18] Richard P. Feynman, *"What Do You Care What Other People Think?"* (New York, 1988), 126-127.

front is an integral number of wavelengths. This difference can be seen to be $2d \sin \theta$, where d is the perpendicular distance between the planes. Thus the condition for coherent reflection is

$$2d \sin \theta = n\lambda \qquad (n = 1, 2, \ldots). \qquad (38.9)$$

If, for example, the crystal is such that the atoms happen to lie on planes obeying condition (38.9) with $n = 1$, then there will be a strong reflection. If, on the other hand, there are other atoms of the same nature (equal in density) halfway between, then the intermediate planes will also scatter equally strongly and will interfere with the others and produce no effect. So d in (38.9) must refer to *adjacent* planes; we cannot take a plane five layers farther back and use this formula!

As a matter of interest, actual crystals are not usually as simple as a single kind of atom repeated in a certain way. Instead, if we make a two-dimensional analog, they are much like wallpaper, in which there is some kind of figure which repeats all over the wallpaper. By "figure" we mean, in the case of atoms, some arrangement—calcium and a carbon and three oxygens, etc., for calcium carbonate, and so on—which may involve a relatively large number of atoms. But whatever it is, the figure is repeated in a pattern. This basic figure is called a *unit cell*.

The basic pattern of repetition defines what we call the *lattice type*; the lattice type can be immediately determined by looking at the reflections and seeing what their symmetry is. In other words, where we find any reflections *at all* determines the lattice type, but in order to determine what is in each of the elements of the lattice one must take into account the *intensity* of the scattering at the various directions. *Which* directions scatter depends on the type of lattice, but *how strongly* each scatters is determined by what is inside each unit cell, and in that way the structure of crystals is worked out.

Two photographs of x-ray diffraction patterns are shown in Figs. 38-5 and 38-6; they illustrate scattering from rock salt and myoglobin, respectively.

Incidentally, an interesting thing happens if the spacings of the nearest planes are less than $\lambda/2$. In this case (38.9) has no solution for n. Thus if λ is bigger than twice the distance between adjacent planes then there is no side diffraction pattern, and the light—or whatever it is—will go right through the material without bouncing off or getting lost. So in the case of light, where λ is much bigger than the spacing, of course it does go through and there is no pattern of reflection from the planes of the crystal.

This fact also has an interesting consequence in the case of piles which make neutrons (these are obviously particles, for anybody's money!). If we take these neutrons and let them into a long block of graphite, the neutrons diffuse and work their way along (Fig. 38-7). They diffuse because they are bounced by the atoms, but strictly, in the wave theory, they are bounced by the atoms because of diffraction from the crystal planes. It turns out that if we take a very long piece of graphite, the neutrons that come out the far end are all of long wavelength! In fact, if one plots the intensity as a function of wavelength, we get nothing except for wavelengths longer than a certain minimum (Fig. 38-8). In other words, we can get very slow neutrons that way. Only the slowest neutrons come through; they are not diffracted or scattered by the crystal planes of the graphite, but keep going right through like light through glass, and are not scattered out the sides. There are many other demonstrations of the reality of neutron waves and waves of other particles.

38-4 The size of an atom

We now consider another application of the uncertainty relation, Eq. (38.3). It must not be taken too seriously; the idea is right but the analysis is not very accurate. The idea has to do with the determination of the size of atoms, and the fact that, classically, the electrons would radiate light and spiral in until they settle down right on top of the nucleus. But that cannot be right quantum-mechanically because then we would know where each electron was and how fast it was moving.

38-5

Figure 38-5

Figure 38-6

Fig. 38-7. Diffusion of pile neutrons through graphite block.

Fig. 38-8. Intensity of neutrons out of graphite rod as function of wavelength.

Page layout from Richard P. Feynman, Robert B. Leighton, and Matthew Sands, *The Feynman Lectures on Physics* (Reading, Massachusetts, 1963), volume 1, 38-5.

*The Gettysburg PowerPoint Presentation
by Peter Norvig*

The PP cognitive style is so distinctive and
peculiar that presentations relying on standard
ready-made templates sometimes appear as
over-the-top parodies instead of the sad
realities they are. Here is an intentional and
ferocious parody: imagine Abraham Lincoln
had used PowerPoint at Gettysburg. . . .

*Um, my name is Abraham Lincoln and, um,
I must now reboot*

*As we see in the Organizational Overview slide,
four score and seven years ago our fathers brought
forth on this continent a new nation, conceived
in liberty and dedicated to the proposition that all
men are created equal. Now we are engaged in
a great civil war, testing whether that nation or
any nation so conceived and so dedicated can long
endure. Next slide please. We are met on a great
battlefield of that war. We have come to dedicate
a portion of that field as a final resting place for
those who here gave their lives that that nation
might live. It is altogether fitting and proper that
we should do this. But in a larger sense, we
cannot dedicate, we cannot consecrate, we cannot
hallow this ground. The brave men, living and
dead who struggled here have consecrated it far
above our poor power to add or detract. Next
slide please. The world will little note nor long
remember what we say here, but it can never
forget what they did here. It is for us the living
rather to be dedicated here to the unfinished work
which they who fought here have thus far so*

nobly advanced. It is rather for us to be here dedicated to the great task remaining before us— that from these honored dead we take increased devotion to that cause for which they gave the last full measure of devotion, next slide please, that we here highly resolve that these dead shall not have died in vain, that this nation under God shall have a new birth of freedom, and that government of the people, by the people, for the people, shall not perish from the earth.

This PowerPoint presentation was created by Peter Norvig; see www.norvig.com. The graph showing "-87 years" for Lincoln's "four score and seven years ago" is brilliant. Norvig notes that other slides were quickly constructed by means of the PP AutoContent Wizard. Ian Parker described PowerPoint's AutoContent Wizard as "a rare example of a product named in outright mockery of its target customers" (*The New Yorker*, May 28, 2001, 76).

PowerPoint and Statistical Evidence

To investigate the performance of PP for statistical data, let us consider an important and intriguing table of cancer survival rates relative to those without cancer for the same time period. Some 196 numbers and 57 words describe survival rates and their standard errors for 24 cancers:

Estimates of relative survival rates, by cancer site[19]

	% survival rates and their standard errors							
	5 year		10 year		15 year		20 year	
Prostate	98.8	0.4	95.2	0.9	87.1	1.7	81.1	3.0
Thyroid	96.0	0.8	95.8	1.2	94.0	1.6	95.4	2.1
Testis	94.7	1.1	94.0	1.3	91.1	1.8	88.2	2.3
Melanomas	89.0	0.8	86.7	1.1	83.5	1.5	82.8	1.9
Breast	86.4	0.4	78.3	0.6	71.3	0.7	65.0	1.0
Hodgkin's disease	85.1	1.7	79.8	2.0	73.8	2.4	67.1	2.8
Corpus uteri, uterus	84.3	1.0	83.2	1.3	80.8	1.7	79.2	2.0
Urinary, bladder	82.1	1.0	76.2	1.4	70.3	1.9	67.9	2.4
Cervix, uteri	70.5	1.6	64.1	1.8	62.8	2.1	60.0	2.4
Larynx	68.8	2.1	56.7	2.5	45.8	2.8	37.8	3.1
Rectum	62.6	1.2	55.2	1.4	51.8	1.8	49.2	2.3
Kidney, renal pelvis	61.8	1.3	54.4	1.6	49.8	2.0	47.3	2.6
Colon	61.7	0.8	55.4	1.0	53.9	1.2	52.3	1.6
Non-Hodgkin's	57.8	1.0	46.3	1.2	38.3	1.4	34.3	1.7
Oral cavity, pharynx	56.7	1.3	44.2	1.4	37.5	1.6	33.0	1.8
Ovary	55.0	1.3	49.3	1.6	49.9	1.9	49.6	2.4
Leukemia	42.5	1.2	32.4	1.3	29.7	1.5	26.2	1.7
Brain, nervous system	32.0	1.4	29.2	1.5	27.6	1.6	26.1	1.9
Multiple myeloma	29.5	1.6	12.7	1.5	7.0	1.3	4.8	1.5
Stomach	23.8	1.3	19.4	1.4	19.0	1.7	14.9	1.9
Lung and bronchus	15.0	0.4	10.6	0.4	8.1	0.4	6.5	0.4
Esophagus	14.2	1.4	7.9	1.3	7.7	1.6	5.4	2.0
Liver, bile duct	7.5	1.1	5.8	1.2	6.3	1.5	7.6	2.0
Pancreas	4.0	0.5	3.0	1.5	2.7	0.6	2.7	0.8

[19] Redesigned table based on Hermann Brenner, "Long-term survival rates of cancer patients achieved by the end of the 20th century: a period analysis," *The Lancet,* 360 (12 October 2002), 1131-1135. Brenner recalculates survival rates from data collected by the U.S. National Cancer Institute, 1973-1998, from the Surveillance, Epidemiology, and End Results Program.

Applying the PowerPoint templates for statistical graphics to this nice straightforward table yields the analytical disasters on the facing page. These PP default-designs cause the data to explode into 6 separate chaotic slides, consuming 2.9 times the area of the table. *Everything* is wrong with these smarmy, incoherent graphs: uncomparative, thin data-density, chartjunk, encoded legends, meaningless color, logotype branding, indifference to content and evidence. Chartjunk is a clear sign of statistical stupidity; use these designs in your presentation, and your audience will quickly and correctly conclude that you don't know much about data and evidence.[20] Poking a finger into the eye of thought, these data graphics would turn into a nasty travesty if used for

[20] PP-style chartjunk occasionally shows up in graphics of evidence in scientific journals. Below, the clutter half-conceals the thin data with some vibrating pyramids framed by an unintentional Necker illusion, as the 2 back planes optically flip to the front:

For such small data sets, usually a simple table will show the data more effectively than a graph, let alone a chartjunk graph. Source of graph: N. T. Kouchoukos, *et al.,* "Replacement of the Aortic Root with a Pulmonary Autograft in Children and Young Adults with Aortic-Valve Disease," *New England Journal of Medicine,* 330 (January 6, 1994), 4. On chartjunk, see Edward R. Tufte, *The Visual Display of Quantitative Information* (1983, 2001), chapter 5.

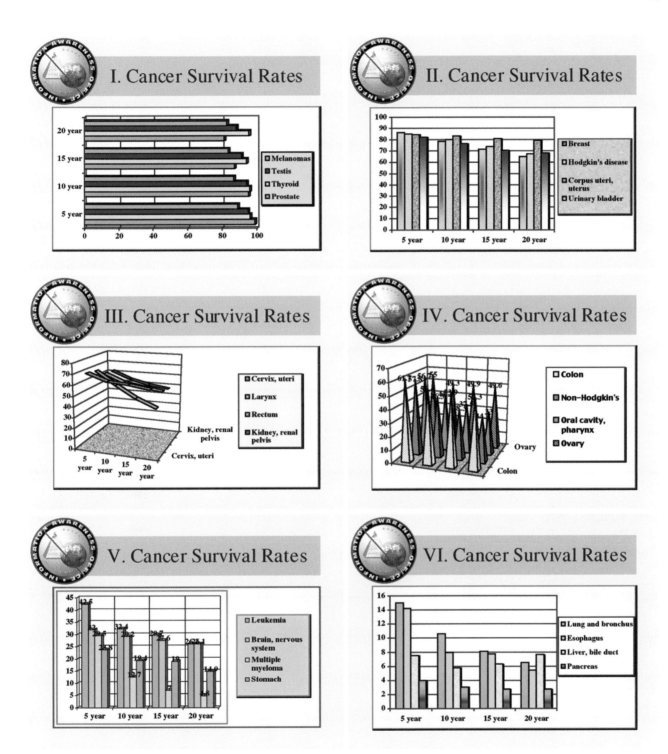

a serious purpose, such as cancer patients seeking to assess their survival chances. To deal with a product that messes up data with such systematic intensity must require an enormous insulation from statistical integrity and statistical reasoning by Microsoft PP executives and programmers, PP textbook writers, and presenters of such chartjunk.

The best way to show the cancer data is the original table with its good
comparative structure and reporting of standard errors. And PP default
graphics are not the way to see the data. Our table-graphic, however,
does give something of a *visual idea* of time-gradients for survival for
each cancer. Like the original table, every visual element in the graphic
shows data. Slideware displays, in contrast, usually devote a majority of
their space to things other than data.

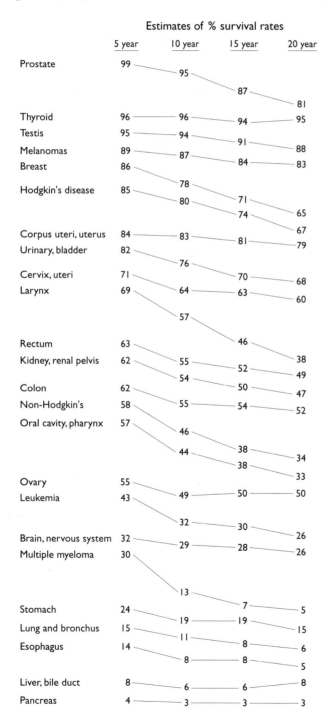

Estimates of % survival rates

	5 year	10 year	15 year	20 year
Prostate	99	95	87	81
Thyroid	96	96	94	95
Testis	95	94	91	88
Melanomas	89	87	84	83
Breast	86	78	71	65
Hodgkin's disease	85	80	74	67
Corpus uteri, uterus	84	83	81	79
Urinary, bladder	82	76	70	68
Cervix, uteri	71	64	63	60
Larynx	69	57	46	38
Rectum	63	55	52	49
Kidney, renal pelvis	62	54	50	47
Colon	62	55	54	52
Non-Hodgkin's	58	46	38	34
Oral cavity, pharynx	57	44	38	33
Ovary	55	49	50	50
Leukemia	43	32	30	26
Brain, nervous system	32	29	28	26
Multiple myeloma	30	13	7	5
Stomach	24	19	19	15
Lung and bronchus	15	11	8	6
Esophagus	14	8	8	5
Liver, bile duct	8	6	6	8
Pancreas	4	3	3	3

PowerPoint Stylesheets

THE PP cognitive style is propagated by the templates, textbooks, stylesheets, and complete pitches available for purchase. Some corporations and government agencies *require* employees to use designated PP Phluff and presentation logo-wear. With their strict generic formats, these designer stylesheets serve only to enforce the limitations of PowerPoint, compromising the presenter, the content, and, ultimately, the audience.

Jane said, "Here is a ball.
See this blue ball, Sally.
Do you want this ball?"

Sally said, "I want my ball.
My ball is yellow.
It is a big, pretty ball."

Here we see a witless PP pitch on how to make a witless PP pitch. Prepared at the Harvard School of Public Health by the "Instructional Computing Facility," these templates are uninformed by the practices of scientific publication and the rich intellectual history of evidence and analysis in public health. The templates do, however, emulate the format of reading primers for 6 year-olds.

Stylesheet-makers often seek to leave *their* name on *your* show; "branding," as they say in the Marketing Department. In case you didn't notice, this presentation is from the "Instructional Computing Facility." But where are the names of the people responsible for this? No names appear on any of the 21 slides.

This must be the Haiku Rule for formatting scientific lectures. At least we're not limited to 17 syllables per slide. Above this slide, the rule can be seen in action—in a first-grade reading primer. The stylesheet typography, distinctly unscientific, uses a capital X instead of a multiplication sign.

But this breaks up the evidence into arbitrary fragments. Why aren't we seeing examples from actual scientific reports? What are the Sox (a rather parochial reference) doing here? The inept PP typography persists: strange over-active indents, oddly chosen initial caps, typographic orphans on 3 of 4 slides.

Why is this relevant to scientific presentations? Are there other principles than ease of following? Didn't the *Harvard Business Review* article indicate that bullet outlines corrupt thought? Text, imaging, and data for scientific presentations should be at the level of scientific journals, much *higher* resolution than speech.

Instructional Computing Facility			
Use Simple Tables to Present Numbers			
	Use Tables	For Your Numbers	But Not too Many
This row	10	90	100
This row	0.6	0.4	1
This row	1	2	3
That row	1	2	3

Try not to make footnotes too small

Harvard School of Public Health

The stylesheet goes on to victimize statistical data, the fundamental evidence of public health. The table shows 12 numbers which is lousy for science, sports, weather, or financial data but standard for PowerPoint.[21] Table design is a complex and subtle matter in typographic work, but there is nothing thoughtful about design here. The unsourced numbers are not properly aligned, the row and column labels are awful, the units of measurement not given. This stylesheet of pseudoscience displays a flippant smirky attitude toward evidence. That attitude—*what counts are power and pitches, not truth and evidence*—also lurks within PowerPoint.

Consider now a real table. Bringing scientific methods to medical and demographic evidence, John Graunt's *Bills of Mortality* (1662) is the foundation work of public health. Graunt calculated the first tables of life expectancy, compared different causes of death, and even discussed defects in the evidence. His renowned "Table of Casualties" (at right) shows 1,855 different counts of death from 1629 to 1659. How fortunate that Graunt did not have PowerPoint and the assistance of the Harvard School of Public Health Instructional Computing Facility. Their silly guidelines above suggest the construction of 155 separate PowerPoint slides to show the data in Graunt's original table!

For tables, the analytical idea is to make comparisons. The number of possible pairwise comparisons in a table increases as the square of the number of cells.[22] In Graunt's table, 1,719,585 pairwise comparisons, of varying relevance to be sure, are within the eyespan of the inquiring mind. In contrast, the 155 tiny tables on 155 PP slides would offer only 10,230 pairwise comparisons, about 6 in 1,000 of those available in Graunt's original table. These PP tables would also block all sorts of interesting comparisons, such as time patterns over many years. What Graunt needs to do for his presentation at Harvard is simply to provide printed copies of his original table to everyone in the audience.

[21] Some 39 tables appear in our collection of 28 PP textbooks. These tables show an average (median) of 12 numbers each, which approaches the *Pravda* level. In contrast, sports and financial pages in newspapers routinely present tables with hundreds, even thousands of numbers. Below, we see a conventional weather table from a newspaper. The Harvard School of Public Health PP guidelines inform presenters that this data set will require 31 PP slides:

Africa	Yesterday	Today	Tomorrow
Algiers	82/ 66 0.55	85/ 60 S	85/ 61 S
Cairo	99/ 70 0	101/ 76 S	96/ 76 S
Cape Town	64/ 54 0.16	63/ 49 PC	60/ 50 Sh
Dakar	87/ 77 0.75	86/ 81 PC	85/ 81 PC
Johannesburg	69/ 42 0	73/ 42 S	71/ 47 S
Nairobi	75/ 55 0	78/ 56 PC	78/ 56 PC
Tunis	80/ 69 –	87/ 73 PC	85/ 71 PC
Asia/Pacific	**Yesterday**	**Today**	**Tomorrow**
Auckland	59/ 45 0.12	58/ 44 Sh	58/ 44 Sh
Bangkok	91/ 82 0	91/ 79 Sh	91/ 77 Sh
Beijing	85/ 57 0	84/ 60 S	78/ 65 PC
Bombay	88/ 75 0.28	87/ 77 T	88/ 78 T
Damascus	96/ 55 0	98/ 59 S	96/ 62 S
Hong Kong	91/ 77 0	88/ 81 PC	92/ 78 PC
Jakarta	89/ 77 0	90/ 77 PC	89/ 77 PC
Jerusalem	87/ 64 0	88/ 66 S	88/ 69 S
Karachi	86/ 80 0	92/ 78 PC	92/ 79 S
Manila	86/ 75 –	84/ 75 R	87/ 78 R
New Delhi	89/ 80 Tr	88/ 76 Sh	92/ 76 Sh
Riyadh	98/ 69 0	102/ 74 S	101/ 75 S
Seoul	78/ 64 2.09	83/ 65 PC	77/ 66 R
Shanghai	75/ 69 0.06	86/ 76 Sh	86/ 73 PC
Singapore	87/ 78 Tr	89/ 76 R	89/ 78 Sh
Sydney	68/ 53 0	71/ 51 PC	71/ 48 PC
Taipei	84/ 77 2.28	87/ 73 PC	88/ 72 PC
Tehran	93/ 73 0	87/ 73 S	87/ 73 S
Tokyo	89/ 77 0	91/ 79 Sh	83/ 80 Sh
Europe	**Yesterday**	**Today**	**Tomorrow**
Amsterdam	56/ 50 0.39	66/ 51 PC	64/ 52 Sh
Athens	87/ 75 0	90/ 75 S	88/ 71 S
Berlin	64/ 55 0.31	61/ 49 R	68/ 52 PC
Brussels	62/ 54 Tr	66/ 53 PC	65/ 52 Sh
Budapest	72/ 59 0	75/ 55 S	67/ 53 Sh
Copenhagen	59/ 51 0.08	63/ 51 Sh	63/ 52 PC
Dublin	66/ 54 0.12	66/ 55 Sh	63/ 47 PC
Edinburgh	63/ 46 0.02	63/ 46 R	64/ 48 PC
Frankfurt	65/ 54 0.01	65/ 54 Sh	66/ 50 PC
Geneva	69/ 57 0.04	64/ 56 Sh	65/ 50 PC
Helsinki	63/ 45 0	62/ 46 PC	63/ 45 PC
Istanbul	84/ 60 0.01	79/ 69 Sh	78/ 67 S
Kiev	66/ 46 0	64/ 47 S	64/ 46 S
Lisbon	84/ 62 0	91/ 65 S	90/ 67 S
London	71/ 53 0.08	66/ 53 Sh	69/ 55 PC
Madrid	86/ 46 0	87/ 55 S	87/ 57 S
Moscow	55/ 41 0	64/ 40 S	62/ 44 S
Nice	78/ 62 0.01	78/ 65 S	78/ 63 S
Oslo	62/ 48 0	57/ 47 PC	59/ 45 PC
Paris	68/ 57 0	69/ 56 PC	68/ 57 PC
Prague	64/ 55 0.04	56/ 49 T	63/ 49 Sh
Rome	75/ 62 –	79/ 61 S	76/ 60 Sh
St. Petersburg	59/ 39 0	66/ 46 S	65/ 47 PC
Stockholm	64/ 46 0	61/ 49 PC	63/ 45 PC
Vienna	64/ 59 0.16	65/ 53 PC	66/ 52 Sh
Warsaw	69/ 46 0	62/ 51 Sh	65/ 49 PC

[22] A table with *n* cells yields $n(n - 1)/2$ pairwise comparisons of cell entries.

John Graunt, *National and Political Observations mentioned in a following index, and made upon the Bills of Mortality. With reference to the Government, Religion, Trade, Growth, Ayre, Diseases, and the several Changes of the said City* (London, 1662); "The Table of Casualties" follows folio 74.

THE TABLE OF CASUALTIES.

The Years of our Lord	1647	1648	1649	1650	1651	1652	1653	1654	1655	1656	1657	1658	1659	1660	1629	1630	1631	1632	1633	1634	1635	1636	1629–1632	1633–1636	1647–1650	1651–1654	1655–1658	1629, 1649, 1659	In 20 Years.	
Abortive, and ftilborn	335	329	327	351	389	381	384	433	483	419	463	467	421	544	499	439	410	445	500	475	507	523	1793	2005	1342	1587	1832	1247	8559	
Aged	916	835	889	696	780	834	864	974	743	892	869	1176	909	1095	579	712	661	671	704	623	794	714	2475	2814	3336	3452	3680	2377	15757	
Ague, and Fever	1260	884	751	970	1038	1212	1282	1371	689	875	999	1800	2303	2148	956	1091	1115	1108	953	1279	1622	2360	4418	6235	3865	4903	4363	4010	23784	
Apoplex, and fodainly	68	74	64	74	106	111	118	86	92	102	113	138	91	67	22	36			17	24	35	26	75	85	280	421	445	177	1306	
Bleach			1	3	7	2				1														4	9	1	1		15	
Blafted	4	1			6	6			4		5	5	3	8	13	8	10	13	6	4		4	54	14	5	12	14	16	99	
Bleeding	3	2	5	1	3	4	3	2	7	3	5	4	7	2	5	2	5	4	4	3			16	7	11	12	19	17	65	
Bloudy Flux, Scouring, and Flux	155	176	802	289	833	762	200	386	168	368	362	233	346	251	449	438	352	348	278	512	346	330	1587	1466	1422	2181	1161	1597	7818	
Burnt, and Scalded	3	6	10		5	11	8	5	7	10	5	7	4	6	3	10	7	5	1		3	12	25	19	24	31	26	19	125	
Calenture	1			1		2	1	1			3									1		3		4	2	4		3	13	
Cancer, Gangrene, and Fiftula	26	29	31	19	31	53	36	37	73	31	24	35	63	52	20	14	23	28	27	30	24	30	85	112	105	157	150	114	609	
Wolf																						8		8					8	
Canker, Sore-mouth, and Thrufh	66	28	54	42	68	51	53	72	44	81	19	27	73	68	6	4	4	1				5	15	79	190	244	161	133	689	
Childbed	161	106	114	117	206	213	158	192	177	201	236	225	226	194	150	157	112	171	132	143	163	230	590	668	498	769	839	490	3364	
Chrifomes, and Infants	1369	1254	1065	990	1237	1280	1050	1343	1089	1393	1162	1144	858	1123	2596	2378	2035	2268	2130	2315	2113	1895	9277	8453	4678	4910	4788	4519	32106	
Colick, and Wind	103	71	85	82	76	102	80	101	85	120	113	179	116	167	48	57					37	50	105	87	341	359	497	247	1389	
Cold, and Cough								41	36	21	58	30	31	33	24	10	58	51	55	45	54	50	57	174	207	00	77	140	598	
Confumption, and Cough	2423	2200	2388	1988	2350	2410	2286	2868	2606	3184	2757	3610	2982	3414	1827	1910	1713	1797	1754	1955	2080	2477	5157	8266	8999	9914	12157	7197	44487	
Convulfion	684	491	530	493	569	653	606	828	702	1027	807	841	742	1031	52	87	18	241	221	386	418	709	498	1734	2198	2656	3377	1324	9073	
Cramp				1																										
Cut of the Stone	2	1	2	1	3		1	1	2	4	1	3							5	1	5	2	2	5	6	10	6	13	47	
Dropfy, and Tympany	185	434	421	508	444	556	617	704	660	706	631	931	646	872	235	252	279	280	266	250	329	389	1048	1734	1538	2321	2982	1302	9623	
Drowned	47	40	30	27	49	50	53	30	43	45	63	60	57	48	43	33	29	34	37	32	32	45	139	147	144	182	215	130	827	
Exceffive drinking			2																								2		2	
Executed	8	17	29	43	24	12	19	21	19	22	20	18	7	18	19	13	12	18	13	13	13	13	62	52	97	76	79	55	384	
Fainted in a Bath					1																					1			1	
Falling-Sicknefs	3	2	2	3		3	4	1	4	3	1		4	5	3	10	7	7	2	5	6	8	27	21	10	8	8	9	74	
Flox, and fmall pox	139	400	1190	184	525	1279	139	812	1294	823	835	409	1523	354	72	40	58	531	72	1354	293	127	701	1846	1913	2755	3361	2785	10576	
Found dead in the Streets	6	6	9	8	7	9	14	4	3	4	9	11	2	6	18	33	26	6	13	8	24	24	83	69	29	34	27	29	243	
French-Pox	18	29	15	18	21	20	20	20	29	23	25	53	51	31	17	12	12	12	7	17	12	22	53	48	80	81	130	83	392	
Frighted	4	4	1		3		2		1	1			9	1		1							2	3	9	5	2	2	21	
Gout	9	5	12	9	7	7	5	6	8	7	8	13	14	2	2	5	3	4	4	5	7	8	14	24	35	25	36	28	134	
Grief	12	13	16	7	17	14	11	17	10	13	10	12	13	4	18	20	22	11	14	17	5	20	71	56	48	59	45	47	279	
Hanged, and made-away themfelves	11	10	13	14	9	14	15	9	14	16	24	18	11	36	8	8	6	15			3	8	37	18	48	47	72	32	222	
Head-Ach		1	11	2		2	6	6	5	3	4	5	35	26								4		6	14	14	17	46	051	
Jaundice	57	35	39	49	41	43	57	71	61	41	46	77	102	76	47	59	35	43	35	45	54	63	184	197	180	212	225	188	998	
Jaw-faln	1	1		1			3			2			3	1	10	16	13	8	10	10	4	11	47	35	02	5	6	10	95	
Impoftume	75	61	65	59	80	105	79	90	92	122	80	134	105	96	58	76	73	74	50	62	73	130	282	315	260	354	428	228	1639	
Itch		1																			10			00	10	01			11	
Killed by feveral Accidents	27	57	39	94	47	45	57	58	52	43	52	47	55	47	54	55	47	46	49	41	51	60	202	201	217	207	194	148	1021	
King's Evil	27	26	22	19	22	20	26	26	27	24	23	28	28	54	16	25	18	38	35	20	26	69	97	150	94	94	102	66	537	
Lethargy	3	4	2	4	4	4	3	10	9	4	6	2	6	4	1		2	2	3		2	2	5	7	13	21	21	9	67	
Leprofy				1								1			2	2						2	2	1	1	1	3	06		
Livergrown, Spleen, and Rickets	53	46	56	59	65	72	67	65	52	50	38	51	8	15	94	112	99	87	82	77	98	99	392	356	213	269	191	158	1421	
Lunatique	12	18	6	11	7	11	9	12	6	7	13	5	14	14	6	11	6	5	4	2	2	5	28	13	47	39	31	26	158	
Meagrom	12	13		5	8	6	6	14	3	6	7	6	5	4			24					22	24	22	30	34	22	05	132	
Meafles	5	92		33	33	62	8	52	11	153	15	80	6	74	42		3	80	21	33		12	127	83	133	155	259	51	757	
Mother	2				1	1	2	2	3		3	1	8	1			3				3	01	3	2	4	8	02	18		
Murdered	3	2	7	5	4	3	3	9	9	6	5	7	70	20			3	7		6	5	8	17	19	17	13	27	77	86	
Overlayd, and ftarved at Nurfe	25	22	36	28	28	29	30	36	58	53	44	50	46	43	4	10	13	7	8	14	10	14	34	46	111	123	215	86	529	
Palfy	27	21	19	20	23	20	29	18	22	23	20	22	17	21	17	23	17	25	14	21	25	17	82	77	87	90	87	53	423	
Plague	3597	611	67	15	23	16	6	16	9	6	4	14	36	14	1317	274	8		1			10400	1599	10401	4290	61	33	103	16384	
Plague in the Guts					1			110	32		37	315	446		253	402							00	61	142	844	253	991		
Pleurify	30	26	13	20	23	19	17	23	10	9	17	16	12			26	24	26	36	21		45	24	112	90	89	72	52	51	415
Poyfoned		3		7																2		2	00	4	10	00	00	00	14	
Purples, and fpotted Fever	145	47	43	65	54	60	75	89	56	52	56	126	368	146	32	58	58	38	24	125	245	397	186	791	300	278	290	243	1845	
Quinfy, and Sore-throat	14	11	12	17	24	20	18	9	15	13	7	10	21	14	01	8	6	7	24	04		5	22	55	54	71	45	34	247	
Rickets	150	224	216	190	260	329	229	372	347	458	317	476	441	521							14	49	50	00	113	780	1190	1598	657	3681
Mother, rifing of the Lights	150	92	115	120	134	138	135	178	166	212	203	228	210	249	44	72	99	98	60	84	72	104	309	220	777	585	809	369	2700	
Rupture	16	7	7	6	7	16	7	15	11	20	19	18	12	28	2	6	4	9	4	3	10	13	21	30	36	45	68	2	201	
Scal'd-head	2				1				2																2	1	2		05	
Scurvy	32	20	21	21	29	43	41	44	103	71	82	82	95	12	7	9		9			00	25	33	34	94	132	300	115	593	
Smothered, and ftifled			2																24					24		2		2	26	
Sores, Ulcers, broken and bruifed	15	17	17	16	26	32	25	32	23	34	40	47	61	48	23		20	48	19	19	22	29	91	89	65	115	144	141	504	
Shot　(Limbs													7	20														07	27	
Spleen	12	17				13	13		6	2	5	7	7												29	26	13	07	68	
Shingles											1					1				1							1	2		
Starved				4	8	7	1	2	1	1	3	1	3	6	7						14		19	5	13	29	51			
Stitch										1																			1	
Stone, and Strangury	45	42	29	28	50	41	44	38	49	57	72	69	22	30			58	56	58	49	33	45	114	185	144	173	247	51	863	
Sciatica													2				1	3		1	6		1		4				15	
Stopping of the Stomach	29	29	30	33	55	67	66	107	94	145	129	277	186	214							6		6	121	295	247	216	669		
Surfet	217	137	136	123	104	177	178	212	128	161	137	218	202	192	63	157	149	86	104	114	132	371	445	721	613	671	644	401	3094	
Swine-Pox	4	4	3					1	4	2	1	1					4	6	3		10	23	13	11	5	5	10	57		
Teeth, and Worms	767	597	540	598	709	905	691	1131	803	1198	878	1036	839	1008	440	506	335	470	432	454	539	1207	1751	2602	2502	3436	3915	1819	14236	
Tiffick	62	47											8	12	14	34	23	15	27	68	65	109				123	8	242		
Thrufh									57	66					15	23	17	40	28	31	34	95	93			123	15	211		
Vomiting	1	6	3	7	4	6	3	14		27	16	19	8	10	1	4	1	2	5	6	7	16	17	27	69	12	136			
Worms	147	107	105	65	85	86	53									19	31	28	27	19	28	27	105	74	424	224	124	830		
Wen	1		1		2			1		1	2	1	1				1		4			1	4	2	4	4	2	15		
Sodainly													63	59	37	62	58	62	78	34	221	233					63	454		

PP Slide Formats for Paper Reports and Computer Screens Are Ridiculous and Lazy

IN addition to accompanying a talk, PP slides are printed out on paper, attached to emails, posted on the internet. Unfortunately, PP slides on paper and computer screens *replicate and intensify* all the problems of the PP cognitive style. Such slides extend the reach of PP's proprietary closed-document format since PP capabilities are necessary to see the slides. This short-run convenience to presenters and long-run benefit to Microsoft comes at an enormous cost to the content and the audience.

As those who have disconsolately flipped through pages and pages of printed-out PP slide decks already know, such reports are physically thick and intellectually thin. Recall that the NASA Return to Flight Task Group observed a massive thinness in the PP closure reports. The resolution of printed-out slide decks is remarkably low, approaching dementia. This data table compares the information in one image-equivalent for books (one page), for the internet (one screen), and for PP (one slide). A single page in the *Physicians' Desk Reference* shows 54 typical PP slide-equivalents of information, and the whole very thick book equals a deck of 181,000 slides. A single page of an Elmore Leonard novel equals 13 typical PP slides. Nonfiction best-sellers show information at densities 10 to 50 times those of printed-out PP decks.

People see, read, and think all the time at intensities vastly greater than those presented in printed PP slides. Instead of showing a long sequence of tiny information-fragments on slides, and instead of dumping those slides onto paper, report makers should have the courtesy to write a real report (which might also be handed out at a meeting) and address their readers as serious people. PP templates are a lazy and ridiculous way to format printed reports.

PP slides also format information on computer screens. Presenters post their slides; then readers, if any, march through one slide after another on the computer screen. Popular news sites on the internet show 10 to 15 times more information on a computer screen than a typical PP slide on a computer screen. The shuttle Columbia reports prepared by Boeing, sent by email in PP format to be viewed on computer screens, were running at information densities of 20% of major news sites on the internet, as the table shows.

The PP slide format has the worst signal/noise ratio of any known method of communication on paper or computer screen. Extending PowerPoint to embrace paper and internet screens pollutes those display methods.

CHARACTER COUNTS AND DENSITY PER PAGE-IMAGE

	CHARACTERS PER PAGE	DENSITY: CHARACTERS/IN2
BEST SELLING BOOKS		
Physicians' Desk Reference	13,600	168
Your Income Tax	10,400	118
World Almanac	9,800	232
Joy of Cooking	5,700	108
The Merck Manual	4,700	117
Guinness Book of World Records	4,600	162
Consumer Reports Buying Guide	3,900	112
How to Cook Everything	3,900	53
Maximum Bob (Elmore Leonard)	3,100	115
Baby and Child Care	2,500	95
NEWS SITES ON THE INTERNET		
Google News	4,100	44
New York Times	4,100	43
People's Daily (China)	4,100	43
Pravda	4,100	43
Los Angeles Times	4,000	42
BBC News	3,400	36
CNN	3,300	35
Yahoo	3,200	34
Time	2,700	28
MSNBC	2,400	26
POWERPOINT SLIDE FORMAT USED ON PAPER OR COMPUTER SCREEN		
Columbia reports by Boeing	630	7
1,460 text slides in 189 PP reports	250	3
654 text slides in 28 PP textbooks	98	1
Content-free slides	0	0

Competitive Analysis of Presentation Tools

OUR comparisons of various presentation tools in action indicate that
PowerPoint is intellectually outperformed by alternative tools. For the
10 case studies and 32 control samples, PP flunks the comparative tests,
except for beating out *Pravda* in the statistical graphics competition.

Some of these comparisons are for *the same users with the same content.*
Matched comparisons control for selection effects, such as the entertaining
hypothesis that PP is a stupidity magnet, differentially attracting inept
presenters with lightweight content (and thereby making PP look bad).
Our evidence helps isolate PP effects, independent of user or content.
Such comparisons—*Consumer Reports* style—provide a competitive analysis
of presentation tools. In these tests, PP's poor performance cannot be
blamed on its users. For example, in the shuttle investigations, given that
the presenters are NASA engineers and the content is rocket science, which
then is the better presentation method, PP or technical reports?

The scope of our evidence is limited. Nearly all the evidence is drawn
from *serious presentations,* with explanations to understand, evidence to
evaluate, problems to solve, decisions to make, and, in several examples,
lives to save. It is hard to know how many presentations are serious.
Perhaps 25% to 75%, depending very much upon the substantive field.

What Are the Causes of Visual Presentations?

AN important but complex issue in evaluating visual presentations,
including PowerPoint, is *what are the causes of a presentation?* What are
the contributions of content quality, presenter skills, presentation methods,
cognitive styles, and prevailing standards of integrity? To begin with,
reasonably certain answers are that the causal structure is multivariate,
that causes tend to interact and are not independent of one another, and
that improvements will result from working on all factors.

George Orwell's classic essay "Politics and the English Language"
gets right the interplay between quality of thought and cognitive style of
presentation: "The English language becomes ugly and inaccurate because
our thoughts are foolish, but the slovenliness of our language makes it
easier for us to have foolish thoughts." Imagine Orwell writing about PP:
"PowerPoint becomes ugly and inaccurate because our thoughts are
foolish, but the slovenliness of PowerPoint makes it easier for us to have
foolish thoughts." The PP cognitive style is familiar to readers of
Orwell's remarkable and prescient novel *1984.*

Or consider the NASA presentations. What are the causes of the dreaded Engineering by PowerPoint? Engineers incapable of communicating by means of standard technical reports? Lack of intellectual rigor? Designer guidelines and bureaucratic norms that insist on PP for all presentations, regardless of content? The cognitive style of PowerPoint? A bureaucracy infected throughout by the pitch culture? The PowerPoint monopoly and the consequent lack of innovative and high-quality software for technical communication? A Conway's Law interaction of causes? Some or all of these factors? In what proportion?

Sorting all this out is not possible. Nonetheless, under most reasonable allocations of causal responsibility, the practical advice remains the same: To make smarter presentations, try smarter tools. Technical reports are smarter than PowerPoint. Sentences are smarter than the grunts of bullet points. PP templates for statistical graphics and data tables are hopeless.

ART historians reason about the causes of visual presentations. What can we learn from their work? To explain artistic productions, art historians make use of 4 grand explanatory variables: (1) differences in styles in art, (2) differences in artists working within a given style, (3) interplay among artists and styles, and (4) sources of new styles.

The prevailing *style* of a particular place and period deeply affects the character of art work. Art history textbooks are written as narratives of distinctive, clearly identifiable styles: Prehistoric, Egyptian, Near Eastern, Classical, Byzantine, Islamic, Baroque, Renaissance, Far Eastern, African, Romanticism, Impressionism, Cubism, and many other distinct styles. In the long history of representational art, the represented objects did not change all that much, nor did artists' retinal images of those objects. The big changes in art resulted from changes in style. Style matters.

Those caught up *within a single style* of visual production, however, must necessarily explain differences in quality by reference to the skills and character of particular presenters, for style is a given. This is the method of the standard defense of PowerPoint, a defense that mobilizes the second grand explanatory variable, presenter variability, as the determinant of visual productions. Lousy presentations are said to be *the fault of inept PP users, not the fault of PP.* Blame the user, not the cognitive style of the presentation tool, not the PP pitch culture.

That is sometimes the case, but causal responsibility for presentations is more complicated than that. Other explanatory variables of visual productions—cognitive style and quality of the presentation tools, user-style interactions, context, character of the content—must be taken into account. Thus Orwell's Principle, for example, sensibly avoids mono-causal explanations: "The English language becomes ugly and inaccurate because our thoughts are foolish, but the slovenliness of our language makes it easier for us to have foolish thoughts." And so our comparisons

of the PP cognitive style with other tools; thus our analysis of the PP metaphors of marketing and hierarchy at work and play in bureaucracies.

What about modest incremental reforms in the cognitive style of PowerPoint? There are inherent problems in PP, and also the record is not promising. Throughout many versions of PP, the intellectual level and analytical quality has rarely improved. New releases feature more elaborated PP Phluff and therapeutic measures for troubled presenters. These self-parodying elaborations make each new release *different* from the previous version—but not smarter. PP competes largely with itself: there are few incentives for meaningful change in a monopoly product with an 86% gross profit margin (as reported in antitrust proceedings). In a competitive market, producers improve and diversify products; monopolies have the luxury of blaming consumers for poor performances. It is scandalous that there is no coherent software for serious presentations.

A better cognitive style for presentations is needed, a style that respects, encourages, and cooperates with evidence and thought. PowerPoint is like being trapped in the style of early Egyptian flatland cartoons rather than using the more effective tools of Renaissance visual representation.

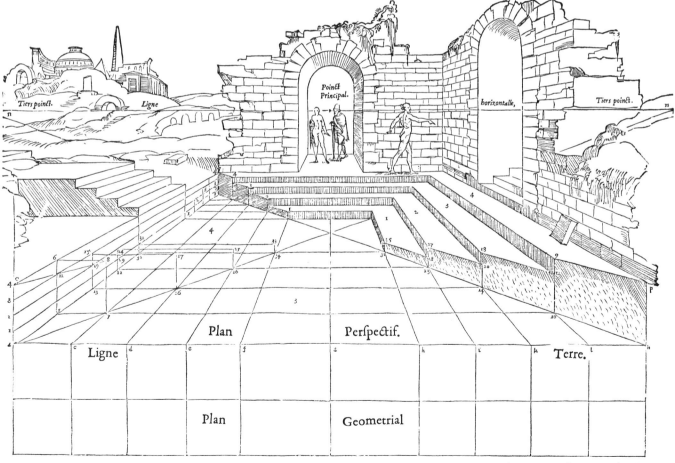

Jean Cousin, *Livre de perspective* (Paris, 1560), I iij.

Improving Presentations

AT a minimum, we should choose presentation tools that *do no harm* to content. Yet PowerPoint promotes a cognitive style that disrupts and trivializes evidence. PP presentations too often resemble a school play: very loud, very slow, and very simple. Since 10^{10} to 10^{11} PP slides are produced yearly, that is a lot of harm to communication with colleagues.

PowerPoint is a competent slide manager, but a Projector Operating System should not impose Microsoft's cognitive style on our presentations. PP has some occasionally competent low-end design tools and way too many Phluff tools. PP might help show a few talking points at informal meetings, but instead why not simply print out an agenda for everyone?

For serious presentations, replace PP with word-processing or page-layout software. Making this transition in large organizations requires a straightforward executive order: *From now on your presentation software is Microsoft Word, not PowerPoint. Get used to it.*

Someday there will be a good technical reporting tool. Focused on evidence analysis and display, this tool should combine a variety of page and screen layout templates (based on formats for serious news reports, an article in *Nature*, Feynman's physics textbook, and so on); publication-quality statistical graphics and tables; scientific notation and typography; graphics tools for placing annotated measurement scales in images; spellchecking for technical terms; *within-document* editing of words, tables, graphics, and images; *open-document* non-proprietary formats; fast color printing for large paper; and a slide manager for talks.

At a talk, paper handouts of a technical report effectively show text, data graphics, images. Printed materials bring information transfer rates in presentations up to that of everyday material in newspaper sports and financial pages, books, and internet news sites. An excellent paper size for presentation handouts is A3, 30 by 42 cm or about 11 by 17 inches, folded in half to make 4 pages. That one piece of paper, the 4-pager, can show images with 1,200 dpi resolution, up to 60,000 characters of words and numbers, detailed tables worthy of the sports pages, or 1,000 sparkline statistical graphics showing 500,000 numbers. *That one piece of paper shows the content-equivalent of 50 to 250 typical PP slides.* Thoughtful handouts at your talk demonstrate to the audience that you are responsible and seek to leave permanent traces and have consequences. Preparing a technical report requires deeper intellectual work than simply compiling a list of bullets on slides. Writing sentences forces presenters to be smarter. And presentations based on sentences make consumers smarter as well.

Serious presentations might well begin with a concise briefing paper or technical report (the 4-pager) that everyone reads (people can read 3 times faster than presenters can talk). Following the reading period, the presenter might provide a guided analysis of the briefing paper and then encourage and perhaps lead a discussion of the material at hand.

Consuming Presentations

OUR evidence concerning PP's performance is relevant only to serious presentations, where the audience needs (1) to understand something, (2) to assess the credibility of the presenter. For non-serious pitches and meetings, the PP cognitive style may not matter all that much. Rather than providing information, *PowerPoint allows speakers to pretend that they are giving a real talk, and audiences to pretend that they are listening.* This prankish conspiracy against evidence and thought should provoke the question, *Why are we having this meeting?*

Consumers of presentations might well be skeptical of speakers who rely on PowerPoint's cognitive style. It is possible that these speakers are not evidence-oriented, and are serving up some PP Phluff to mask their lousy content, just as this massive tendentious pedestal in Budapest once served up Stalin-cult propaganda to orderly followers feigning attention.

Military parade, Stalin Square, Budapest, April 4, 1956. Photograph by AP/Wide World Photos.

Sculptural Pedestals: Meaning, Practice, Depedestalization

APPEARING at this notable Pedestal Garden are a diversity of concrete parallelepipeds of substantial presence. Such pedestals may help conserve outdoor bronzes. But, by intervening between the lawn underneath and the beautiful artwork above, these blocky platforms compete with art and define the garden's visual space. Their solid embedded permanence turns the sculptures into visitors. Gently contoured ground and lower, darker pedestals would provide more serene local horizons for the pieces.[1]

UNITY of pedestal and sculpture at the Pedestal Garden can be achieved by translucent plastic wraps, providing a common visual language that diminishes the pieces but calms down the blocky boxes.

[1] On placing artwork *indoors*, see Victoria Newhouse, *Art and the Power of Placement* (New York, 2005).

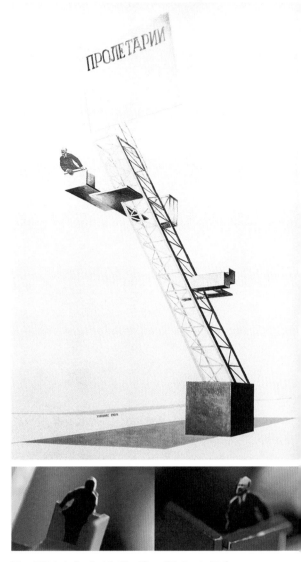

AT right, The Great Designer Pedestal elevates The Great Leader. Leaning like Lenin, El Lissitzky's structure, the *Lenin Tribune* (1920-1924), brought graphic modernism to totalitarian pedestal engineering. Designer Lissitzky and client Lenin both get to show their stuff. (At that very moment in high art, however, the sculptural pedestal was on its way to history's dustbin.) If built, this pedestal would have levitated Lenin's unamplified voice, winded by the long climb up the ladder, to fully 17 meters (56 feet) distant from the *closest* audience member. A massive base cube pedestalizes the pedestal-frame itself, as the whole thing casts an improbable shadow similar to the fantasy shadows found in architectural plans presented to clients other than Lenin. Perhaps those shadows represent memory-traces of a destroyed platform that once uplifted a statue of the previous Maximum Leader, the Tsar. And is that a PowerPoint slide projected up behind Lenin?

SCULPTURAL mass in three-space is an inevitable prisoner of gravity; the earth resists, supports, aligns the piece. Representing the physical and symbolic transition from ground–flatland to sculpture-spaceland, the intersection of land and sculpture announces the beginning of art. Sculptors make the initial statement about intersection of figure and ground but that is hardly the last word. Other influences operate and compete at this intersection: clients, architects, curators, planning boards, building code inspectors, and the Maintenance Department of Museum Buildings and Grounds. Once the artwork is complete, its time stops, while the bureaucracies overseeing artwork presentation tinker on and on forever, sometimes cooperating with the art, sometimes not. How can the integrity, coherence, beauty, and dignity of sculpture survive installation and maintenance? More generally, how can the integrity of creative productions be enhanced—or at least not be corrupted— by the bureaucracies of presentation?

What are architects and curators thinking when they pedestalize sculptures on alien blocks? Now and then, pedestals lift the piece to beautiful, changing, and uncluttered backgrounds of sky and light. More often, pedestalization is Sculpture's equivalent of Data Graphic's chartjunk and PowerPoint's Phluff. At higher levels of modern achievement, sculpture-on-a-pedestal has faded away, replaced by grounded abstract pieces. Pedestalized great leader statues now appear as corny hackwork. Richard Serra describes the rejection by sculptors of autocratic bunkers that diminish artworks and viewers, that pitch out and corrupt within:

> The biggest break in the history of sculpture in the twentieth century was to remove the pedestal. The historical concept of placing sculpture on a pedestal was to establish a separation from the behavioral space of the viewer. "Pedestalized" sculpture invariably transfers the effect of power by subjugating the viewer to the idealized, memorialized or eulogized theme. As soon as art is forced or persuaded to serve alien values it ceases to serve its own needs. To deprive art of its usefulness is to make other than art.[2]

Top, El Lissitzky (with Ilia Chasnik), *Lenin Tribune*, 1920-1924, photomontage. Architectural model of *Lenin Tribune* by Paul Groenendijk, Piet Vollard, Arthur Meyer, and Melchior van Dansik.

[2] Richard Serra, *Writings Interviews* (Chicago, 1994), 170-171. For the history, see Jack Burnham, "Sculpture's Vanishing Base," *Beyond Modern Sculpture* (New York, 1968), 19-48.

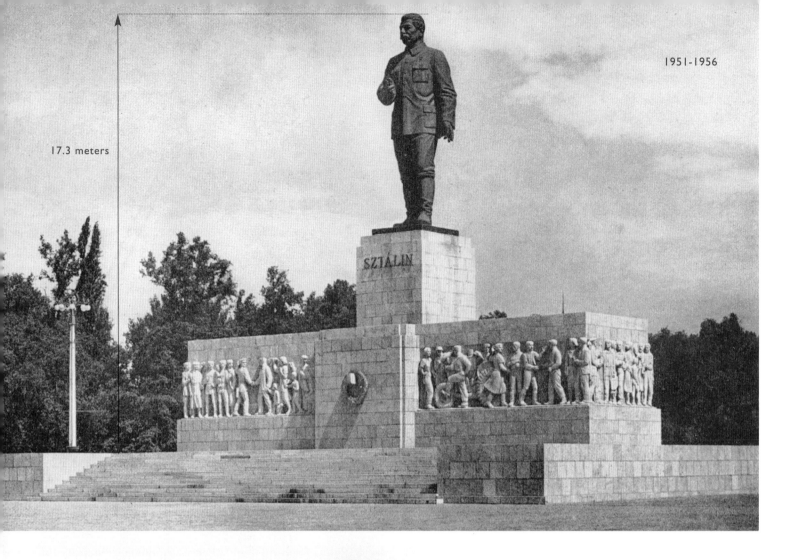

17.3 meters

1951-1956

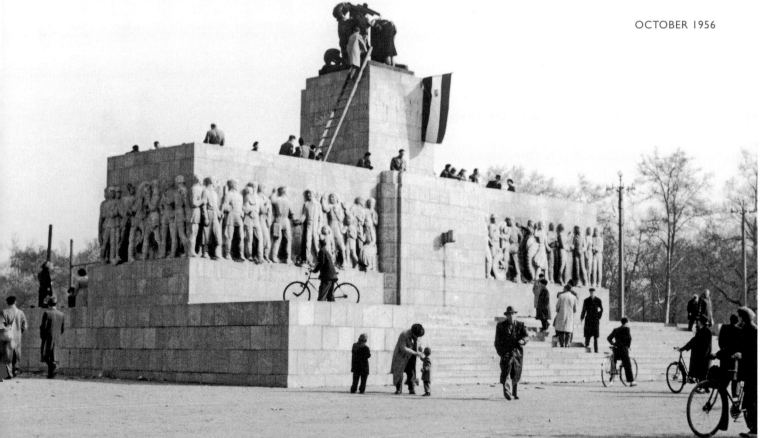

OCTOBER 1956

OCTOBER 1956

OCTOBER 1956

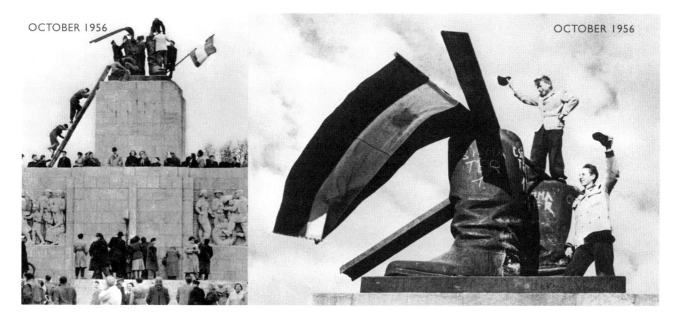

HERE are some architectural redesign strategies for pedestals, and the piece itself.[3] At far left a wedding-cake Stalin is promoted by big blocks to a total height of 17.3 meters (57 feet), matching Lenin's elevation by El Lissitzky. Stalin is shown as a speaker about to begin a presentation, his hand half-raised in an *ad locutio* gesture. Installed in Budapest during 1951, the statue was torn down the night of 23 October 1956 during mass protests against the communist regime in Hungary.

People gathered at the empty plinth and stood on the tribune where party leaders had watched parades and military displays. After the Great Leader's depedestalization and demolition, 2 vivid symbols remained: empty boots and an empty pedestal. Stalin's gigantic boots (above right) stayed in place, irreverent, defaced, empty. Ten days later, Soviet troops suppressed the Hungarian revolution. The disembodied plinth remained 11 more years, a reviewing platform for party leaders and government officials, a stony symbol of their longevity not Stalin's.

All told the meaning of the base-plinth came to exceed that of the statue it once supported. Eventually even the plinth vanished, leaving behind now a faint memory-trace on the plaza flatland:

[3] These two pages are co-authored with Reuben Fowkes, based on his "The Role of Monumental Sculpture in the Construction of Socialist Space in Stalinist Hungary," in *Socialist Spaces: Sites of Everyday Life in the Eastern Bloc*, edited by David Crowley and Susan E. Reid (Oxford, 2002), 65-84; Anders Åman, *Architecture and Ideology in Eastern Europe During the Stalin Era* (New York, 1992), 192-197; and Sergiusz Michalski, *Public Monuments: Art in Political Bondage 1870-1997* (London, 1998), 140-143.

Picture sources: Stalin statue, Lyka Károly, *Budapest szobrai* (Budapest, 1955); days after demolition, Géza Boros, *Statue Park* (Budapest, 2002); Stalin's boots, National Museum Photo Archive, Budapest; plinth traces, photograph by Reuben Fowkes.

DECEMBER 2002

DEPEDESTALIZATION in the Budapest style, where pedestals achieve new meaning by the absence of the pedestalized, requires engineering analysis and a shrewd sense of political mischief. Ryszard Kapuściński describes the daring Golam, a persistent and skilled rigger of Shahs of Iran (father and son) statue depedestalization. This account illuminates the craft of a serious critic, who one hopes avoids trashing works of artistic or historic merit:

> The picture clipped from a newspaper shows a monument of a man on a horse, atop a tall granite pedestal. The rider, a figure of herculean build, is seated comfortably in the saddle, his left hand resting on its horn, his right pointing to something ahead (probably the future). A rope is tied around the neck of the rider, and a similar rope around that of his mount. In the square at the base of the monument stand groups of men pulling on the two lines. All this is taking place in a thronged plaza, with the crowd watching as the men tugging on the ropes strain against the resistance of the massive bronze statue. The photograph captures the very moment when the ropes are stretched tight as piano wires and the rider and his mount are just tilting to the side—an instant before they crash to earth. We can't help wondering if these men pulling ropes with so much effort and self-denial will be able to jump out of the way, especially since the gawkers crowded into the plaza have left them little room. This photograph shows the pulling down of a monument to one of the Shahs (father or son) in Teheran or some other Iranian city. It is hard to be sure about the year the photograph was taken, since the monuments of both Pahlavis were pulled down several times, whenever the occasion presented itself to the people.

> A reporter from the Teheran newspaper *Kayhan* interviewed a man who wrecks monuments to the Shah:

> *You've won a certain popularity in your neighborhood, Golam, as a man who pulls down monuments. You're even regarded as a sort of veteran in the field.*

> That's right. I first pulled down monuments in the time of the old Shah, the father of Mohammed Reza, when he abdicated in 1941. I remember what great joy there was in the city when news got around the old Shah had stepped down. Everybody rushed out to smash his monuments. I was just a young boy then, but I helped my father and the neighbors pull down the monument that Reza Khan had set up to himself in our neighborhood. I could say that that was my baptism of fire.

> *Were you persecuted for it?*

> Not on that occasion.

> *Do you remember 1953?*

> Of course I remember, that most important year when democracy ended and the regime began. In any case, I recall the radio saying that the Shah had escaped to Europe. When the people heard that, they went out into the street and started pulling down the monuments. And I have to say that the young Shah had been putting up monuments to himself and his father from the beginning, so over the years a lot accumulated that needed pulling down. My father was no longer alive then, but I was grown up and for the first time I brought them down on my own.

So did you destroy all his monuments?

Yes, every last one. By the time the Shah came back, there wasn't a Pahlavi monument left. But he started right back in, putting up monuments to himself and his father.

Does that mean that you would pull down, he would set up, then you would pull down what he had set up, and it kept going on like this?

That's right. Many times we nearly threw in the towel. If we pulled one down, he set up three. If we pulled down three, he set up ten. There was no end in sight.

And when was the next time, after 1953, that you wrecked them again?

We intended to go to work in 1963, when the rebellion broke out after the Shah imprisoned Khomeini. But instead the Shah began such a massacre that, far from pulling down monuments, we had to hide our ropes.

Am I to understand you had special ropes for the job?

Yes indeed! We hid our stout sisal rope with a rope-seller at the bazaar. It was no joke. If the police had picked up our trail, we would have gone to the wall. We had everything prepared for the right moment, all thought out and practiced. During the last revolution, I mean in 1979, all those disasters happened because a lot of amateurs were knocking down monuments, and there were accidents when they pulled the statues onto their own heads. It's not easy to pull down monuments. It takes experience, expertise. You have to know what they're made of, how much they weigh, how high they are, whether they're welded together or sunk in cement, where to hook the line on, which way to pull, and how to smash them once they're down. We were already working at pulling it down each time they set up a new monument to the Shah. That was the best chance to get a good look and see how it was built, whether the figure was hollow or solid, and, most important, how it was attached to the pedestal and how it was reinforced.

It must have taken up a lot of your time.

Right! More and more monuments were going up in the last few years. Everywhere – in the squares, in the streets, in the stations, by the road. And besides, there were others setting up monuments as well. Whoever wanted to get a jump on the competition for a good contract hurried to be the first one to put up a monument. That's why a lot of them were built cheaply and, when the time came, they were easy to bring down. But, I have to admit, there were times when I doubted we'd get them all. There were hundreds of them. But we weren't afraid to work up a sweat. My hands were all blisters from the ropes.

So, Golam, you've had an interesting line of work.

It wasn't work. It was duty. I'm very proud to have been a wrecker of the Shah's monuments. I think that everyone who took part is proud to have done so. What we did is plain for all to see. All the pedestals are empty, and the figures of the Shahs have either been smashed or are lying in backyards somewhere.[4]

[4] Ryszard Kapuściński, *Shah of Shahs* (Orlando, Florida, 1985), translated from the Polish by William R. Brand and Katarzyna Mroczkowska-Brand, 134-137.

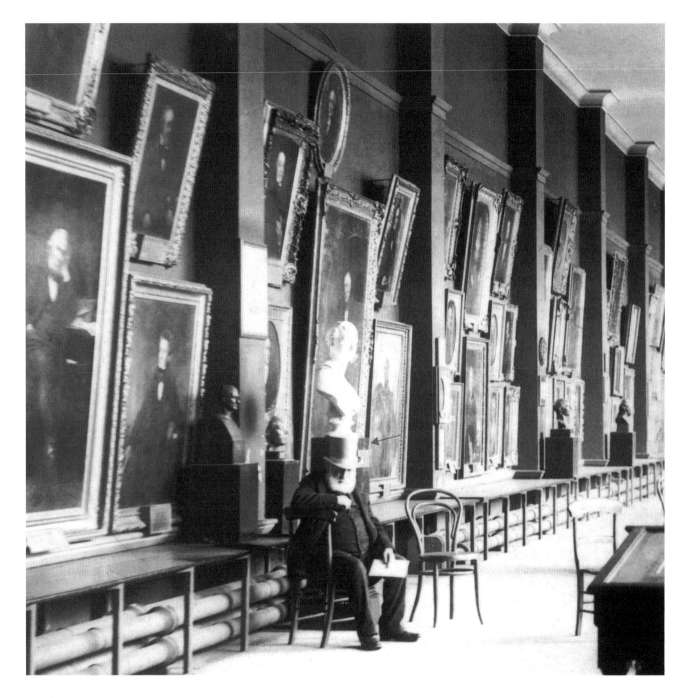

IN the Pedestal Garden, the parallelepipeds presenting sculptures are impediments to seeing. Similarly, at London's National Portrait Gallery in 1885, the 3-dimensional frames, occupying a third of the visual space, overwhelm the flat paintings. Pedestal blocks rest heavily on the long table. These ostentatious bureaucracies of display—including the bulky director, whose indoor hat appears to serve conveniently as a sculptural pedestal—dominate the scene. Like pedestals, all-purpose big-deal picture frames did not thrive in the 20th-century.

Above, the National Portrait Gallery at South Kensington, 1885, photograph (detail) by Praetorius and Messrs. Wood & Co., as shown in Jacob Simon, *The Art of the Picture Frame* (London, 1996), 148.

5 "A rare Khmer, Baphuon style, sandstone figure of probably Sadasiva, 11th century, item 154," *Indian, Himalayan and Southeast Asian Art,* Christie's Amsterdam, 18 October 2005.

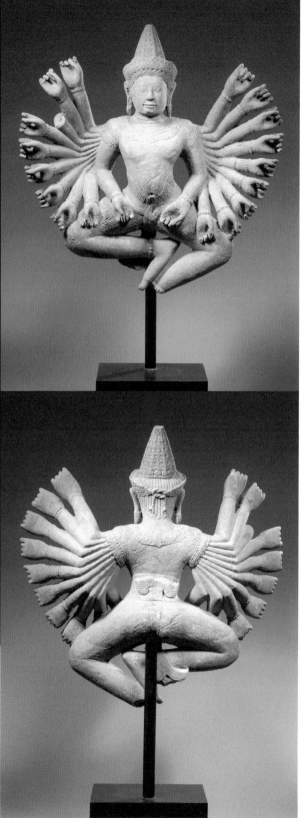

THIS 11th-century sandstone work "represents Siva in his Sadasiva manifestation. . . . his 20 hands are raised in the gesture of teaching."[5] The 3-dimensional multiplicity, shown directly above, subtly integrates and confounds the spatial and the temporal (2 arms moving, or 20 still?). Unfortunately the front and back views at right reveal an unforgettably rude pedestal-perch that undermines the sculpture's spirit.

AT the base of David Smith's *Cubi XXVI*, sculptural volumes generate relationships among themselves, with the grass beneath, and in the air. On stainless steel surfaces, beautiful natural colors result from interplay of sunlight, steel, grass. Above left, however, a small exposed concrete base creates a flat unsculptural shape in the grass along with a light gap underneath between the stainless steel cube and the concrete block. Above right, the *Cubi XXVI* concrete block is altered photographically to bring the grass right to the piece. The actual practical engineering to allow sculptures to land without incident is usually not that difficult.

Below, another *Cubi* sits cleanly on a verdant lawn. It is, however, held down by anomalous clamps, covering part of Smith's welded inscription. Surely a better engineering solution to secure the piece can be found. Would a museum allow a picture frame to cover a painter's mark?

David Smith, *Cubi XXVI* (1965), detail, National Gallery of Art Sculpture Garden, Washington, DC.

David Smith, *Cubi VII* (1963), detail, sculpture garden, Art Institute, Chicago. Smith's welded inscription on the base-plane reads:

David Smith March 28 1963 Cubi VII

Another fine David Smith piece, *Cubi XII*, is installed at the Hirshhorn
Sculpture Garden in Washington, DC. A thoughtfully engineered base
brings the stainless steel sculpture serenely down on the land:

David Smith, *Cubi XII* (1963), detail
of mounting base, Hirshhorn Sculpture
Garden, Washington, DC.

SCULPTURES, especially large abstract landscape works, interact with
their surroundings. This sculptural context helps to create and hold
the space around every work, the space that the viewer sees and walks
through. Except for some fortunate installation art, the surrounding
arena is rarely under artistic control. Yet the relevant issue is *how a work
alters a given site,* as Richard Serra pointed out. Better that the artwork
is the event not the presentation design, and that the installation avoids
The Fallacy of the Pedestal: *The insertion of arbitrary visual events between
artworks and their ground and space, events created by the bureaucracies of
presentation, not sculptors.*

Landscape Sculptures: My Back Pages

I CONCLUDE with my landscape installation sculptures that sit directly
on the grass or float free in Birdspace. For support, those works on the
land have elaborate structural bases, buried entirely in the earth.

THESE landscape sculptures, along with the material on pedestals,
begin an exit from the flatlands of paper and computer screen, where
things are represented, and an entry into the realities of spaceland.
The sculptures serve, in part, to provide experiences with *walking,
seeing, and constructing*—the topic of the next book.

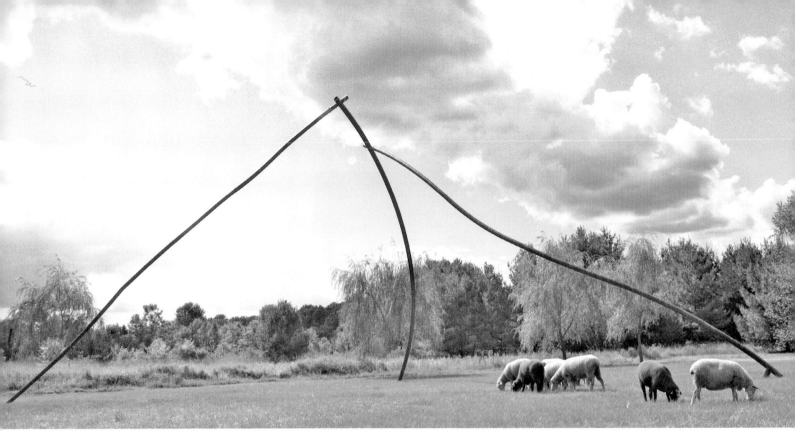

LARKIN'S TWIG 2004 steel footprint 59 × 66 × 70 feet, height 32 feet

Edward Tufte footprint 18 × 20 × 21 meters, height 10 meters

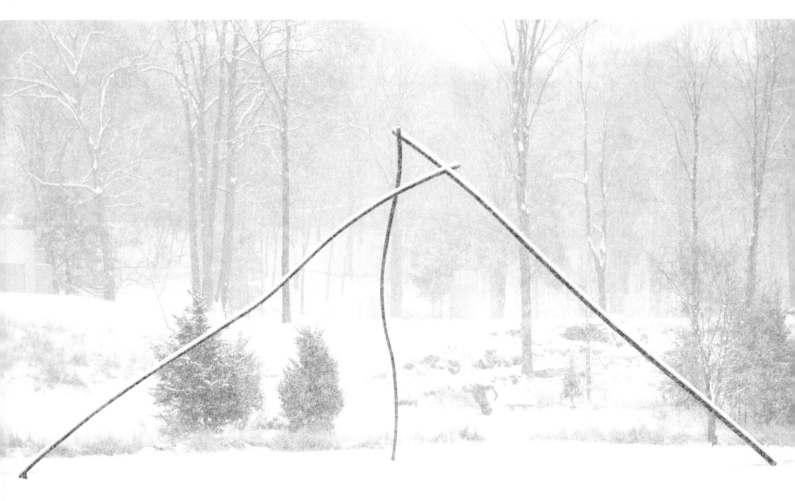

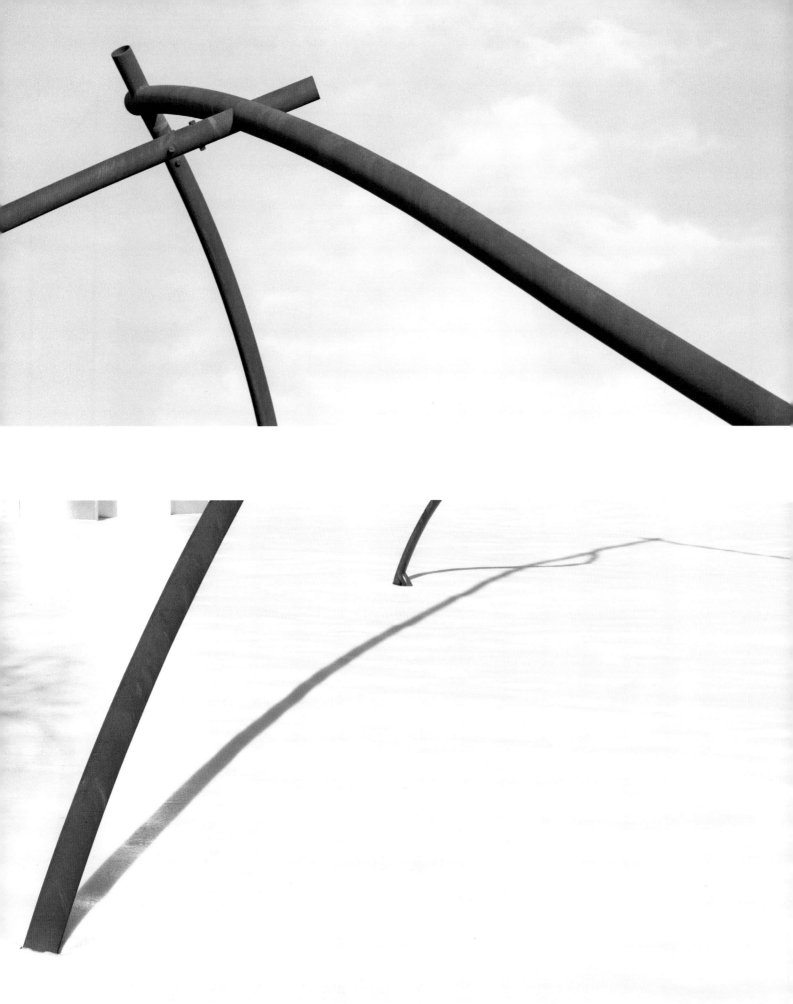

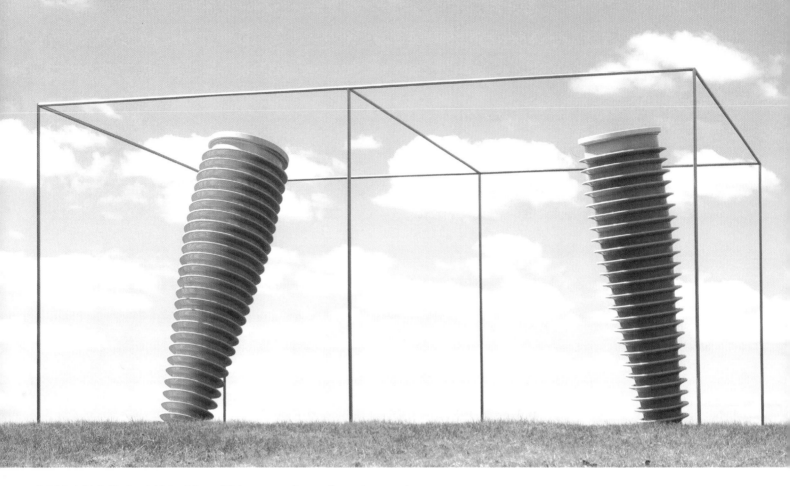

DEAR LEADER I 2006 Edward Tufte porcelain and stainless steel
21´ 6˝ × 14´ × height 10´ 6˝ or 6.6 × 4.3 × height 3.2 meters

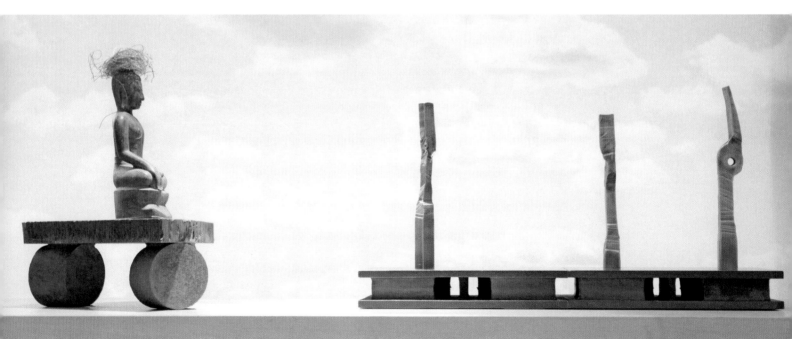

BUDDHA MOBILE 2009 Edward Tufte
bronze, steel, bird's nest
18˝ × 14˝ × height 18˝ or .5 × .4 × height .5 meters

THREE TONG FORGINGS 2010 Edward Tufte steel
28˝ × 10˝ × height 15˝ or .7 × .2 × height .4 meters

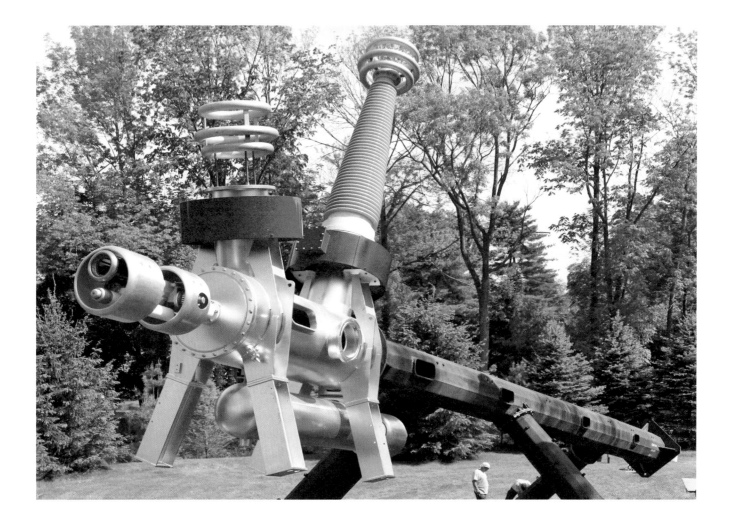

ROCKET SCIENCE 2, LUNAR LANDER 2009 Edward Tufte steel, aluminum, porcelain
length 70′ or 21.3 meters, height 35′ or 10.7 meters

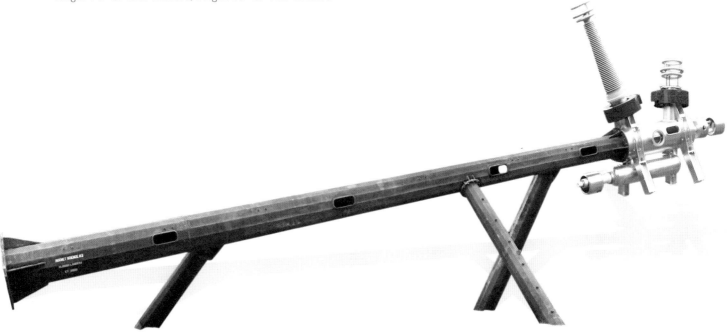

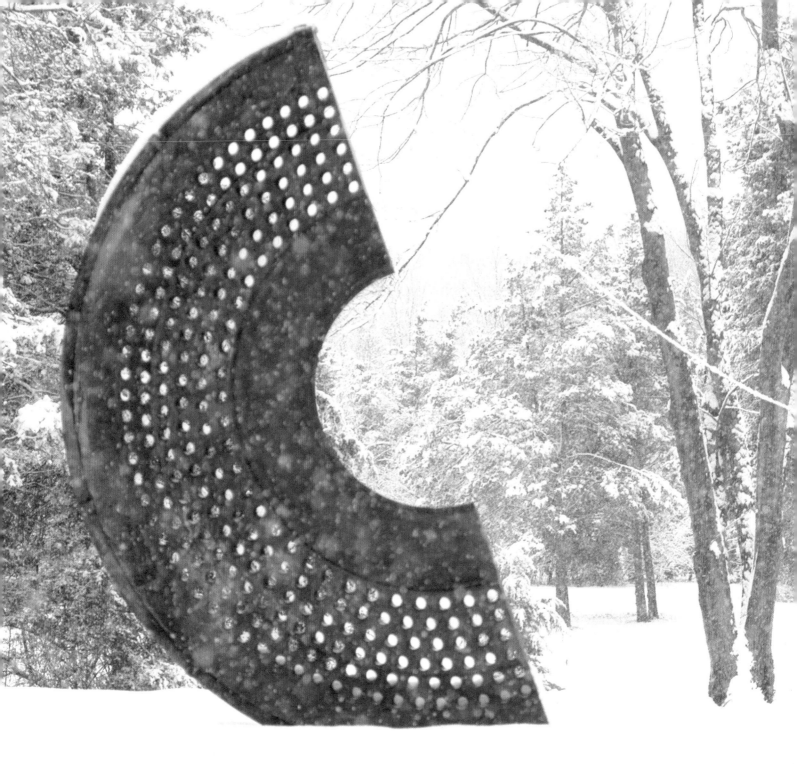

MILLSTONE 3 and MILLSTONE 1 2003

Edward Tufte

mild steel

diameter height 13´ 8˝ or 4.2 meters

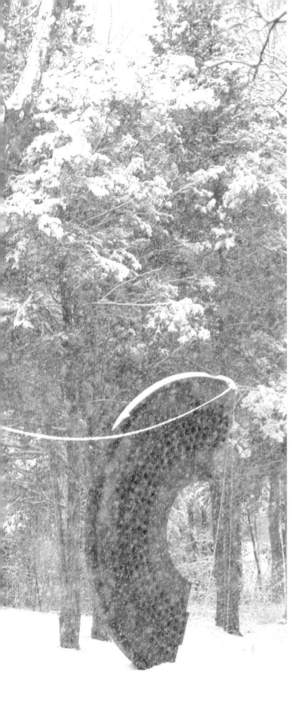

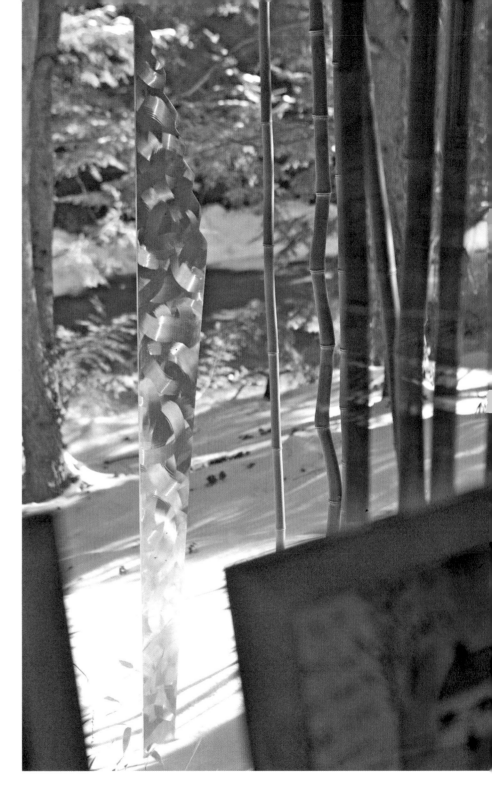

BOUQUET 5 2007
Edward Tufte
stainless steel, single action grinding
height 6′ 10″ or 2.1 meters

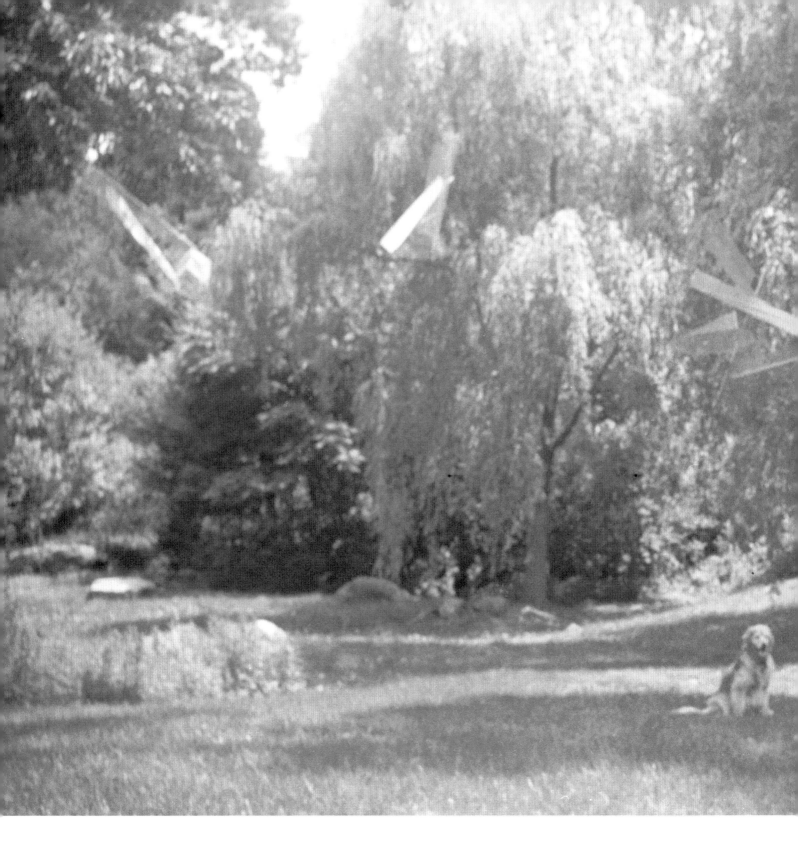

BIRDS 11, 14, 15, 16, 18 2005-2006
Edward Tufte
anodized aluminum
variable sizes ~60 × 40 × 80 inches or ~1.5 × 1.0 × 2.0 meters
photograph by Dmitry Krasny

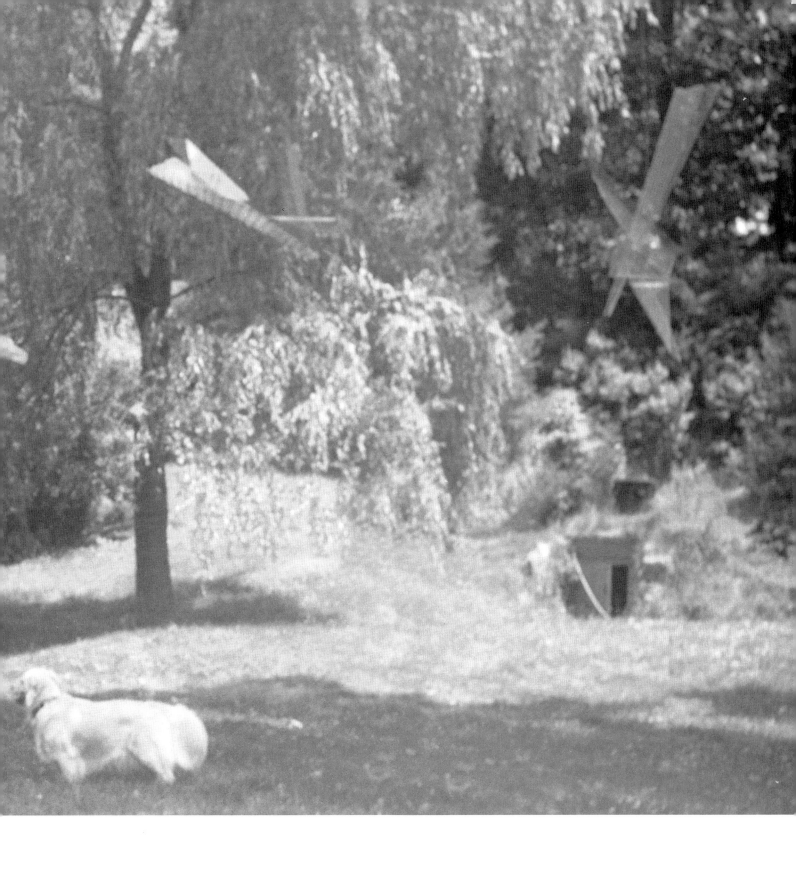

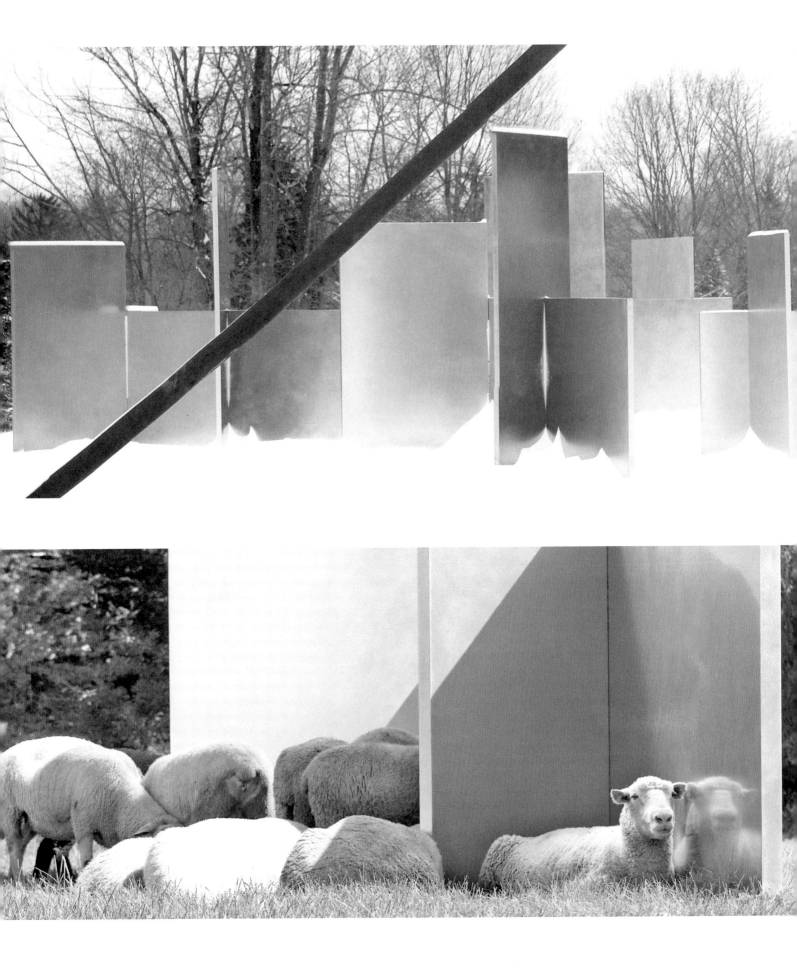

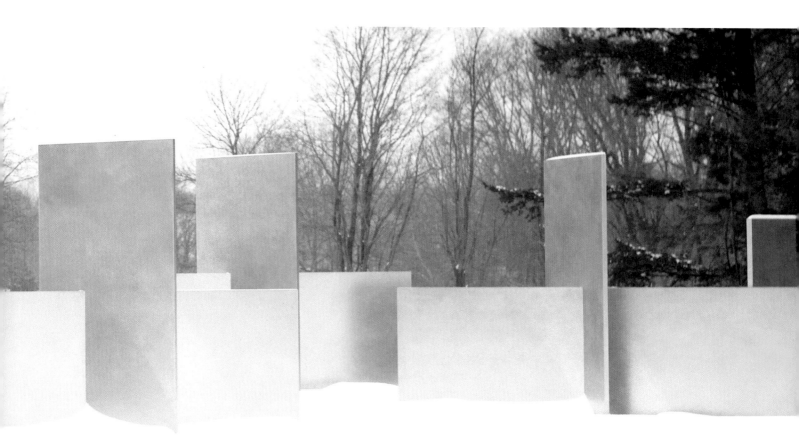

ESCAPING FLATLAND 5-10 2001-2002 Edward Tufte stainless steel width 50 feet or 15 meters

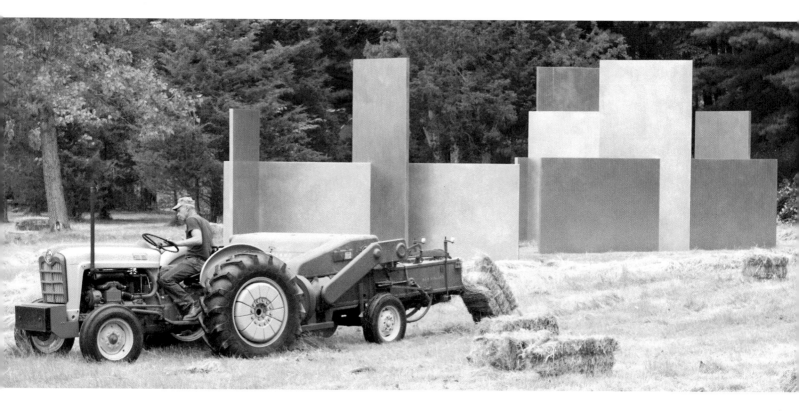

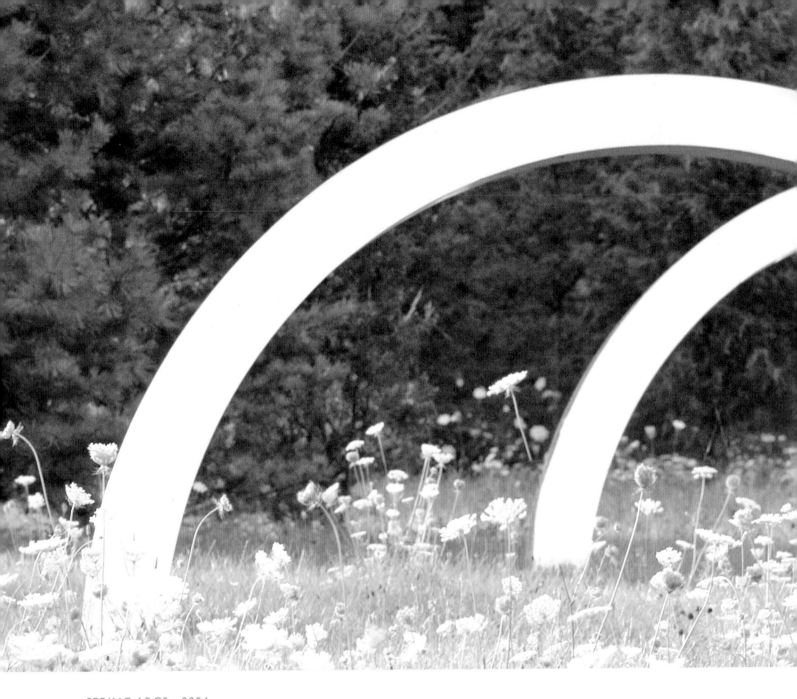

SPRING ARCS 2004

Edward Tufte

solid stainless steel, arc diameter 12 feet or 3.7 meters

footprint 12 × 67 feet, height 6 feet or 3.7 × 20.4 meters, height 1.8 meters